PENGUIN BOO

OLD MASTERS, NEW WORLD

A former reporter for *Forbes* and *The Wall Street Journal*, Cynthia Saltzman earned degrees in art history at Harvard and Berkeley and an MBA at Stanford. Her last book, *The Portrait of Dr. Gachet*, was a Barnes and Noble Discover Great New Writers selection.

Praise for *Old Masters, New World*

"*Old Masters, New World,* a lively, knowledgeable chronicle of a three-decade buying spree that relocated some of the Western world's most venerated paintings to the homes of American millionaires and, eventually, the museums they endowed. . . . Saltzman's graceful prose is equally effective in conveying the aesthetic splendor of an Old Master and the sharp financial maneuvers of an art dealer." —*Chicago Tribune*

"Cynthia Saltzman has written a history as luminous as some of the canvases her Gilded Age moguls collected. A superb telling of how America's entrepreneurs came into possession of Europe's most beautiful paintings."
 —James Grant, author of *Money of the Mind*

"A vividly narrated and highly informative study . . . Saltzman deftly demonstrates that the often highly competitive process and volatile acquisition of cultural capital by dealers and their eager employers gives fascinating and important insight into the often fraught fusion of the culture and commodity that built world-class American collections." —*Publishers Weekly*

"Cynthia Saltzman offers the reader a fascinating and fabulous peek into the Gilded Age, when vulgar tycoons and stuffy patricians competed shamelessly to own the best that Europe could offer."
 —Dr. Amanda Foreman, author of *Georgiana: Duchess of Devonshire*

"[Saltzman] draws on both her art history and business backgrounds in this vivacious, anecdotal, and perceptive chronicle of the 'great migration of art' across the Atlantic. . . . Art lovers will be thoroughly entertained by these tales of masterpiece fever." —*Booklist*

"By focusing on individual collectors, collections, and even on the often fascinating stories of individual paintings, Saltzman brings this fast-paced, high-stakes world vividly to life. . . . Appealing to history buffs, art lovers, and biography fans, *Old Masters, New World* will certainly give visitors to our country's premier art museums something new to ponder." —*BookPage*

Old Masters, New World

AMERICA'S RAID ON

EUROPE'S GREAT PICTURES

Cynthia Saltzman

Penguin Books

PENGUIN BOOKS
Published by the Penguin Group
Penguin Group (USA) Inc., 375 Hudson Street, New York, New York 10014, U.S.A.
Penguin Group (Canada), 90 Eglinton Avenue East, Suite 700, Toronto,
Ontario, Canada M4P 2Y3 (a division of Pearson Penguin Canada Inc.)
Penguin Books Ltd, 80 Strand, London WC2R 0RL, England
Penguin Ireland, 25 St Stephen's Green, Dublin 2, Ireland (a division of Penguin Books Ltd)
Penguin Group (Australia), 250 Camberwell Road, Camberwell,
Victoria 3124, Australia (a division of Pearson Australia Group Pty Ltd)
Penguin Books India Pvt Ltd, 11 Community Centre,
Panchsheel Park, New Delhi – 110 017, India
Penguin Group (NZ), 67 Apollo Drive, Rosedale, North Shore 0632,
New Zealand (a division of Pearson New Zealand Ltd)
Penguin Books (South Africa) (Pty) Ltd, 24 Sturdee Avenue,
Rosebank, Johannesburg 2196, South Africa

Penguin Books Ltd, Registered Offices:
80 Strand, London WC2R 0RL, England

First published in the United States of America by Viking Penguin,
a member of Penguin Group (USA) Inc. 2008
Published in Penguin Books 2009

1 3 5 7 9 10 8 6 4 2

THE LIBRARY OF CONGRESS HAS CATALOGED THE HARDCOVER EDITION AS FOLLOWS:
Saltzman, Cynthia.
Old masters, new world : America's raid on Europe's great pictures / Cynthia Saltzman.
p. cm.
Includes bibliographical references and index.
ISBN 978-0-670-01831-4 (hc.)
ISBN 978-0-14-311531-1 (pbk.)
1. Painting, European. 2. Painting—Collectors and collecting—United States—History—
19th century. 3. Painting—Collectors and collecting—United States—History—20th century.
4. Painting—Europe—Marketing—History—19th century. 5. Painting—Europe—
Marketing—History—20th century. I. Title.
ND450.S25 2008
759.94075—dc22 2008022141

Printed in the United States of America
Designed by Nancy Resnick

For Warren, Matthew, and William

Contents

List of Illustrations ix

Introduction 1

Part One: The Collectors

I. "American Citizen . . . Patron of Art" 11
 Henry Gurdon Marquand and van Dyck's Portrait of James Stuart

II. "C'est Mon Plaisir" 45
 Isabella Stewart Gardner, Bernard Berenson, Otto Gutekunst,
 and Titian's *Europa*

III. "Mr. Morgan Still Seems to Be Going on His Devouring
 Way" 93
 J. Pierpont Morgan, Raphael's Colonna Madonna, Gainsborough's
 Georgiana, Reynolds's *Lady Elizabeth Delmé,* and Lawrence's
 Elizabeth Farren

IV. "Greco's Merit Is That He Was Two Centuries Ahead
 of His Time" 109
 Mary Cassatt, Harry and Louisine Havemeyer, Spain, and El Greco

V. "A Picture for a Big Price" 145
 Henry Clay Frick, Charles Carstairs, Otto Gutekunst, and
 the Ilchester Rembrandt

Part Two: The Painting Boom

VI. "Octopus and Wrecker Duveen" 199
 Joseph Duveen Enters the Old Master Market

VII. "Highest Prizes of the Game of Civilization" 213
 Holbein's *Christina of Denmark*, Rembrandt's *Polish Rider*,
 Velázquez's *Philip IV*, Three Vermeers, and Record Prices

VIII. "Thanks Not in [the] Market at Present" 231
 Bellini's *St. Francis* and Falling Prices

Part Three: The Great War and the Picture Market

IX. "If This War Goes On, Many Things Will Be for Sale" 241
 Old Master Spoils

X. *The Feast of the Gods* 253
 Bellini and Titian's Masterpiece Comes on the Market

Epilogue 261

Acknowledgments 267

Notes 271

Bibliography 309

Index 325

List of Illustrations

TEXT

Page

2 Henry James, ca. 1906.

11 Corsham Court, Wiltshire.

15 The Picture Gallery, Corsham Court, ca. 1890.

24 John White Alexander, *Henry G. Marquand,* 1896.

30 Frederick, 2nd Baron Methuen.

44 The Metropolitan Museum of Art—Fifth Avenue facade, 1917.

48 Isabella Stewart Gardner, 1888.

56 Isabella Stewart Gardner and a gondolier on the Grand Canal, 1894.

59 Bernard Berenson, 1886.

65 Bernard Berenson at Villa I Tatti, 1903.

66 Bernard Berenson and Mary Berenson in England, 1901.

87 Otto Gutekunst.

91 Isabella Stewart Gardner, ca. 1915.

94 J. Pierpont Morgan, 1902.

103 Thomas Gainsborough, *Georgiana, Duchess of Devonshire,* 1785–88.

111 H. O. Havemeyer and Louisine W. Elder, ca. 1883.

122 Mary Cassatt, *Portrait of the Artist,* 1878.

133 Paul Durand-Ruel, ca. 1910.

147 Henry Clay Frick, ca. 1880.

153 Adelaide Childs Frick, 1901.

165 Adelaide Frick and Roland Knoedler playing cards, 1904.

169 Charles Carstairs, ca. 1928.

181 Cable from Charles Carstairs to Henry Clay Frick, November 5, 1906.

201 Joseph Duveen, ca. 1900.

210 Sir Joshua Reynolds, *Elizabeth, Lady Taylor*, ca. 1780.

228 Raphael, *The Small Cowper Madonna*, ca. 1505.

236 Hans Holbein, the Younger, *Thomas Cromwell*, 1532–33.

252 Arthur Morton Grenfell, ca. 1914.

256 Isabella Stewart Gardner, ca. 1910.

262 Courtyard, Isabella Stewart Gardner Museum, 1915.

265 John Singer Sargent, *Mrs. Gardner in White*, 1922.

INSERT

Page

1, above: Anthony van Dyck, *James Stuart, Duke of Richmond and Lennox*, ca. 1634–35.

1, below: John Singer Sargent, *Elizabeth Allen Marquand* (Mrs. Henry Gurdon Marquand), 1887.

2, above: Johannes Vermeer, *Young Woman with a Water Pitcher*, ca. 1662.

2, below: Johannes Vermeer, *The Concert*, ca. 1665.

3, above: John Singer Sargent, *Portrait of Isabella Stewart Gardner*, 1888.

3, below: Rembrandt Harmensz. van Rijn, *Self-Portrait, Aged 23*, 1629.

4: Titian, *Europa*, 1560–62.

5 above: Raphael, *Madonna and Child Enthroned with Saints* (the Colonna Madonna), ca. 1504.

5, below: Sir Joshua Reynolds, *Lady Elizabeth Delmé and Her Children*, 1777–79.

6, above: El Greco, *Portrait of a Cardinal. Probably Don Fernando Niño de Guevara* (The Grand Inquisitor), ca. 1600.

6, below: Edgar Degas, *At the Louvre*, ca. 1879.

7, above: Rembrandt Harmensz. van Rijn, *The Polish Rider*, ca. 1655.

7, below: Rembrandt Harmensz. van Rijn, *Self-Portrait*, 1658.

8, above: Giovanni Bellini, *St. Francis in the Desert*, 1480.

8, below: Giovanni Bellini and Titian, *The Feast of the Gods*, 1514/1529.

He was a plain American citizen, staying at an hotel where, sometimes for days together, there were twenty others like him; but no Pope, no prince of them all had read a richer meaning, he believed, into the character of Patron of Art.

—HENRY JAMES, *THE GOLDEN BOWL*

Introduction

*One takes, moreover, an acute satisfaction in seeing America
stretch out her long arm and rake in, across the green cloth of
the wide Atlantic, the highest prizes of the game of civilization.*

— HENRY JAMES, 1876

In the late nineteenth century, as industrialization transformed the
United States into a world power, artists and writers decried the na-
tion's meager collections of art. "I cannot tell you what I suffer for want of
seeing a good picture," Mary Cassatt complained from the confines of
Hollidaysburg, Pennsylvania, in June 1871. The twenty-seven-year-old
artist had spent five years painting in Europe and longed to return.
The novelist Henry James viewed the problem more broadly. Ameri-
cans, he told his mother in 1869, seem to have "the elements of the
modern man with *culture* quite left out." Ten years later, in writing
about Hawthorne and famously listing the cultural assets missing from
the United States in the early part of the century, James, who had him-
self decamped for England in the mid-1870s, conveyed his own sense of
deprivation: "no cathedrals, nor abbeys, nor little Norman churches, no
great Universities nor public schools—no Oxford, nor Eton, nor Har-
row; no literature, no novels, no museums, no pictures." Later, in 1906,
when the British critic Roger Fry served as curator at the Metropolitan

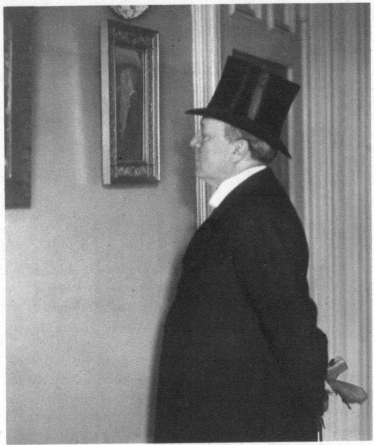

Henry James looking at a painting, ca. 1906. A friend of Isabella Stewart Gardner's, the novelist explored America's appropriation of European art in his fiction.

Museum of Art, he tallied the museum's pictorial shortfall: "no Byzantine paintings, no Giotto, no Giottoesque, no Mantegna, no Botticelli, no Leonardo, no Raphael, no Michelangelo."

This book tells the story of the first Americans who set about to erase the country's deficit in Old Master pictures. They were a small group of culturally ambitious individuals made fabulously rich by the industrial revolution; they would spend record-breaking sums to acquire European canvases. From the 1880s through the First World War,

American collectors drew scores of pictures out of ancestral houses in England and on the Continent and shipped them across the Atlantic, setting in motion one of history's great migrations of art. At the center of this enterprise were the coke and steel tycoon Henry Clay Frick, the banker J. Pierpont Morgan, the sugar magnate H. O. Havemeyer and his wife, Louisine Waldron Elder, the Boston aesthete Isabella Stewart Gardner, and the Metropolitan Museum of Art's second president, the railroad financier Henry Gurdon Marquand. It is a story not simply of collectors, but also of connoisseurs and dealers; of rivalry, nationalism, and economic conquest; and of the extraordinary pictures themselves.

The phrase *Old Master* came into common currency in Paris, art capital of Europe since the reign of Louis XIV, following the French Revolution, to distinguish the painters who worked before the overthrow of the ancien régime from the modern artists who came after. The Old Masters are the painters who shaped the European tradition from the Renaissance through the eighteenth century, particularly the seminal figures from the Italian, Flemish, Dutch, French, German, and Spanish schools. An "Old Master picture" implies not simply a painting of a certain age, but one of uncanny allure, worthy of contemplation, study, and even passion—an illusion of the physical world, created by an artist of consummate skill, arresting in its imaginative range, its aura, its beauty, and its truth.

To the West, a "painting" generally refers to "oil on canvas"—a picture created by mixing pigment with oil and brushing it onto fabric attached to a wooden rectangle, and when completed framed in wood or gold. These gilded borders not only set off the colors of a canvas, but also suggest the high value—aesthetic and monetary—assigned by Europe to its finest pictures. In the early Renaissance, artists in Italy painted in tempera on wooden panels and in "fresco," where they applied colors to wet plaster, enlivening walls of churches and palaces, and fixing images to a particular place. Then in the mid-fifteenth century, artists in Northern Europe, including Jan van Eyck and Rogier van der Weyden, began experimenting with oil paint. Gradually, the Venetians and others in Italy adopted the technique, which enabled them to layer colors in transparent glazes, to articulate rich blacks and deep browns for the first time, and to exploit brushwork to new effects.

At the same time, artists shifted from painting on wood to painting on canvas. Also in the Renaissance, painters elevated themselves from craftsmen paid for their time to professionals compensated according to the more elusive notion of reputation. Soon, Europe's best artists became larger-than-life figures, engaged and handsomely rewarded by temporal and spiritual rulers for glorifying their reigns.

The American demand for Old Masters at the turn of the century caused the art market to boom. In the early 1880s, a Rembrandt portrait cost an American financier only $25,000. By 1911, Rembrandt's landscape, *The Mill*, went to the Philadelphia streetcar tycoon Peter A. B. Widener for $500,000, a record sum for a painting. That record was smashed only two years later, on the eve of the First World War, when Widener acquired a Raphael *Madonna*, and again, soon after, when Czar Nicholas II bought the Benois *Madonna* by Leonardo da Vinci for 310,000 pounds, or over $1.5 million. The equivalent of more than $30 million in dollars today, the Leonardo's price remained, in relative terms, the highest sum paid for a work of art for seven decades. Only in 1987, when van Gogh's *Sunflowers* was auctioned at Christie's in London for $39.9 million, did a modern canvas eclipse an Old Master as the world's most expensive picture. More recently, paintings by Pablo Picasso, Gustave Klimt, and Jackson Pollock have raced to the top of the art market. The precipitous ascent of prices for twentieth-century pictures reflects the taste for large modern and contemporary canvases but also their relative abundance; they are plentiful enough to fill seasonal auctions in New York and London and to sustain a market.

In contrast, no matter what a collector is willing to spend, finding a masterpiece of Renaissance, Baroque, or even eighteenth-century painting on the market borders on the impossible. When, in 2004, the Metropolitan acquired *Madonna and Child* by Duccio di Buoninsegna, painted around the year 1300, they paid some $45 million for a painting no larger than a sheet of typing paper. The price spoke to the Duccio's formidable beauty and importance in the history of art, but also its absolute rarity: It is one of only twelve Duccios in existence and, unless another is discovered, the last that will ever be sold. The eleven other paintings now reside in public museums (in Florence, Paris, and London), which in the course of the nineteenth and twentieth centuries

acquired the majority of Old Master pictures, removing them from the art trade for good. Those Old Masters that remain in European private collections are unlikely to leave the countries where they now reside because of export restrictions.

From the moment of creation, paintings are fragile and easily punctured, torn, or abraded, and their vulnerability enhances the sense of their rarity and value. Even a large canvas is surprisingly light, weighing only a few pounds. Most of the weight of a "picture" lies in its frame. If taken out of their frames and off their stretchers, paintings can be reduced to only a fraction of their size. In 1907, to transport seven van Dyck portraits—one over seven feet tall—secretly from Italy, a dealer reportedly rolled them up and inserted them into a metal tube that he attached to the undercarriage of a car to disguise it. Because they are highly portable, paintings have always been traded and moved—pulled down from one wall and put up on another, bought and sold by dealers, hauled from country to country by conquering armies. The van Dyck portraits had hung for four centuries ("Some blackish, but all of them recoverable, and most of them exquisite," a dealer reported) in a palace in Genoa, passing down through generations of the family for whom van Dyck had painted them.

At the beginning of the twentieth century, countless other Old Masters quietly bided their time in European private collections waiting to be summoned onto the market by American fortunes. Acquiring masterpieces demanded colossal wealth but also discrimination, taste, timing, and opportunity. To respond to America's demand for Old Masters, experts and dealers raced around Europe, following every lead to see pictures face-to-face and to negotiate purchases and sales. The most aggressive kept up relentless travel schedules. In the course of a single week in January 1913, the dealer Ernest Duveen sped from Paris to London, moved on to Edinburgh the following day, returned to London, then to Paris, from where he shot south to Florence for a meeting, before boarding a train back to the French capital at the close of the weekend.

Suddenly the staid picture trade accelerated its pace to keep up with

the industrial age. Dealers in New York whipped off letters and dispatched them to the docks along the Hudson River to make sure their mail would catch the next steamer. Telegrams flew back and forth between galleries in London, Paris, and New York. In 1910, when two Raphael *Madonnas* appeared in a London exhibition, the dealer Joseph Duveen telegraphed the connoisseur Bernard Berenson, who was in Italy: "WIRE WHETHER THEY ARE AUTHENTIC. ARE THEY IN GOOD CONDITION? MUST HAVE YOUR ADVICE." Berenson was the first American to earn his way into the circle of Europeans who were professionalizing art history and who wielded the power to attribute Old Masters and set their value in the marketplace. Preparing to converse with Henry Clay Frick about a Vermeer that a colleague had just secured in London, the dealer Charles Carstairs could not recall the details of the picture and refused to risk waiting to receive the information by mail. He sent a telegram from New York: "CABLE COLORS VERMEER FORGOTTEN." The Vermeer to which he referred was one of three that he handled in 1911 and 1912. Of the thirty-five canvases Johannes Vermeer painted, the United States would eventually possess thirteen.

International politics and competition played no less a part in Old Master collecting in the industrial age than they did in the seventeenth century when England's Charles I had vied with Marie de Medici and Cardinal Richelieu for masterpieces. "Bless the war, that you have the chance [to buy]," Bernard Berenson sardonically wrote Isabella Stewart Gardner in 1917, when he delivered the news that Giovanni Bellini's legendary *The Feast of the Gods*, long locked in an English castle, was on the market. "For without it the *Feast* never would have left its old home, nor I be in a position to urge it upon you."

Gardner had started acquiring Old Masters in the 1890s and for a while she had the field largely to herself. But by 1906, when Joseph Duveen invited her to survey a Paris collection of one hundred Old Master pictures (including eleven Rembrandts) that he had recently bought, she had to contend with Pierpont Morgan, Henry Clay Frick, the retailer Benjamin Altman, and Arabella Huntington, the widow of the railroad baron Collis P. Huntington. The one painting Gardner wanted was Andrea del Castagno's *Portrait of a Young Man*—its subject a Florentine in a red tunic whose intelligence and confidence jump

out of the frame. His contoured face is dominated by black eyes and his piercing gaze sizes up his viewer. Berenson advised Gardner to buy the Castagno and two other Italian Renaissance paintings. She replied: "Woe is me! Why am I not Morgan or Frick?"

The legacy of America's Gilded Age art-buying binge now stretches across the country in rooms full of Old Masters in New York's Metropolitan Museum of Art, the Museum of Fine Arts in Boston, the Philadelphia Museum of Art, the National Gallery of Art in Washington, D.C., the Art Institute of Chicago, the Henry E. Huntington Library near Los Angeles, and other public museums. But the stillness and beauty of the museum galleries reveal little of the rough and tumble involved in the very worldly pursuit of pictures.

That aspect of the story unfolds in written records. Letters and cables, penned and typed out a century ago by dealers, experts, and collectors reveal the tangle of motivations and circumstances behind each art purchase. Large leather sales books document the canvases that went in and out of galleries and the details of every transaction—dates, prices, sellers, buyers, investors, and middlemen. These account books rivet the attention with such names as Rubens and Rembrandt, Bruegel and van Eyck, Caravaggio and Botticelli, Watteau and Poussin, Dürer and Holbein, and the titles of their masterpieces. These documents unveil the combination of ego, idealism, and ambition that fired America's Old Master collecting, and they suggest the complexity of the process by which a nation acquires its culture and art.

PART ONE

The Collectors

"American Citizen . . . Patron of Art"

Henry Gurdon Marquand and van Dyck's
Portrait of James Stuart

Henry Gurdon Marquand approached Corsham Court through a large stone gate leading down a drive banked by tall trees, through which he could glimpse pastures and woods stretching into a ten-thousand-acre estate. Close to the city of Bath, and almost exactly one hundred miles from London, Corsham was a towering asymmetrical building of honey-colored bathstone with rows of pointed gables, turrets, and chimneys dating back to the reign of Elizabeth I. Since the eighteenth

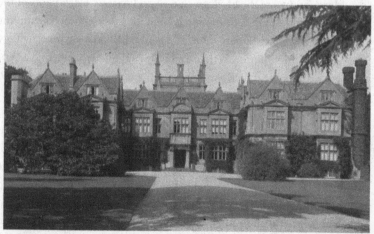

Corsham Court, in Wiltshire, was bought by Paul Methuen in the 1760s to house the famous London collection of Old Masters he had inherited.

century, Corsham had been the country seat of the Methuen family, who had renovated and expanded the building so that it now contained over sixty rooms.

It was late September 1886. Marquand was sixty-eight, an American banker, railroad magnate, and insatiable collector of art. Earlier, from Paris, he had written Charles Deschamps, a London art dealer, that he planned to "rest 1 or 2 days" at Brown's Hotel in London after which time "I will go to Corsham to see the pictures." He added: "I find everyone here desirous in the extreme to sell & solicit a bid."

Marquand's trip was prompted by two paintings by the seventeenth-century artist Anthony van Dyck: *The Betrayal of Christ* and the portrait *James Stuart, Duke of Richmond and Lennox*. He had come not as a casual tourist to admire the Old Masters in the Methuens' celebrated collection, but as a self-appointed ambassador from the New World on a cultural mission, scouting for a fledgling museum that New Yorkers had founded in 1870 in a Manhattan brownstone: the Metropolitan Museum of Art. Charged with this public quest, Marquand had no interest in run-of-the-mill canvases but wanted only pictures by the most celebrated painters in the history of art—masterpieces that would set a standard for American artists and public taste, and help define and advance American culture.

Marquand wore the black frock coat and narrow black pants of the American middle class, disguising (except for his gold watch chain) the fact that he was a rich man. Thin and gaunt, he had a vigorous, craggy face, with a Roman nose, arched eyebrows, a high forehead, and a serious gaze. His appearance was purposefully understated and he looked more like a professor than a financier.

In a formal, full-length portrait, the artist John White Alexander rightly cast Marquand as both a thinker and a doer—an angular gentleman in a dark suit, interrupted while hard at work, standing with spectacles in one hand, architectural plans in the other. Although the desire to expand the Metropolitan's collections was one Marquand shared with his fellow museum trustees, characteristically he had handed himself the assignment and had come to Corsham alone. Born to a family of silversmiths, he had made his fortune most recently by speculating in railroads, and for a time left his Wall Street desk to take

charge of a Missouri line. If asked to explain his search for masterpieces, no doubt he would have spoken of the educational and moral value of great art, particularly for shaping an immigrant nation. What he might not confess was that for him acquiring art was not a duty, but a passion. He had earned his place on the Metropolitan's board not simply as a pillar of the community and a donor, but because for decades he had campaigned to promote American architecture and art. In his twenties, he had befriended New York's artists (one a fishing companion), patronized their work, and taken up their struggle to forge an American School. Before sailing to Europe in the 1850s, he had asked the Hudson River School's Asher B. Durand and other artists to make sketches that he would carry with him to broadcast their achievement to painters abroad. As a collector, he had stocked his oversized Manhattan house with so many works of art that to fend off a dealer he once asserted he could find no space for even a clock.

To reach the van Dycks at Corsham Court, Marquand crossed a dark stone vestibule. As he passed through a series of state rooms, each lined with Old Master paintings, he began to suspect he had come to the right place. But when he entered the picture gallery, he was certain. The gallery stretched seventy-two feet, its walls covered in gleaming crimson damask, and on three sides, dark Old Masters in gilded frames formed tiers of rectangles from the chair rail to the ceiling. Built in the 1760s and preserved almost exactly as it had been created, Corsham's red gallery was an accounting in fine and decorative arts of the economic and political might of eighteenth-century Britain. The sole purpose of the room was to display a splendid array of mostly Italian canvases—pictures by Caravaggio, Bronzino, Veronese, and others painted in the sixteenth and seventeenth centuries, when these artists believed their highest calling was to portray the human figure in complex narrative scenes and when a major patron was the Catholic Church. Marquand counted some forty paintings. There were images of the Madonna and Child, the Adoration of the Shepherds, and many saints, but also portraits, landscapes, an enormous image of Charles I on horseback, and romantic vistas of the Italian countryside by Salvator Rosa. Over the white marble mantel was Peter Paul Rubens's *Wolf and Fox Hunt*—a battle scene of sorts, with two men and a woman, finely

clothed and mounted on horses, their chargers rearing over a tumult of foxes, wolves, and dogs tearing apart the flesh of their prey.

Marquand discovered one of the two van Dycks, *The Betrayal of Christ*, to the right of the fireplace. The Flemish painter, a prodigy, had famously distinguished himself as the most talented apprentice in Rubens's Antwerp workshop, and here at Corsham, hanging beside his master's hunting scene, *The Betrayal* more than held its own. It was a dark, turbulent canvas (nine feet across and seven feet high) of physical and psychological drama. Van Dyck had chosen to paint the moment of treachery: Judas Iscariot, shoved by Roman soldiers, leans toward the dark-haired Jesus, grasps his hand, and prepares to deliver the false kiss. Faces only inches apart, betrayer and betrayed almost collide before a teeming crowd. Above their heads, a pair of disembodied hands shoots upward, flinging a rope intended to settle around the prisoner's neck. Van Dyck, whose father was in the textile trade, poured the theatrics of the scene into the painted drapery. A gold cloak billows up over the back of Judas, conveying his momentary power, and a red stream of cloth cascading over the outstretched arm of Christ, who is robed in blue, prefigures the bloody tragedy about to transpire. The artist set the encounter beneath menacing branches, in stormy darkness, and the protagonists' faces are illuminated by torchlight. Henry Marquand recognized that the van Dyck before him was more complex and possibly finer than any painting he had ever seen in America.

Casting his eyes down the length of the English gallery, Marquand became acutely aware of the impoverished state of the painting collection in his museum in New York. The Metropolitan was smaller than the English country house, and at sixteen years old was still struggling to escape its provincial character and youth. Yet, in contrast to the silent private gallery, the New York museum already boasted over 350,000 visitors.

The Metropolitan had progressed from its original brownstone to a freestanding house on West Fourteenth Street, and then in 1880 to a new building, constructed (with $500,000 from New York City) in Central Park—an awkward redbrick, neo-Gothic structure that warned of aesthetic deficiencies within. Glass cases crowded a large central exhibition hall. They contained porcelain, enamels, and manuscripts,

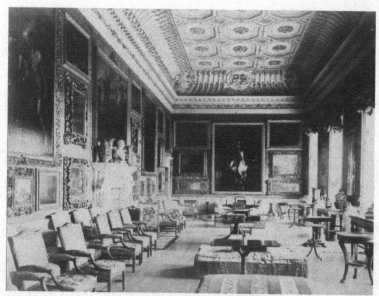

The Picture Gallery at Corsham Court, ca. 1890. The eighteenth-century room with van Dyck's *Betrayal of Christ* to the right of the fireplace remains much as it was when Henry Marquand visited in 1886.

as well as Cypriot art, from a ten-thousand-piece collection, the museum's largest and most important. Ancient sculpture and artifacts were indispensable attributes of a traditional museum, but the *New York Times* complained: "there are too many of these Cyprian objects . . . it's bad art. . . . Archaeologically, ethnologically, they may touch us a great deal, but artistically hardly any."

The Methuens' collection of Old Masters—not even one of England's finest—was grander than the hodgepodge of mostly mediocre pictures lodged in two rooms at the back of the Metropolitan's second floor. Writing anonymously in the *Atlantic Monthly*, Henry James took accurate measure of the museum's paintings: "It is not indeed to be termed a brilliant collection, for it contains no first-rate example of a first-rate genius."

The lackluster state of the Metropolitan's collection was not for want of ambition. The founders sought to create an art museum that would hold its own against the Louvre, London's National Gallery,

and other museums in Europe, and would establish New York, the capital of American commerce and finance, as the capital of American culture as well. In 1869, the publisher and poet William Cullen Bryant made the case that an art museum was mandatory for the booming industrial America. "Our republic has already taken its place among the great powers of the earth. It is the richest nation in the world." But, even Spain, "a third-rate power of Europe and poor besides" had a major museum in the Prado, "the opulence and extent of which absolutely bewildered the viewer." Indeed, a series of Enlightenment-inspired public collections had appeared in Europe in the early nineteenth century, after the opening of France's national museum in the Louvre. In 1793, four years after the Revolution, the painter Jacques-Louis David and the Committee of Public Safety transformed the palace of the Bourbons (a royal residence since the fifteenth century) into a public gallery, granting French citizens access to the royal collections of classical antiquities, paintings, sculpture, furniture, and decorative arts. After Napoleon's defeat in 1815, France's rivals asserted their nationalism by creating art galleries in their capital cities: the Rijksmuseum (State Museum) in Amsterdam in 1817; the Prado in Madrid in 1819; the National Gallery of London in 1824. In Germany, the return of the art seized by Napoleon spurred the Prussian King Frederick-William II in 1823 to found the Berlin Gemäldegalerie (Picture Gallery).

Although based on European models, the Metropolitan had a distinctly American character—founded and managed not by a city or state but by private citizens with a public mission "to humanize, to educate and refine a practical and laborious people." The idealistic Marquand threw himself into building the museum and its collections, joining fifty members of the New York establishment including the Unitarian minister Henry W. Bellows, the artists John Kensett and Worthington Whittredge, the architects Calvert Vaux and Richard Morris Hunt, and the railroad owner John T. Johnston, the museum's first president. Marquand had served as a museum trustee since 1871, soon joined the influential executive committee, and in 1883, he became the Metropolitan's treasurer. Marquand saw the Metropolitan more as a school than as a temple. "The trustees had no idea of making this a show place or a mere palace of amusement," he insisted in a

speech. "Their prime object and grand aim has been to provide here a collection of objects that would be strictly useful in the improvement of the arts, bringing up the taste of the people of this country to the highest standards." He also charged the museum with improving the quality of American design: "This building is as much intended for the humblest artisan in wood and metals as for the most luxurious patron of the fine arts."

In line with their exalted aims, the Metropolitan's founders imagined a universal collection—painting and sculpture, but also decorative and industrial arts. ("A great museum—one worthy of New York City and of our country"—one trustee asserted, "should represent the History of Art in all countries and in all ages, of art both pure and applied.") But problematically, where most European museums originated as the collections of princes and kings, amassed over centuries, the Metropolitan was a contemporary of the railroad station; it began simply as an idea, a vision in the minds of New Yorkers, who asked for donations of money and art, and who dreamed of treasures to come. At the opening of the Metropolitan's Central Park building, the attorney and trustee Joseph C. Choate called on his audience, which included the United States president Rutherford B. Hayes, to fund the new museum. "Think of it, ye millionaires of many markets—what glory may yet be yours, if you only listen to our advice, to convert pork into porcelain . . . and railroad shares and mining stocks . . . into the glorified canvas of the world's masters." One of the museum's most generous benefactors, Marquand would give hundreds of thousands of dollars—in part, to launch an art school and to fund the purchasing of plaster casts. He donated American pottery, Renaissance sculpture, and decorative arts, antiquities, bronzes, enamels, porcelain, and Roman glass.

But Marquand came to realize that to secure the Metropolitan's place among the ranks of European museums he needed to elevate its collection of Old Masters. Again the Louvre set the standard. When Napoleon conquered Europe, he affirmed the legitimacy of his regime and advanced the glory of France by expanding the Paris collections with art seized by the French armies from Italy, Holland, and Spain. When plundered pictures arrived in Paris, the emperor's museum

director, Dominique Vivant Denon, hung them in the Louvre. Breaking away from the haphazard picture displays traditionally favored by aristocrats, he gave the Paris collection new weight by arranging the paintings in chronological order and according to school. From then on, to compete with the Louvre, a museum needed to display a lineup of the best European pictures—Flemish, Dutch, French, Spanish, and Italian—and above all, examples of the groundbreaking works on which the tradition stood, the art of the High Renaissance. By the end of the nineteenth century, Europe's "national" galleries boasted collections not simply of their own schools of art but of virtuosic Old Masters that related the history of Western painting and that signified political authority and cultural achievement.

In 1871, before the Metropolitan officially opened its doors, the museum's board had stocked it with 175 European pictures—mostly Dutch and Flemish paintings, which William Tilden Blodgett, a businessman and trustee, had bought in Brussels and Paris for $147,000 from dealers who claimed to be selling two private collections forced onto the market by the Franco-Prussian War. In fact, the dealers had cobbled the "collections" together, unloading their own inventories on the gullible Americans. Only a year later, the trustees acknowledged their disappointment: "Perhaps, a half dozen [pictures] may be sold or exchanged for other works of art." Later, in 1906 the Metropolitan's curator, Roger Fry, complained of the painting collection's poor quality and the museum's unsystematic approach to acquisitions. The paintings, for example, "have been brought together by no fixed and determined law. They express the aim of no one intelligence nor even of what a museum may sometimes boast—a communal intelligence or tradition." Fry argued that the one aspect of "art which is adequately represented" was the "sentimental and anecdotal side of nineteenth century painting."

By 1882, the pioneering Marquand was searching for canvases of an entirely different order. He insisted to the London dealer Charles Deschamps: "I care not to buy common place good things—it is more desirable to go slowly and acquire the *best*."

When the American artist J. Alden Weir was setting off for Europe, Marquand assigned him to scout for acquisitions. Shortly after

arriving in London, Weir discovered Rembrandt's *Portrait of a Man* at Agnew's gallery. "We began the day by spending $25,000 for a rare picture," Weir wrote his father. "Of all the pictures I have ever seen for sale, this is, I think, the finest. Now we will have one very remarkable picture of which the country will be proud." When Marquand saw his Rembrandt in New York, he thanked Weir: "What a gorgeous thing! The pleasure of owning such a work is very great." He added, "If one fine thing in a year could be had, what a gallery I would get in time."

A cosmopolitan patron and collector, Marquand shared the perspective of America's leading artists and architects, who after the Civil War looked to the Old World to set standards and sought their art education abroad. "My God, I'd rather go to Europe than go to heaven," the artist William Merritt Chase reportedly observed in 1872. Commentators argued that American culture needed to overcome its insularity and isolation. By the 1860s, there was a "different sort of confidence, a belief in American ability to benefit from full participation in the international cultural arena," the art historian H. Barbara Weinberg writes. In the early 1850s, Richard Morris Hunt became the first American to get the rigorous, classical French architectural training of the Ecole des Beaux-Arts in Paris. Determined to bring the neoclassical monumentality of Parisian architecture to New York, he began to change Manhattan's landscape. "It has been represented to me that America is not ready for the Fine Arts, but I think they are mistaken," he wrote his mother. "There is no place in the world where they are more needed, or where they should be encouraged." Painters like James McNeill Whistler, John Singer Sargent, and Mary Cassatt moved to Paris; all three made their reputations there and remained in Europe, benefiting not simply from the high level of instruction, but from the abundance of Old Master pictures. Sargent and Cassatt, as well as Thomas Eakins traveled to Spain to study Velázquez, and, in Haarlem, Sargent copied Frans Hals. Marquand had made his fortune in the rapid transformation of the United States from an agrarian to an industrial nation now challenging England in its economic might, and he presumed that in taking cultural lessons from Europe, the New World would more than measure up. As a financier at a time when

European money funded American railroads, Marquand believed that Old Masters would work as artistic capital to stimulate the development of American art.

Henry Gurdon Marquand

Marquand's own affinity for the visual arts originated with his father, Isaac, and his eldest brother, Frederick. The two Marquands had distinguished themselves as silversmiths whose decorative wares, redolent of material and social success, were renowned for their craftsmanship and design. But Isaac and Frederick (who was twenty years older than Henry, his youngest brother) were also entrepreneurs who readily shifted gears to keep pace with the accelerating economy of New York. Born in Connecticut, Isaac had worked as a silversmith in Savannah, Georgia, before moving north to Manhattan. There, in 1803, he opened a jewelry store at 166 Broadway, in one of the narrow, four- and five-story buildings that lined the fashionable street, lit by whale oil lamps until the 1830s when gaslight replaced them. The silver trade was international, and Isaac Marquand and his partners in Savannah and New Orleans marketed not only American pieces, but also silver and jewelry from England, which they imported on their own ships.

Henry Gurdon Marquand was born in New York in 1819, six years before the opening of the Erie Canal transformed the city into America's major port and the center of the nation's international trade, manufacturing, and commerce. The population of Manhattan was then not much larger than Philadelphia's and the tallest structures were steeples. In 1844, standing on the walls surrounding the reservoir near Forty-second Street, it was possible to look straight down to the Battery and to the Hudson and the East rivers on either side. Commentators complained of the monotony of New York's architecture and the absence of civic monuments. "One sees neither dome, nor bell tower, nor great edifice, with the result that one has the constant impression of being in a suburb," Alexis de Tocqueville wrote in 1835.

Marquand had scant education, and at fifteen he went to work for Frederick at Marquand Bros., now at 181 Broadway. He commuted to Manhattan by ferry from the family's brownstone in Brooklyn Heights.

"My wages to be something like [$]150," he wrote, "which was considered a good salary for [the] 1st year. Rather better than it would have been had it not been my brother's store." Early on, he was hungry to learn and restless. "Dull, dull, dull. . . . Bookkeeping is very tedious work," he complained to his journal. "I felt [a] great deal like quitting my business & trying some more professional life." A devout Presbyterian, he attended church at least once a day and in his journal he transcribed the sermons he had heard. Struggling to adhere to the tenets of Calvinism, he admonished himself for his impatience with work and for his persistent professional and intellectual ambitions. "Oh why this longing after something else? This thirst for worldly wisdom, this desire of worldly entertainment . . . ought not I to be filling my mind with heavenly knowledge?" Indeed, soon New York's most worldly entertainment of all—its soaring financial markets—grabbed his attention and did not let go. (Later, Marquand rejected the arguments of the Presbyterians and voted to open the Metropolitan on Sundays, enabling the working class who had only that one day off, to visit the museum. "Must a man who walks in Central Park shut his eyes when he comes to a statue or a work of art? . . . New York has a great mixed population and we cannot expect those who have been differently brought up to agree with the early New England notions.")

In 1838, Isaac Marquand died and Frederick sold the jewelry store to several of his partners in order to concentrate on real estate and finance. (The firm's successor, Ball, Tompkins & Black, became Tiffany's chief rival, and, for a while, stamped the prestigious Marquand hallmark on its silver.) In New York, the real estate market boomed, as the city advanced to the north. "The spirit of pulling down and building up is abroad, the whole of New York is rebuilt about once in ten years," the mayor Philip Hone observed in 1835. Working for Frederick, Marquand began by collecting rents, but soon turned to investing: "Nothing is so engrossing as the love of money and the occupation of the mind with the grasp of wealth," he wrote on June 6, 1842, at the age of twenty-three. "I have, for the past week had before my eyes a speculation in a certain stock and the prospect of a profit and found I have had no relish whatever for taking up a book of any kind." In the seven years leading up to 1835, the volume of trading on

the New York Stock exchange had multiplied fifty times to reach some 8,500 shares a day.

At the same moment Marquand was facing a crisis with his thirty-three-year-old brother, Josiah: "What scenes and trials we have here to endure, truly our path is thorny," he wrote on June 7. "This day's transactions furnish bitter recollections and retrospection. With case of bros Josiah who has recently or gradually for some one or two years, undergone mental alienation. Having come to the conclusion that it would be to his and our advantage to have him put under restraint, he went quietly out today with Mr. Trask and myself to the asylum, then to receive medical care & treatment." Josiah doesn't appear again in Marquand's journal, but characteristically, in 1877 Henry and Frederick endowed a building at Bellevue Hospital in their brother's name.

Five months later, in November, perhaps to escape New York and also to further his education, Marquand suddenly announced to his journal he might go abroad: "Now contemplating to commence on Tuesday a tour through France, Italy & Switzerland." At the time, few Americans traveled to Europe. Only three years before, Cunard launched the first regularly scheduled transatlantic crossings, with steamships sailing from Liverpool to Boston twice a month. The innocent, even puritanical Marquand anticipated dangers ahead, and melodramatically bid his "native land . . . a land of Sabbaths & much privilege . . . farewell." He even asked for the "grace, to be kept from temptation." Nevertheless, he sailed, and, as he feared, the voyage changed him.

In Rome, Marquand met Henry Kirke Brown and other American expatriate sculptors, who had moved to the city to study its Ancient and Renaissance sculpture, and he began "to frequent studios" and to understand the artists' "hopes, aims, and aspirations." There Marquand fell under the spell of what Henry James called "the old and complex civilization." He seemed to experience the sort of aesthetic awakening described by the New England heroine of James's 1875 novel, *Roderick Hudson*, when she is in Rome: "Beauty stands there . . . and it penetrates to one's soul and lodges there, and keeps saying that man was not made to suffer but to enjoy." By the time Marquand returned to New York, art and architecture had usurped the place that religion had held at the center of his life, and from then on he put himself in the front

lines of the campaign to support the visual arts in America. He confirmed the significance that Rome held for him in 1852 when he decided to spend a year there with his new wife, Elizabeth Love Allen. The first of their six children was born during the course of their Italian stay.

Once back in New York, Marquand built up a fortune speculating in foreign exchange and then in railroads, as Americans raced to lay tracks across the continent. By the end of the century, the United States would be linked by 175,000 miles of tracks—a network whose length had multiplied five times in the thirty-five years since the Civil War and was larger than Europe's. Railroad securities dominated the New York Stock Exchange, and Marquand and his brother-in-law, Thomas Allen, plunged into the cut-throat industry in 1867 when they bought the St. Louis and Iron Mountain Railroad, which ran from St. Louis to a mining region in southeastern Missouri and then to Arkansas and Texas. The business climate was volatile and at one point the railroad went into receivership, but by 1880, Allen and Marquand had made it profitable. At that moment, Jay Gould was building a southwestern railroad network and bought up lines that competed directly with the Iron Mountain and also one that formed a critical link in its system. Seeing their business siphoned off, Allen and Marquand agreed to sell out to Gould, in a deal that brought Marquand $1 million.

In his drive to accumulate capital and to advance American art, Henry Marquand was emblematic of New York. Even in 1856, *Harper's Monthly* observed that "a man born forty years ago finds nothing, absolutely nothing, of the New York he knew." Between 1820 and 1880, Manhattan's population had grown by a factor of eight, to 1.2 million, and by 1900 the city (with 3 million people) was surpassed only by London as the largest metropolis in the Western Hemisphere. Half of New York's inhabitants were immigrants, mostly from Ireland and Germany, but recently Russian and Polish Jews and other Eastern Europeans had joined them. Tenements lined the Lower East Side, a dark, disease-ridden quarter and one of the most densely populated places on Earth. Commentators decried the city's persistent contrast of wealth and poverty. Although New York had struggled for recognition as a

center of art and culture, the city gained ground in the late 1860s and 1870s with the founding not only of the Metropolitan Museum but also the American Museum of Natural History, the New York Oratorio Society, and the New York Symphony Society. In 1883, the Metropolitan Opera opened a 3,700-seat house on Broadway and Thirty-ninth Street.

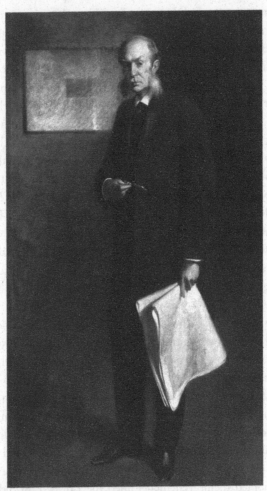

John White Alexander, *Henry G. Marquand*, 1896. Princeton University Art Museum. Marquand served as president of the Metropolitan Museum of Art for more than a decade.

For decades Marquand had championed and purchased the work of American painters: the Hudson River landscapists Frederick Church and Thomas Cole, as well as Kenyon Cox, Samuel Colman, Eastman Johnson, and John La Farge. Starting in the early 1880s, he stepped up his commitment to the arts. In 1882, he commissioned Richard Morris Hunt to design an office tower in lower Manhattan and a mansion on the Upper East Side. ("I like noisy fellows around & you come under that head," Marquand told the architect, who had built the financier a summer house in Newport.) Hunt's Beaux Arts architecture adapted the grand forms of the European past to meet the demands of the Gilded Age. He had erected one of Manhattan's first skyscrapers (the eleven-story Tribune building), and an equally conspicuous turreted castle, for William K. Vanderbilt, which inspired a procession of mansions up Fifth Avenue.

If not on the Vanderbilt's scale, Marquand's red-brick-and-sandstone house at Sixty-eighth Street and Madison Avenue nevertheless enclosed one of New York's most spectacular private "museums." Visitors stepped into a central hallway gleaming with mosaics that shot up four stories to a skylight and they immediately encountered a nine-foot blue and white Renaissance altarpiece. Throughout the ground floor and the bedrooms above, the collector displayed a Victorian abundance of art from his own day and the past—paintings and sculpture, Chippendale furniture, Dutch and English silver, Venetian glass, Greek coins, Persian textiles, Limoges enamels, Roman mosaics, Gobelin tapestries, snuffboxes, and watches. Despite its eclecticism, Marquand's collection gave no hint of the revolution in the theory and practice of painting recently sparked in France by Gustave Courbet, Edouard Manet, and the Impressionists. Examples of the new painting, which rejected history and myth to focus on contemporary life, had appeared in New York early in April 1886, when the dealer Paul Durand-Ruel opened an exhibition of over two hundred French pictures.

Marquand had no interest in Impressionism. He would probably disagree with the avant-garde painter who quipped, "a well-painted turnip is as beautiful as a well-painted Madonna." Yet in his quest for Old Masters he sought those that were "well-painted," revealing that he

shared the modernists' conviction that the value of a painting depended first and foremost upon its formal aspects.

"The Rest of the World Painted for Them"

Early in 1886, Frederick Henry Paul, 2nd Baron Methuen, had written Frederick Burton, director of the National Gallery, to say that "there were several pictures at Corsham that . . . [he] might be ready to part with." It was not an easy letter to write. The famous Methuen collection had been assembled in the 1720s by his ancestor Sir Paul Methuen, a wily diplomat who had served as English ambassador to Portugal and Spain, and as Treasurer of His Majesty's Household in the courts of George I and George II. Described by Voltaire as "one of the most generous, bravest, and most sincere men his country ever employed in an embassy," Sir Paul now looked out from a portrait in a powdered wig and ceremonial uniform. Like many English diplomats, Methuen found that his travels on the Continent wetted his appetite for pictures and gave him opportunities to buy them. He kept his renowned collection at his house in London and when he died in 1765, he left it to his cousin and namesake, an affluent woolen manufacturer and Frederick Methuen's great-grandfather, who acquired Corsham Court and built the gallery to house the pictures.

Sir Paul was a member of England's wealthy and powerful ruling class, which in the course of the eighteenth century became Europe's most relentless collectors of art. Britain's amassing of Old Master pictures went hand in hand with the rise of its empire. As the English nobility came to dominate the country's economic, political, and social life, they erected enormous houses in the country and took the Grand Tour, a cultural pilgrimage to the Continent, whose most important destination was Italy. There, they spent part of their vast wealth on art—particularly on Italian Baroque paintings. Even before 1700, the British (ignoring laws forbidding the importation of pictures) began purchasing canvases from Europe at a rapid rate. In the season between September and March, when the aristocracy stayed in London, art auctions occurred on a regular basis. In 1766, James Christie began holding both "estate" sales with assorted property and sales consisting

simply of Old Master pictures. By 1778, when Thomas Gainsborough painted his portrait, Christie had established his firm as the principal art auction house in London. (Sotheby's was launched in 1744 by Samuel Baker and began by dealing only in books.)

At first the English kept their new collections in London, but in the middle of the eighteenth century they started moving them to their country estates—to Blenheim Palace, Houghton Hall, and Alnwick Castle. The Methuen van Dycks were only two among hundreds of paintings now scattered throughout England, Ireland, and Scotland— the geographical dispersion of pictures signifying the distribution of economic and political power of a landed aristocracy. By contrast, France concentrated its Old Masters in Paris where a series of absolute monarchs had made certain their art collections outpaced those of the nobility. The French Revolution in 1789 and the Napoleonic wars caused a massive uprooting of works of art and ushered in the halcyon days of British collecting. "Scarcely was a country overrun by the French when Englishmen skilled in the art were at hand with their guineas," observed the German museum director Gustave Waagen. Between 1770 and 1830, the English imported unprecedented quantities of pictures. In London, "Caraccis, Claudes, Poussins, arrived by ship-loads," noted the English art writer Anna Jameson. "One stands amazed at the number of pictures introduced by the enterprise of private dealers into England between 1795 and 1815, during the hottest time of the war." Indeed, the period between 1780 and 1820 was the first "bull market" in Western art, according to the economist William Goetzmann, and "coincided with rising consumer price levels."

That England's Old Master paintings were privately held and dispersed throughout the country had the effect of keeping them under wraps. But the quantity and quality of these Old Master holdings became absolutely clear in 1857, when an exhibition entitled *Art Treasures of Great Britain* in the industrial city of Manchester brought many of the finest canvases together under one roof. After the French critic Théophile Thoré visited the show, it must have caused him some pain to acknowledge that "the collection of pictures . . . is about on a level with the Louvre." Two decades later, Henry James observed the vast

dimensions of England's aesthetic wealth: "Whether or not the English have painted, the rest of the world has painted for them."

Frederick Methuen had grown up with his family's pictures, as had his father before him, and was well aware that the gallery had stood still in time, not only because it was worthy of preservation but because Sir Paul's heirs had failed to match his achievements and had drained the family's resources. Now Methuen needed money. A veteran of the Crimean War, in his late sixties, the baron held a largely ceremonial job at Victoria's court; he loved shooting and cricket, and had recently added property to the Corsham estate and thus to his taxes. His collection offered a way to raise funds. In the 1840s, his father had financed renovations at Corsham by selling Rubens's *David and Abigail*, Rembrandt's *Noble Slav* (*Man in Oriental Costume*), and a pair of Claudes.

Methuen's cash shortfall spoke to a wider financial crisis plaguing Britain's landowning nobility, some seven thousand five hundred families who still held over three quarters of the real estate in the British Isles. Starting in the 1870s, Britain imported cheap grain from the American Midwest, Canada, and New Zealand, causing the price of English wheat to decline, and, with it, the income from farmed estates, as well as their value. At the same time, the nobility faced higher taxes and Parliament passed a series of Reform Acts, which undercut its long-held political power.

Historically, the British legal code forbade the nobility from selling "settled land" and tangible property, but in 1882, to allow beleaguered landowners some flexibility to respond to their economic troubles, Parliament passed the "Settled Land Act," to permit the sale of land and "chattels," of which Old Master paintings were often the most valuable. Between 1870 and 1919, according to the historian David Cannadine, seventy-nine of the country houses in England, Scotland, and Wales were torn down. Within months of the passage of the Settled Land Act, the Duke of Hamilton auctioned part of his collection in a sale with two thousand lots that ran seventeen days, and generated 500,000 pounds. Frederick Burton purchased fourteen major pictures for the National Gallery. Four years later, the Duke of Marlborough put dozens of paintings (including eighteen Rubens and fifteen van Dycks) from Blenheim Palace on the block. Already, Burton had bought the

most celebrated of the Marlborough pictures—Raphael's Ansidei Madonna for 70,000 pounds ($350,000), making the altarpiece the most expensive Old Master on record.

Methuen's first hope was to sell some of his paintings quietly to the National Gallery—to deposit them close by and in a setting worthy of their quality and of his family's achievement as collectors. Parliament had founded the gallery in 1824 after buying thirty-eight Old Masters assembled by the late John Julius Angerstein, a German Jew and founder of Lloyds—a collection England wanted to keep. Twelve years later, in 1836, to house the new museum, the British government constructed a building with a columned portico on Trafalgar Square appropriately facing the monument to Napoleon's conqueror, Lord Nelson. In contrast to his predecessor, who sought pictures on the Continent, Frederick Burton focused on securing paintings from Britain's own collections and on preserving the nation's fabulous pictorial wealth. Burton replied to Methuen that he "would take the *earliest* opportunity of laying the matter before the [National Gallery's] board." But he waited until May to visit Corsham with two trustees, and then failed to make offers on any of Methuen's pictures. Meanwhile word that the Methuen van Dycks were on the market traveled fast. By the end of February 1886, the dealer Charles Deschamps approached H. Herbert Smith, a real estate agent who managed the Corsham property, and asked if he could make an appointment to see the van Dycks. Smith passed Deschamps's request on to Frederick Methuen.

At first Methuen put Deschamps off, but in early May he invited the dealer to inspect the paintings. He told Smith that he did "not think they [the National Gallery trustees] have the slightest intention of bidding for either of the van Dycks," and hoped Deschamps would "do his best" for the paintings. Methuen had assured Smith that "the van Dycks have never been in the market in my time or offered to anyone. I have not seen any dealer or had any communication with one on the subject—but have left Mr. Deschamps' hands free and shall wait until he can make me an offer."

In early July, the artist Lawrence Alma-Tadema, whose elaborate grand piano for Marquand was still being finished by craftsmen in London, informed his American patron that his friend Charles

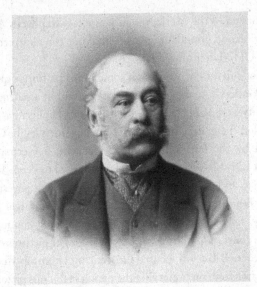

Frederick, 2nd Baron Methuen. In 1886 he told the
director of the National Gallery in London that he
"might be ready to part" with some of his family's
Old Masters.

Deschamps "has all the threads of the van Dyck sale in hand." Ever
since Marquand let it be known he was looking for Old Masters, Des-
champs had tried to supply them. But the Belgian-born dealer and the
American collector had an uneasy relationship, as Marquand distrusted
people in the art trade. He turned to Deschamps only because he had
established links to English owners of Old Master paintings and Ta-
dema recommended him.

By early July, Deschamps tried to convince Marquand to take the
two Methuen van Dycks, sight unseen, and recruited two of America's
expatriate painters—John Singer Sargent and Frank Millet—to help
him. At the time, professional artists were leading experts on Old Mas-
ter pictures and Deschamps knew that Marquand relied on them to
advise him. Millet, a Harvard graduate and former newspaper corre-
spondent, just that year had moved with his family to the Cotswolds,
where he gathered an informal colony of American artists and writers

including Henry James and Sargent, who was spending the summer. The thirty-year-old Sargent had made his name as a portrait painter in Paris, but had recently fled to London. He had exhibited a full-length of a dark-haired, sharp-profiled woman (the American Virginie Gautreau) in a long black dress, provocatively titled *Madame X*. The French critics had complained that the skin was too pale and the dress, with its strap down off the shoulder, too risqué.

"I can only say that both Millet and Sargent were most enthusiastic about the pictures," Deschamps wrote Marquand on the evening of July 16. Of course, the 'Duke of Richmond' is the greatest work; but the 'Betrayal in the Garden' is also a magnificent picture. It has all the strength and glow of colour of Rubens, but with more delicacy." For both pictures together, he explained, "the steward of the estate . . . has reason to believe that £12,000 would be taken," but suggested that Marquand offer £11,000. He added: "The Portrait alone is worth at least £8,000." He urged Marquand not to wait. "Such pictures are seldom on the market, and it is only 'bad times,' that have induced the owner & his next heir to sell. The pictures must have hung on the walls for several generations, but they have in no way suffered. . . . The family are about to take up their residence at the house, and I fear that Lord Methuen is very anxious to arrive at some decision. A good crop, and circumstances might alter the necessity of selling."

Only days later, Deschamps told Marquand that Methuen, now informed of the American's interest, insisted on getting no less than 15,000 pounds ($75,000) for both canvases. "Under these prices he does not care to sell." The dealer jumped in to justify Methuen's price. He claimed he had heard that Frederick Burton "considers it [*James Stuart*] one of van Dyck's very best works. They [the National Gallery trustees] would certainly have bought it for the nation, had they not unfortunately bought Lord Marlborough's Charles I." He added that "Millet & Sargent are in ignorance of the price wanted, but they both were saying that the picture was beyond any value that could be put on it."

But Marquand held off. He grasped the risks involved in buying Old Master paintings. Wishful thinking had directed the labeling of many pictures and misattributions abounded. Van Dyck's early paintings could be mistaken for the work of Rubens, whose pictures were

more valuable—and whenever possible, they were. Problems origi-
nated with artists like Rembrandt, Rubens, and El Greco, who all ran
large workshops and seemed to have signed canvases executed by as-
sistants when they closely enough resembled their own. There were
also thousands of Old Master copies—oil paintings made over the cen-
turies in good faith by aspiring artists, for whom copying was part of
academic training. Further muddying the waters were fakes and for-
geries.

Yet, even without an authoritative text on van Dyck, the long his-
tory of the two Methuen paintings in an illustrious English collection
where various commentators had taken note of their presence, gave
Marquand confidence that they were authentic. By the end of the sum-
mer, he resolved to see the van Dycks for himself.

Marquand sensed that his visit to Corsham would embarrass and
unsettle Baron Methuen and he chose a time when the owner was
away. Now, standing on a vast Oriental rug in the silent gallery,
Marquand was making a first American sortie into one of England's
treasure vaults. If Marquand did not share Sir Paul Methuen's passion
for Italian Baroque pictures, he couldn't help but admire the English
diplomat's ambition, and the way he had assembled a fine collection of
paintings from the Continent and made it his own—made it English.
The New Yorker, who had filled his mansion floor to ceiling with
works of art, recognized that he was in a way Sir Paul Methuen's right-
ful heir. Although he had come to examine the stars of the collection,
he suspected that virtually all the paintings in the house were for sale.

James Stuart, Duke of Richmond and Lennox

Marquand found the portrait of *James Stuart* in the dining room where
traditionally the English hung their portraits. The canvas is a lifelike,
life-sized "full-length," close to seven feet in height, and more an En-
glish than a Flemish picture. It portrays a lanky, fair-haired young
man, with golden curls falling to his collar, standing with his right
hand on the head of a brown greyhound, which looks devotedly
up at him. He is splendidly dressed, in a suit of black satin—a black
doublet with slashed sleeves, black breeches, a black jacket, a black

cloak—and stockings of the palest green. His tapered fingers are splayed against the ink-colored doublet. He wears a tall, wide collar, a triangle of intricate white lace (later known as a van Dyck collar). Emblazoned on his sleeve is a white, eight-point star and hanging from a green ribbon around his neck is a gold medal—both decorations, like the ceremonial "garter" on his left leg that he wore as a member of the Order of the Garter, or the Society of Saint George. He appears the embodiment of grace and nobility, his pose conveying his highborn rank. His opulent dress buttresses his sense of refinement, elegance, and sophistication. He has a delicately arched nose and a long, thin, pale face, which is open and innocent. His eyes gaze straight out, and slightly down, and his glance is oddly contemplative, tempering the bearing and clothing that otherwise epitomize a distant, arrogant royal realm, and hinting at weakness. In the portrait, van Dyck constructed the image of an aristocrat who appears also to be a flesh and blood human being. He captured his mood and a flicker of doubt that took possession of his face.

The portrait was one of some two hundred that van Dyck painted in England in the 1630s, when Charles I lured him to London to serve as his court painter. James Stuart was a favorite cousin of the king. Educated at Cambridge, he served in various government posts, including Heritable High Chamberlain of Scotland. Like certain others in the royal family, he may have been a Catholic.

As Charles I intended, van Dyck left a glorious visual record of the court and his reign—in portraits of the king, his queen, and their children, and of members of the nobility who sought out the artist's ability to transform them from ordinary creatures into unforgettable self-possessed individuals, each of whom embodied the fullest meaning of the word *aristocrat*. Famously, van Dyck elongated the proportions of his sitters so their height was sometimes as much as nine times the length of their heads. Van Dyck had stayed in England less than a decade, but his influence on English portraiture had been radical and pervasive—an influence visible in the parade of Methuen family portraits by Sir Joshua Reynolds, Thomas Gainsborough, and George Romney, hanging with the van Dyck in the dining room.

What made the portrait of James Stuart unforgettable was the play

of bold, visible brushstrokes that evoke the physical presence of the seventeenth-century nobleman, as in the green that suggests the weight and texture of the gleaming silk of his stockings, which sag slightly on his well-formed legs.

Well aware of the portrait's appeal, Frederick Methuen set the price of *James Stuart* at more than twice the price of the van Dyck altarpiece. Portraits generally had a larger market than religious pictures since collectors wanted canvases that easily fit into their houses. The Duke's figure offered a cultivated presence; the dark, violent image of the Garden of Gethsemane did not. Yet both *James Stuart* and *The Betrayal of Christ* more than met Marquand's criteria for the Metropolitan Museum. Together they represented van Dyck's two sides—the religious (or history) pictures and the portraits painted for private clients, which generated his large income. Still, the Protestant Marquand could not look at *The Betrayal* in purely art historical or aesthetic terms. He balked at buying a canvas that had originated as an altarpiece and whose life-sized theatrics may have smacked too much of what the American historian John Lothrop Motley called the "superstition and despotism" of seventeenth-century Catholicism.

In contrast, the portrait of the Duke of Richmond suited his Anglophile taste. A formal portrait of a royal cousin of a doomed English king, it celebrated the English ruling class, English power and English traditions, and provided a noble ancestor for the American, whose grandfather had been born in England. But above all, the portrait more splendidly manifested van Dyck's genius. The enthusiasm that Sargent and Millet expressed for the picture would be echoed throughout the twentieth century, recently by an art historian who saw it as proof of van Dyck's "inexhaustible inventiveness." Marquand's choice of a portrait over a religious picture was one that would be made again and again by American collectors.

Determined not to be overcharged, Marquand negotiated. "I have thought carefully over the picture belonging to Lord Methuen," Marquand wrote Deschamps on October 5. "I feel sure that the great dealers would not give over 6 or 7,000 pounds for it [*James Stuart*] at the *utmost*." Nevertheless, "I wish to be liberal & do not expect any bargain." The van Dyck's value in the marketplace was bound up with its

identity as a celebrated work of art, its greatness ratified by Sir Paul Methuen's prominence as a collector, and by the consensus of commentators who recognized the painting's aesthetic impact and the ways it realized van Dyck's ambitions. The handsome subject, the large scale, and the fine condition were all desirable attributes. (Paintings with faded colors, abraded surfaces, and flaking paint became ghosts of their original selves.) But Marquand knew that the van Dyck's value also depended largely upon what he was willing to pay. The market for Old Masters was idiosyncratic and inefficient and had few players. Once the National Gallery had backed away, he remained the only serious contender; he offered Methuen 8,000 pounds ($40,000)—the exact amount that Deschamps had told him the painting was worth. The collector also refused to pay the dealer a commission. (To the cost he would have to add a 30 percent tariff that the United States charged for importing works of art.)

Earlier Methuen insisted to Herbert Smith that he would not negotiate. "I have consulted the best authorities in England among others Lord Northbrook—who advises me not to take less than £10,000." He claimed Marquand faced competition from one of "the most independent and best judges in Europe—who are more than anxious to possess the picture" but happened to be short of cash. He threatened to "hold the picture back until next year when they are in funds." Yet within days Methuen accepted the American's offer.

Seizing the opportunity, Marquand now decided to buy more. Into the transaction he brought three additional Old Masters that he had admired at Corsham, for which Methuen added only 1,600 pounds ($8,000) to the bill. Two were Flemish—a large, unfinished canvas of *Christ Before Pilate* by Lucas van Leyden and a Rubens, *Portrait of a Man* (a man in black with a white ruff). The third had been painted in fifteenth-century Florence by a giant of the Italian Renaissance—Masaccio. It was a double portrait of a young woman in a cranberry-colored dress looking into the eyes of a young man on the left, whose face and red hat are only partially in view, cut off by a window frame through which he is leaning, his hands on its lower edge. Her luminous, subtly sculptured face is the center of attention. But, throughout the canvas, every detail, from the pearls along the edge of

her headdress to the trees in the garden seen in the distance through a second window, is described with arresting precision. While formal and ceremonial, the portrait possessed a disarming intimacy in the two faces set so close together and gazing at each other.

In deference to Methuen, the American agreed not to broadcast his purchases in England. "I wish you to present my compliments to Lord M & ask him to give me all the historical details he can of the 4 pictures—and tell him specially that whatever his wishes may be—I will respect them concerning the public exhibit of them," Marquand wrote Deschamps on October 12. "If he does not wish it—I will not lend them to Grosvenor, nor [the] National Gallery." A gentleman, he put the best face on the Englishman's loss. "I know it must be a struggle to part with such old friends," he wrote. "They will, however, educate a new country & do good service I trust where they are going."

At the end of October, the artist George Boughton delivered a check for 9,600 pounds (about $1 million in 2006 dollars) to Methuen and had Marquand's pictures delivered to London. A friend "who is writing a paper on van Dyck in England was saddened to think such a master work was leaving the country," Boughton told the collector. By Christmas the Methuen paintings arrived in New York and Marquand hung the van Dyck in his front hall. He invited members of the public—"those who are sincere in art, not the curious and shallow," as one journalist put it—"to study the picture between three and six o'clock on Monday afternoons."

"There stands before you an unmistakable type of the English gentry, a representative of royal blood and manners," wrote a reporter in the *Boston Evening Transcript*. "All is grace and taste, feeling and intelligence." Another critic praised the portrait's "beauty and freshness, power and vitality of color." He mused that Sir Frederick Leighton, head of London's Royal Academy, might "exclaim on hearing that the portrait had gone to America, 'it is a national calamity; it is van Dyck's masterpiece.'"

But the most eloquent praise would come from John Singer Sargent, and not in words. Late in the summer of 1887, Marquand commissioned the artist to paint his wife, Elizabeth. In September, Sargent sailed for America and she sat for him in Newport.

"Sargent has done a grand thing of Mrs. Marquand & leaves in 2 or 3 days," Marquand wrote Deschamps on October 25. Marquand failed to mention that in the full-length, Sargent had taken inspiration from America's new van Dyck. Not only is Elizabeth Marquand dressed in a long black dress with a white lace collar, but in setting her against shadowy brown and in placing her elegant white fingers splayed against black, he borrowed from *James Stuart*. Most importantly, he gave the American aristocrat a sophisticated and easy confidence, which suited her just as the sense of hauteur had suited the seventeenth-century English lord.

Sargent exhibited the portrait in Boston in 1888 and then at the Royal Academy in London. Henry James immediately understood that the "noble portrait" would repair the damage done by *Madame X*. "Mrs. M. will do him great good with the public—they will want to be painted like that—respectfully honourably, dignement," James told Henrietta Ruebell on April 1, 1888. From Newport, Sargent went on to Boston and then New York, and the commissions he executed in the course of the trip established him as America's leading portrait painter. Later, Auguste Rodin would label the American expatriate the "van Dyck of the period." Sargent himself thanked Marquand for the commission. "My debt of gratitude to you is one of very long standing. You have not only been a constant friend to me personally, but a bringer of good luck. My going to America to paint Mrs. Marquand's portrait was a turning point in my fortunes for which I have most heartily to thank you."

Earlier Marquand had attempted to appease Methuen with the thought that his paintings would "educate a new country." Already, one of them had.

Vermeer's *Young Woman with a Water Pitcher*

The encounter with van Dyck's *James Stuart* elevated Henry Marquand's collecting ambitions. "In regard to buying anything else, I do not expect to waste my time on seeing everything which will not rank with the Rembrandt & van Dyck," he told Deschamps on October 13, 1886. In 1887, he set out for Europe, again tracking Old Masters. At a Paris gallery, he saw Johannes Vermeer's *Young Woman with a Water Pitcher*.

The painting's subject was nothing more than a pale woman in a dark blue dress, standing in the corner of a darkened room, one of her hands grasping the handle of a brass pitcher and the other holding the frame of a leaded-glass window, which she might be opening, although the intent of the gesture remains unclear. Vermeer stayed close to his subject and set her into an intricate arrangement of shapes and colors—a chair, a table covered with a thick tapestry, a brass plate reflecting the tapestry's reds, blues, and golds, and a string of pearls on a blue ribbon hanging on the edge of a wooden box. On the wall is a large map of the Netherlands, suggesting the world outside. The woman's face is turned and framed by a luminous white headdress. Vermeer has conveyed her beauty in the delicate balance of her outstretched arms, the ultramarine dress that narrows at her waist, the planes of elusive blue, gray, and yellow in the translucent white fabric that crowns her head. Light from the window spreads across the background wall and flows down the left edge of the young woman's arm, and everywhere accentuates and sharpens the contrasts of texture and hue. What might at first glance have seemed a straightforward and easy-to-read Dutch genre scene was in fact a seductively intricate and complex surface of paint.

Until he saw the painting, Marquand may never have heard of Vermeer. The seventeenth-century Dutch artist had only been "rediscovered" two decades before by the French critic Théophile Thoré after over a century when many of his pictures had been misattributed to other Dutch artists whose works were more valuable. In 1742, August II, the Elector of Saxony, bought *Girl Reading a Letter at an Open Window*, thinking it was a Rembrandt. Two decades later, England's George III acquired *The Music Lesson* (*A Lady at the Virginals with a Gentleman*) as a picture by Frans van Mieiris. Even Vermeer's masterpiece, *The Art of Painting*, went to Count Czernin in the early nineteenth century as a Pieter de Hooch. Similarly, the Vermeer that Marquand saw in Paris had until recently been attributed to Gabriel Metsu. Thanks to Théophile Thoré, Vermeer's reputation was ascending. In the 1870s, the Louvre bought *The Lacemaker* and Berlin's Gemäldegalerie *Woman with a Pearl Necklace*.

Seventeenth-century Dutch painting readily appealed to American collectors. Where the artists of Italy and Spain focused on the human

figure and illustrated narratives chosen from history, literature, my-
thology, and the Bible, artists in the Netherlands painted portraits,
landscapes, still lives, and genre scenes. "As distinguished from the
narrative art of Italy," writes the art historian Svetlana Alpers, "central
aspects of seventeenth-century Dutch art—and indeed of the North-
ern tradition of which it is a part—can best be understood as being an
art of describing." Painters recorded the complicated and prosperous
Protestant world they saw around them—the well-ordered city streets
and canals, harbors crowded with square-rigged ships, stark white
church interiors, and scenes of peasant and bourgeois life. Artists like
Jan van Goyen, Jacob van Ruisdael, and Meindert Hobbema painted
vast reaches of flat green pastureland beneath even vaster expanses of
volatile sky. In portraits brimming with character and life, Frans Hals
and Rembrandt depicted the merchants and bankers of Holland (in
their fine black clothes and white ruffs) with at least as much tran-
scendent virtuosity and penetrating analysis as van Dyck had brought
to bear on kings and aristocrats. Americans had long valued the re-
public of Holland as a model for the United States and counted its
citizens among their forebears. But the attraction of Dutch paintings
for Americans sprang from their potent marriage of realism and vis-
ual splendor.

The $800 price of *Young Woman with a Water Pitcher* failed to re-
flect its brilliance and rarity. (Thoré attributed some seventy paintings
to Vermeer, but later scholars cut the number to thirty-five.) Marquand
decided to acquire the Dutch canvas, making it the first Vermeer to ar-
rive in the United States. With this Vermeer and van Dyck's *James
Stuart*, Marquand launched Dutch pictures and grand manner English
portraits as the two categories of Old Master pictures that the Ameri-
can tycoons who succeeded him would insist on possessing.

Within a year, Henry Marquand had amassed some thirty-five
Old Masters, most of them seventeenth-century Dutch pictures.
Wanting an audience to judge his new canvases, he put them on dis-
play at the Metropolitan. The positive response spurred him to act.
"Being impressed that they would be of far greater service to the pub-
lic to remain where they are in a public gallery, rather than in pri-
vate hands, I hereby offer them to the Metropolitan Museum of Art

without condition," he wrote the trustees on January 10, 1889. Later
that year, he was elected the Metropolitan's second president. In 1890,
he added thirteen more pictures, including a Leonardo da Vinci *Madonna*, Jan van Eyck's *Lamentation*, and Jacob van Ruisdael's *Landscape*.

Every painting is "interesting" and Marquand is "the most liberal
patron of the fine arts in New York, and we might even say in the
whole country," wrote a critic in *Harper's*. In *The Collector*, Alfred
Trumble called Marquand "the greatest collector in America because
he collects not for himself alone, but for a whole people and for all the
world." England also took note. "Everyone here who cares for art is
much interested in this step of yours," the London *Times* critic J. Humphrey Ward wrote Marquand. "But we tremble a little at the thought
of what may happen to our old collections if our Old Masters become
a fashion over there!"

The most important assessment came from Wilhelm von Bode, the
Berlin Gemäldegalerie's director, who visited the United States for the
first time in 1893. Bode was one of the German scholars who had
since the 1860s been laying the foundations of fine arts as an academic
discipline. He had a doctorate in art history from Leipzig, and was
working on a Rembrandt "catalogue raisonné," which identified the
artist's paintings, for the first time set them in chronological order, and
illustrated each with a black-and-white photograph. Such catalogs established the canon, while providing an invaluable reference for dealers
and collectors. (In the United States, Yale had first offered fine arts
courses in the 1870s, and Harvard followed suit a decade later. At Princeton, in 1882, Marquand's own son Allan, whose doctorate in philosophy came from Johns Hopkins, began teaching a course in Early
Christian and Byzantine art. Marquand paid Allan's salary with funds
from his brother Frederick's estate.)

Bode found the Metropolitan's new building "ponderous and in bad
style," but claimed that the Marquand pictures "would be a treasure to
every gallery on the continent." To the European, the number of paintings seemed small: "only fifty." He pronounced both Rembrandts genuine, but reattributed several pictures, including the Masaccio double
portrait, which he thought "probably a work by Cosimo Rosselli." He

identified the van Eyck as "an especially fine, bright work by Petrus Christus." Finally, the Leonardo he demoted to a "school picture." (In the latter two cases, Bode proved right.)

What Bode failed to acknowledge was that he stood as Henry Marquand's foremost competitor for Old Master pictures. Bode had preceded the American financier in the art market, and had an advantage that Americans would take time to acquire—scholarly knowledge and expertise. In 1893, Bode breathed a sigh of relief. Even if the Americans showed "extraordinarily good taste" in their European purchases and willingly paid high prices, he reassured his German audience that "no one [in the United States] collects Old Master pictures systematically." Indeed, as Americans focused on Rembrandt portraits, Bode acquired ten of the Dutch artist's religious and mythological pictures for Berlin.

As the Metropolitan drew international recognition, behind the scenes, Marquand had a revolution to quell. In 1895, the attorney Robert de Forest headed a group of museum trustees campaigning to oust the controversial and incompetent director Luigi P. di Cesnola. According to the trustee Hiram Hitchcock, in the course of a meeting Joseph Choate and others claimed that Cesnola "hindered progress, prevented gifts, was deceptive, brusque, insulting, domineering, unjust to subordinates, not a good manager, not in touch with art here and in Europe, does not fairly represent us, is a martinet, owns the Museum, controlled Mr. [John T.] Johnston and now controls Mr. Marquand." In his midseventies and depressed over the death of Elizabeth, Marquand resisted change and saw de Forest's plans as insubordination—a battle between the "conservative forces" and the "Impressionists." Hyperbolically, he predicted ruin, "unless the youthful element be kept quiet." On February 10, de Forest and another trustee stopped at Marquand's house, and his son Allan turned them away. "I am angered," Henry Marquand wrote, "at the manner in which I heard yesterday that a scheme was on foot to remove the Director of the Museum." Soon after, when the Metropolitan's board voted on Cesnola, J. Pierpont Morgan took Marquand's side, and the director held on to his job. While Marquand kept the trustees' respect and devotion, the fight over the director cost him influence and power.

By 1901, when the trustees commissioned John Singer Sargent to paint Marquand's portrait, the elderly collector looked thin and frail. Sargent painted him in his customary black suit, but placed his head in his hand, and his elbow on a table, in the classic pose of "melancholy." Yet he suggested Marquand's former energy in the arm he has thrown over the back of his chair, and made him at once both resolute and sad. Marquand had recently watched his financial legacy collapse when the investment firm owned by his son (Henry Marquand & Co.) and to which he had loaned over $100,000, went bankrupt.

In February 1902, Henry Marquand died. Because of the family's troubled finances, the collection that had filled the house on East Sixty-eighth Street went on the auction block in New York in a series of sales that ran for five days and raised $700,000. The most expensive picture was Lawrence Alma-Tadema's *Reading from Homer*, which sold for $30,000. At the turn of the century, the taste for modernist art had not yet knocked the Victorian artist into obscurity. But the private collection, scattered by the auction, was inconsequential compared to the fifty Old Masters the visionary Marquand had already given the Metropolitan. These paintings rightly stood as the collector's legacy, recalibrating the museum's aesthetic standards and laying the foundation for what would become one of the great Old Master painting collections in the world. At the start of the twenty-first century, the Metropolitan still keeps thirty-five of Marquand's pictures. Five or six of the collector's paintings "rank with the finest works of art in the Museum," notes Everett Fahy, chairman of the Metropolitan's Department of European Paintings—Frans Hals's *Portrait of a Man*, Ruisdael's *Landscape* (the *Forest Stream*), the Petrus Christus *Lamentation*, as well as Vermeer's *Young Woman with a Water Pitcher* and van Dyck's *James Stuart*. In the 1970s, scholars identified the Masaccio *Portrait of a Man and a Woman at a Casement*, which Marquand had bought at Corsham Court, as a Fra Filippo Lippi and as one of the museum's rarest and most important pictures—the "first double portrait in Italian art."

In the end, Henry Gurdon Marquand shaped not only the Metropolitan's content but also its form. In 1894, he and his fellow trustees decided to expand the museum with an "east wing" and asked Richard Morris Hunt to prepare drawings for the new addition. They

wanted to reorient the museum and erect a new entrance on Fifth Avenue. But before completing the plans, Hunt unexpectedly died. When asked whether the trustees should choose a new architect, Marquand insisted that they "carry out the Hunt design." He told Cesnola: "There will be no chance for anybody else to come in and snatch his monument," and he turned the project over to Hunt's son, Richard Howland Hunt, also an architect. Completed in 1902, the Fifth Avenue facade transformed the Metropolitan into one of New York's most spectacular buildings.

In his design, Hunt took inspiration from Greece, Rome, and the High Renaissance, weaving classical forms into a pale, vast, and elaborate scheme befitting a museum of the industrial age and trumpeting its identity as a temple of art, intended to both dazzle and instruct. The front climbed two tall stories and stretched half a city block. (Later it expanded both north and south.) Four pairs of colossal Corinthian columns soared almost to the roof, to form a central portico and frame three arches. Hunt envisioned paying homage to the artists of Europe by decorating the architecture with inscriptions and sculpture, but budget constraints eliminated much of the detailing. Nevertheless, high up six stone medallions with portraits of Michelangelo, Raphael, Rembrandt, Velázquez, and Dürer as well as of the architect Bramante paid tribute to Europe's Masters.

Inside, the architecture also celebrated the European tradition, sweeping visitors from a great hall (crowned by three domes) and up the forty-six steps of a grand, stone staircase to a gallery filled with over one hundred Old Masters. Marquand's fifty pictures were hanging in a nearby room. When the modernist critic Roger Fry took charge of the Metropolitan's paintings in 1906, he insisted on separating out the finest pictures and placing them in a single gallery—Gallery XXIV—in imitation of the Salon Carré at the Louvre, to point out that "some things are more worthy than others of prolonged and serious attention." Five years later, the director Edward Robinson underlined Fry's point by pulling masterpieces from Gallery XXIV and setting them center stage in the room at the top of the stairs, which the trustees now renamed the Marquand Gallery. There, directly across from the arched entrance, stood *James Stuart, Duke of Richmond and Lennox*—the

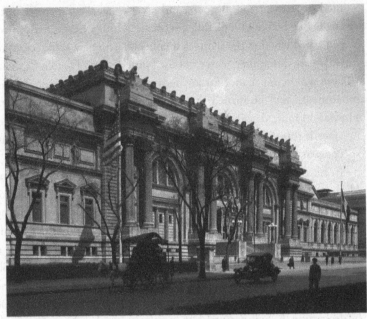

The Metropolitan Museum of Art, photographed in 1917. Richard Morris Hunt's 1902 Fifth Avenue facade transformed the museum into one of New York's most spectacular buildings.

centerpiece of a single line of five extraordinary pictures—Frans Hals's portraits at either end, as well as Vermeer's *Young Woman with a Water Pitcher* and a second Vermeer, called *A Lady Writing*, to balance it. Marquand had given four out of the five canvases two decades before and now the museum hung them against dark damask and gave each room to breathe and cast its spell.

"C'est Mon Plaisir"

Isabella Stewart Gardner, Bernard Berenson, Otto Gutekunst, and Titian's *Europa*

"How much do you want a Botticelli?" The question was sent to Isabella Stewart Gardner in Boston in a letter posted by Bernard Berenson on August 1, 1894, from London. Berenson, thirty-one, had, with the publication of the groundbreaking *Venetian Painters of the Renaissance*, recently established himself as an expert on Italian art. Four months before, he had sent Gardner a copy of his book, and earlier that summer, when she was in Paris, he urged her not to miss an exhibition of English pictures.

Soon after, Isabella Gardner asked Berenson his opinion of several Italian Old Master pictures proposed to her by dealers in France. Berenson replied that the paintings were not what these dealers claimed and offered her the Botticelli instead. "Lord Ashburnham has a great one—one of the greatest: a *Death of Lucretia*," he wrote. But, he "is not keen about selling it." Yet, Berenson thought that "a handsome offer would not insult him."

Berenson also named a price: "about £3,000," or some $15,000. He added, "If you cared about it, I could, I dare say, help you in getting the best terms."

Isabella Stewart Gardner had made her first major purchase of an Old Master painting two years before, on December 5, 1892, at the Paris auction of the collection of the late Théophile Thoré. The day before the sale, an artist friend had accompanied her to peruse Thoré's

art, and there she saw the three Vermeers that were to be auctioned. To bid for her, Gardner hired Fernand Robert, a Paris antiques dealer. At the time, auctions generally operated as a wholesale market, where dealers acquired stock. If they knew that a collector wanted a particular work of art in a sale, they would try to buy it in hopes of selling it to the collector immediately afterward.

The first Vermeer in the Thoré auction, *A Young Woman Standing at a Virginal*, went to a Paris dealer, Stephen Bourgeois, for 29,000 francs. Bidding for the second, *The Concert*, again climbed to 29,000 francs, and Fernand Robert won the picture.

"Mrs. G. bought the van der Meer picture for fr. 29, 000," John Lowell "Jack" Gardner, Isabella's husband, noted matter-of-factly in his diary.

No doubt *The Concert* struck Isabella Gardner because of its understated, well-plotted beauty. The small picture was a Dutch interior where two young women, one in a glimmering white skirt seated at a harpsichord, and a young man in a brown jacket with a lute, are performing a piece of music on the far side of a room, across a floor patterned with black-and-white squares. On the wall behind them hang two large Dutch Old Masters in black frames. In the complex interlocking of colors and shapes made from the musicians, the instruments, the fabrics, the paintings, and the furniture, some in shadow and others in light, Vermeer captured the fleeting enchantment of the music, translating the elusive spell of one art form into another. Gardner's new acquisition was the first Vermeer to reach Boston and the second in the United States. With a commission, the canvas cost Gardner 31,175 francs, or just over $6,000. Although Henry Marquand had paid only $800 for his Vermeer five years before, Gardner's purchase soon looked like a bargain. In August a friend reported that a Dutch art expert "says your concert is now worth *easily* between 150 and 200 thousand [francs]!" Indeed, soon after, Stephen Bourgeois turned around and sold his *Young Woman Standing at a Virginal* to the National Gallery in London for 50,000 francs, or $10,000. Prices of Old Master pictures were rising.

Still, in the mid-1890s, the number of Americans buying Old Masters remained small. Gardner's purchase at a Paris auction showed her independence of mind and her ambitions as a collector—and that she had her ear to the ground among progressive artists in London and

Paris. In proposing the rare Botticelli to Gardner, Berenson knew well she was likely to leap at the chance to acquire it. She had definite, individual taste, with particular likes and dislikes. She had spent several summers in Venice and was drawn to the art of the Italian Renaissance. Rembrandt was the favorite artist of America's tycoons, but not hers. "You know, or rather, you don't know, that I adore Giotto," she wrote Berenson in 1900, "and really don't adore Rembrandt. I only like him." He shared her pioneering taste for Italian art and sympathized: "I am not anxious to have you own braces of Rembrandts, like any vulgar millionaire," he wrote. A devout Anglican, Gardner had no problem with religious imagery. The same summer she won the Vermeer, she had also purchased a Spanish *Madonna* and a Florentine *Virgin and Child*. Soon she spelled out her wish to buy Italian pictures, claiming that a Filippino Lippi and a Tintoretto (along with "a Velasquez [*sic*] *very* good") were her "foremost desire always." She added: "Only very good need apply!" Unlike Marquand, Gardner was buying for herself, her own pleasure, and her Beacon Hill house, where she hung both new and old paintings and propped the extras on chairs. Like Marquand and even more emphatically than him, she insisted upon masterpieces.

When Berenson proposed the Botticelli, Isabella Stewart Gardner was fifty-six, slim, and elegant. She directed her life with a theatrical sense of style. She had pale skin, dark hair, an oval face with almond-shaped eyes, a long straight nose, and a full, awkward mouth, which, like her eyes, curved slightly down and suggested the seriousness that, for all her flamboyance, was at the core of her personality. She had a long neck and an erect carriage. She wore well-cut clothes (many designed by Charles Worth and imported from Paris), which spoke to her love of textiles but also to her creativity and skill in shaping her own image. In a black-and-white photograph, she stares out with a mix of wisdom and innocence, her willowy figure clad in a fitted dress of dark watered satin with a high collar, long sleeves, and buttons running straight down its front. In summer, she wore large-brimmed hats festooned with veils that she tied down around her neck. Perhaps increasingly self-conscious about her

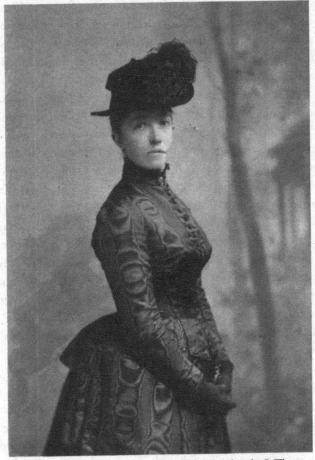

Photograph of Isabella Stewart Gardner, 1888, taken by J. Thompson, Grosvenor Street, London. Isabella Stewart Gardner Museum, Boston. An aesthete, she brilliantly shaped her public image and pioneered the collecting of Old Masters.

face, she covered it as she aged. In her sixties, she would maintain her narrow form, holding her neck straight and her head high.

Energetic and self-possessed, Isabella Gardner was a New Yorker who cut her own path in Boston, breaking the establishment rules in dress, social practice, and collecting. Her marriage to Jack Gardner, a Boston Brahmin, brought her to the top of Boston's social hierarchy

and gave her the freedom to shape her own role as a visible patron of advanced art. She is "the most dashing of fashion's local cynosures," as one critic put it, "who can order the whole symphony orchestra to her house for a private musicale."

Diva and muse, she gathered about her a circle of artists, writers, and musicians—young men whose careers she championed, who kept her up with their work and who were drawn to her larger-than-life persona. "She lives at a rate and intensity," Berenson wrote, "and with a reality that makes other lives seem pale, thin and shadowy." But after three decades in Boston, Gardner still described herself as a "New York foreigner." Indeed, Boston society never embraced her, and she in turn exploited her outsider identity to fullest advantage. If Bostonians frowned on extravagance, she spent freely on clothes, jewelry ($83,000 on a necklace and a ruby ring), and concerts. By traveling frequently in Europe and making a habit of summers in Venice, she joined a circle of influential American expatriates, including not only John Singer Sargent but also James McNeill Whistler and Henry James, who in various ways encouraged her collecting.

In 1886, Henry James had taken Isabella Gardner to Sargent's London studio specifically to see the notorious portrait *Madame X*. Far from frightened off, Gardner commissioned Sargent to paint her own portrait, which he began immediately after he finished painting Elizabeth Marquand. Where he had portrayed the wife of the Metropolitan Museum's president conventionally and naturalistically, as an American aristocrat smiling and seated in a chair, he turned Isabella Gardner into an icon, a symmetrical image set before a hanging of Venetian brocade with a radiating pattern of red, ochre, and gold, designed to convey her singularity as a devotee and patron of art. She stands, facing us straight on in a long black dress with a low neck and short sleeves, her shoulders drawn back and her hands clasped so her white arms form an oval. Henry James suggested the artifice of the Sargent portrait when he described it as a "Byzantine Madonna with a Halo." Sargent showed the portrait in his first American exhibition at the St. Botolph Club on Boston's Beacon Hill, entitling it "Woman, an Enigma." What shocked Boston were the ropes of pearls around Gardner's neck and waist, and the décolletage of the dress. In her slightly parted lips and her bold gaze, Sargent also suggested Gardner's engaged presence and

quickness of mind. The artist painted the portrait six years before Gardner bought the Vermeer, but his tribute to her as a high priestess of art was one she embraced. Her appetite for art was not a pose but a passion; aestheticism became the guiding principal of her life. Given money, she acquired paintings, sculpture, antique furniture, and other decorative arts—casting herself by means of her collection as a Renaissance patron, and taking the domestic environment to which she as a woman was restricted and turning it ultimately into a public space designed to display art and express herself as a collector. "Mrs. Gardner's collecting seems to have been part of a strategy" the art historian Kathleen Weil-Garris Brandt has written, "that developed to win for herself as a woman, albeit a rich and powerful one in Victorian Boston, the freedoms, the self-definition, and—crucially—the social and intellectual respect which she believed her Renaissance woman models to have enjoyed."

Later, when Gardner built the museum where she also lived, she placed above the door a coat of arms, with a phoenix, and into the stone carved the words "C'est Mon Plaisir"—It Is My Pleasure. The phrase was not simply a declaration of ego ("the justification for her every action," as one biographer put it), but resonated with the aestheticism of the nineteenth century and summarized the creed that art above all involved sensuous pleasure and spiritual enlightenment.

Gardner's cosmopolitanism and spirited approach to life began early. She was born on April 14, 1840, at 20 University Place in New York, the oldest of four children of Adelia Smith and David Stewart, a wealthy, first-generation Scottish entrepreneur who had made money importing linen from Ireland and Scotland and then investing in iron mines. In 1854, when Isabella was fourteen, her younger sister, Adelia, died. Two years later, the Stewarts, socially and culturally ambitious for their surviving daughter, took an extended trip to Europe, where they enrolled Isabella in a Paris school. There she met Julia and Eliza Gardner, the daughters of John Lowell Gardner, a Boston shipping magnate, and through them their brother Jack. "The Stewarts are as usual all kindness," Julia Gardner wrote her mother on a visit to New York on October 8, 1859. "They are constantly repeating, 'Make yourself perfectly at

home, this is Liberty Hall,' and, moreover, they provide their guests with every comfort and luxury." Julia and Isabella went to the theater, the opera, Central Park, and to see Frederick Church's enormous landscape, *Heart of the Andes*, exhibited at the artist's Tenth Street studio.

Jack Gardner had dark, straight hair, a high forehead, dark eyes, and an open, boyish face. He had left Harvard after his sophomore year to work for his father's shipping company. A sailor, he owned a series of yachts and joined the syndicate that built the *Puritan*, a sloop that in 1885 successfully defended the America's Cup. Later, Henry James described Jack as kind, courteous, and generous. "He remains one of my images (none too numerous) of those moving in great affairs with a temper that matched them & yet never lost its consideration for small affairs & for the people condemned to them."

Like Isabella, Jack loved to have fun. He was "all abundance & health & gaiety as I last saw him," James wrote. But he was also modest and self-effacing. Henry Lee Higginson, a founder of the Boston Symphony, found him a kindred spirit and seemed to speak directly to his character when he later wrote to Isabella that "Jack, you and I have held the same view of life and its duties and in doing so may have forgotten the painful subject—one's self. It was the natural result."

By February 28, 1859, Isabella and Jack were engaged, and a year later they were married at Grace Church, the fashionable neo-Gothic Episcopal church near the Stewart's house in Manhattan. "Surely no one has so many causes to rejoice as myself," Isabella wrote Julia Gardner. The couple moved to Boston and lived in a hotel before moving into the house that her father built for them at 152 Beacon Street. In 1880, the Gardners expanded by buying the house next door, where they added a music room for concerts. Later, they also owned houses in Brookline, where Isabella kept a greenhouse, and in Prides Crossing, on Boston's North Shore. In August they would spend two weeks on a private island down east off the coast of Maine, where Isabella, an athlete, described her "great amusement" as "Indian canoeing on visits to the seals."

Almost from the start, the Gardners suffered a series of losses. On September 10, 1860, Isabella gave birth to a stillborn baby boy. Three years later she had a son, John Lowell Gardner III ("Jackie"), who contracted pneumonia when he was not yet two years old and, on May

15, 1865, he died. Shortly thereafter, Isabella seems to have suffered a miscarriage, and went into a deep depression.

Hoping to mend her broken spirits, the Gardners sailed for Europe in the spring of 1867 and traveled for a year. On the trip, which took them to Scandinavia, Russia, Austria, and France, she began to recover. Six years later, the Gardners went abroad again for almost twelve months—this time to see Egypt, Palestine, Turkey, and Greece. Isabella kept an elaborate travel book, which she filled with photographs and where she recorded her perceptions in evocative, hyperbolic prose that suggested her aesthetic leanings. "I have never had such an experience," she wrote, after seeing the temples at Karnak at night, "and I felt as if I never wanted to see anything again in this world; that I might shut my eyes to keep that vision clear. It was not beautiful, but most grand, mysterious, solemn." At Esneh, she wrote: "The river runs liquid gold and everything seems turned into the precious metal, burning with inward fire." Traveling helped her escape the heartbreaking recollections in Boston, and her writing shows that she had also left behind the conventional role the Victorians assigned to women, one centered upon children and the home.

Still, tragedy pursued the Gardners. Isabella's brother David, in his midthirties, died shortly before they set sail. Then, in Constantinople, on July 16, the Gardners received word of the death of Jack's brother, Joseph. ("J. went for the letters and found the two terrible telegrams about poor dear Joe," she wrote.) Joe, a widower, had three sons, who moved into Jack and Isabella's Beacon Street house. Seven years later, in 1886, the Gardner's oldest nephew, also named Joe and described by a Harvard classmate as "the wittiest man of his epoch," committed suicide. He was only twenty-five, and not long before had been traveling in Europe with Isabella and Jack.

In 1879, Isabella Gardner met Henry James, who was thirty-six and had published his first three novels: *Roderick Hudson*, *The American*, and *Daisy Miller*. In Isabella Gardner, James found a friend (to whom he wrote one hundred letters) and a source for fiction in which he explored the American encounter with Europe and the appropriation of cultural treasure. "If you 'like being remembered,'" he told her, "it is a satisfaction you must be in constant enjoyment of, so indelible is the image

which you imprint on the consciousness of your fellow-men. . . . Look out for my next big novel: it will immortalize me. After that, some day, I will immortalize you." Indeed, James's biographer Leon Edel observes that Isabel Archer, the heroine of *The Portrait of a Lady*, "embodies a notion not unlike that of Isabella of Boston with her motto of *C'est mon Plaisir.*" The collector may also have inspired Adam Verver in the 1904 novel *The Golden Bowl*, who is building a "museum of museums, a palace of art" and whose religion is "the passion for perfection at any price." Phrases that James wrote in his notebook suggested the darker themes he observed in Gardner's incessant energy and habit of acquisition: "the 'where are you going' age of Mrs. Jack, the figure of Mrs. Jack, the American . . . the Americans looming up, dim vast, portentous in their millions, like gathering waves, the barbarians of the Roman Empire."

Henry James invited the Gardners into his expatriate American sphere, and they accepted. The year he met them he introduced them to Whistler in London. Only two years before John Ruskin had attacked Whistler's abstract paintings claiming he "never expected to hear a coxcomb ask two hundred guineas for flinging a pot of paint in the public's face." Whistler had sued Ruskin for libel, and after a notorious trial, in 1878, where he explained that the title of his painting *Nocturne in Blue and Silver* was meant to suggest "artistic interest alone, divesting the picture of outside anecdotal interest," he won. But the court awarded the artist only a farthing in damages and the cost of the lawsuit drove him into bankruptcy.

Isabella Gardner felt immediately enthusiastic for Whistler's nearly abstract works. Shortly after they met, she commissioned the artist to do her portrait. In pastel, he drew her in a yellow dress on brown paper—characteristically giving the portrait the title *The Little Note in Yellow and Gold*. In 1892, again in London, she persuaded the reluctant artist to let her have (for 600 guineas, or about $2,400) a seascape, *Harmony in Blue and Silver: Trouville 1865*, to which he was particularly attached. "When can we find you?" she wrote him, on December 4. "I want to bring you the cheque and get my picture. *Both* have to be signed, you know!" Whistler was a dandy who kept his dark hair long, wore a monocle, and carried a cane. No doubt Isabella Gardner appreciated the skill with which the American artist crafted a public

image to promote himself and his work. In 1895, she proposed that Whistler paint murals for the Boston Public Library; she had considered purchasing his famous *Peacock Room* and installing it there. "How can you let the peacock room belong to anybody else!" Sargent asked Gardner. Whistler would credit Gardner for advancing American art. "There was a time when I thought America far away—but *you* have really changed all that—and this wonderful place of yours on the [Back] Bay [of Boston] ends by being nearer to us than is the Bois to the Boulevards on a summer afternoon!"

The iconoclastic taste that attracted Gardner to Whistler's paintings played its part in her choice of Old Masters. Like the artist, the collector was an aesthete who shared his conviction that art "is withal selfishly occupied with her own perfection only—having no desire to teach—seeking and finding the beautiful in all conditions and in all times." She judged paintings on their intrinsic formal qualities—the visual interplay of color, shape, texture, and tone. Gardner's emphasis on masterpieces reflected her pursuit of the "art for art's sake" doctrine, her practice of measuring a work of art by its beauty and its power to transmit aesthetic experience.

Meanwhile, Isabella Gardner had begun a love affair with Italy. In 1878, she had attended a series of public lectures given by the Harvard professor Charles Eliot Norton on the poetry of Dante. Characteristically, Gardner threw herself into the subject. She studied Italian and joined the Dante Society, a group that gathered in Norton's living room. With Norton's encouragement, she purchased rare editions of Dante's works—a bound edition of *The Divine Comedy*, dating from 1508, and another from 1481. She took immediately to collecting. "Books, I fear are a most fascinating and dangerous pursuit," she wrote Norton on July 12, 1886. "But one full of pleasure, and I owe it entirely to you, if I have made a good beginning."

In 1883, the Gardners took a yearlong trip around the world, stopping in India, China, Japan, Java, and Cambodia, where Isabella insisted that guides take them on an arduous all-day river voyage to reach the legendary twelfth-century temples at Angkor Wat. ("We . . . started in five small boats . . . In about two hours the boats could go no farther, so bullock and buffalo carts were got ready with much talk and wait

and off we started again.") They ended the trip with a month in Venice. There, Isabella fell under the city's thrall—its beauty, history, antiquity, and watery exoticism. A day after arriving, the Gardners visited the Palazzo Barbaro, one of the palaces on the Grand Canal. Built in the sixteenth century by the Barbaro family, the palace was now owned by Americans—Daniel and Ariana Curtis, who were expatriates from Boston and whose son Ralph was a painter and one of the Gardners' friends. Henry James described the magnificent palace as "all marble and frescoes and portraits of Doges." It had an open central courtyard and a grand "salone," whose walls and ceiling were decorated with enormous Baroque paintings set into elaborate gold moldings. In 1898 Sargent painted the Curtises in their late-nineteenth-century white trousers and long skirts, taking tea and reading the newspaper in the ancient Venetian interior that was now their living room.

Starting in 1890, the Gardners leased the Palazzo Barbaro from the Curtises for several months every other summer for eight years. They entertained a steady stream of guests and made the ancient European residence a center of their life. We "were enjoying the moonlight from the second story," Jack Gardner wrote. "We all five then got into the gondola and floated along the outside, the music accompanying us and the moon sinking into the lagoon." The constant excitement orchestrated by the Gardners in Venice comes through in a portrait Anders Zorn painted of Isabella at night bursting through double doors from outside into the light of a room. "I am on the balcony, stepping down into the salone pushing both sides of the window back with my arms raised up and spread wide! Exactly like me," she told a friend. Importantly, for Isabella, the Palazzo Barbaro was only one building away from the bridge that crossed the Grand Canal to the Academia, with its unsurpassed collection of Venetian Old Masters, and she filled an album with black-and-white photographs of the museum's Renaissance pictures.

When Henry James spent two weeks at the Palazzo Barbaro with the Gardners, in 1892, he was forced by the large number of houseguests to sleep on a cot in the library. Shortly after he left, he thanked his hostess, evoking in his slightly mocking tone the imperious style with which she held court: "I don't know where this will find you, but I hope it will find you with your hair not quite 'up'—neither up nor down, as it were,

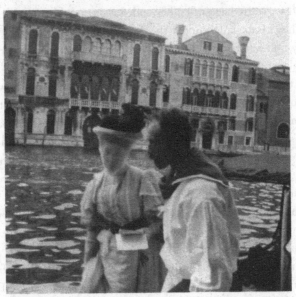

Isabella Stewart Gardner and a gondolier on the Grand Canal, 1894. Isabella Stewart Gardner Museum, Boston. Starting in 1890, the Gardners rented the Palazzo Barbaro in Venice every other summer for eight years.

in a gauze dressing-gown, on a seagreen (so different from peagreen!) chair, beneath a glorious gilded ceiling, receiving the matitudinal tea from a Venetian slave."

In his 1902 novel, *The Wings of the Dove*, James would use the Barbaro as a model for the Venetian palace (the Palazzo Leporelli) where his young heroine retreats to spend her final days. He describes "high, florid rooms, palatial chambers . . . where the sun on the stirred seawater, flickering up through open windows, played over the painted 'subjects' in the splendid ceilings." He commissioned a photograph of the Barbaro's facade to place in the front of volume II of the New York edition of the book.

With the death of her father in 1891, Isabella Gardner inherited close to $2 million—an endowment that allowed her to begin collecting Old Masters. "I had two fortunes—my own and Mr. Gardner's," she explained. "Mine was for buying pictures, jewels, bric à brac etc etc.

Mr. Gardner's was for household expenses." Jack Gardner provided Isabella, whom he clearly adored, with not only a financial foundation but also an emotional foundation, on whose bedrock she stood.

In December 1894, four months after Berenson had written Isabella Gardner about Lord Ashburnham's Botticelli, they met in Paris and went to the Louvre together. The following day, she agreed to buy the painting from him for 3,000 pounds, or $15,000—more than twice what she had paid for the Vermeer. *The Death of Lucretia* was the first Botticelli to travel to America. The painting was richly colored—a scene with small figures set in an open square framed by monumental classical buildings. Lucretia is a young woman in a green dress prostrate on a tomb, a knife in her chest, surrounded by soldiers who have discovered her suicide. In addition to conveying the emotion of the charged encounter, Botticelli also conclusively demonstrates his abilities to create the illusion of space with linear perspective in the setting of the scene. Later, the art historian Laurence Kanter described it as "certainly one of the great masterpieces of Florentine painting from the last years of probably its greatest period, the golden age of the fifteenth century."

With the Botticelli, Isabella Gardner took American collecting in a new direction, and her collaboration with Bernard Berenson began. She enlisted him as a scout for Old Masters and agreed to pay him a 5 percent commission on the price of each purchase. As dealers typically charged commissions of 10 percent when they acted as brokers, she thought she was getting Berenson's advice for a bargain. At least in the short run, she would be wrong.

Bernard Berenson

When Bernard Berenson wrote to Isabella Stewart Gardner about a Botticelli, he could safely assume his word alone would make the painting of interest to her. The older woman and the younger man had been friends for close to a decade. They met in the mid-1880s, through Charles Eliot Norton, the Harvard professor, whose enthusiasm for Dante and early Renaissance art would leave an imprint on both their

lives. She was in her early forties, already a prominent cultural figure in Boston. He was an undergraduate in his early twenties, and far more of an outsider than she could ever be. Born a Lithuanian Jew, Berenson had immigrated to Boston with his family in 1875 when he was ten. Even before he got to Harvard, he exploited his intellectual prowess to cross the social and economic divide between himself and the privileged Americans who became his fellow students and friends.

At Harvard, Berenson gave Gardner his photograph. He had a rough-cut, boyish face, a straight nose, full, curving lips, and wavy dark hair that fell to his jacket collar and lent him the look of a romantic poet. She kept the picture and above it she wrote: "Bernhard Berenson as I first saw him." Berenson happened to be two years younger than her late son and she must have noticed that he had been born in June 1865, only one month after her child had died. Despite their differences in background, Gardner and Berenson had much in common, their friendship founded upon their shared enthusiasm for Italian art, their reverence for beauty.

Over the course of thirty-odd years, Gardner and Berenson saw each other fewer than a dozen times. Yet the relationship loomed large in both their lives, thriving on a transatlantic correspondence they infused with sensuality and romance, as they described to each other their ecstatic encounters with landscape, music, and art. They wrote each other more than one thousand letters, many of them testimonies to late-nineteenth-century aestheticism. The letters are intimate, their language seductive.

Gardner relished playing the part of Berenson's supporter, patron, and confidant, and he the complicated, conflicted role of art adviser, suitor, and friend. "Well, I come again trying to despoil you," Berenson wrote in August 1895. "This time it is a Tintoretto I wish you to buy." She would answer in kind. "The delightful letter ... by the way made me quite frantic to fly to Fiesole and drink in the air—and perhaps saunter with you in the sunny afternoons." When he sent her a photograph of a Rembrandt, she replied: "I am bitten by the Rembrandt, and today being Sunday, I wait until tomorrow and then cable 'Yes Rembrandt'! Also 'Yes Tintoretto.' ... And of course, I am hoping for the Guardi."

Hungry for economic and social advancement, he laced his prose with flattery. Gardner basked in his attention, thrilled by the chance to purchase pictures and to voice her thoughts to someone who so exactly

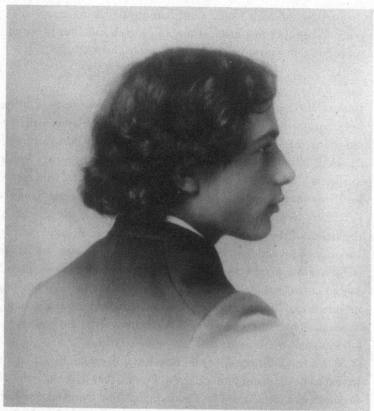

Bernard Berenson, 1886. Isabella Stewart Gardner Museum, Boston. "As I first saw him—" Gardner wrote on the photograph. They met when she was in her midforties and he a student at Harvard.

shared her passions and taste. Berenson also delivered practical advice and when it suited his purposes invited the Gardners into the exclusive European art world. When they traveled in Italy, he suggested collections to see, and introduced them to Count Moroni, who, he explained, had "the finest Moronis in the world." He then insisted Isabella tell him "whether in your opinion there is a more distinguished, and more refined, as well as more genial portrait in the world than Moroni's *Man in Black*. You will see it was not by any means Whistler who invented tone."

Both Gardner and Berenson would exploit their relationship and collaboration in the collecting of Old Master pictures to reinvent

themselves, and each would contribute to the lasting legacy of the other. When they first met in Cambridge, each had already begun a process of self-transformation.

Bernard Berenson was born on June 26, 1865, in Butrimonys, a village in Lithuania, then the western part of Russia where Jews were permitted to live. He was the first child of Albert Valvrojenski and Judith Mickleshanski, who had married the year before. Valvrojenski was an intellectual, a devotee of Voltaire and the Enlightenment, who earned his living buying and selling timber. According to Ernest Samuels, Berenson's biographer, Valvrojenski "avidly imbibed the anticlerical skepticism of the German-Jewish writers. German became the first language of his children, though Yiddish, Polish, Russian, and scraps of Lithuanian met day-to-day needs in the polyglot life of the village." Later Bernard would acknowledge his father's early role in promoting his intellectual life. "I found you the most stimulating and fascinating of companions," he wrote Albert. "I don't know what I don't owe to the talks I used to overhear between you and your friends."

When the Valvrojenskis (who now had a daughter, Senda, and a second son, Abraham) immigrated to Boston, they took the name of Berenson, already adopted by a cousin, and Albert worked as a peddler. (Berenson spelled his name "Bernhard" until World War I, when he anglicized it, dropping the "h.") They had always encouraged the intellectually precocious Bernard to study, and they sent him to the elite Boston Latin School. In Boston, two more Berenson children, Elisabeth and Rachel, were born.

Bernard proved himself an excellent student with a facility for languages. He worked his way to Boston University, and after a year transferred to Harvard, entering as a freshman in 1884. He studied Hebrew, Latin, Greek, Arabic, Sanskrit, and German and took Professor Charles Eliot Norton's courses on Dante and on Ancient, Medieval, and Renaissance art. He also joined a circle of undergraduate aesthetes and Norton followers—including Charles Loeser, Logan Pearsall Smith, and George Santayana. At Harvard, he had himself baptized as an Episcopalian. Before he graduated, in 1887, Berenson applied for a traveling

fellowship, which he failed to win. But a Harvard instructor raised $700 from friends, among them Isabella Gardner, to fund a year abroad. Berenson sailed for Europe, planning to become a writer.

But after only a few months, while in Italy, Berenson set his mind on turning himself into an expert on Italian Renaissance art. Later he described the decision to give himself up "to learning, to distinguish between the authentic works of an Italian painter of the fifteenth and sixteenth century, and those commonly ascribed to him," as a revelation. "Here at Bergamo," he wrote, "and in all the fragrant and romantic valleys that branch out northward, we must not stop till we are sure that every Lotto is a Lotto, every Cariani a Cariani, every Previtali a Previtali." His ambitions to become a professional connoisseur suited the Harvard graduate and aesthete, who recognized that much work had to be done to sort out Italian pictures and that the American desire for Old Masters was driving up demand for such art expertise.

Meanwhile, he kept Isabella Stewart Gardner abreast of his progress. By the time he wrote to her from Vienna on the Fourth of July, 1888, she had already bought paintings by Whistler and had her portrait painted by Sargent. He let her know he shared her interest in art and her sensibility as an aesthete: "I know no pleasure equal to that I get from pictures, from great Venetian pictures. It is like the pleasure I have when I come across a wonderfully beautiful line of verse, or when I catch a strain of infinitely tender melody."

In 1889, Berenson informed Gardner he would spend a third year abroad, sponsored now by Edward Warren, a Boston friend and collector. Soon after, Gardner, apparently disappointed with his progress as an author, stopped responding to his letters. Berenson had not communicated with her for five years, when on March 11, 1894, he purposefully sent her a copy of *The Venetian Painters of the Renaissance*. "I venture to recall myself to your memory," he wrote. "Your kindness to me at a critical moment is something I have never forgotten, and if I have let five years go by without writing to you, it has been because I have had nothing to show that could change the opinion you must have had of me at the moment when you put a stop to our correspondence." He promised to send her "two or three other books in the course of the next two years."

Berenson's gift to Gardner of the small book with a gondolier embossed in gold on its cover immediately reestablished their correspondence. Gardner's response conveyed an intense interest in him and his work. "I write immediately to thank you for the remembrance, and to hope that, if we go to Europe this summer, I may see you and talk over the book, the painters, and in fact many things," she wrote. What certainly drew Gardner (who had already spent two summers in Venice) to Berenson's book was his claim that Venetian painting was "the most complete expression in art of the Italian Renaissance." He made his case strictly on aesthetic terms, celebrating the visual splendor of the art of Venice, evaluating its achievement on the art-for-art's sake criteria that Gardner embraced. "In Venice, there had long been a love of objects for their sensuous beauty," he argued. In his view, Venetian pictures, even religious images, "seemed intended not for devotion, . . . nor for admiration, . . . but for enjoyment." The Venetians, he concluded, "perfected an art in which there is scarcely any intellectual content whatever, and in which colour, jewel-like or opaline, is almost everything."

More importantly, *Venetian Painters* gave Berenson the credentials to help Gardner fulfill her ambition to buy Old Master paintings. The book catapulted Berenson to the forefront of the field of Italian art and launched him as the first American "connoisseur." In *Venetian Painters*, Berenson boldly put forth a list of the thirty-four artists (Bellini, Carpaccio, Giorgione, Titian, Lorenzo Lotto, etc.) who in his opinion constituted the Venetian school and attempted to identify every single surviving picture they had painted. With this list, Berenson threw down the gauntlet before the reigning experts in the field, Joseph Arthur Crowe, an English journalist, and Giovanni Battista Cavalcaselle, an artist and connoisseur, who had published a series of books together, including *A History of Painting in North Italy*. In an attempt to bring new rigor to the field, Berenson trimmed the absolute number of genuine Venetian pictures accepted by Crowe and Cavalcaselle. In the case of Titian, they claimed the artist painted over one thousand pictures. Berenson slashed the number to 133. Crowe and Cavalcaselle "laboured under terrible disadvantages, because most of their work was done at a time when traveling was much slower than it has now become, and when photography was not sufficiently perfected to be of great service," Berenson wrote.

Attributing pictures had become "something like an exact science," he contended, thanks largely to photography, which produced accurate reproductions of paintings located all over Europe. Berenson emphasized that he had seen face-to-face all the paintings he discussed, except for a few in Saint Petersburg. Berenson's *Venetian Painters* advanced the study of Renaissance art and brought attention to the field. By winnowing paintings, he gave collectors new confidence in the market and in their ability to find authentic pictures; in reducing the number of Venetian paintings, he raised the prices of those that made the cut.

To compose his list of Venetian painters, Berenson explained he had practiced the "scientific connoisseurship" of Giovanni Morelli, an Italian politician who in his efforts to catalog and record the paintings in Umbrian churches and protect them from foreign buyers had developed a system of analyzing and classifying Old Master pictures. Trained in anatomy and medicine in Germany, Morelli argued that a painter's particular style was revealed not in a picture's central passages but in peripheral details—an ear or a hand—which were produced quickly and unselfconsciously.

By allying himself to Morelli, Berenson automatically set himself in opposition to Wilhelm von Bode. Angry with Bode's purchases of Old Masters in Italy, Morelli had published an inflammatory text challenging the attributions of the Italian pictures in the galleries of Berlin, Dresden, and Munich, three of Germany's most prestigious museums. In 1891, Bode fought back in the English *Fortnightly Review*, denouncing Morelli as a "quack doctor," and mocking his method for its "air of infallibility." The tone of Bode's attack reflected the high stakes involved in the attribution of paintings at this time. "Connoisseurship" had become an embattled line of work and disputes between experts on whether a painting was or was not a Raphael or a Rembrandt had financial implications and involved, as Jaynie Anderson writes, "the politics of acquisitions between competing nations and their developing national museums." But connoisseurship was more art than science, and a century later the identity of many Old Masters remains elusive, their attributions fluid and controversial.

What distinguished Berenson from Bode and other European experts who held posts at museums or universities was his choice to operate independently. He had to rely for his income on his writings and on fees

earned advising collectors. When his sister suggested he work as a teacher, he protested. "Who that is wealthy is independent in America nowadays, teachers [are] absolute slaves to headmasters, clerks bondsmen to employers, Harvard professors crouching before an Eliot [the university's president]." If Berenson wanted income, he also yearned for social position, a less tangible attribute but one he could gain as a professional connoisseur. When Berenson first told Gardner of his plans to become a connoisseur, he acknowledged his ambition to make money off his expertise. "I shall be quite quite picture wise then, not unlearned in the arts, perhaps they will enable me to turn an honest penny." On the surface, his idea seemed logical enough. As art scholarship and the art market were evolving, connoisseurs assumed multiple roles, acting as counselors to museums and private collectors, but also as brokers, involved one way or another in the buying and selling of art. Bode was often compensated indirectly for the advice he gave collectors with donations of art to the Berlin museum. But Berenson knew that he would undermine his reputation as a disinterested expert if it was learned that he profited from the pictures he authenticated and attributed. In public, he distanced himself from the art market, so as not to threaten his hard-won identity as a scholar and gentleman.

By 1894, Berenson had cut his dark hair short. His hairline had receded and he had a long, elegant forehead, and a dark, neatly trimmed beard. With age, his features and appearance continued to grow more refined. In a black-and-white photograph of 1903, he posed in a pale, double-breasted suit, leaning against an antique sideboard, with a cigarette in his hand and a Florentine Madonna on the wall behind him. Not only did the American immigrant dress the part of an affluent gentleman, but he constructed a persona of a cosmopolitan aesthete and glamorous expatriate. He moved to Fiesole, an ancient town, in the olive- and cypress-covered hills above the city of Florence, and spent much of his time traveling.

In 1891 Berenson had begun a complicated love affair with the twenty-seven-year-old Mary Smith Costelloe, a free-thinking, strong-willed intellectual from a Philadelphia Quaker family, the sister of Logan Pearsall Smith, his Harvard friend. Mary had a relaxed Anglo-Saxon beauty. She had studied at Smith College and the Harvard Annex (later Radcliffe

College) and was married to Frank Costelloe, an Irish barrister. They lived in London and had two daughters. By 1893, Mary had left Costelloe and their daughters in England and had moved to a house close to Berenson's in Fiesole, joining his mission to track down Old Master pictures in Italy. Ambitious for Berenson, Mary contributed to his books, pushed him to publish, and championed his method. Writing in the *Atlantic* under the name Mary Logan, she argued that Berenson "should be able to classify Italian paintings with the accuracy of a botanist in classifying plants." In fact, *Venetian Painters* had begun as an essay of hers, but she agreed to omit her name as its coauthor.

Berenson steadily built his reputation as an authority on Italian art. He quickly followed *Venetian Painters* with three other books: *Lorenzo*

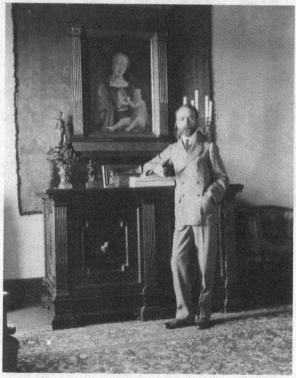

Bernard Berenson, age thirty-eight, in 1903 at the Villa I Tatti, posing as the connoisseur that he was, in front of a Renaissance Madonna.

Bernard and Mary Berenson in England in 1901, a year after their marriage.

Lotto, in 1895; *The Florentine Painters of the Renaissance*, in 1896; and *The Central Italian Painters of the Renaissance*, in 1897. Later, scholars would judge his 1903 *Drawings of the Florentine Painters* his most important work. In 1897, he rattled the field again, when in a pamphlet about a London exhibition of Venetian pictures from English private collections, he claimed that many attributions were wrong. "To Titian, for example, thirty-three paintings are ascribed," he explained. "Of these, one only is actually by the master." Eighteen

other works were labeled "Giorgione." Berenson dismissed all but one—a drawing.

In 1900, after Frank Costelloe died, Mary and Berenson married. They leased property called "I Tatti" with a stone house, a barn, a small chapel, and a beautiful view in Settignano, close to Fiesole. The villa demanded extensive renovations, which he immediately began. In 1907, the Berensons bought the villa and expanded it, surrounding it with formal gardens. At I Tatti, they entertained often. Berenson's expatriate life—his books, his photographs, his travels—cost him increasing amounts of money.

Otto Gutekunst

What Berenson failed to reveal to Isabella Stewart Gardner when he sold her the English Botticelli was that he had not dealt directly with its owner, Lord Ashburnham. In fact he obtained the painting through Otto Gutekunst, a German-born dealer with P. & D. Colnaghi & Co. Ltd., at 13-14 Pall Mall East, a prestigious London gallery that had been established in the eighteenth century.

New to the field and without capital, Berenson relied on European dealers, particularly Otto Gutekunst, to find canvases that he could offer to Gardner. A restless opportunist, Gutekunst (whose name appropriately means "good art" in German) recognized that the United States was the most promising market for Old Masters and he exploited Colnaghi's ties to the British aristocracy to pursue pictures in England that would appeal to Americans. Starting with the purchase of the Botticelli, Gutekunst became Berenson's silent partner in shaping Gardner's collection, and a critical source of extraordinary European pictures.

About the purchasing of paintings, Bernard Berenson kept Gardner, as much as he could, in the dark. He didn't fully explain how or where he acquired pictures and let her believe he had tracked them down himself. In 1897 Berenson admitted that he had gotten hold of a Velázquez and a van Dyck through Colnaghi, but he minimized the London dealer's work. In Berenson's letters to his patron, Otto Gutekunst's name simply doesn't appear. Although lacking scholarly credentials, Gutekunst became an experienced connoisseur and buyer of Old Master pictures, and Berenson seemed to have complete confidence in his judgment and

"eye." In October 1900, Berenson tried to persuade Gardner to purchase a small Raphael, which Gutekunst had described to him in a letter. Berenson pretended he knew the picture well: "So golden clear is the colour, so dainty the feathery trees." Gutekunst was glad Berenson "offered Mrs. G the little Raphael," but added: "The only pity is that you never saw it, for it is such a . . . little gem!"

From the start, Gardner gave Berenson credit for helping to create her collection and he took it; in fact Gutekunst played at least as important a part. The author Colin Simpson, harshly but not inaccurately, described Gardner's collection as "a monument to a combination of talents: Gutekunst's . . . scholarship, Bernhard's salesmanship and Isabella's good-natured self-indulgence and credulity." Later, when Gardner and Berenson had become cultural legends, Gutekunst would die in obscurity.

By 1895, Otto Gutekunst was thirty years old and handsome, his face well-proportioned, his dark eyes deep set beneath a prominent brow and a forehead framed by neatly combed dark hair. He was a knowledgeable and talented art dealer—an expert in the northern European schools of painting. Berenson and Gutekunst had met through Jean Paul Richter, a German connoisseur living in Florence. In Gutekunst, Berenson found a level of expertise in Old Masters that matched his own and a knowledge of German, Flemish, and Dutch painting that complemented his command of the Italian Renaissance. "We are very anxious to know if you are convinced of its genuineness," Gutekunst asked Berenson in 1900 about a Correggio, whose photograph he had sent. In turn, he wrote Berenson about a panel painting "that most people would call a Holbein," and informed him that Christoph Amberger in fact painted the picture. In a moment of intellectual seriousness, Gutekunst expressed his love for the art of his native Germany—calling the portraits of Hans Holbein and Albrecht Dürer the "children of my fancy & longing."

Like many art dealers, Otto Carl Heinrich Gutekunst had been born into the trade, the son of Heinrich Gutekunst, who ran a Stuttgart auction house specializing in drawings and prints. Gutekunst was presumably trained by his father, and soon after moving to London in 1885, he and a Belgian dealer, Edmond Deprez, opened a print gallery, at 18 Green Street, St. Martin's Place. In 1894, Gutekunst and Deprez were

invited by William McKay to become partners in Colnaghi, a highly respected fixture in the London art market, and in need of new blood.

Colnaghi had a long and illustrious history. It had been launched by Paul Colnaghi, the son of a Milan attorney, who in 1784 went to work for the Paris print seller Anthony Torre and within four years had acquired the dealer's London branch. Colnaghi thrived as print publisher whose clients included the prince regent, who became George IV. Under Paul's son Dominic Colnaghi, the firm (P. & D. Colnaghi) continued to flourish. In his 1824 "Picture Galleries of England," William Hazlitt described the gallery as "a capital print-shop . . . a point to aim at in a morning's walk—a relief and satisfaction in the motley confusion, the vulgarity of common life." Two decades later, the gallery appeared in William Makepeace Thackeray's *Vanity Fair,* when Becky Sharp "went to Colnaghi's and ordered the finest portrait of [King George] that art had produced, and credit could supply."

By the time Gutekunst joined Colnaghi, the firm had plunged into the Old Master market. William McKay had become acquainted with Wilhelm von Bode, and may have brought Gutekunst into the gallery in part to help them correspond with the Berlin museum director in German. (McKay's letters to Bode written in German are in Gutekunst's hand.) Bode was one of Colnaghi's most important clients. He seemed happy to give opinions on attributions and to make introductions to European collectors, in exchange for market intelligence and the first refusal on pieces he wanted. While Gutekunst was trying to sell Lord Ashburnham's Botticelli through Berenson to Gardner, the Colnaghi dealers negotiated the sale of the nobleman's Rembrandt—a double portrait, *Anslo and His Wife,* to Bode in Berlin, where it became one of the museum's most celebrated pictures.

The letters Gutekunst wrote Berenson provide a rare view into the workings of the fin de siècle international art market. They reveal a gregarious, shrewd, confident trader who prided himself not only on his art expertise but also on his honesty and loyalty, and who valued Berenson as a colleague and friend. As rising demand boosted the prices of Old Masters, Gutekunst spoke of his work in the art market as though he were engaged in a high-stakes, often amusing, game. He was too busy in London to leave, he wrote Berenson. "Can't you arrange to be here in September & October when I have nothing to do & could quietly go about with

you, incognito, & see many collections you don't know & lay foundations for new schemes and plans of battle?" He thrilled at the thought of getting his hands on valuable pictures. Everything seemed possible, everything for sale, and he was one of the very few who had an eye on the source of supply and, thanks to the position of his firm, the ability to tap it.

The dealer and the connoisseur were exact contemporaries, both exiles in adopted countries, and shared a love of pictures. Gutekunst often employed a jocular, familiar, mocking tone, addressing Berenson by 1894 as "My dear boy" or "Carissimo Bernardo." He also constantly gave Berenson advice, playing the part of the experienced dealer, counseling a naive and uninitiated connoisseur. "It seems to me people only want what they cannot get," he wrote, "those things that can be got being too comparatively easily within their reach. The best plan with them is therefore generally to put certain things as problematical; and difficult to get, so as to make them eager, or to at least interest them."

Gutekunst envied Berenson his residence in the Florentine hills. "Spring must by this time be making its glorious entrance into Toscana!" he wrote. He often complained about the stress of the business. "I am driven mad with work & worry & very tired. I can scarcely write." Without fail, he closed his letters with a reference to his "beloved" wife, Lena Obach, the daughter of a Swiss art dealer who worked in London, to whom he referred as "the Countess." They had no children.

Gutekunst rarely minced words, freely condemning competitors or works of art that he didn't like or that he hadn't handled. Annoyed when Berenson sold a painting by Cima obtained from a dealer in Italy, he told the connoisseur the picture was rubbish. He denounced Elia Volpi, a Florentine dealer, from whom Berenson sometimes bought pictures, as a "beast & a liar."

Berenson, for his part, complained when Gutekunst hadn't alerted him to the Earl of Carlisle's Velázquez, which an American dealer sold to the Museum of Fine Arts in Boston. Gutekunst retorted: "Lord Carlisle's Velasquez [sic], the child & dwarf, was ugly & quite repainted & flat, yet he sold it to [Arthur] Sulley . . . who placed it in America for something like £15,000." He reassured Berenson, "We could buy the beastly thing for £5000 for years but would not touch it." In fact, the fine Velázquez (*Don Balthasar Carlos with a Dwarf*) still hangs in the Boston museum.

When Berenson questioned whether one of Gutekunst's paintings was not fresh to the market, the dealer denied it. "Do you think then, that I am so short sighted, and such a blasted idiot to offer you pictures which have been . . . about, already either here or in America, as which might mislead you or get you into trouble?"

Under Gutekunst, Colnaghi came to rival Agnew's as London's leading gallery for Old Master paintings. "If I were a rich man wishing to collect works by the Old Masters," wrote Charles J. Holmes, director of the National Portrait Gallery in 1902, "judging by their keenness of sight and the uniform accuracy of their judgment in the sale-rooms, I think I should myself go to Mssrs. P. & D. Colnaghi."

The Rape of Europa

Once Isabella Gardner began to rely on Berenson to find pictures, he fanned her collecting ambitions: "If you permit me to advise you in art-matters as you have for a year past, it will not be many years before you possess a collection almost unrivalled—of masterpieces, and masterpieces only." Seven months later, she replied: "Shan't you and I have fun with my Museum?"

As soon as Otto Gutekunst recognized that Berenson had an American client for Old Masters, he leaped at the chance to provide them. When Gardner said she wanted a "Filippino Lippi; and a Velasquez [sic] very good—and Tintoretto," Berenson relayed the message to Gutekunst and the dealer responded. "We are on the track of the Filippino, & of a Tintoretto, and also the Velasquez [sic]. What is your friend prepared to give? Does she require one of the tip top quality? We know one which we think is of such quality and which you may have seen at the Old Masters [exhibition] last time."

In Berenson, Gutekunst had a link to the American market. The connoisseur and the dealer served as go-betweens, brokers, and experts, negotiating the transfer of Old Masters between buyers and sellers who otherwise wouldn't come together and lacked an easy means to communicate. As they promoted Old Masters, they exploited the fact that the market was embryonic and inefficient, transactions were often secret, and information was hard to get. Naturally, they preferred buying

pictures in private sales rather than at auction, where prices were public information. When the Colnaghi partners bought a van Dyck at auction, Gutekunst pointed out they would be forced to limit their commission.

By mid-January 1896, Gutekunst had obtained a Tintoretto, *Portrait of a Man*, and also a Rembrandt self-portrait—one of his earliest, painted in 1629, when he was only twenty-three years old. Berenson sent Gardner photographs of the canvases, assuring her that the Rembrandt would be reproduced in Bode's catalog and claiming that "if not sold by Feb. 18, [the canvas] goes to the National Gallery." The price of the Rembrandt was 3,000 pounds ($15,000) and the Tintoretto 500 pounds ($2,500) and she bought both. After the Rembrandt arrived, she held "quite a little reception . . . [with] some delicious music."

Meanwhile, Gutekunst set his sights high—on two of the most celebrated paintings in England. "Could you place such a picture as Gainsborough's famous *The Blue Boy*, or Reynolds' *Mrs. Siddons as Tragic Muse*?" he asked Berenson. *The Blue Boy* is a full-length portrait of a dark-haired, innocent-faced youth named Jonathan Buttall, wearing a gleaming, pale blue silk "van Dyck suit," and striking a sophisticated pose with his hand on his hip. He is set against a stormy sky. Exhibited at the Royal Academy the year it was painted, the portrait instantly became famous. "I advise you to borrow, to do anything, but to get that picture," Berenson told Gardner on April 14. "To bring that beauty to land . . . a bait of less than $100,000 will be out of the question." Seeming to want to test her resources and resolve, Berenson asked her to agree to buy it before he specified the price. Twelve days later, he informed her he had gone ahead and bid 30,000 pounds ($150,000) for the Gainsborough, instructing her to reply by cable: "NOBB=no, *Blue Boy*" . . . YEBB = Yes *Blue Boy*." On May 8, she cabled: "YEBB."

"*Now*, you see me steeped in debt—perhaps in Crime—as the result!" she wrote. Gardner often complained about spending large sums for pictures and planned to borrow money to buy the Gainsborough. Still, her $150,000 offer signaled that she wanted masterpieces and was willing and able to pay for them.

Already Gutekunst was working on a far more important painting: Lord Darnley's Titian: *Europa*—a "picture for a great 'coup,'" and "one of the finest & most important Titians in existence." There is

"absolutely nothing against it," Gutekunst argued, "except perhaps for some scrupulous fool, the subject, which is very discreetly and quietly treated." The "subject" was the "Rape of Europa," a myth from Ovid's *Metamorphoses*; in the center of a canvas that measured almost six by seven feet, Titian had placed the large, pivoting figure of Europa, flung across the back of a white bull, the naked body offset by a commotion of diaphanous white drapery.

According to Ovid, Jupiter had spied Europa, the daughter of the king of Tyre, when she was with friends on a beach. Struck by her beauty, he disguised himself as a friendly bull ("No threat no menace in his eye; his mien peaceful"). But the moment Europa climbed on his back, the bull took off, carrying her across the water and eventually to Crete, where he returned to human form. Later, Europa gave birth to Jupiter's son, Minos—founder of Ancient Greece, and thus, of Western Civilization.

Titian painted the bull sweeping Europa away, swimming from left to right across the canvas, through the water. Her legs are lifted and her arms reach above her head. One hand grasps one of the bull's horns, to keep her from sliding off his back into the sea, and the other catches a length of pale crimson drapery now soaring against a volatile blue sky. Crowned with a garland, the bull is strangely human—intelligence painted into large black eyes that glance behind at a dolphin in the water. Europa casts her gaze high into the sky, where in the upper-left-hand corner of the picture float two winged cupids carrying bows and arrows. Her head is thrown back, her face in shadow, her mouth slightly open in an expression of alarm and capitulation. The unstable position and the flying drapery convey the violence of the abduction and the complicated passions involved. "Just as the position of her body suggests surrender as well as fear," wrote the art historian Erwin Panofsky, "so does the action of her arms suggest an embrace as well as a desire for self-preservation." The painting had an illustrious provenance—commissioned by Philip II of Spain, one of six "poesies," painted for the king by Titian, each illustrating a myth from Ovid. "I have finally, with the help of divine grace, brought to completion the two pictures that I began for Your Catholic Majesty," Titian wrote the King in 1562. "One is Christ in the Garden, the other the *poesia* of Europa carried by the bull, which I send to you." In the lower left corner, the artist signed the canvas: TITIANUS. P.

A master of the High Renaissance, a contemporary of Michelangelo and Raphael in Rome, Titian was long celebrated as the greatest of the Venetians. Born around 1485, he was apprenticed to Giovanni Bellini and worked with Giorgione. There seemed to be nothing he couldn't do in paint. He produced not only subtle, magnificent, and penetrating portraits, but also large, complicated religious and mythological scenes. (Gardner certainly knew the twenty-foot-tall *Assumption of the Virgin* on the high altar of Santa Maria Gloriosa dei Frari in Venice.) By the time Titian was in his thirties, the courts of Europe wanted his work. He received commissions not only from Philip II but also from Philip's father Charles V, the Holy Roman Emperor, Alfonso I, Duke of Ferrara, and his sister Isabella d'Este, in Mantua.

The Rape of Europa exemplified Titian's late style, its loose brushwork and dissolving atmospheric effects seeming to anticipate Impressionism. "The old Titian was, in his way of painting, remarkably like some of the best French masters of to-day," Berenson observed. Oddly, Berenson had omitted *Europa* from *Venetian Painters* and seems not to have laid eyes on the picture. ("You will find all about it in Crowe and Cavalcaselle pages 317 etc.," Gutekunst told him.) Titian's *Europa* had remained in the Spanish royal collection until the early eighteenth century when Louis Philippe, duc d'Orléans, acquired it. When, in 1798, the Orléans collection was sold and the paintings went to England, *Europa* ended up in the possession of the 4th Earl of Darnley, who hung it in his house, Cobham Hall, in Surrey. Its condition Gutekunst described as "perfect," "not considering a certain amount of dark varnish. The landscape alone is a masterpiece of the 1st water," he added. Even among the dazzling company of Italian paintings from the Orléans collection displayed in London in 1798, according to the art historian Francis Haskell, *Europa* "was possibly the single most beautiful picture in the whole Orléans gallery."

The Colnaghi dealers themselves had "discovered" *Europa* in part through Wilhelm von Bode, who had been corresponding with Lord Darnley about the painting for more than two years. But, at some point, possibly because of the cost, Bode had turned the painting down. In February 1896, Gutekunst told Berenson that to persuade Lord Darnley to let go of his Titian would require 18,000 pounds. In his view, they could then sell the picture for 20,000 pounds, or $100,000.

What Gutekunst needed from Berenson was a "firm offer." He didn't dare to inquire about the picture without one—or even to ask for a photograph. "Lord Darnleigh's [sic] . . . name, by the way, must not be mentioned," he warned, "as he is a very touchy and peculiar man."

The art dealer was in a delicate position. Officially, as he explained, "in the owner's words," the Titian was "not for sale. . . . At the same time, it *can* be bought for £18,000." Simply by suggesting to Lord Darnley that he might want to dispose of his heirloom Old Master, the dealer risked insulting him. Thus Gutekunst maintained the fiction that Lord Darnley had no thought of selling, while at the same time delivering a bid. Owners often wanted dealers to tell them what their paintings were worth. "There is no wish to sell the Portrait by Velasquez [sic]," an English nobleman wrote in 1902, "but if Mssrs. Colnaghi's client can give £30,000 for it, his offer would be entertained."

Gutekunst hoped to buy and sell the Titian without investing a cent of Colnaghi's capital—engineering what financiers later called a "riskless-principal transaction." Once he identified a saleable Old Master, he lined up a buyer who agreed to a specific price (enough to cover both the cost and a commission), and at that point approached the picture's owner. (Problematically, if the buyer reneged, the Colnaghi partners would have to come up with the funds to purchase the picture.) Dealers generally preferred to buy pictures outright, but few had the capital. Frequently when investing in an expensive picture, the Colnaghi dealers brought in partners to raise enough cash. "We will do everything we possibly can to make it worth your while selling pictures for us," Gutekunst explained to Berenson in October 1895, "but as we naturally lay out a lot of money in various ways constantly, we have sometimes in certain cases to take in another person to go 1/2 shares or 1/3 shares." He even proposed to loan Berenson funds to invest in certain pictures with him.

While he was waiting for the Duke of Westminster to accept Isabella Gardner's 30,000 pounds for *The Blue Boy*, Berenson proposed Titian's *Europa* to one of her Boston rivals—Susan Cornelia Warren, whose husband, Samuel Warren, was president of the Museum of Fine Arts. Berenson hadn't seen a photograph of the picture because Gutekunst hadn't been able to get ahold of one, but perhaps that was just as well. The erotically charged canvas was a radical choice for an American at

the end of the nineteenth century. None of the fifty pictures that Henry Marquand gave the Metropolitan Museum depicted a nude; in Boston, only ten years before when the Museum of Fine Arts opened on Copley Square, a committee had made the decision to cover the plaster casts with fig leaves.

"Sorely troubled about the confounded Titian," Gutekunst wrote Berenson in early April. He still couldn't get ahold of a photograph. "Fancy one of the *finest* Titians in the world, of spotless preservation & pedigree . . . as it were, in the market, and we should not be able to see it!?"

Then, in early May, the Duke of Westminster let Gutekunst know he would not sell *The Blue Boy* after all. He "only smiled coldly . . . at the same time he was interested to hear of the offer, etc.," Gutekunst reported.

Earlier Gutekunst wired Berenson to ascertain what he could "safely get for" Titian's *Europa*. Once "I know that, you may rest assured that we will get it as cheap as it can be had. I like a good margin!" By the end of April, he finally sent Berenson a photograph. "There is more money in this than in the other things," he wrote, "and if I try and pull that through for you, you must please try and pull this through for me. . . . I want some of his other pictures badly. Tata!" He worried still about the picture's propriety: "Let me know at once . . . your impression of the subject." But he described the condition as "matchless," and "the colours, particularly of the landscape, wonderful."

On May 10, Berenson finally told Gardner about Titian's *Europa*. If the painting's large size, mythological subject, flamboyance, and eroticism would put off most Americans, these very qualities would, on the contrary, appeal to her. In fact, the extraordinarily beautiful canvas by a celebrated Venetian was exactly the sort she wanted to have, and far more to her taste than *The Blue Boy*. (She had bought only one English picture and then sold it.) But Berenson knew Gardner would not be pleased she was second in line. Recently, after he proposed she purchase a Tintoretto and a Giottino but before she had made up her mind, he sold them to another collector. "I should only like to say first that in future and for all time," she told him, "*please* don't let me and some one else know of the same picture at the same time."

Berenson tried to explain away his offer of the Titian to Warren.

Knowing he was skating on thin ice, he chose his words carefully. "Now as you can not have *The Blue Boy*," he wrote, "I am dying to have you get the *Europa*, which in all sincerity, personally I infinitely prefer. It is a far greater picture, great and great tho' *The Blue Boy* is. No picture in the world has a more resplendent history." He told her about the commission from Philip II and claimed that Philip IV gave it to Charles I when he was visiting Madrid. "It was then packed up to await his departure." But when "the negotiations (for his marriage to Philip's sister) came to nothing, and Charles left Madrid precipitately, the picture remained carefully packed—this partly accounts for its marvellous preservation." Berenson called *The Rape of Europa* "one of the few greatest Titians in the world . . . being in every way of the most poetical feeling and of the most gorgeous colouring," and "the finest Italian picture ever again to be sold."

A few days before, Gutekunst, impatient to sell the Titian, encouraged Berenson to lower the painting's price. "If you can't get 20,000, take 18,000. But I see far more chance in it, than in the Damned B. B. [*Blue Boy*]." Ignoring Gutekunst's counsel, Berenson told Gardner the Titian's cost was 20,000 pounds. He failed to inform her that the *Europa* was not officially on the market, that, in fact, its "price" would be set by what she was willing to pay. Gardner immediately agreed and sent Berenson a check that covered the 20,000 pounds, as well as his commission of 5 percent. Meanwhile, Gutekunst succeeded in purchasing the Titian for only 14,000 pounds: "I commenced by offering [Darnley] £12,500." Gutekunst explained to Berenson, "but had to come up to £14,000 to pull it off, in the end and no more pictures from Him!!" He was disappointed because he assumed Berenson had gotten her to pay only 18,000 pounds. "We must be content with 2,000 [pounds] a side," he wrote. In fact, Berenson never revealed to his partner how much Gardner actually gave him. He sent Colnaghi's the 14,000 pounds due Lord Darnley, but instead of splitting the 6,000 pounds left over with the London dealer, he sent simply the 2,000 pounds that Gutekunst expected. He also never mentioned the additional 1,000 pounds Gardner gave him as commission. In the sale of *Europa*, Berenson deceived both his partner and his client. Seven thousand out of 21,000 pounds (or some 30 percent) of the Titian's price amounted to profit; and of that, 5,000 pounds went to Berenson.

Only weeks before Gutekunst had warned Berenson that he was risking his reputation as a disinterested expert. A dealer he had recently seen in London "seemed to think he had heard that you had been selling pictures, that is to say not only advising people or friends to buy certain ones, but making money in this way ... so be careful."

For his part, Berenson managed to keep his conversation with Isabella Gardner away from the market. "The Europa is yours," he wrote to her from Paris on June 18. A month after she paid for the picture, it remained in London. As was her habit, she had left the heat of Boston for her summer house, Beach Hill, in Prides Crossing. "When comes Europa?" she demanded on July 19. "I am feverish about it. Do come over, just to unpack her and set her up in her new shrine! Do!" She kept up her correspondence with Berenson, evoking the heady atmosphere in which she thrived and elevating their level of intimacy. "I am leading such an open air life just now—driving, seeing polo, and people. Flowers and pictures seem to belong to another existence—flowers in Brookline, pictures in Boston!" ... Some day, by the way, you must say a little to me about that heart of yours." In late July, Gutekunst had the *Europa* packed and taken to the ocean liner *Lucania*, and the canvas set sail for America.

Berenson continued to travel, "plunging into the wilds of Scottish country houses." He visited Alnwick, the castle of the Duke of Northumberland, where he could see Giovanni Bellini's *Feast of the Gods*. "Fine pictures too, but who shall speak of them to the owner of *Europa*?" he asked. "I hope you have now received her, and had your first honeymoon with her. What a beauty." About his heart, he continued: "It exists but it is not to be written about. Some day with leisure before us I shall tell you." But he turned quickly to the subject of art acquisition. "Meanwhile a good bit of it throbs for your museum, and again I come with a proposition."

Enclosed in his letter was a photograph of a Rembrandt, entitled *Portrait of a Young Artist*, which he described as in "perfect condition," and revealing the "sheer simplicity of supreme genius." Gutekunst had purchased the portrait from the Earl of Carlisle, who kept some 274 paintings (including fifty Canalettos) at the enormous Castle Howard in Yorkshire. "I have never seen a Rembrandt which I personally have

liked so well," Berenson claimed. As he wrote from Scotland, it seems likely that Gutekunst recently showed him the picture in London.

In August, the Gardners took their annual voyage to Roque Island in Maine. By the time they returned to Boston on the eighteenth, Gardner had decided against the Rembrandt. "I have not one cent and Mr. Gardner (who has a New England conscience) won't let me borrow even one more! I have borrowed so much already. He says it is disgraceful. I suppose the picture-habit, (which I seem to have) is as bad as the morphine or whisky one—and it does cost."

A week later Isabella Gardner announced: "She (*Europa*) has come! I was just cabling to you to ask what could be the matter, when she arrived, safe and sound. She is now in place. I have no words! . . . I am too excited to talk." She immediately recognized the Titian as a masterpiece, a painting that allowed her the very sort of aesthetic ecstasy for which she longed: "I am having a splendid time playing with *Europa*. She has adorers fairly on their old knees—men of course." A week later she wrote again. "I am breathless about the *Europa*, even yet! I am back here tonight (when I found your letter) after a two days' orgy. The orgy was drinking my self drunk with *Europa* and then sitting for hours in my Italian Garden in Brookline, thinking and dreaming about her. Every inch of paint in the picture seems full of joy." Her response echoed the argument Whistler had made in his "Ten O'Clock Lecture" that "Art and Joy go together."

Gardner hung the painting to the left of the fireplace in the living room of her Beacon Street house, where it took up most of the wall. The Renaissance masterpiece more than held its own in a Victorian room crowded with pictures (even over the doors), tables, chairs, chandeliers, and a tall potted palm. The collectors Quincy Adams Shaw, Edward William Hooper, and William Sturgis Bigelow, "and many painters have dropped before her," Gardner told Berenson. "Many came with 'grave doubts'; many came to scoff; but all wallowed at her feet. One painter, a general skeptic, couldn't speak for the tears! all of joy!!! I think I shall call my Museum the Borgo Allegro. . . . Mr. Hooper long ago pleased me greatly by saying that I was the Boston end of the Arabian Nights. And now he only adds 'I told you so.'" No doubt it also gave Gardner great pleasure when Henry James called her "Daughter

of Titian." She revealed to Berenson that she had borrowed a "pile of money" to buy the Titian, and "I think it was a good thing to do—and would do it again for a *whacker*; but don't you agree with me that my Museum ought to have only a few, and all of them A. No 1.*s*." She concluded: "*Europa* has made an impression." *Europa* made its greatest impression upon her. She seemed to decide that paintings of this caliber were what she wanted, and it set her on an acquisition course.

Soon after her purchase of *Europa*, Gardner asked Berenson if she could acquire Giorgione's famous *Tempest* from the Giovanelli Palace in Venice, a painting of a nude set in what was thought to be one of the first "landscapes" ever painted. In December 1896, she bought a major Velázquez—*King Philip IV of Spain*. When she heard that the Museum of Fine Arts was after a small Giorgione, *Christ Bearing the Cross*, she wanted it for herself. "They won't move quickly enough to get it I fear." Two years later she bought it. "Is the Pope going to sell you one of the rooms of the Vatican?" Henry James quipped.

From London, Gutekunst scanned the horizon. "I have been thinking of other great masterpieces we might try & propose to Mrs. G. if they can be got at all," he wrote Berenson. He suggested "the largest and most showy Rembrandt in existence, Lord Cowper's (at Panshanger) *Portrait of Turenne on Horseback*." His mind wandered about the British Isles—to the "magnificent" van Dycks and a Moroni in Warwick Castle, Giorgione's *Adoration of the Shepherds* in the Wentworth Beaumont collection, and Rembrandt's *The Mill*, Lord Lansdowne's large landscape with a menacing sky. As a native of Germany, he did not share an Englishman's sense that selling these Old Masters would mean disposing of British patrimony. From his perspective, the northern Renaissance paintings in English collections had long ago left home. "You can only make your future once," he told Berenson, "and such a chance as Mrs. G. does not occur again in one lifetime. Do you agree or not?"

Meanwhile, thanks to Gardner, Berenson's financial fortunes were improving. "Berenson has made a lot of money," Mary Berenson wrote her sister, "and I have helped in it so I shall be able to see that [Mother] has everything to make her comfortable." Gardner agreed to buy Rem-

brandt's *Mill*, but complained of struggling to find money for her art purchases. She asked Berenson if he was doing his best to make the most of her expenditures; as always her tone was that of a close friend: "Don't be cross with me! . . . About the terrible prices! . . . I want to pay *the least* necessary. Don't you think I am right; and aren't you entirely on my side of all these questions."

On March 1, 1897, the Colnaghi partners asked Lansdowne if he would sell *The Mill* for 10,500 guineas. Turned down, they raised the bid to 16,000 pounds. Again Lansdowne refused them. Six months later, Gutekunst went after Holbein's 1526 portrait *Sir Thomas More* in the collection of Edward Huth. His overtures failed. No less ambitious, Berenson wrote Gardner about his hopes to secure the great Czernin Vermeer, *The Art of Painting* ("one of *the* pictures of the world"), and Titian's *Sacred and Profane Love*, in the Borghese collection in Rome. Both legendary canvases remained where they were.

For three years following the acquisition of *Europa*, Isabella Gardner purchased Old Master pictures supplied by Colnaghi at a rapid pace—two major Flemish portraits (Rubens's *Portrait of Thomas Howard, 2nd Earl of Arundel* and van Dyck's *Portrait of a Woman with a Rose*), Botticelli's *Virgin and Child with an Angel*, Fra Angelico's *Death and Assumption of the Virgin*, as well as Carlo Crivelli's *Saint George Slaying the Dragon*, which Berenson described as a "marvellous fairy-tale in gold and lacquer." But the collaboration between Berenson and Gutekunst became increasingly strained and unstable. In March 1897, Gutekunst cautioned Berenson to reveal more to Isabella Gardner about his method of buying pictures. "People begin to find out that Mrs. G. buys of & through us and some other person abroad & although she will stick to you, it may be as well to forge the iron as long as it is hot & make hay while the sun shines, eh?" In January 1898, Isabella herself warned Berenson: Jack Gardner "thinks every bad thing of you, and I too am beginning to look upon you as the serpent; I myself being the too-willing Eve."

A few weeks later, on February 2, Berenson attempted to deflect her criticism, apologizing for a delay in sending the Crivelli and turning to potential acquisitions—a Holbein from Vienna and Raphael's Cardinal *Tommaso Inghirami*, a tour de force in which the artist painted the

prelate close up, at a desk, pen in hand, and has him turning to look up to heaven, somewhat disguising his distorted eye. The price of the *Inghirami* was 15,000 pounds. Problematically for Berenson, Jack Gardner learned that a Florentine dealer was offering the same Raphael for only 200,000 lire, or half Berenson's price. When Isabella informed Berenson, he immediately claimed the owners suddenly agreed to take less than what they had originally asked. Satisfied with this explanation, Isabella Gardner bought the portrait. (Although in 1895 the American tariff on works of art had been eliminated, two years later the Dingley tariff act reimposed it. Thus Gardner had to pay a 20 percent duty when she imported Old Master pictures.)

"Our last week at Venice was one of great anxiety," Mary Berenson noted in her diary on June 23, 1898. "Business complications with Mrs. Gardner—Bernhard was simply awfully worried and felt at times almost suicidal." Despite his fears, Berenson continued to charge Gardner as much as he thought she would pay, sometimes recklessly when paintings had been recently sold and their prices were matters of public record.

That summer Gutekunst and the dealer Asher Wertheimer had spent 121,550 pounds to acquire eighty Dutch and Flemish pictures from the collection of Francis Pelham Clinton-Hope. Secretly Bode had arranged to have the Friends of the Kaiser-Friedrich Museum advance money to make the purchase, and he got the first choice of the pictures, among them Vermeer's *The Glass of Wine*. As Gutekunst hoped, Gardner agreed to take three of the finest Dutch paintings—two Rembrandts (*Portrait of a Lady and a Gentleman in Black* and a rare seascape, *Christ in the Storm on the Sea of Galilee*) and *The Music Lesson* by Gerard ter Borch. For these three, Berenson charged her 30,000 pounds ($150,000), or about 25 percent of what Gutekunst had paid for the entire collection.

"There is a terrible row about you," Isabella Gardner wrote Berenson on September 25. "*They* say (there seem to be many) that you have been dishonest in your money dealings with people who have bought pictures. Hearing this Mr. G. instantly makes remarks about the Inghirami Raphael you got for me. He says things I dislike very much to hear . . . and quotes the differences of prices. I cannot tell you how much I am distressed . . . but I feel sure that you have enemies, clever and strong."

"This danger may blow over," Mary Berenson wrote Bernard. But she recommended he change the way he priced paintings to Isabella Gardner: "A new system must come into operation." On October 17, she wrote in her diary: "Bad news . . . weighed on both our hearts. Bernhard's enemies are trying to persuade Mrs. Gardner that he has cheated her over the pictures he has bought her, and her husband (who was always jealous) believes it. Still, she does not, & that is the important thing."

On November 10, Otto Gutekunst again warned Berenson to stop taking risks:

> Surely the money you & we have made all along was easily
> made and we had our lion's share not of the glory but of the
> trouble and disappointment & hard work of it . . . you must
> not now talk of throwing it all up wantonly like a spoilt
> child who is tired of his toy. . . . Neither you nor we have
> ever had such a windfall as Mrs. G. before, nor shall we ever
> in our lives have another & you ought rather throw up for a
> time other—any other—work than the work with her. It
> will stop of its own account soon enough.

He couldn't have known that less than a month later, Isabella Gardner's circumstances would suddenly and permanently change. On December 10, 1898, she lost her most important ally when Jack Gardner suffered a heart attack and died. Now Gardner was in charge of her own financial affairs and felt the full weight of the responsibility.

Within weeks of Jack's death, Gardner followed through on plans they had made together and bought property on Boston's Fenway, where she would have enough space to build a gallery for her collection. She also commissioned the architect Willard Sears to make drawings for a new building; by June 1899 construction of her museum began.

Meanwhile, Berenson persuaded Gardner to buy a pair of Holbeins—portraits of *Sir William Butts* (physician to Henry VIII) and *Lady Margaret Butts*, which had to be disentailed by Chancery Court, and whose 16,000-pound price was a matter of public record. "The principal question remains now," Gutekunst advised Berenson, "how will you treat Mrs. Gardner in the matter? This we must entirely leave to your wisdom,

your knowledge of the woman's character & your shrewdness." He suggested that Berenson be honest, report the 16,000-pound price, and charge her a commission on top of it. Instead, Berenson informed her the Holbeins came from Colnaghi's and the price was 20,000 pounds.

"Alas, alas." She sighed. But, by early March she cabled Berenson the money and his usual 5 percent commission. She made plans to travel to London in the summer. Suddenly, on May 31, she demanded that Berenson explain. "Tell me exactly what you paid for the Holbeins." She had received "a most singular letter from the former owners. I am afraid something is wrong in the transaction." She already blamed the problem on the London dealers. "I never liked the Colnaghis, and . . . I absolutely did not want to have anything to do with them again. I have been very sorry to see that you have still employed them, but now I am sure the end has come."

From England, on June 9, 1899, Mary delivered practical advice, suggesting Berenson reveal to Gardner about the way the art market truly worked:

> Argue with her to prove that Colnaghis are *invaluable* for her gallery. Take her to Agnew's miserable show which is the best he could have done for her in all these years and compare that with the Titians, the Crivelli, the Botticellis, the Pessellinos and all the other things *they* [Colnaghi] have got for her!

She wanted Berenson to explain that to "get Frizzoni's Bellini" he "should be able to bribe his friends to urge him to part with it and so on."

But instead Berenson threatened in a letter to Isabella Gardner not to "ever again undertake such big and complicated transactions as that Holbein business." He continued to mislead Gardner into thinking her doubts about Colnaghi were well founded. "I am sorry you wrote!" Gardner replied. "Every word you said only confirmed my opinion of Colnaghi. . . . Agnew seems an innocent babe compared to them."

When Gutekunst learned that an English seller had been in touch with an American buyer, he was alarmed. "The news is a great blow indeed. And Pole-Carew is a great scoundrel for it must be he who

wrote to her," he told Berenson. "May she not endeavor to find out from other [picture] owners what was paid to them? Naturally we will shield you." He couldn't understand why Berenson continued to deceive Isabella Gardner and suggested that instead he raise the commission he charged. "Might it not be safer and better in future to do business for her openly, for 10 percent or 15 percent rather than take such risks?"

Six weeks later, at the end of July, Berenson visited Gardner at the Savoy in London. They persisted in their mutual seduction. She was in mourning, dressed in black, and looked "aged," he wrote Mary. "But as fascinating as ever, an American girl, she seemed, not really grown up but mellowed by life." He had succeeded in persuading her of his innocence, or at least convinced her that whatever role he played with Colnaghi, he was serving her interests. The art transactions he treated as something that transcended simple business, and she accepted that.

Gardner informed Berenson that she was cutting back on her art acquisitions. She depended upon a trust set up by Jack Gardner for her income, which had fallen to about "half what it was before his death." She complained that people thought her richer than she was:

> The income of mine was all very well until I began to buy big things. The purchase of *Europa and the Bull* was the 1st time I had to dip into the capital. And since then those times have steadily multiplied. . . . Probably much of the misunderstanding comes from the way I spend my money. I fancy I am the only living American who puts *everything* into works of art and music; I mean, instead of into show, and meat and drink.

Nevertheless, in the course of 1900 she bought a small Raphael *Pietà* (5,000 pounds), Rembrandt's *Landscape with an Obelisk* (4,500 pounds), and a fifteenth-century Italian *Annunciation*, which was attributed to Fiorenza di Lorenzo. All three came through Berenson from Gutekunst.

But gradually Berenson began to cut his ties to Colnaghi. Wanting to salvage the partnership, Gutekunst defended himself:

Business is not always nice and I am the last man to blame you, a literary man, for disliking it. But you want to make money like ourselves and so you must do likewise as we do and keep a watchful eye on all good pictures and collections you know or hear of and let me know in good time. . . . If the pictures you put us up to do not suit Mrs. G. it does not matter we will buy them all the same with you or by giving you an interest in them—as you please. Make hay while Mrs. G. shines.

At the end of March, Gutekunst reminded Berenson of the success of their business in America. "As to our relations to Mrs. G. remember that *almost all* her finest pictures came to her *and to you* through us and that some of them nay most of them are now worth already more than she paid for them." Economic self-interest buttressed the Berenson-Gutekunst partnership on both sides, but their art market alliance depended upon mutual trust and became fraught as that trust diminished. Gutekunst felt angry that it was Berenson who accused him of betrayal. "I am too proud to contradict or even enter upon any of the allegations you make against *me* personally!" he wrote on March 26. "I could *say* a vast deal on that subject, but I refuse having nothing to 'repent' for, except the vanity of thinking that you believed in me, as a friend, should."

The last painting to come into Gardner's collection from Colnaghi was Albrecht Dürer 's *Portrait of a Man in a Fur Coat*—one of the "children" of Gutekunst's "fancy and longing," which she bought for $55,000 in 1902. His influence on her collection had been profound—his taste for and expertise in Dutch and German pictures running alongside her passion for Italian Renaissance art. She claimed not to adore Rembrandt, but she bought four of his canvases, as well as the two Holbeins, and a ter Borch.

Gutekunst understood she wanted masterpieces and he delivered them. In only eight years, between 1894 and 1902, Colnaghi provided Isabella Stewart Gardner with twenty-two pictures and most of her finest Old Masters. For these she paid $750,000. One hundred years later, the Botticelli, the Titian, the Holbeins, and the ter Borch all had held their attributions. The delicate, muted *Annunciation* by Fiorenza di

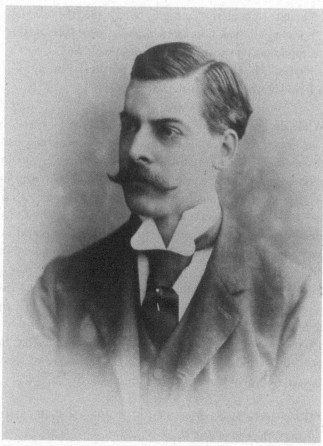

Otto Gutekunst, the dealer at P. & D. Colnaghi in London who secured masterpieces for both Isabella Stewart Gardner and Henry Clay Frick.

Lorenzo would be reattributed to various artists (including "the Master of the Gardner Annunciation") and eventually to Piermatteo d'Amelia. Three out of the four Rembrandts remained in the Rembrandt canon. Only *Landscape with an Obelisk* has been reassigned to Govaert Flinck, a Rembrandt contemporary.

In 1909, in a note apparently meant for posterity, Gardner herself put down her final assessment of her fraught relationship with the London art gallery and the Holbein transaction:

I bought through the Colnaghis in June 1899 the two Hol-
beins from the Pole Carews. Colnaghi's cheated Pole Carew &
I think me. I do not care again to deal with the Colnaghi's.
However the Holbeins are splendid pictures & now in 1909
I can say, more than worth the money.

While she blamed Colnaghi instead of Berenson for overcharging
her, she recognized that in the end, as the prices of pictures soared, she
came out ahead—not only in financial terms, but more importantly as
a collector. Her pragmatic assessment of Colnaghi helps explain her
ability to overlook Berenson's deceit. If he had betrayed her as a friend
and adviser, in the end, as a collector she had gotten from him what she
wanted—a number of extraordinary pictures. She continued to buy
pictures from him and kept up their correspondence until the end of
her life.

In 1934, when both Gutekunst and Berenson were close to seventy,
Gutekunst spoke bitterly to Berenson about his dismissive and conde-
scending attitude. He felt Berenson had insulted him with a backhanded
compliment—saying that if Gutekunst "had devoted . . . [his] life to
study, . . . [he] would have ranked with the best . . . who have."

"Down from your pedestal!" Gutekunst replied.

To what else have I devoted my life?! Who are all this holy
Circle, 'the best of you??'
Do they not all make mistakes? Have they not all from
time to time accepted things they rejected afterwards or re-
jected some they accepted later? Are not you all, like us, just
after money—we openly you quietly & less candidly! . . .
We know too much about one another. . . . But I do mightily
resent this high brow & superior attitude. I will not take
second place to any living soul regarding eye & experience
or honesty of endeavor & dealing & sincerity nor in balanced
knowledge & understanding of Art: pictures, drawings &
prints of all schools. I am no specialist, nor an Art Histo-
rian, critic, or writer. I am an expert who has to stand by his
guns & always have paid for my mistakes myself.

And he had. Starting in October 1903, at Gutekunst's urging and hoping to enlarge their "circle of friends," the Berensons spent six months in the United States, where the art world received them as conquering intellects. By now Berenson had written eight books and thirty-seven articles. "They take it for granted here that he is honorable and learned and sincere whereas in England from Roger [Fry] down they take the opposite for granted and of course in Germany and Italy and France he is much more loathed than liked," Mary wrote in her diary. Frederick Rhinelander, who had succeeded Marquand as president of the Metropolitan Museum of Art, and other trustees met with him, raising the possibility that they might offer him the director's job. In Philadelphia the Berensons visited the collections of the traction tycoon Peter A. B. Widener ("about the rottenest we have yet seen," according to Mary) and of the Philadelphia lawyer John G. Johnson, who recruited Berenson to scout for pictures. Also, in New York, he agreed to advise Eugene Glaenzer, a Paris dealer with a branch on Fifth Avenue.

Fenway Court

By 1900 the heyday of Isabella Stewart Gardner's Old Master collecting had come to an end. The one picture she continued to want was a Raphael Madonna and she pestered Berenson to find her one. He had tried to discourage her; they rarely came on the market. "And buy me a *heavenly* Raphael *Madonna*," she wrote Berenson on March 11, 1901, "and then let's to sleep on our laurels. I think of putting on my pearls and begging from door to door—no other clothes but my Rosalina point lace!"

Meanwhile, she had collected hundreds of other objects—sculpture, columns, sarcophagi, and mosaics from Ancient Rome, screens from Japan, and some 450 pieces of furniture. As a collector, she had largely achieved her aims, acquiring fine, sometimes extraordinary examples of many of Europe's greatest masters. While pleading poverty, she worried that inexpensive pictures did not meet her standards. "But I am beginning to feel very sure I must not have any *2nd* rate things," she told Berenson. "Is the Botticini one?"

In the summer of 1900, the foundations of her museum were laid,

and for two years she worked on constructing the building she called Fenway Court—her tribute to Venice, its palaces and art, in particular to the Palazzo Barbaro. The exterior of the museum was disarmingly plain. But inside, she created a four-story, sky-lighted courtyard, into whose stone walls she set arches, balustrades, and other architectural fragments she had gathered in Italy. (She had brought back "columns, capitals, reliefs, frescoes, mirrors, cassoni, chairs, fountains, balconies," as Berenson put it.) The courtyard was a vast version of the courtyard in the Palazzo Barbaro. In it she placed Greek and Roman sculpture. As she invoked the ancient city of Venice in the architecture she embedded in the museum's walls, she worked it into a design, whose emphatic individualism and subjectivity was strangely modern.

She hung her Old Master paintings on the museum's second and third floors in galleries also filled with sculpture, furniture, and other decorative arts. She gave each of the rooms a distinct character, lining some with dark wood paneling, others with damask—and setting up startling juxtapositions. She placed a Roman mosaic with the head of Medusa in the center of the courtyard, not far from a chapel. Works of art also ran along the corridors. With her highly personal installation, she determined the way viewers would experience the art—figuratively taking them by the hand in hopes that they too would revel in it as she had. The private American museum with a collection acquired in less than two decades resembled "a great Italian villa," wrote Rollin van N. Hadley, the museum's director, "with the accumulation of generations dispersed in a seemingly haphazard fashion." From her apartments on the fourth floor, Gardner could look out through the Venetian arches at her creation below.

She hung *Europa* with ten other Old Masters in a third-floor room that evoked the ancient grandeur of the Barbaro, its walls covered with rich red damask. There she also placed Benvenuto Cellini's life-sized bronze bust of Bindo Altoviti, as well as gilded tables and chairs, on a Persian carpet. On the wall below the Titian, she spread a six-square-foot expanse of pale olive green silk, which came from a dress designed for her by Worth, and with this fabric tied herself to her masterpiece.

Fenway Court opened on January 1, 1903, with a party for three hundred, which began at 9 p.m. Members of the Boston Symphony

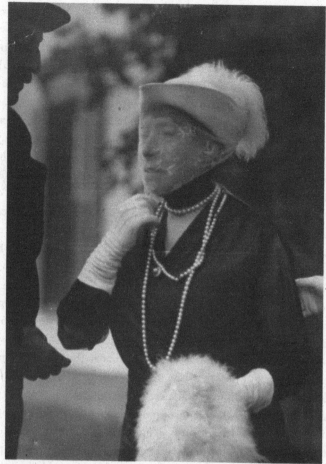

Isabella Stewart Gardner, ca. 1915, wearing the pearls that appear in John Singer Sargent's portrait. Image courtesy of the Boston Public Library, Print Department.

played in a "music room" on the ground floor. Gardner set potted palms and flowers in the courtyard and illuminated it with candles and torch-light. The public was invited on February 23; admission required a $1 ticket and she limited attendance to two hundred a day. Subsequently, she opened the museum for a few weeks every spring and fall.

In 1903, Wilhelm von Bode visited Fenway Court. The German museum director had been keeping his eye on America. The year

before, in an article titled "The American Competition in the Art Trade and Its Danger for Europe," he identified the threat posed by the new tycoons: "These gentlemen from the iron trust stepped indeed with iron feet into the art market, stomping out the old order and creating a peculiar new one." After his Boston visit, he tried to reassure the Old World, claiming that most of the paintings lost to America had already been rejected by Europeans, and he named three Gardner pictures (the Titian *Europa*, the Raphael *Tommaso Inghirami*, and the Dürer portrait) to prove it. He failed to mention that he himself had turned them down. But Gardner's Benvenuto Cellini bust was one of three pieces he had seen in the United States that he believed "every large museum would love to own." The Rembrandt expert praised the "splendid, tasteful installation" at Fenway Court, as well as the array of Italian and Dutch pictures, and declared all four of Gardner's Rembrandts genuine.

In 1904 Henry James visited the United States, and three years later he published his thoughts in *The American Scene*. Although he wrote only a few lines on the "wonderfully gathered and splendidly lodged" Gardner collection, these observations opened his chapter on Boston and drew it to a close. He celebrated the museum and its founder as part of the "new" Boston—a "rare exhibition of the living spirit lately achieved, in the interest of the fine arts, and of all that is noblest in them, by the unaided and quite heroic genius of a private citizen." But he paid his greatest compliment to Gardner in calling her museum (its "results magnificently attained, the energy triumphant over everything") part of the old Boston and its "fine old disinterested tradition."

Fenway Court—private house and public museum—was Isabella Gardner's self-portrait and reflected both her brilliance and her eccentricities. Titian's *Europa* continues to stand apart from the mainstream of American Old Master collecting. One hundred years later, many would agree with the art historian who called it "the greatest Venetian painting in the United States."

"Mr. Morgan Still Seems to Be Going on His Devouring Way"

J. Pierpont Morgan, Raphael's Colonna Madonna,
Gainsborough's *Georgiana*, Reynolds's *Lady Elizabeth Delmé*,
and Lawrence's *Elizabeth Farren*

Although Isabella Stewart Gardner could only dream of possessing a Raphael Madonna, J. Pierpont Morgan actually succeeded in buying one. To describe Morgan as Gardner's rival oversimplifies the situation, as his fortune was many times greater than hers and paintings were only part of his vast, encyclopedic collecting project. In April 1901, at Charles Sedelmeyer's Paris gallery, Pierpont Morgan saw Raphael's Colonna Madonna, the central panel of a Renaissance altarpiece painted for the convent church of Sant'Antonio of Padua in Perugia in the sixteenth century and dismantled a hundred years later by the nuns needing to pay the convent's bills. Hoping to capitalize on Raphael's popularity and prestige and on the painting's resemblance to the Ansidei Madonna (whose $350,000 price to the National Gallery in 1885 was still a record), Sedelmeyer was asking 2 million francs, or $400,000, for the picture. Although taste in Old Master pictures had fluctuated, Raphael, along with Titian and Leonardo, had been held in the highest critical esteem for centuries. Dying at thirty-seven (like van Gogh), Raphael had painted relatively few canvases. The astronomical asking price would not be a problem for Pierpont Morgan. Only weeks before, the sixty-four-year-old banker announced he was assembling United States Steel, the largest industrial conglomerate in the world, and the first to be capitalized at over $1 billion.

Morgan was already forging a reputation as the most omnivorous

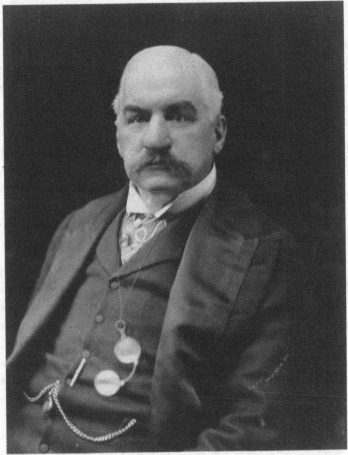

The banker J. Pierpont Morgan in 1902 at age sixty-five. Morgan out-stripped all other American collectors, buying not only magnificent single pieces like the Colonna Madonna but also entire collections.

American collector of art. He began amassing a collection in 1890, the year that his father, Junius Spencer Morgan, died and left him a London merchant bank and $15 million. In the last decade of the century, his wealth had doubled. "Having become the greatest financier of the age," Morgan "determined to be its greatest collector," the *Burlington Magazine*, an English art periodical, later observed. Although Morgan

did not spell out his intentions as Henry Marquand had, his relentless art buying seemed driven in part by a desire to transform the Metropolitan Museum of Art, and the museum became a depository for segments of his sprawling collection. Since 1888, Morgan had served as a museum trustee and in November 1904 he became the Metropolitan's fourth president. But whatever his future plans, Morgan kept most of his art holdings in London, determined to avoid the 20 percent tariff that the U.S. government imposed in 1897 on art over one hundred years old. (In 1904 Isabella Gardner would pay a $200,000 fine for customs duties levied against works she purchased for her museum six years before.) Meanwhile, he lobbied to have the customs duty eliminated.

In sheer numbers, Morgan outstripped all other American collectors. He went after not only single, magnificent pieces, like Rembrandt's portrait *Nicolaes Ruts* and a sixteenth-century tapestry once owned by Cardinal Mazarin, but entire collections. In 1902, Morgan purchased two thousand pieces of Chinese porcelain, a collection that James A. Garland had previously loaned to the Metropolitan. (After Garland's death, the dealer Henry Duveen bought Garland's porcelain for $500,000, and sold it for $600,000 to Morgan, who donated it to the museum.) He plunged into French decorative arts and also into Medieval art by gathering up (for $1.5 million) two collections created by Georges Hoentschel in France. He gave the eighteenth-century collection to the Metropolitan Museum, where he also sent the Medieval art as a loan. In 1909, the banker suddenly went into Old Master drawings— acquiring the collection of 1,500 sheets put together by the English dealer and connoisseur Charles Fairfax Murray. In the course of two decades he would spend a staggering $60 million on art, or well over $1.2 billion in 2006 dollars.

Morgan's collecting was so far flung that his taste was difficult to define. He seemed drawn to the ornate and elaborate, to decorative arts—bronzes, porcelain, glass, clocks, tapestries, furniture, Medieval ivories and enamels—and in particular to finely crafted objects. One of the most beautiful was a gold and steel helmet whose motifs were so subtly sculpted (by Filippo Negroli, in sixteenth-century Milan) that it is at first not obvious that the peak is a mermaid, lying on her back and

grasping strands of hair from the head of Medusa in her outstretched hands. Dominated by objects rather than paintings and spanning so many periods and media, Morgan's collection recalled the old-fashioned "Kunstkammer"—a cabinet of wonders, which might range from painting and sculpture to shells, skeletons, and scientific instruments. If Old Master paintings constituted only one of Morgan's collections, the banker nevertheless still had great influence in the small, highly visible picture market, whose participants (both European and American) studied his acquisitions, many of which he hung in his London house (opened to visitors by invitation in 1901).

Raphael's Colonna Madonna

If not the greatest of all Raphaels, the Colonna Madonna was nevertheless a fine example of his extraordinary ability with paint—a complex image of smooth-surfaced artifice, at once delicate and monumental, where, responding to the demands of his Catholic patrons, the artist cast the Madonna (with her innocent pale oval face) as the queen of heaven and paid tribute to her role in the church. She is seated on a throne, which climbs to a canopy far above her head and is set back into the picture's space by three sharply drawn gray steps, distancing her and formalizing the scene. She is cloaked in dark blue and she bends her head. Both the mother and the young child in her lap stare down at the child Saint John the Baptist, standing at her left knee and looking up to return Jesus's gaze. The forms of the children and the mother are gracefully drawn into the dark azure pyramid of her robe, which is evenly patterned with specks of gold. From under her hem, a pale blue shoe emerges, casting a shadow over the edge of the platform on which she sits.

In the foreground, the church's two founding fathers stand guard: Peter, an older man in an ochre-toned robe, his expression serious and sad, and Paul, dark haired, dressed in red, and absorbed in a book he holds open in his hand. These male saints are among the finest passages in the picture—flesh and blood figures whose robes have the weight of sculpture and whose naturalism seems slightly out of sync with the idealized female saints (one in gray and rose, the other in

green), whose porcelain-like faces resemble the Virgin's. Although the Virgin and her small company fill most of the painting, behind them Raphael describes a hilly landscape with two small buildings, one with a steeple that pricks the luminous aquamarine sky. Above the central scene is a semicircle with God the father holding the orb of the world and raising his hand in blessing. On either side float two light-haired angels whose billowing green and gold robes echo the curves of their wings.

The provenance of the Colonna Madonna reflected the political and economic vicissitudes of Italian history and it had been on the market (not always officially) for thirty years. After leaving the convent church, the Raphael altarpiece was purchased by a member of the Colonna family and went on display in the long picture gallery of their palace in Rome. There it remained until Napoleon's invasion of Italy in 1798, when an English dealer negotiated its purchase by Ferdinand I, King of Naples and the Two Sicilies. When Garibaldi dethroned Ferdinand's heir, he fled to Spain and took the Raphael, which he decided to sell. Turned down by the National Gallery, the king (now the Duke of Ripaldo) hoped to have better luck with the Louvre. His agent loaned it to the Paris museum, where it became known as the "Madonna of a Million," because he wanted a million francs. Several French critics called upon France to buy the painting by Raphael, whose name, as one wrote, "has become almost a synonym of painting itself." The outbreak of the Franco-Prussian War in 1870 prompted the duke, fearful for the painting's safety, to ship it to London, where it went on view at the National Gallery. After the director Frederick Burton acquired the Ansidei Madonna in 1885, he dispatched the Colonna Madonna to the South Kensington Museum, where officials found it "to be in such an unsatisfactory state as to make it unfit for public exhibition." In 1896, a London dealer managed to get the Raphael for 17,000 pounds, restored it, and sold it to Sedelmeyer.

In 1897, the Paris dealer proposed the Colonna Madonna to Isabella Stewart Gardner, but when she asked Berenson's opinion, he gave a damning appraisal: "As an expert I affirm that while doubtless Raphael superintended the execution of this altarpiece, laid it in himself, and painted *some* upon it, the altar-piece as a whole when it left his

studio could not have been called an *autograph* work by Raphael."
Quickly Gardner lost interest in that "tiresome dreary Colonna Ra-
phael."

Charles Sedelmeyer missed Morgan's visit to his gallery, but the
banker seemed to need little convincing; he decided to buy the Raphael
and pay the dealer's $400,000 asking price. Sedelmeyer's elegant hand-
written invoice reveals that Morgan supplemented the altarpiece with
Titian's *Holy Family*, and portraits by Rubens and by Jean-Marc Nat-
tier, and a hunting scene by an English artist named Morland. The bill
amounted to 3 million francs, or $600,000. "Morgan the collector was
recognizably the same man as Morgan the banker," observes the histo-
rian Ron Chernow. "He hated to haggle." Morgan's banking partners
fretted about his spending on art. "I hope, though we cannot hint it,
that Flitch [Morgan] will not buy the National Gallery at the end of the
year," Clinton Dawkins wrote in December 1901. Seven months later he
added: "We never see him and it is difficult to get hold of him. He
spends his time lunching with Kings or Kaisers or buying Raphaels."

Berenson naturally heaped scorn on Morgan's acquisition. "Pier-
pont Morgan's 'Raphael'—the one I urged you *not* to buy—is exhibited
in London at the Old Masters, and critics, I am happy to note are pretty
well agreed about its worthlessness—relatively to pretensions and price,"
he wrote Gardner on January 14. While Berenson and others in the art
world sniped, the record-breaking Raphael thrust Morgan forward as
the Old Master market's most extravagant player, one who competed
with the likes of the National Gallery and to whom painting dealers
could now hope to sell their best and most costly wares. If the National
Gallery's director first gave Raphael's Ansidei Madonna the distinction
of being the world's most expensive work of art, the Anglophile Mor-
gan followed the English lead with his Colonna altarpiece. The art es-
tablishment's view that Raphael's art embodied immutable standards
of beauty was one with which Morgan no doubt concurred. He saw the
Colonna Madonna as a rare and magnificent High Renaissance paint-
ing and paid the asking price. Morgan "responded less to abstract
qualities in works of art than to subject, history, rarity, and prove-
nance," explains his biographer Jean Strouse. The Raphael would have
extraordinary value to the United States as it struggled to gather a

group of pictures that would illustrate the history of European art. Morgan immediately put the Colonna Madonna on display at London's National Gallery, suggesting that he intended to give the painting to the Metropolitan. "With the eventual disposition of his collection in mind, Morgan may well have felt it was his patriotic duty to acquire the painting," writes the art historian David Alan Brown. In fact, the Colonna Madonna was the only major Raphael altarpiece to end up in America.

Born into the most privileged circles of America's affluent middle-class, Morgan collected art not as a means of upward mobility but as a matter of course. He began buying rare books and manuscripts, and by 1902, he had secured ten thousand rare volumes, which he shipped from Europe to New York. (Books and manuscripts were exempt from the art tariff.) Eventually he would possess a library with over six hundred Medieval and Renaissance manuscripts, including the *Farnese Hours* by Giulio Clovio, whose delicate images translated the sort of large-scale High Renaissance figures painted by Michelangelo and his Mannerist followers onto the pages of a book.

Just as Isabella Stewart Gardner liked to model herself on the Renaissance patron Isabella d'Este, Morgan similarly presented himself as a modern heir to the Renaissance bankers who were legendary buyers of art. While Gardner was erecting her Venetian palace, Morgan was constructing a Renaissance "library" in New York, beside the large brownstone at Madison Avenue and Thirty-sixth Street that he shared with his wife, Frances Louisa Tracy. Designed by Charles McKim, the neo-Renaissance marble pavilion calmly asserted classical order and well-bred grandeur against the architectural medley rising in Manhattan. Although intended to hold Morgan's books and manuscripts, the library would have worked well as a setting for his new Raphael. In the West Room, which he used as a study, he hung two other, smaller Raphael Madonnas. There Morgan sat at a desk and held business meetings beneath a sixteenth-century ceiling he imported from Italy. He had the walls of the room covered in crimson damask, which was woven with the insignia of Raphael's patron, the Roman banker Agostino Chigi. "No one could really know Mr. Morgan at all unless he had seen him in the West Room (which was regarded as peculiarly his own room) in

the Library ... because the room expressed his conception of beauty and color in varied and wonderful forms," wrote Herbert L. Satterlee, Morgan's son-in-law and biographer. Although set in midtown Manhattan, Morgan's magnificent library seemed worlds away from the financial and industrial hurly-burly that enabled its creation.

On October 23, 1901, the *New York Times* reported that "J. Pierpont Morgan has bought the celebrated Holy Family, by Raphael," then asked: "Will he bring it to this side of the Atlantic? That is the question connoisseurs in Europe are asking with pardonable anxiety." The paper repeated Sedelmeyer's claim that the Raphael was "finer than anything in the Louvre or the National Gallery by the same painter." On January 1, 1902, the New York *Herald* inflated the price that Morgan paid for the painting to $500,000. If the American press tended to celebrate Morgan's patriotic purchase, in Europe the newspapers pointed to the record price as warning of future plunder, and demonized the American collector as the most rapacious of robber barons. "Curiously enough [Morgan's] operations in pictures, tapestries & curios have done him more harm with the general public than steel or shipbuilding," wrote Gaspard Farrer, of Baring Brothers. "Of the value of the latter they do not pretend to judge: but their imagination is struck when they hear of 2 to 10 times as much being given for curios as has ever been paid before."

If the press portrayed Morgan as the most American of tycoons, he was in fact the most cosmopolitan of American collectors, a descendent not only of Renaissance bankers, but of eighteenth-century English collectors like the Earl of Cowper, who preceded him as a buyer of Raphael Madonnas. Morgan played the part of the English gentleman and collector with ease, brought up to take over the London bank that Junius Morgan had built, and spending much of his time in London at a grand house at 13 Princes Gate, which he inherited from his father. (Junius also left him Dover House, seven miles outside the city.) The Morgans were "a cross between Connecticut Yankees and London aristocrats," Ron Chernow explains. Pierpont Morgan's cosmopolitanism began at an early age. He was educated abroad, sent to school in Switzerland, and then to Gottingen University in Germany.

In 1854, when Pierpont was seventeen, Junius moved to London,

where with George Peabody he established America's first international merchant bank. Three years later, Pierpont went to work in New York as an agent for his father and in the 1870s launched Drexel Morgan and Company, which became J. P. Morgan. Pierpont's American partnership evolved from and followed Junius's London model, and over the next thirty years, the Morgans fed capital to America's booming railroads and industries, catapulting their linked New York and London firms into a dominant position in the international financial markets by the turn of the century. The Morgan banks "probably do not fall very far short of the Rothschilds in capital," a Morgan partner boasted in 1901. They "are immensely more expansive and active, and are in with the great progressive undertakings of the modern world." By financing America's explosive industrial growth from New York, Morgan thrust the city into a position where it competed with London as the capital of finance. Just as his style of banking was traditional in its reliance on handshakes and gentleman's agreements and yet modern in its scale, so his art collecting combined the old and new, reflecting traditional taste and industrial-age purchasing power.

"Such Was the Glamour of the Eighteenth Century"

Only weeks before Morgan bought Raphael's Colonna Madonna in Paris, he had acquired one of the most famous of English portraits in London—a painting that his father had attempted to acquire: Thomas Gainsborough's *Georgiana, Duchess of Devonshire*. The duchess (Georgiana Spencer) was a notorious eighteenth-century beauty, who at seventeen had married William Cavendish, the 5th Duke of Devonshire. She was "famous for her glamour, and infamous for her love of gambling and her close association with the hard-living opposition politician Charles James Fox," the art historian Martin Myrone writes. Gainsborough had painted *Georgiana* as a "full-length," but at some point the portrait had been cut down, its lower half chopped off—supposedly to make the canvas fit above a mantelpiece. Even diminished, Georgiana fills the canvas with her animated face, abundant cascades of powdered hair, sumptuously clad torso, and a knowing sideways glance. She wears a gray and white dress, and a black hat with

plumes and ribbons whose absurdly large proportions and steep angle suggest the risks involved in meeting its wearer in the flesh.

Gainsborough seems to have painted the duchess in the 1780s. For two decades he had flourished as the most popular portrait painter in England—more sought after even than the more prestigious Sir Joshua Reynolds, his archrival and the principal painter to George III. Gainsborough was a master of suggestion, who used brushstrokes to evoke rather than describe. He also infused his portraits with a sense of immediacy, cleverly posing his subjects to appear unposed—catching them in the split second they happened to turn, or to take a step, and engaging them so as to engage the viewer. Like van Dyck, his seventeenth-century forebear, Gainsborough had a father in the textile trade and he was a master at representing various fabrics in paint. Even Reynolds acknowledged the brilliance of Gainsborough's technique: "This chaos, this uncouth and shapeless appearance, by a kind of magick [*sic*], at a certain distance assumes form, and all the parts seem to drop into their proper places." Georgiana sat for Gainsborough more than once, also for Reynolds; these portraits hung at Althorp and Chatsworth, the Spencer and Devonshire estates. That *Georgiana* was not one of Gainsborough's best portraits, and that some had even questioned its authorship, seemed not to affect its appeal.

Some twenty-five years before, *Georgiana* had come up for auction at Christie's in London. "Such was the glamour of the eighteenth century in 1876 that for the sake of a likeness of the famous Georgiana the whole of King Street was blocked with carriages, which overflowed into St. James's Square," writes Gerald Reitlinger. Bidding for *Georgiana* "shot from 1,000 guineas to 3,000 at a single call," and William Agnew, a flamboyant and frequent auction buyer, competing against both Ferdinand de Rothschild and the Earl of Dudley, won the picture for 10,100 guineas, or over $50,000, making the half-length Gainsborough famous as one of the most expensive paintings ever sold at auction. (The Ansidei Madonna's $350,000 record price, in a private sale, came a decade later.) Only days after the auction, Junius Morgan bought the painting from Agnew's, intending to give it to Pierpont as a present. But before Agnew's delivered the painting to Morgan's house, thieves broke into the gallery and stole it. No doubt the robbers planned to

profit by ransoming or selling their famous beauty, but the painting disappeared.

William Agnew, who had put Agnew's gallery front and center in London's art trade, certainly didn't forget about the Gainsborough, particularly as the popularity of English portraits only increased. Agnew and his brother, Thomas, had joined their father Thomas Agnew

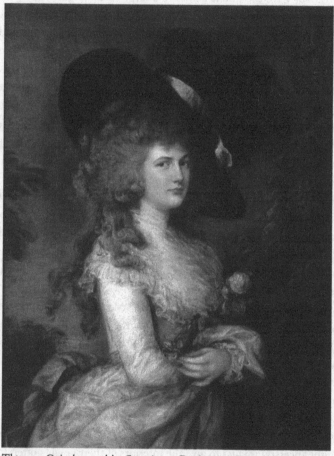

Thomas Gainsborough's *Georgiana, Duchess of Devonshire*, 1785–88. Morgan spent $150,000 on the notorious English portrait, which his father had agreed to buy from Agnew's twenty-five years earlier, just before it was stolen from the gallery.

in the Manchester gallery in 1851, and in 1860 they opened in London. Although primarily a publisher of prints, the firm had taken an early lead in the Old Master market in 1857 when they helped organize the Manchester exhibition of England's finest Old Masters, an assignment that put them in touch with picture owners all over the British Isles. In 1875, they opened a new, large, wood-paneled gallery at 43 Old Bond Street, whose layout reflected the changing market. Agnew's front door gave the public access to a large upstairs gallery where the dealers held exhibitions and a back door allowed clients to go straight to the gallery's private rooms to see particular works of art and conduct business.

Finally, early in 1901, Morland Agnew, William's son, retrieved the kidnapped *Georgiana*—which the thieves had taken to the United States, paying its ransom at a Chicago hotel. By then Morland and his cousin Lockett Agnew had taken charge of the firm. The dealer brought *Georgiana* back to London and whisked the canvas to the restorer to repair the damage it had suffered in captivity. When Pierpont Morgan arrived in London, the dealers at first declined to show him the painting, insisting on waiting until the restoration was finished. Even before Morgan saw the canvas, he agreed to buy it for 30,000 pounds ($150,000), three times what Agnew had spent in 1876, and one and a half times what Gardner had paid for Titian's *Europa* only five years before. "If the truth [about the price] came out," he quipped, "I might be considered a candidate for the lunatic asylum."

Although a far cry from a Raphael Madonna, the come-hither Gainsborough seemed a logical choice for the Anglo-American banker. Lockett Agnew thought Morgan enjoyed the painting's recent notoriety. "Sentiment played a role as well," argues Jean Strouse. "Junius had wanted the picture, and Pierpont carried out his father's wishes without regard to content or cost."

The prices of English portraits had been rising, thanks to the demand from an international band of bankers and industrialists who sought ancestral images to give the interiors of their newly gotten mansions the look of old money and blue blood. "Just now Gainsboroughs are at the pinnacle of fame and price," George Boughton told Henry Marquand on September 20, 1888. "The Rothschilds are outbidding

the Barings for them just for a whim. I should stand back for a time and wait my chance." The most voracious buyer of English portraits was the Irish Edward Cecil Guinness, who had taken his family's brewery public in 1886, and soon after moved to London with a fortune that generated an annual income of £500,000. In the course of only four years, Guinness, later the Earl of Iveagh, purchased (mostly from Agnew's) a total of 73 English portraits—36 by Reynolds, 22 by Romney, and 15 by Gainsborough. By 1891, Otto Gutekunst called the prices of English pictures idiotic and bewildering, but he hoped to sell one to Isabella Gardner. If "she wants to create a stir, what would more generally do so than such a Gainsborough," he asked Berenson, "at a time like this when everybody looks at nothing unless it is an English picture and you cannot buy them for love or money." Portraits of beautiful women (whose appeal remained undiminished through the ages) were generally more expensive than portraits of men. (Not surprisingly, Isabella Stewart Gardner wanted no such competition, and the subject of the one eighteenth-century English picture she really wanted, *The Blue Boy*, was a young man.)

Morgan placed Gainsborough's *Georgiana* over the mantel of the "red drawing room," a room where he kept his important Old Masters. There he invited her to hold her own against Rembrandt's life-sized *Nicolaes Ruts*, van Dyck's full-length Genoese *Portrait of a Woman and Child*, and a Velázquez Spanish princess. An elaborate candelabra stood at each end of the mantel—giving a momentarily startling impression that *Georgiana* was the center of an altarpiece. On either side of her, Morgan hung smaller, half-length Dutch, French, and English portraits. In papering his house with grand manner English portraits, he followed the dynastic tradition of his own family and of the English aristocrats whose patronage of Reynolds and Gainsborough in the eighteenth century had advanced English portrait painting into its Golden Age.

Ultimately Morgan hung six English portraits in the library, six in the "oak room," and three in the dining room, most importantly Joshua Reynolds's seven-foot *Lady Elizabeth Delmé and Her Children*. Lady Delmé has a long, elegant face, heavy-lidded eyes, and towering powdered hair. She wears a white dress and a cloak that covers her knees in

a cascade of rose-colored satin that speaks both to her beauty and to the luxury at her command. Standing to her left and leaning against her are a small boy and girl. A lively black-and-white dog looks up at them. Borrowing from Raphael, Reynolds set Lady Delmé and the children into the pyramidal arrangement that the Renaissance artist had created for many of his *Madonna*s, attempting to pass a secular blessing over the English aristocrats. Instead of a throne with a canopy, Lady Delmé sits beneath an enormous beech tree, its trunk dappled with sunlight. In the background, beyond a balustrade, stretches a wooded landscape. Indeed, a Raphael *Madonna* embodied Reynolds's notion of "Ideal Beauty," which he contended was "superior to what is to be found in individual nature." In Reynolds's hierarchy of painters, Raphael stood (with Michelangelo) at the very top; they "certainly have not been excelled, nor equaled since."

By the time Reynolds was named the first president of the Royal Academy in 1768, he was forty-five, and the most influential painter in London. By the late 1750s he held as many as five or six sittings a day. His clients included Samuel Johnson (a friend) and the Prince of Wales, who became George III. By 1782, he was charging 200 guineas for a full-length. "To paint particulars is not to paint nature, it is only to paint circumstances," Reynolds contended. "It is very difficult to ennoble the character of a countenance but at the expense of the likeness." Lady Delmé demonstrated Reynolds's stated intent not to describe the natural world but to improve it and to raise portraiture to the level of history painting.

Despite the references to Raphael, Lady Delmé was first and foremost a woman of fashion. In Reynolds's paean to motherhood, virtue came richly clothed in glamour and worldliness. Most of the Americans who admired *Lady Delmé* in Morgan's London dining room probably failed to pick up on the Renaissance allusions. Instead, they registered a more secular, material ideal that the British artist invented, and they imitated Morgan by buying English portraits in quantity. English portraits furnished Americans with "ancestors," but their appeal had much to do with the life they portrayed and the virtuosity and bravura with which they were painted. They flattered their sitters, casting women as beauties, and men as leaders and heroes, and both

sexes as members of a glorious, cultivated ruling class—true nobles, comely, genteel, and confident—portrayed as mortal gods who had fashioned profits of the empire into an earthly paradise, as if their very presence, set often against the green of an English garden or the wilder English countryside, could create a better world. Gainsborough's manner of painting was eloquent and sensual, conjuring glimmering fabrics and a sense of individual character, while passages of pigment in their dash and vibrancy seemed to escape representational obligation and called attention to their own sovereign beauty. The great English portraits enlivened a room with a living, breathing company. In Reynolds's portrait *The Honorable Henry Fane and His Guardians, Inigo Jones and Charles Blair*, which Junius Morgan donated to the Metropolitan, one of the young men seems equally ready to jump onto a steed or to converse with his two friends. Gainsborough's *Georgiana* appeared more than prepared to respond to the viewer who is the subject of her gaze.

At the start of the twentieth century, with industrialization well advanced and moving at full throttle, Reynolds's and Gainsborough's keen and elegant canvases of the English aristocracy and a lost, pastoral world particularly appealed to American financiers and industrialists. Although it may seem ironic that Americans were drawn to images of England in the era of George III—the king from whom they had won independence in the Revolution a century before, by taking possession of the portraits, Americans marked a financial and cultural conquest.

In 1906, Morgan added another eighteenth-century female full-length to his collection—*Elizabeth Farren*, painted in 1790 by Thomas Lawrence, who succeeded Reynolds as painter to George III. Elizabeth Farren was an Irish actress and the lover of the Earl of Derby, who commissioned the portrait. Lawrence painted her as the aristocrat she would become (after Derby married her)—walking in a groomed landscape and turning to look out of the picture, as though the viewer had just caught her attention. She is dressed in a white satin cape trimmed with white fur, which she holds at her neck with a gloved hand. Behind her is a shifting blue gray sky, streaked with pale clouds,

which echo the light glimmering on the white fabric descending her back. Lawrence exhibited the portrait at the Royal Academy the year it was painted and it became immediately famous.

The year Morgan acquired *Elizabeth Farren*, King Edward VII, who had succeeded his mother, Victoria, to the British throne in 1902, visited Princes Gate—a social call inspired by the monarch's desire to see Morgan's collection. As he surveyed the English portraits, the king couldn't help but notice that he had seen some of them before, in the houses of his English friends. They drank iced coffee in the library and Edward eyed the famous Lawrence portrait and thought something didn't look right. "The ceiling is too low in this room for that picture," he told Morgan. "Why do you hang it there?"

"Mr. Morgan looked at the portrait steadily for quite a long time," recalled Herbert Satterlee, "and then said, 'Because I like it there, sir.' They were just two friends together and seemed quite content to sit in silence sometimes and not try to entertain each other." In fact, Morgan would move the alluring *Elizabeth Farren* from the library of his London house, but not because he was displeased with its placement on the wall. Left unstated between the English monarch and the American banker was the knowledge that the Lawrence portrait, along with the surfeit of other treasures on display at 13 Princes Gate, was on its way to America.

CHAPTER IV

"Greco's Merit Is That He Was Two Centuries Ahead of His Time"

Mary Cassatt, Harry and Louisine Havemeyer, Spain, and El Greco

In the spring of 1901, when Morgan bought Raphael's Colonna Madonna in Paris, the New York sugar magnate Harry Havemeyer, his wife, Louisine, and the artist Mary Cassatt spent some six weeks in Italy and Spain hunting for Old Masters. At fifty-seven, Cassatt was one of America's most successful painters—the only American to exhibit with the French Impressionists. For close to three decades she had lived and worked in Paris. She was also Louisine Havemeyer's closest friend. Tall, thin, and sophisticated, Cassatt wore fashionable clothes and spoke fluent French, and in her straight posture conveyed an aristocratic sense of entitlement, confidence, and serious-minded purpose. On January 30, the Havemeyers had sailed from New York on the *Kaiserin Augusta Victoria* for Genoa. (As they docked, Louisine Havemeyer "could see Miss Cassatt walking impatiently up and down the wharf.") From Genoa, the three Americans headed to Turin, Milan, Florence, and Rome. After a short stay in Paris in late March, they had made their way to Spain, setting their sights on Spanish paintings—specifically canvases by Francisco Goya and El Greco.

At the turn of the century, Spain was exotic and off the beaten track. Baedeker's guide gave travelers fair warning: "Hotels with the comfort and international character of the large first-class hotels in the leading European countries do not exist . . . with a very few exceptions in such towns as Madrid or Seville." The trains were "generally dirty

and neglected," and crawled along at less than twenty-five miles an hour. Foreigners like the Havemeyers, who spoke no Spanish, were subject to "inconvenience and extortion." They were advised not to accept silver coins without testing them on stone slabs provided for that purpose and knowing the "true ring" of money.

Decades before, Mary Cassatt had found inspiration in the melodrama of Spanish painting. As part of her training, she had "braved" Seville for six months starting in the fall of 1872 to study Velázquez. "I really feel as if it was intended I should be a Spaniard & quite a mistake that I was born in America," she told a friend. Madrid boasted one of Europe's great museums, the Prado, whose collection of Spanish paintings, once owned by the royal family, had no equal. In fact, to introduce the Havemeyers to El Greco, Cassatt realized they had to visit Spain, where the artist had painted the majority of his pictures and where, three centuries later, they remained—in the Prado, in churches (where they served as altarpieces), and in palaces, often passed down through generations of Spanish nobility. In theory, the many El Grecos still in private hands made Spain a gold mine for buyers. Yet thanks in part to the country's relative isolation, Spanish painting had not yet attracted the same degree of scholarly attention as either the Italian or Dutch school.

Mary Cassatt also knew El Greco firsthand because her friend, the artist Edgar Degas, owned two of his pictures—*Saint Ildefonso* and *Saint Dominic in Prayer*, which he kept in his Paris apartment, where she was a frequent visitor. "Oh Greco . . . the most beautiful of all and how happy I am to know that it belongs to you," Henri Rouart had written Degas after one of these El Greco purchases. Rouart, an engineer and collector, acquired four El Grecos himself, and the dealer Michel Manzi, another member of Degas's circle, had two.

Cassatt plainly stated the significance of the sixteenth-century Spanish painter to her avant-garde contemporaries: "Greco's merit is that he was two centuries ahead of his time. That is why painters Manet amongst others thought so much of him." Later, she observed, "Cézanne's nude figures are almost a copy of some of Greco's."

Although Cassatt and the Havemeyers could have found Old Masters in the French capital, they had purposefully fled. In contrast to Henry Marquand, Pierpont Morgan, and Isabella Stewart Gardner,

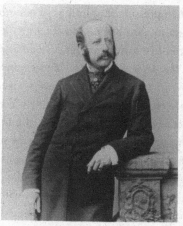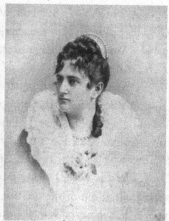

H. O. (Harry) Havemeyer and Louisine Waldron Elder, probably at the time of their marriage in 1883.

who shopped for pictures at established dealers in London and Paris, Cassatt and the Havemeyers went in search of Old Master paintings still in the hands of private collectors—before they reached the market. Cassatt steered clear of Old Master dealers and thought the Havemeyers would do better without them. One of the only dealers she did trust (though cautiously) was the Impressionists' dealer and her own—Paul Durand-Ruel. She believed that her connections would permit her to breach aristocratic residences in Italy and Spain and her expertise enable her to identify authentic paintings. Bypassing the trade, she hoped to buy art at the lowest possible price.

At first glance the Havemeyers appeared a conventional enough upper-middle-class couple, but their ordinariness belied their exceptional place among American collectors. That they were scouting for El Grecos and Goyas in Spain with Mary Cassatt suggested the advanced taste and spirit of adventure that propelled their collecting. They had come to Madrid literally and figuratively by way of Paris, their interest in El Greco and Goya evolving from their appetite for modernist French art—the work of Gustave Courbet, Edouard Manet, and the Impressionists, most importantly, Edgar Degas.

For seven years, with Mary Cassatt as their adviser, Harry and

Louisine Havemeyer had bought Impressionist paintings in quantity. They had jumped into the market in 1894 at Durand-Ruel's gallery in New York, where they acquired five canvases: Manet's *Ball at the Opera*, Alfred Sisley's *Banks of the Seine*, and three landscapes by Claude Monet. The following year, when the Havemeyers visited Durand-Ruel in Paris, they shipped eleven pictures back to New York, including six by Degas and Manet's *Boating*, a close-up view of a man and a woman seated in a sailboat, surrounded by an aquamarine sea. In 1898 and 1899, they bought seven more Manets, including the *Gare Saint-Lazare*, a horizontal image of a seated young woman in blue, looking out of the picture, beside a girl in a white dress with a blue sash, whose back faces the viewer. Both the woman and the child have a classic, monumental beauty, set against contemporary Paris and in front of a black iron fence through which white steam is rising from a train. The canvas cost $15,000. The Havemeyers also owned three of Manet's "Spanish" pictures (including *A Matador* and *Mlle. V . . . In the Costume of an Espada*). In the end, the Havemeyers' relentless purchasing totaled 64 by Degas (paintings, pastels, and drawings), 45 Courbets, 30 Monets, 25 Manets, 25 Corots, 13 Cézannes, and 17 by Mary Cassatt. Already in 1901 the Havemeyers were well on their way to building one of the greatest collections of Impressionist painting ever assembled.

Later, Cassatt told Frank Gair Macomber, "It has been one of the chief pleasures of my life to help fine things across the Atlantic." Cassatt saw her advocacy of Impressionism as part of a larger American project—to stock the nation's museums with European art. "As to the Havemeyer collection," she told her friend Theodate Pope, "I consider they are doing a great work for the country in spending so much time & money in bringing together such works of art, all the great public collections were formed by private individuals."

Louisine Waldron Elder Havemeyer had a handsome, open face and a neoclassical profile. Her eyes were deep set, and from a photograph she gazes out with forthright intensity and a slight smile. She disliked pretension and had a no-nonsense quality about her, perhaps modeled on her mother, whose close friends were suffragettes. Later, she herself campaigned for the suffrage cause and famously was ar-

rested and spent a night in a Washington, D.C., jail. She had three children but motherhood was only one of the roles she played. She came to think of herself first and foremost as a collector.

Harry (Henry Osborne) Havemeyer was fifty-four, stout, and balding, with a prominent nose and a mustache. Dressed in a dark frock coat and a bowler hat, he looked the self-assured tycoon that he was. Although he had been handsome in his youth with curly dark hair and slightly hooded eyes, now he was an easy target for cartoonists whose caricatures had made him a well-known, sometimes despised public figure. "Restless" and "impulsive," according to Louisine, Havemeyer had for almost two decades run Havemeyers & Elder, the largest sugar refinery in America. The never-say-die industrialist had in 1887 helped engineer the creation of the "Sugar Trust" (officially named the Sugar Refineries Company) by organizing the merger of seventeen sugar refineries and closing twelve, so that only the five most profitable remained. He had managed the Sugar Trust for over a decade.

The Havemeyers lived in a fortresslike neo-Romanesque mansion at 1 East Sixty-sixth Street, off Fifth Avenue, which encased an interior designed by Louis Comfort Tiffany and Samuel Colman, who had tied the decoration (including lighting fixtures and furniture) together into a single, exotic design, intended to dazzle and impress. Visitors entered through a round-arched doorway into a vestibule and then a hall lined from floor to ceiling with hundreds of thousands of gleaming glass mosaics in blues, greens, yellow, white, and gold. The staircase was based on the one in the Doge's palace in Venice. Many of the Havemeyers' paintings ringed two balconies in a sky-lit gallery. The massive stone house with its finely decorated rooms conveyed the way Havemeyer presented himself—his tough public persona erected to shield a thoughtful, intelligent individual, who collected art, kept a Stradivarius violin on his desk, and organized his social life around his family. "Mr. Havemeyer disliked notoriety more than anyone I ever knew, and believed that a man had a right to the quiet enjoyment of his own home," Louisine remarked. Yet Havemeyer ran the Sugar Trust as a fiefdom and his name was regularly in the press.

El Greco

In Old Masters, as in contemporary art, Cassatt and the Havemeyers wanted to be on the cutting edge. In contrast to Rembrandt and Raphael, who had enjoyed centuries of adulation and acclaim, El Greco had been seen as an "eccentric" and "even a little mad," his work largely ignored or forgotten. In 1901, not much had been written about El Greco, but his life conformed to the Romantic notion of the artist as someone who stood apart from the mainstream and never fit in. Born Domenikos Theotokopoulos, the artist became known in Spain as El Greco ("the Greek") because he was born in Crete in 1541, when the island was a colony of Venice. He started out as a painter of religious icons for the Orthodox church, and then spent a decade in Italy at the time of the High Renaissance—moving first to Venice where he saw the lushly toned paintings of Titian and Tintoretto, and then to Rome, where he encountered the Vatican frescoes of Michelangelo. In Italy, he mastered the skills to carry out major commissions for the Catholic Church and learned to paint pictures filled with animated full-length, flesh-and-blood figures moving in convincingly drawn space. In the *Purification of the Temple*, he paid tribute to the Italians by including portraits of Titian, Michelangelo, the miniature painter Giulio Clovio and (perhaps) Raphael in the picture's lower-right-hand corner. In search of more work, the artist had moved to Spain by 1577. He settled in Toledo, the political and ecclesiastical capital of the kingdom of Castile, where the church of Santo Domingo el Antiguo immediately commissioned him to create the high altar—an elaborate, two-story structure with six large paintings, including an *Assumption of the Virgin*, which climbed thirteen feet.

Carrying out Catholic commissions in Counter-Reformation Spain, El Greco veered from the naturalism of the High Renaissance and developed a highly original Mannerist style. He populated his canvases with long, thin, weightless figures set in a world lacking natural atmosphere and light and where linear perspective seems to have collapsed. He exaggerated not only proportions, but colors, and he shot passages of drapery with white highlights. Often his canvases seem to flicker as

though in flame. In *The Adoration of the Shepherds*, which he painted for his own tomb, both the shepherds on the ground and the angels in the sky float in a darkened space, the vibrant yellows, blues, and greens of their clothes illuminated by pale light emanating from the crooked image of the infant Jesus.

El Greco and his large workshop also produced devotional pictures that he sold to clients who placed them in private chapels. Problematically for later collectors, the workshop churned out these religious images, with El Greco himself painting more or less of the canvas depending on the price. There were four versions of *The Purification of the Temple*, five of *St. Jerome as a Cardinal*, and five of *Christ Carrying the Cross*. In 1962, the art historian Harold E. Wethey attributed 285 paintings to El Greco, but identified 458 other canvases as "school works, copies or wrong attributions."

The rediscovery of El Greco began with the Romantics early in the nineteenth century, and by 1869, the Paris critic Paul Lefort praised him as an "audacious, enthusiastic colorist, perhaps too fond of strange juxtapositions and unusual tones, who, piling boldness on top of boldness, finally managed first to subordinate, then to sacrifice everything in his search for effects." Lefort argued that "despite his mistakes, El Greco can only be considered as a great painter." Soon, the Paris avant-garde embraced the Mannerist artist as a radical Old Master who had broken the rules and pointed the way. To a generation "brought up with Rembrandt, Rubens, Michelangelo," El Greco was "neccessarily unique and of a completely different variety from all other artistic impressions," explained the German critic Julius Meier-Graefe.

Not long after arriving in Madrid, the Havemeyers went to the Prado and Cassatt showed them the El Grecos. According to Louisine they immediately responded to his art: "its intensity, its individuality, its freedom and its color," and were struck by the portraits. In the Prado's *Portrait of an Elderly Gentleman*, the artist removed all props and pared the image down to the essentials of character: a noble, melancholy face, with nearly black eyes and a graying beard, set against a lushly brushed white ruff and a black torso. "We went to a photographer's and bought a photograph of every Greco and

Goya we could find, and adroitly managed to find out where some of them could be seen," Louisine wrote. In a private house, they climbed a "narrow staircase" and saw two Goya portraits. Cassatt bid 20,000 pesetas ($4,000) for both; but when the owner countered with a price of 100,000 pesetas, the Havemeyers withdrew. In Madrid, they "learned" of Manuel B. Cossio, a scholar writing an El Greco biography and catalog, and arranged to meet him. Cossio instructed them to see two paintings—the *Burial of the Count of Orgaz* in Toledo and a canvas he had discovered in the Oñate palace in Madrid, a *Portrait of a Cardinal*, in which the cardinal is wearing glasses. Harry was skeptical: "Spectacles in a portrait! I would not consider it."

Harry was a "mighty sightseer," Louisine wrote, and he grew restless in Madrid, so the couple headed south—to Toledo, Cadiz, Seville, and Granada. In Seville they hoped to acquire one of the two versions of Goya's famous *Majas on the Balcony* from the Duke of Montpensier, but failed to get access to the picture. In Toledo, after losing their way, they found the church of Santo Tomé, where their encounter with the *Burial of the Count of Orgaz* left Harry Havemeyer convinced it was "one of the greatest pictures" he had ever seen.

In the fifteen-foot altarpiece, brimming with life-size figures, El Greco convincingly describes the living and the dead, the real world and the divine. In the foreground, two saints lift the fallen count's limp body (clad in flint-toned armor) into a tomb. Behind them, paying homage to the count, stand twenty-one Spanish noblemen, dressed in black, their elongated faces set against white ruffled collars. In the sky, the count (now naked) kneels before the Virgin, dressed in blue and red. At the very top floats the figure of Christ enthroned. Anchoring the visionary scene of resurrection are myriad details—from brocade embroidered in gold to a white vestment worn by a priest over a black robe whose transparency is so convincingly rendered in paint that it conveys the miraculous nature of the count's resurrection. In the center of the canvas is an angel in flight, whose spreading wings and floating gold drapery make the transition from earth to the cloudy realm of heaven. But as part of the high altar, the vast and magnificent *Burial* was not for sale.

"As to the Havemeyer Collection"

As an adviser on Impressionist painting, Mary Cassatt had impeccable credentials and she played the part not only for the Havemeyers but for other Americans, including her brother Alexander Cassatt, president of the Pennsylvania Railroad. She rightly considered herself a connoisseur whose pioneering aesthetics allowed her to discern exactly which contemporary works of art would survive and prove most influential. A member of the Impressionists' circle, she understood the nature of their art and could judge their pictures; she also knew the Paris art world—the painters, dealers, critics and collectors—and ably managed both the mechanics and politics of the marketplace.

Mary Cassatt had her own, distinctive iconoclastic taste—a taste for difficult art. She disdained the pretty, the conventional, and the picturesque, and this credo (forged as a practicing artist) ran through her likes and dislikes of Old Masters. She argued that authenticity and "truth" were more important in painting than conventional "beauty." Speaking of the American banker James Stillman, she wrote to Louisine, "I like the way he is learning and subordinating his taste for the agreeable to the quality of Art—he learnt that in your house." Elsewhere she argued that "Degas's art is for the very few. I cannot believe that many would care for the nude I have. Those things are for painters and connoisseurs." Indeed, by conventional standards, Degas's nude was awkwardly posed—standing in a tub and leaning over to sponge her left foot—and awkwardly viewed, very close up and from the back. Edgar Degas captured Cassatt's complex identity and paid tribute to the strength and justice of her opinions when he chose to paint his friend, not as an artist, but as a viewer—in a gallery at the Louvre. He shows her from the back as a willowy, fashionable figure in a long black dress and a large black hat, striding along, with a black umbrella that extends the line of her sleeve straight down to the floor.

Not surprisingly, Cassatt had no patience for eighteenth-century English portraits. When she heard that Oliver Payne was thinking of buying a Hoppner she sniffed that the price was "fantastic [for] a third rank painter from a school which had not produced a single painting

of absolute first rank! In comparison, the Goyas are a bargain." Goya
had portrayed the Spanish queen with brutal candor, refusing even in
an official commission to finesse her awkward face and protruding jaw.
(When later the Havemeyers, well-schooled by Cassatt, had a chance to
purchase one of these odd royal portraits, they took it.) Cassatt also
dismissed the French rococo of François Boucher, Jean-Honoré Frago-
nard, and Jean-Antoine Watteau. "I was rather cut-up," she wrote,
"when Mr. S. [Stillman] told me he had bought one of the Nattiers be-
cause I admired it. So I did," she added, "for a Nattier."

At heart, Cassatt preferred modernist French painting above even
the greatest Old Masters, and she never stopped fighting for the
avant-garde cause. "Durand-Ruel has just returned from Vienna, where
he saw a ver Meer von Delft, which he says is beautiful," she wrote to
Louisine in 1890. The dealer had seen the Czernin Vermeer, *The Art of
Painting*, perhaps the artist's greatest picture. "Two million marks was
asked or refused for it, I forget which," she added. "Col. Payne's Degas is
more beautiful than any ver Meer I ever saw. Tell him that."

Cassatt sought to duplicate the insider position she held in the field
of Impressionist painting in the more complicated territory of Old
Masters where she assumed she had a unique and privileged pass. As
an artist, she looked at Old Masters as models and sources of inspira-
tion, as bearers of brilliance and truth. She had taken the Havemeyers
to studios in Paris and she sought a similar experience in the old
world, or at least its remnants, from which Old Masters came. Al-
though she accepted commerce as a necessary part of her own artistic
enterprise, when it came to Old Masters, her perspective as a profes-
sional led her to underestimate the different challenges of the market.
Seeking Old Masters in their countries of origin, she hoped to find
them as yet untouched by commerce—in a place where dealers and
American money hadn't yet arrived.

If Cassatt's taste was modern, her approach to buying Old Master
pictures was not. She sought out dealers on the margins of the trade
whom she hoped would get her directly in touch with owners of pic-
tures. In Florence she recruited Arthur Harnisch, an artist she had
known years earlier, as a scout and he took her and the Havemeyers to
a private collection. In "a large dark room," according to Louisine, they

found "many pictures, most of them as dark as the room," including a Veronese portrait of the artist's wife. Harry was not impressed, but Cassatt insisted he buy it. "In Italy they don't think her ugly," she later wrote.

Although Bernard Berenson had by then published three books on Italian Renaissance painting and lived in Florence, Cassatt seemed not yet to know his work. Later she told Louisine that Berenson "boasts he is incorruptible; I was told he took no *small* commission, but occasionally made a big haul." In rediscovering El Greco, she and other artists had given new value to his work, and she was reluctant to cede authority to professional connoisseurs or dealers: "I don't care for Berenson. He is a bit too commercial for me."

The Havemeyers endorsed Cassatt's approach. "Our collecting enabled us to penetrate into some vast estates where the dealer had not been permitted to apply his trade," boasted Louisine. The trip to Italy only confirmed the Havemeyers' doubts about the art trade. In Rome, a dealer made the mistake of showing them a "Moroni," claiming he had sneaked it out of a private collection, but they recognized the painting as the same one that another dealer had tried to sell only days before in Milan.

Following the "indefatigable Miss Cassatt," Louisine Havemeyer relished the adventure of traveling to parts of Europe that most Americans overlooked or disdained and the novelty of the "shabby third-class train that jolted along . . . with a lot of noisy passengers." She put up with "dirt, dust and discomfort" in the hunt for great works of art. To the American, such experiences in Europe gave the works of art a sense of age and authenticity, disguising the fact that age and authenticity were precisely the qualities they often lacked.

Mary Cassatt

The Cassatt family had prepared their daughter to be an expatriate when they took her to live in Europe at an early age. Mary Cassatt was born in 1844 in Allegheny City, across the river from Pittsburgh, the fourth of five children of an affluent banker, Robert Cassatt. The Cassatts lived briefly in Philadelphia, but in 1851, when Mary was seven,

they moved to Europe for seven years, stopping in London, Paris, and eventually settling in Heidelberg and then in Darmstadt so that their son Alexander could study engineering. Toward the end of their stay, another son, who was only thirteen, died, and soon after, Mary, now eleven and fluent in both German and French, returned with her family to Philadelphia.

By the time she was fifteen, Cassatt decided to become an artist—one of the few careers open to women at the end of the nineteenth century. A dry-eyed realist about her much Romanticized calling, Cassatt knew that to become a painter in the European tradition required steadfast dedication and constant work: "There are two ways for a painter," she told Louisine. "The broad and easy one and the narrow and hard one." In 1860, she became a student at the Pennsylvania Academy of the Fine Arts in Philadelphia, the leading American art school, where women made up more than 20 percent of the students.

In 1865, Cassatt moved to Paris, whose studios now drew ambitious painters from throughout the Continent as well as the United States. For two centuries, France had been Europe's foremost patron of the visual arts. Even after the Revolution toppled the monarchy and overturned the system of patronage that artists had enjoyed under the ancien régime, the new French government sought to maintain its traditional and influential role as a champion of the fine arts. In Paris, Cassatt studied with the academic painters Jean-Léon Gérôme and Thomas Couture, made copies in the Louvre, painted in the countryside, and succeeded in getting her pictures accepted for exhibition at the Paris Salon. Although in 1870, shortly after the outbreak of the Franco-Prussian War, she returned to Philadelphia, four years later she moved permanently to Paris, and her sister and parents joined her there. Within three years, Cassatt had met Edgar Degas, whose wealth and social position paralleled her own, and she looked to the groundbreaking, if difficult, artist as a mentor. "The first sight of Degas['s] pictures was the turning point in my artistic life," she later acknowledged.

Like Edgar Degas, Cassatt was a figure painter, and in 1877, he invited her to exhibit with the Impressionists. Two years later, in the fourth of their famous group exhibitions, she showed four paintings,

including *A Corner of the Loge*, whose subject was two young women in the balcony of a theater. Cassatt heightened the sense of intimacy and immediacy, with a snapshot composition, cutting off the figures with the frame and placing an upright white-gloved hand (holding opera glasses to a face) and an open Japanese fan in the center of the canvas. Visible brushstrokes weave together the foreground and a distant crowd in balconies on the other side of the theater—four bands of freely worked paint. Cassatt painted women—not only at the theater but also at home, figures who are reading, knitting, or engaged in the ritual of drinking tea. Eventually she concentrated on painting women and children. In 1891, she produced perhaps her greatest works: a series of ten color prints, each a scene with one or two women, in a pared-down style that took its cue from Japanese prints in its flat shapes, sharp contours, and compositions that ignore traditional perspective.

By escaping America, living as a foreigner in France, and remaining single, Cassatt shrewdly extracted herself from the expectations and restrictions imposed on nineteenth-century women and earned herself an extraordinary degree of freedom. Yet living with her parents in Paris, she kept the security of her place in the family and in her American social class while overseas.

Louisine Havemeyer

As Mary Cassatt blazed the trail to the new French painting, Louisine Havemeyer enthusiastically followed. She traced her passion for art to a moment in Paris in 1874 when, at the age of nineteen, she encountered Cassatt. "I felt then that Miss Cassatt was the most intelligent woman I had ever met," she wrote. The year before, Louisine's father, George Elder, had died, and soon after, her mother, Mathilda Waldron Elder, decided to take Louisine and her two other marriageable daughters, Anne and Adaline, to Paris, and enroll them in Madame Del Sartre's boarding school. Her fourteen-year-old son, George, went to school in Switzerland. The Philadelphia artist Emily Sartain also happened to be staying at the Del Sartre's, and she introduced the Elders to Mary Cassatt. Three years later, again in Paris, Cassatt took Louisine to a paint-seller's shop to show her some recent pictures by Edgar

Degas. Louisine bought a pastel entitled *Ballet Rehearsal*, becoming one of the first Americans to own one of his pictures.

The small gouache describes a scene at the edge of a stage, where a ballet master is directing a group of dancers—one of them balancing on her toes. Degas sketched in broad strokes of color, setting the white diaphanous triangles of the dancers' skirts against a scattering of tur-

Mary Cassatt, *Portrait of the Artist*, 1878. Louisine Havemeyer bought the portrait of her friend some five years after Cassatt introduced her to Impressionist painting in Paris.

quoise and green. He heightened the effect of the colors by infusing the scene with a white glow, raking up from the footlights. The ravishing image is charged with a sense of contemporary Paris. In recalling the purchase of a Degas, Louisine characteristically romanticized the event, remembering herself as younger than she was. But she rightly revealed herself an innocent abroad, fascinated by the world and the art to which Cassatt introduced her. Cassatt "left me in no doubt as to the desirability of the purchase and I bought it upon her advice." The pastel cost Louisine 500 francs, or $100. Although she fretted at spending "half my art balance," her allowance was substantial enough to afford works of art. By 1879, Louisine had also acquired a Monet canvas (*The Drawbridge*) and a gouache in the shape of a fan (*The Cabbage Gatherers*) by Camille Pissarro. Louisine also conveyed her affection and respect for her artist-friend by acquiring a small *Self-Portrait*, where Cassatt presents herself as a woman of the world, leaning against a sofa, seemingly caught unawares. She is dressed in a narrow-waisted white dress and a black hat with flowers. Her gloved hands, far from ladylike, are a burst of gray and white pigment.

To Louisine, Cassatt, who was eleven years older, seemed the most remarkable of teachers—at once passionate and authoritative, and she immediately provided a role model. Louisine listened well to Cassatt, and the painter's modernist convictions became her own. Louisine called Cassatt "my inspiration and my guide," and credited her for the "the best things" she owned, bought with the artist's "judgment and advice." For over three decades, Havemeyer and Cassatt sustained their friendship through transatlantic correspondence. Cassatt's letters— hundreds of them, addressed "dear Louie," and signed "heaps of love"—document the intensity of their friendship and its central place in both their lives.

Collecting Impressionist paintings enabled Louisine to support the work of Cassatt and her circle, but also to imitate the artist's example— by making art the calling to which she devoted herself and through which she fashioned her own identity. She approached art collecting with missionary zeal, a sense of righteous indignation toward what she saw as the benighted and outmoded taste of American private collectors and American museums. Later, when Louisine wrote an autobiography,

she titled it *Sixteen to Sixty: Memoirs of a Collector.* In it, she said little about her parents, her childhood, or her education—as though not much had happened before she met Mary Cassatt in Paris or before she married Harry Havemeyer.

What Louisine chose to skip over in the memoirs is that she had known Harry Havemeyer since childhood. Their two families were part of a sugar merchant clan linked by business and marriage. Her father, an affluent grocer, seems to have met the Havemeyers because he sold their sugar. When Louisine was two years old, her uncle J. Lawrence Elder married Harry's older sister, Mary Havemeyer. Then, in 1870, when Louisine was fifteen, Harry himself had married Louisine's twenty-three-year-old aunt Mary Louise Elder. The couple remained married for over a decade, but by 1882, they had separated. Both were living in Stamford, Connecticut, she with her parents and he in a boarding house. In October of that year they were divorced. What happened to the marriage is not clear, but ten months later, on August 22, 1883, Harry married Louisine, and they moved to a brownstone on the East Side of Manhattan, at 34 East Thirty-sixth Street.

Louisine introduced Harry to Mary Cassatt in Paris in 1889. The Havemeyers had been married for six years and had three children— Adaline, who was five, Horace, who was three, and Electra, born the year before. Louisine claimed that what she admired most about both her husband and her closest friend was their independence of mind. But she too was independent, and in bringing the American artist and the tycoon together, she forged a collecting triumvirate in which she was as influential as each of the other members. She used her role as a collector to define herself within the Havemeyer family and its sugar empire, into which she had been swept at an early age. In Louisine, Cassatt found a warm, loyal, generous, and open-minded friend. She prided herself on her frugality, which she viewed as a virtue even for someone who split her time among mansions in Manhattan and Greenwich, Connecticut, and on Long Island's South Shore, and owned a $100,000 pearl necklace.

As a collector, Louisine was competitive. She carried on a long-distance rivalry with Isabella Stewart Gardner and, following Mary Cassatt, expressed contempt for the Boston collector's grand gestures

and theatrical style, which differed so completely from her own. Early on in her memoirs, she recalls going out of her way to welcome Mrs. Gardner to her house in New York, and then was stung when Gardner did not reciprocate in Boston. "When the time arrived she ran true to Gardner form and gave some feeble excuse in order that a competitor should not see her works of art. I was very angry." Cassatt commiserated: "Of course, Mrs. Jack Gardner did not like to see the riches in your house, & her pictures must have increased in number if she has the 'best collection of Old Masters in America!'" Cassatt concluded with faint praise: "I was struck with a Cranach."

However different, Mary Cassatt, Louisine Havemeyer, and Isabella Gardner shared an advanced taste in Old Master painting that set them apart from the American tycoons who ran the country's museums and favored seventeenth-century Dutch art and eighteenth-century English portraits. The women's lack of power and position freed them to go their own way and allowed them to experiment. Like Isabella Gardner, Louisine Havemeyer had not balked at buying nudes. At Cassatt's urging, she acquired a Courbet nude, knowing Harry would not be pleased. Characteristically, he came around and eventually they owned six.

H. O. Havemeyer

By the time, Harry Havemeyer met Mary Cassatt, he was already a major Old Master collector, who famously snapped up eight Rembrandt portraits in five years and hung them together in his study in the Sixty-sixth Street house. He bought the first two Rembrandts together in December 1888 from Cottier, a New York dealer, for $60,000, and only three months later, in March, added the third—the portrait *Herman Doomer*, called *"The Gilder."* In 1884, the dealer William Schaus reportedly spent $42,000 on the picture in Paris (in addition to a $12,500 customs fee), hung it in his gallery in New York, and asked at least $60,000. "Chances to study pictures of this kind are rare enough, and the art world ought to feel grateful to the man who has risked so large a sum as must be hazarded in the purchase of a picture so costly," wrote the *New York Times*. What Havemeyer paid isn't certain but it

seems unlikely that the tycoon would have paid full price after the dealer had failed to sell the painting in New York for over four years.

Havemeyer seemed to buy his Rembrandts with the Metropolitan Museum of Art in mind, because within days of purchasing the first ones he loaned them to the museum. Already in 1888 he had given the museum a portrait of George Washington by Gilbert Stuart, which he had bought from Samuel Avery, a dealer and museum trustee. But Havemeyer's generosity earned him little respect at the Metropolitan. "I think Havemeyer is quite interested in our museum," Henry Marquand wrote the director Luigi Cesnola, "& if he gives the *Gilder* [after the Gilbert Stuart] he can keep the others to decorate his house. It will all come right. . . . I think you have done Havemeyer twice." But Harry Havemeyer was rarely "done," and he kept the *Gilder* and his other Rembrandts for himself.

Despite the Rembrandt loans and gifts to the Metropolitan (Japanese textiles, Tiffany glass, and $10,000 to keep the building open on Sundays), Havemeyer failed to break into the circle that ran the museum. According to Marquand, Samuel Colman had claimed that "Mr. Havemeyer is a hard man to *get along with*!—though very knowing." Marquand concluded, "fear he won't do." Avery thought Havemeyer would have no more interest in the Metropolitan than the museum had in him. "I doubt if H. O. H. would accept a position [on the board], he seems to shrink from all outlying associations. He is a most able businessman, has a strong character, rather positive and unyielding, of few words and rather rough in manner." Then he added with all the false modesty that his patrician condescension could muster, "I think he would lose patience with our slow and often unbusinesslike way of doing things in our board." Later, in 1903, and again in 1904, the trustees nominated Havemeyer to their board, but failed to elect him.

To the Metropolitan's rebuffs, Havemeyer characteristically responded by assembling an array of Rembrandts in a private house more spectacular than those at the museum. If Rembrandt was the measure of art and taste, and in New York of 1890 it was, Havemeyer proved that he could do better than the museum's entire board. "I am quite sure that no other person owns eight examples of the works of Rembrandt as beautiful as the eight Rembrandts which are in one room of

Mr. H. O. Havemeyer's house in Fifth Avenue," Wilhelm von Bode told the *New York Times.*

Harry Havemeyer's rise to a dominant position in the sugar refining trade began within his own family. His victory over his older brother in the line of succession was the first of many he would savor in the constant survival-of-the-fittest struggle required to turn the family firm into an empire and then to manage and manipulate the sugar refining monopoly in the United States.

Born in 1847, Harry Havemeyer was the eighth child of Frederick Christian Havemeyer, who with his cousin had inherited their fathers' "sugar house" in lower Manhattan, then expanded the firm, and across the East River, in Brooklyn, constructed a refinery that was the largest in the United States. There, ships delivered casks of raw sugar and barges pulled by tugs picked up the refined.

Harry grew up in a large brownstone but his childhood was anything but smooth. When he was four, his mother died, and within a year a younger brother was also dead. Although Frederick Havemeyer, who had attended Columbia University for two years, could afford to send his five surviving sons to college, he apprenticed four—George, Theodore, Thomas, and Harry—in the sugar firm so they would learn the competitive trade from the ground up. Despite its sweet scent, the Brooklyn refinery was a dangerous place, and in 1861, twenty-four-year-old George was killed in a machinery accident. At that point, Frederick made Theodore and his son-in-law Lawrence Elder partners in the firm, and changed its name to Havemeyers & Elder. The following year, at age fifteen, Harry went to work on the floor of the Brooklyn factory. There was "no part [of the business] we considered too dirty or too arduous or beneath us," Theodore later claimed. In 1869, Harry moved to the firm's headquarters, at 98 Wall Street, where he learned financing and merchandising. Eventually, he took over that aspect of the business, while Theodore ran the refinery; at twenty-two, Harry too became a Havemeyers & Elder partner.

By the early 1880s, a stampede of new entrants into sugar refining intensified competition on the East Coast, slashing profits even for the

most efficient firms, and forcing the inefficient to operate at a loss or to go out of business. So confident were the Havemeyers of their dominating position in the industry that in 1882 when a fire destroyed their Brooklyn plant, they spent $7 million to construct a sixteen-acre, state-of-the-art refinery, which produced three million pounds of sugar a day, "cheaper," as Theodore Havemeyer put it, "than anyone else."

Three years later, Harry insisted that his father put him in charge of the firm and threatened to leave if he failed to get his way. Although Theodore objected, Frederick Havemeyer acquiesced to the demands of his younger son. Frederick's response to Theodore suggests that Harry had inherited his gruff forthrightness from his father: "Get it down as a *fact*, that Harry is King of the sugar market," Frederick wrote."

Harry Havemeyer's next steps confirmed his father's assessment to be correct. He gained his grip on the sugar industry because his family controlled 55 percent of the country's capacity, and by the sheer force of his recalcitrance and hard work. Havemeyer's personality riled even other participants in the Sugar Trust. One Boston refiner hesitated to join because "he considered him [Havemeyer] a brute." Secretive about the operation of the trust, Havemeyer kept information from other stockholders. When trust officials were testifying before a congressional committee, the *New York Tribune* reported that "Nobody has seemed to know anything whatever about the trust's business, although the witnesses have included those most largely interested." If the trust's board kept records of its meetings before 1891, they don't survive. Early on, Havemeyer was disarmingly direct about the Sugar Trust's purpose. When asked by a member of the Ways and Means Committee, if "when you sell in this country you control the price?" he answered "Yes, Sir." In another response, he called price control the trust's "principal object." In 1890, when the McKinley Tariff Act eliminated import duties on the raw sugar purchased by American refineries, the profits of the Sugar Trust (with 80 percent of the refining capacity) soared to $28 million.

Maintaining that level of success, Havemeyer fought off not only competitors but government regulators, who kept the trust under con-

stant attack. In 1890, responding to the unprecedented power of the "trusts," the United States Congress passed the Sherman Anti-Trust Act. It ruled that "every contract, combination in the form of trust or otherwise, or conspiracy in restraining of trade or commerce among the several states, or with foreign nations" was illegal. When that same year New York State found the Sugar Trust in violation of its corporate laws, Havemeyer reincorporated in New Jersey. Asked about the new company, Havemeyer snapped: "Well, from being illegal as we were, we are now legal as we are; change enough, isn't it?". Harry, now forty-four, officially took over from Theodore as President and Chief Executive of the blandly named American Sugar Refineries Company and paid himself a salary of $100,000. Two years later, when the Justice Department charged American Sugar with violating the Sherman Act, the case (*U.S. vs. E. C. Knight*) went to the Supreme Court. To defend the Sugar Trust, Havemeyer hired John G. Johnson, the Philadelphia attorney and art collector. In a landmark ruling, the Supreme Court dismissed the suit in January 1895, finding that sugar refining involved manufacturing and not interstate commerce, and that whether the Sugar Trust restrained trade was an issue not for the federal government but for the states. A near-lethal blow to the Justice Department's attempts to enforce the anti-trust act, the Court's decision was a victory for Havemeyer.

But Havemeyer endured the most brutal battles in the marketplace. Two years after the Sugar Trust was formed, Claus Spreckels, a San Francisco refiner, threatened the monopoly by building a Philadelphia plant that refined three thousand barrels of sugar a day. In response, Harry and Theodore Havemeyer and a third partner bought 45 percent of Spreckels's firm, and then sold it to the trust, which bought out the rest. The Havemeyers made $1.1 million on the deal. Harry waged a far costlier war against John Arbuckle, a Toledo coffee roaster, who developed a machine that filled a paper bag with coffee, sealed it and labeled it, and who then began to package sugar and to construct his own refinery. Havemeyer retaliated by buying a coffee-roasting plant in Toledo and slashing the price of coffee. Arbuckle parried, driving the margin between raw and refined sugar to an all-time low. "There was only one way to get along with Mr. Havemeyer, and that was to be

just as arbitrary as he was and not give way," Arbuckle argued. One newspaper cartoon showed the plump tycoons standing on barrels heaving packages of coffee at each other. After hemorrhaging millions, Havemeyer and Arbuckle agreed in early 1901 to call off the fight and to cooperate. The resolution of the three-year Arbuckle war allowed Havemeyer the freedom to travel, and only weeks later, on January 30, 1901, he and Louisine set sail for Italy.

"Why Buy a Monk When You [Can] Have a Cardinal?"

After their excursion to the south of Spain, the Havemeyers returned to Madrid, where Mary Cassatt had remained. In their absence Cassatt had enlisted an unlikely and amateur agent, Joseph Wicht, to seek out Old Masters; he spoke English, and was a godson of an "intimate" of an Infanta (a Princess)—a connection Cassatt assumed would lead her to members of the Spanish nobility. Wicht took the Havemeyers to see a Velázquez portrait in the Duchess of Villahermosa's collection, but they "did not admire it sufficiently to buy it." From a dealer they acquired (for $4,000) a painting by the Flemish artist Joachim Patinir. But the canvas was "too primitive and the whole transaction scarcely big enough to interest deeply Mr. Havemeyer," Louisine observed. Searching for Old Masters, she and Cassatt found a small El Greco, *Christ Carrying the Cross*, and for some $250 Louisine bought it. Harry didn't like it and said so. (Later, scholars recognized the small "El Greco" as a copy.)

Before sailing for New York, the Havemeyers stopped in Paris and expanded their modern French holdings with canvases by Millet, Corot, Manet, Degas, Cassatt, and their first three Cézannes. Although Louisine Havemeyer later reminisced in her memoirs about the romance and adventure of their European trip, Harry Havemeyer probably recalled it with more frustration. After three months, he returned to New York with only two Old Masters—the small El Greco and the Patinir; Veronese's homely "wife," which he had reluctantly agreed to swallow, arrived sometime later. Back in Paris, Cassatt quickly grew discontent with Joseph Wicht's progress in Madrid. "I must explain

why I said I thought it would be better to see about the pictures before September," she wrote Louisine on June 16.

> All the pictures Wicht spoke about are in private collections where they had been probably for generations, & the suggestion was made either by Wicht or some one for him that the owners should sell. Now *he* thinks that any time will do. My opinion is in the contrary, that if you shake the tree you ought to be around when the fruit falls to pick it up; in other words now that the idea of selling has been put into their heads, if some one else offers to buy they will let the things go.

That June Cassatt returned to Spain, and through Wicht she purchased a Goya portrait of the Duke of Wellington. "Wellington is yours at 17,975 francs [some $3,600]," she wrote Harry triumphantly: "As you left it to my discretion I bought it on the principal I have always seen you follow of getting a fine thing when it comes in your way. The picture is full of character & fire. I hope it will please you . . . I am ready to be off again if any other prize is in view. . . . Perhaps Louie & I will get you the Prado if you only give us time, & even if I have to take more journeys with disappointments."

Soon after, Louisine asked Mary Cassatt if she would recommend that the Havemeyers try to acquire the *Cardinal*, the El Greco portrait that Manuel Cossio had discovered in the Oñate palace. Cassatt's reply on August 30 was characteristically frank: "As to the Cardinal, I would not dare to advise buying the picture, until I had seen it myself," and she reminded Louisine of the risks. "This summer or rather spring, . . . D. R. [Durand-Ruel] wrote me an enthusiastic note, to hurry down & see the head of the Cardinal, a splendid Greco!" she explained. "*Palpably* a copy & a poor one; & when I turned it down, the owner went off to [the critic and dealer Theodore] Duret & he came hurrying to tell me what a find!" Perhaps recalling that Cossio had described the *Cardinal* as one of El Greco's two masterpieces, Cassatt suddenly changed her mind; the *Cardinal* "*must be* a fine picture & it is so unique. You ought to have it, nothing of such a rare artist of that quality exists in a private

gallery." Presumably at this point Cassatt sent word to Joseph Wicht to take the steps necessary to secure the *Cardinal* for the Havemeyers.

But after a year, Wicht had made no progress in negotiating the El Greco's purchase. That spring of 1902, the Prado was presenting a retrospective of El Greco, with sixty-one paintings, including many on loan from private collections. Presumably not wanting to miss the Prado exhibition, Paul Durand-Ruel decided to go to Spain, and on June 16, he telegraphed Harry Havemeyer: LEAVE FOR MADRID WEDNESDAY CAN I DO ANYTHING FOR YOU.

Paul Durand-Ruel was seventy-one years old, a grandfatherly gentleman, a monarchist, a devout Catholic, and a pioneering dealer, who in the 1870s had been the first to support the controversial art of the Impressionists. For two decades, he and Mary Cassatt had worked together. He exhibited and sold her pictures and she served as an intermediary with the Havemeyers and other Americans, advocating paintings he represented. But they had a somewhat stormy relationship, as Cassatt periodically felt the dealer did not promote her work as she wanted him to. "She has a lot of influence and Durand, who suspects that she is irritated with him, is trying to calm her down with promises and offers which he does not make good," Camille Pissarro wrote his son Lucien. In introducing the Havemeyers, Cassatt had delivered some of the French dealer's most important clients. From Durand-Ruel, the Havemeyers had already purchased dozens of modern French paintings but also five of their Rembrandt portraits. (Between 1890 and 1908, the Paris gallery stocked over 550 Old Master pictures.) Eventually, over forty percent of the Havemeyers collection would come from Durand-Ruel. The dealer's support of the French avant-garde and his relationship to Cassatt more than convinced the Havemeyers that he stood apart from the rest of the trade.

Although Durand-Ruel purposefully presented himself as a disinterested lover of art, he had also proved a skillful speculator, who in the 1860s profited from a near monopoly in Barbizon paintings and the following decade recognized the Impressionists as an opportunity. He purchased his first canvas from Claude Monet in 1871 and within two years he had spent 70,000 francs on Impressionist pictures. In 1876, the group held its second exhibition in Durand-Ruel's gallery. Gradually, the dealer changed the marketing of modern art, by shifting attention

Paul Durand-Ruel, the Impressionists' first dealer, in his Paris gallery around 1910.

away from particular canvases to the entire span of an artist's work. He also pioneered one-man exhibitions (for Monet, Pissarro, Sisley, and also Cassatt) and expanded the audience for the Impressionists by publishing illustrated catalogs and periodicals that extolled and explained their pictures. To her brother Alexander, Cassatt explained Durand-Ruel's rationale for the 1886 exhibition of French paintings he held in New York. "Affairs here [in Paris] he complains are at a standstill & he hopes to have better luck in America." In May, Durand-Ruel moved the show from its original location to the National Academy of Design, and added twenty-one pictures, including two Cassatts from Alexander's collection. "The exhibition was successful. . . . The public and all the collectors did not come to laugh, but to see for themselves the notorious paintings that had created such a stir in Paris," Durand-Ruel wrote. He reiterated: "Do not think that Americans are savages. On the contrary they are less ignorant, less close-minded than our French collectors." The United States would prove the most important market

for modern French pictures. At the 1886 New York exhibition, Havemeyer bought a small still life by Manet, entitled the *Salmon*, for 15,000 francs, or $3,000. Two years later, Durand-Ruel opened a branch in New York and delegated his sons Joseph and Charles to run the gallery, which, in 1894, moved to a brownstone at 389 Fifth Avenue owned by Harry Havemeyer.

Durand-Ruel's voyage to Spain proved well worth the effort. At the Prado, among the dozens of El Grecos, he found the *Portrait of a Cardinal*, loaned by the Count of Paredes de Nava from the Oñate palace and for the first time on public display. "It is a beautiful thing—something for a museum," the dealer wrote. Indeed, the canvas is over five and a half feet in height, and the cardinal himself is a towering figure, tall and thin, seated in a throne-like chair. He is dressed in ecclesiastical vestments—a loosely brushed expanse of cranberry, pink, and maroon, laced with white highlights—falling to the floor. His body fills most of the canvas, the folds of his watered silk robes spreading out beyond his chair on either side, almost to the frame, and a red cap standing on his head coming within inches of the top. El Greco exploited the expanses of billowing fabric to convey magnificence and power, animating the crimson surface of paint with strokes of white, crisscrossing, zigzagging, and running in vertical rivulets, echoing a vertical line of buttons.

Although possessing the attributes of a formal portrait, the picture is highly unusual, not a flattering description of the appearance of a powerful prelate, but a complex and penetrating study of character, and difficult to read. The cardinal is an older man with a neat, graying beard, a high narrow forehead, and nearly-black eyes circled by round black glasses, which strike a strangely modern note in an official likeness three hundred years old. On two fingers of each of his gray and pale elongated hands, he wears jeweled rings, and his left hand curves to grip the arm of the chair. Instead of looking straight out at the artist, he glares through the spectacles, off to his left as though his mind was elsewhere, perhaps on the contents of a piece of paper he seems to have dropped on the floor in front of his chair, at the lower edge of the painting. Across the paper El Greco had signed his name in Greek letters: Domenikos Theotokopoulos. The white paper is deli-

cately rendered to show creases left where it had been folded twice, and it lies on a black circle, which is part of a pattern of tiles composing a marble floor.

Although the cardinal is seated perfectly still, a sense of disquiet emitted by the stare boring out of the dark eyes through the black glasses is amplified in various ways throughout the canvas, most conspicuously in the turbulence of the crimson robes. Behind him is a wall, but the background is oddly asymmetrical, split between a bright surface of gold brocade on the right and wooden paneling on the left, the two sides divided by a vertical column of dark green. El Greco also played with the rules of linear perspective, distorting the geometry of the tiled floor and the background wall, making it difficult to determine exactly how the sitter fits into the actual space of the room. In addition to spatial distortions, visible brushstrokes, and strident colors (crimson against dark, patterned yellow), what seems modern about the religious portrait is the way the artist employed the paint not to describe the exact look and texture of fabric, flesh, wood, or marble, but for expressive purpose. Strokes of beige, white, and gray model the contours of the cardinal's long narrow face; vertical lines of black and white, his beard. The seriousness of his expression emerges in a line of dark pigment that separates his lips and in gray shadows around his eyes. Manuel Cossio had identified the subject of the *Cardinal* as Don Fernando Niño de Guevara, archbishop of Seville, a notoriously unyielding Inquisitor General, and for most of the twentieth century art historians saw the portrait as the personification of the ruthless Spanish Inquisition. And yet in the 1980s, two scholars argued that the subject was not Niño de Guevara, but his successor, the more moderate intellectual, Bernardo de Sandoval y Rojas. What in the countenance had been read as anger, and thoughts of condemnation and retribution, might simply reflect a troubled, unsettled situation or state. Later Durand-Ruel told Mary Cassatt that the "Cardinal was *by far* the finest thing of Greco's there [in the exhibition in Madrid]."

By July 1, the dealer was back in Paris. That day he saw Cassatt. They discussed the *Cardinal* and questioned whether the Havemeyers would want to own the large religious portrait: "It is too big for an individual," Durand-Ruel wrote Joseph Wicht. "Miss Cassatt whom I

have seen yesterday on my return is convinced that the painting would not work for Mr. Havemeyer because of its large size." Nevertheless, Durand-Ruel asked Wicht to find out the *Cardinal*'s price.

If Havemeyer heard the dealer's reservations, he ignored them. By now, he had lost all patience with Cassatt's failure to obtain Spanish pictures, and on July 1, he fired off a brief note to her, politely asking her to turn the *Cardinal*'s purchase over to Durand-Ruel. He undoubtedly knew the request would come as a blow to Cassatt, who had emphasized that the dealer lacked her knowledge of Old Masters. Harry's excuse was that he was following his wife's desires: "Louie's wish is that the purchase of the Greco be entrusted to Mr. Durand-Ruel." Nevertheless, Havemeyer kept Cassatt involved, asking that she cable him the *Cardinal*'s price so he could telegraph Durand-Ruel "whether to buy or not."

Now charged with acquiring the *Cardinal*, the Paris dealer immediately sent off a letter to Ricardo de Madrazo, a well-connected painter and dealer in Madrid, whose father and grandfather had served as court painters to the Spanish king and as directors of the Prado. Within days Durand-Ruel also wrote Havemeyer, emphasizing that the *Cardinal* was the finest picture in the El Greco exhibition and confirming that the collector in fact wanted it. "It is a beautifully drawn work and one of very beautiful color, but it is very large: 1 meter 94 by 1 meter 30." Also he stated that officially the painting was not on the market.

Durand-Ruel's enthusiasm also fired Cassatt, who still worried that dealers would take advantage of her American friends and who wanted them to "possess the Cardinal at a reasonable price." After Joseph Wicht was killed in a hunting accident in 1902, she turned to his widow, whom she dubbed with the code name "Pepita." Cassatt had emphasized to her new agent "the necessity of secrecy as regarded the name of the would be buyer, for if the count suspected Mr. Havemeyer of wishing to buy the picture he would create all the difficulties possible"—that is, demand the sugar tycoon pay a high sum. She meanwhile encouraged Louisine not to lose hope. "It would be rather a triumph to posses a really fine Greco, for with all their crowing none of them, not [Degas's friend] Manzi more than the others has a really

good specimen of that artist. I imagine this [the *Cardinal*] is the finest thing outside the Public Galleries in Spain. . . . My head is set on your having that picture for the new gallery."

On Christmas night 1902, Cassatt reported that she had instructed "Pepita" to attend to the four things: the *Majas on a Balcony*, two other Goyas, and El Greco's *Cardinal*, for which she wanted her agent to offer $10,000. How she arrived at that figure she didn't explain. She had few benchmarks to use as no major El Grecos had recently sold. Still, Cassatt's price was only one third the cost of Havemeyer's cheapest Rembrandt, and less than what he had paid for Manet's *Boating*, which was not even twenty-five years old. If Cassatt's $10,000 bid was delivered, the Count of Paredes de Nava rejected it. Cassatt placed the blame on snobbery. "On *no account* will the owner of the Greco sell to a stranger (or rather I fancy to us)," she wrote Louisine on January 5, 1903. In fact, the count thought Cassatt's offer too low.

By now Durand-Ruel had a second El Greco in mind—*Assumption of the Virgin*, once the centerpiece of the high altar of Toledo's Santo Domingo el Antiguo but recently on display in the Prado exhibition. The thirteen-foot canvas had impressed the French dealer. In it, life-sized figures crowd around an empty tomb and gesture up at the Virgin—in flowing robes of red and blue—standing on a half moon, her arms outstretched across the sky, almost to the frame. "Durand-Ruel pere is in Madrid," Cassatt wrote Louisine, and he had concluded that the *Assumption* was "a better picture to buy than the *Cardinal*!" No doubt the dealer's enthusiasm for the large religious painting sprang in part from his knowledge that it was on the market. Cassatt questioned his change of heart. "Still I would prefer the Cardinal. I asked DR if it was very characteristic of Greco, & he said *yes* especially the *head, but* it is a large picture." Four days later, she pressed the Havemeyers not to compromise, reminding Louisine that when the dealer had seen both El Grecos at the Prado exhibition, he "then preferred the Cardinal. No let us stick to the Cardinal, if we can get it."

At least Durand-Ruel's trip to Spain produced one picture for the Havemeyers—a Goya portrait, *Doña Narcisa Barañana de Goicoechea*. That July, Harry again asked the dealer to rely less on Cassatt. "She very kindly advises Mrs. Havemeyer and myself in reference to art

matters, but the price between us is never mentioned, except as a matter of interest; therefore, she can be entirely eliminated as a medium of conveying to us the price of pictures." . He also requested that Durand-Ruel be more straightforward: "A simple cable, or letter, from yourself recommending a picture and classifying it, as you know there are so many different classes of pictures, would have more influence than the voluminous correspondence that has been carried on between us."

Nine months later, Durand-Ruel reassured Havemeyer that he hadn't abandoned Spain: "I have always my attention on the beautiful pictures by Goya or by El Greco that I have seen in Spain, but the greatest difficulty is to bring their owners to admit that they want to sell and to decide to give a price. They ask me to make an offer and warn me that it is necessary to make them very high to have a chance to succeed; it is difficult and dangerous."

Now, Cassatt gave up on the *Cardinal* ("truly too expensive") and told Louisine that instead she should buy the *Assumption*, which the Prado's exhibition catalog had named as one of El Greco's "*three* masterpieces." But, the Havemeyers didn't want El Greco's altarpiece; it was simply too big for their house.

Meanwhile, in Paris the dealer Eugene Glaenzer, was selling El Greco's "*Saint Ferdinand.*" "Is it authentic? And what price does Glaenzer ask?" Cassatt inquired of Durand-Ruel. Then she dismissed it: "Outside of Spain there are none of beauty." Cassatt's views notwithstanding, Glaenzer succeeded in selling the El Greco to the Louvre. Manuel Cossio had recognized the subject as the medieval king Saint Louis of France, and thus of historical interest to the French national museum. El Greco had secured a place in the world's most prestigious collection, and the prices of his paintings would only rise.

Within weeks, Harry Havemeyer asked Durand-Ruel to approach the Count of Paredes de Nava and this time to offer 100,000 francs ($20,000), for the *Cardinal*. On December 29, 1903, Durand-Ruel informed Cassatt that the count "not only refused this offer, but declared he didn't want to sell at all."

At this point, Durand-Ruel suggested yet a third El Greco from the 1902 Prado exhibition—*Fray Hortensio Félix Paravicino*, a painting of

a friar and poet with short black hair and dark eyes. Although the artist clad the friar in church vestments and posed him in a high-backed chair, he created a reserved yet intimate portrait that was radically different in mood from the *Cardinal*. The friar holds two books in his left hand, and he seems to gaze both at the viewer and off to the left, as though lost in thought. El Greco narrowed his palette, setting black and white against a background of dark brown and giving potency to the red of the friar's lips and of the cross emblazoned on his robe. The inexact technique, the sketching in paint, breathes life into the serious face and robed body of the artist's philosophical and melancholy friend.

"This painting is superb and absolutely the same quality as the Cardinal," Durand-Ruel told Cassatt. He also sent a photograph of the painting to his son Joseph at the gallery in New York to show the Havemeyers. But the price was high: 200,000 pesetas or $40,000. "The painting is most remarkable and I will do my utmost to buy it," the Paris dealer told his agent Ricardo Madrazo on January 9. Durand-Ruel was not the only one who had expressed interest in the picture. The summer before, Madrazo had shown John Singer Sargent the stunning *Fray Hortensio Félix Paravicino*. Now, in February 1904, Sargent raved to Edward Robinson, the director of the Museum of Fine Arts in Boston, about the El Greco, calling it "most beautiful," and "one of the best El Greco's I ever saw." Sargent observed "there seems to be a considerable awakening of interest in El Greco's pictures." Madrazo told Sargent the painting's price was £4,000, or $20,000, half of what he quoted to Durand-Ruel. That "the Louvre has lately bought two may account for the big price," Sargent wrote.

Judging only from a black-and-white photograph, Harry Havemeyer declined to purchase the painting. According to Louisine, he thought it a poor substitute for the El Greco he really wanted: "Why buy a monk when you [can] have a cardinal?"

When later that spring Edward Robinson himself saw the friar's portrait in Madrid, he authorized Sargent to purchase it, thinking that an artist would be able to negotiate a cheaper price than a museum director. Within weeks Sargent acquired *Fray Hortensio Félix Paravicino* for only $17,000. The news exasperated Paul Durand-Ruel, who later passed it along to Havemeyer ("Perhaps you may regret not having

bought it") to prove that in calling the El Greco "superb," he hadn't exaggerated and to spur Havemeyer to buy the *Assumption*. Although the dealer acknowledged that the size of the altarpiece was "an insurmountable obstacle" for Havemeyer, he reminded his client that the "painting is a masterpiece and that Cassatt hoped to see you [Havemeyer] purchase [it] for an American museum." Ignoring the dealer, Havemeyer wrote on April 11, asking him to "cable us the price of the Cardinal by Greco."

Soon after, on April 22, Durand-Ruel wired the Count of Paredes de Nava, who was in Rome, and offered him 150,000 francs for the *Cardinal*. The response came back that the count would now refuse even 200,000 francs. But within days, he cabled a price: 225,000 francs—$45,000, or more than twice what Boston had paid. "The Count de Nava would be, at this moment, disposed to give up his painting," Durand-Ruel wrote Havemeyer, "but he might change his opinion and I believe it is necessary to move fast." The price is high, the dealer acknowledged, but "really beautiful works by El Greco are very rare." On May 6, Harry replied by cable: "BUY GRECO 225."

On May 10, Durand-Ruel responded. Madrazo would "inform by telegram the Count of Paredes de Nava, who is in Italy, that I have agreed to buy his portrait of the Cardinal at his price." By May 20, Durand-Ruel had received the 225,000 francs from Havemeyer and sent them on to Madrid. Havemeyer complained about the sum he had agreed to pay. "It seems to me that the mistake is made of an offer on these pictures at the full value one is willing to give. It is always desirable to bring a man to declare the lowest price which he will take, and if within the limit, then buy the picture, as otherwise they merely use the offer as a basis of dealing with somebody else to get a higher price."

If the Havemeyers' advanced taste inspired their quest for El Greco, the purchase of the *Cardinal* depended also upon their tenacity and Harry's recruiting of Durand-Ruel to confirm the painting was a masterpiece and worth the sum its owner was demanding. The silent member of the pioneering group who sent the *Cardinal* to America was Manuel Cossio, whose 1908 biography and catalog would remain an important source on El Greco for the next century.

At the count's request Madrazo painted a copy of the *Cardinal*, which took him about two weeks. By May 31, the original arrived at Durand-Ruel in Paris and the dealer kept it until October. "It is the most beautiful Greco to have left Spain," Cassatt told the critic Theodore Duret. Exactly as she feared, art dealers now jumped into the market.

"You are quite right, the Greco boom has come," Eugene Glaenzer declared to Bernard Berenson, on May 31, 1904. "I started it last year with the Louvre picture & now no self-respecting museum can afford to be without one." Glaenzer, who had a branch of his gallery in New York, had purchased an El Greco, *Adoration of the Shepherds*, and he had ambitions to sell it to the Metropolitan Museum of Art. Berenson had tipped off Glaenzer that *Adoration* was coming up at auction, and in return the dealer promised the connoisseur 25 percent of the profits if he assisted in the sale to the New York museum. Painted in El Greco's most mannered style, with its weightless figures, flickering light, and contracted space, *Adoration* resembled the canvas the artist had made as an altarpiece for his own tomb. "Ours is fortunately one better than any on the market or any that will come on the market," Glaenzer boasted to Berenson. "It is my intention to play this card for all it is worth. . . . The purchase of a Greco by the Boston museum will help us tremendously as a great rivalry exists between museums." The dealer, who had paid $7,500 for the canvas, planned to ask $40,000.

To convince the Metropolitan to take the El Greco, Glaenzer arranged to have Berenson at his Paris gallery on July 27, when the museum's president Frederick Rhinelander came to see the painting. "They seem to have been very much impressed by it [the El Greco], & I trust they paid some attention to my statement that they should have a Greco," Berenson told Isabella Gardner, "and that if ever they were going to have one, Glaenzer's was the one to have. But, I doubt whether the picture spoke to them, whether the form of art is one they really approve." As Rhinelander hadn't decided to buy the El Greco, Berenson tried to sell it to Gardner, and in early August Glaenzer agreed to hold it for her until August 15. But, she refused it, telling Berenson the $40,000 price was "preposterous."

Meanwhile, Louisine Havemeyer tried to persuade the Metropolitan to acquire El Greco's thirteen-foot *Assumption of the Virgin*. In July, she told Samuel Avery that the painting was on the market in Madrid for only $17,000. Avery explained that the museum trustees were already negotiating for an El Greco. Then, in September, Frederick Rhinelander suddenly died, and two months later, the trustees elected J. Pierpont Morgan to succeed him as the Metropolitan's president. ("I hope that now that Mr. Pierpont Morgan is Director of the Metropolitan Museum in New York that some truly fine paintings will be acquired," Cassatt told Théodore Duret.) In October, Durand-Ruel (with a loan from Havemeyer) had bought *Assumption of the Virgin*, and by December he had written to Morgan. In March, when the banker was in Paris, the dealer showed him the picture and reported to Cassatt that Morgan "found it superb" and would "cable New York to advise the museum to buy it for 250,000 francs."

But the Metropolitan continued to pursue the other El Greco. In January, William Laffan, a Metropolitan trustee and Morgan confidant, had telephoned Eugene Glaenzer from the banker's house and asked him point blank "what interest has Berenson in the sale of this picture [*Adoration*.]" The dealer denied knowing that Berenson had any interest in the El Greco but later admitted to the connoisseur he felt uncomfortable not being forthright with the museum trustee. In the end, the Metropolitan's board decided to purchase Glaenzer's picture. If Berenson's scheming earned him a fee, it also seems to have removed his chance to work for the Metropolitan and ruined his reputation with Morgan.

Cassatt now turned her attention to selling *Assumption of the Virgin* to another American museum and in January 1905, she approached Charles L. Hutchinson, the president of Chicago's Art Institute: "It is a *great* museum picture," she wrote. "I doubt if such another is for sale in Europe—It is in perfect condition and untouched." On July 17, 1906, the Art Institute's trustees approved the El Greco's purchase, but only barely, by a vote of seven to six. Rightly, Cassatt credited herself and the Havemeyers for the presence of the "magnificent Assumption of the youthful Greco" in Chicago. "Did we not work hard to get it to America?" Cassatt wrote Louisine. "It never would have gone there if it had not been for Mr. Havemeyer."

The El Greco boom continued. Two more canvases—*St. Jerome as a Cardinal* and *Gentleman of the House of Leiva*—arrived in Paris from Spain, purchased from the Cathedral of Valladolid for only 25,000 pesetas ($5,000) by a Madrid dealer. The following year, Durand-Ruel began negotiating for two Toledo altarpieces—*Saint Martin and the Beggar* and *Madonna and Child with Saint Martina and Saint Agnes*—but they went to a rival Paris gallery. Then, in June 1907, Durand-Ruel bought a second canvas from the Oñate palace—one of El Greco's two landscapes—*View of Toledo*. Although he sent the Havemeyers a photograph, they declined the painting.

Three months later, agents from the Department of the Treasury walked onto the docks of Havemeyers & Elder's Brooklyn refinery and in the course of their inspection discovered that the scales used to weigh raw sugar and determine import duties had been tampered with. A week later, the sixty-year-old Harry Havemeyer became ill, and on December 4, he died.

For over a year after Havemeyer's death, Louisine showed little appetite for pictures. But early in 1909, she and her daughter Electra sailed for Italy and Spain. Again in Madrid, she went looking for El Grecos, making a pilgrimage to a church in the town of Illescas to see *Saint Ildefonso*. Ricardo Madrazo tried to negotiate the picture's purchase, but, as he explained, the government was enacting laws to "prevent objects of art from leaving Spain." When Louisine returned to Paris, Durand-Ruel showed her El Greco's *View of Toledo*. One of the first landscapes ever painted in Europe, it would remain one of the most unusual. El Greco described Toledo as a cluster of grey Gothic buildings on a distant hill. A line of jagged structures climbs up to the city, where the cathedral and the palace (the Alcazar) are silhouetted against a dark sky. While across a lush foreground landscape loose strokes of green suggest tall grass and trees, the night sky exploding with lightning dictates the character of the painting; the threat to the spindly far-off city suggests the fragility of even the grandest human effort before a possibly vengeful god.

The painting reminded Louisine of Toledo as she remembered it in 1901. "The city is perched high in the clouds and is painted like a

miniature," she wrote. The art historian Kenneth Clark saw the canvas as "an exception to all rules, far removed from the spirit of Mediterranean art and from the rest of seventeenth-century landscape painting. It has more the character of nineteenth-century romanticism, though Turner is less morbid, and van Gogh less full of artifice." On April 29, 1909, Louisine Havemeyer acquired the landscape for 70,000 francs ($14,000), securing a second El Greco masterpiece.

"A Picture for a Big Price"

Henry Clay Frick, Charles Carstairs, Otto Gutekunst,
and the Ilchester Rembrandt

On June 6, 1899, Henry Clay Frick and his family sailed from New York for France. At fifty, Frick was chairman of Carnegie Steel Company and one of America's towering industrialists. He had several reasons to make the trip and hoped to mix work and pleasure, planning to travel and to visit galleries in Paris and London. Over the past five years, the Pittsburgh tycoon had become the city's most voracious collector; he owned some seventy, mostly nineteenth-century canvases, including a fine array of Barbizon landscapes—lush, melancholy images of the countryside outside of Paris, with its fields, gigantic trees, and moody skies. The year before, Frick had bought several eighteenth-century English portraits and began to shift his attention away from the Barbizon school. Now he had reason to think of acquiring a Rembrandt. Recently, at the New York gallery of the London dealer Arthur Tooth & Sons, he had seen a canvas entitled *Portrait of a Young Artist*, a dark, three-quarter-length image of a man in a black cloak and tall, wide-brimmed hat. The figure was set into a dark weave of browns, blacks, and grays, and of shadow and light. A beam illuminated the man's face and hands and sparkled on the brass buttons of his doublet. In the upper right corner, the picture was signed "Rembrandt 1647."

The *Portrait of a Young Artist* happened to be the same Rembrandt that Bernard Berenson had recommended to Isabella Stewart Gardner three years before, and she had turned down. Ever since, Otto Gutekunst

had been quietly trying to dispose of the canvas, which had appeared in the 1898 Rembrandt retrospective, at the Stedelijk (State) Museum in Amsterdam. Wanting to tap the American market, Gutekunst at some point turned the Rembrandt over to Arthur Tooth to sell.

The seventeenth-century Rembrandt was older and more serious than anything Frick yet owned—and, at $38,000, more expensive. At that moment, Rembrandt portraits were among the most coveted works of art in Europe and America—unsurpassed symbols of wealth and arrival. Only months before, Alexander Byers, a leading Pittsburgh collector, had acquired one, introducing the Dutch artist's work to the city. The competitive Frick wanted to keep up; he knew that a Rembrandt would launch him as a collector of Old Masters and into an altogether new league.

But in June 1899, Frick, who was known as "Clay," had much on his mind besides art. Frick was a strong-willed, unbending, complex individualist, who had come to a pivotal point in his career as a partner of Andrew Carnegie. Frick had made his first fortune by the age of thirty in the manufacture of "coke," or "coal cake," which was burned with ore to produce iron, and fired with iron to make steel. By 1887, Frick had sold his coke company to Carnegie. Gregarious and charismatic, Carnegie was internationally famous not only for his talents as a businessman, but also for his philanthropies and popular writings, in which he championed the rights of workers and contended that "the man who dies thus rich dies disgraced." Wanting to step back from the day-to-day operations of Carnegie Steel, Carnegie tapped Frick to run the firm. As partners in steel, Frick and Carnegie had proved an invincible team, investing in the most technologically advanced equipment, slashing production costs, and successfully pressing their mills to make them the most profitable in the United States at a time when steel was catapulting the nation into the forefront of the world's industrial powers.

As a young man, Frick was thin and handsome, with dark hair and large gray eyes rimmed with white below the pupil, which as a child gave him a look of weary innocence and later a steady gaze. A photograph taken when Frick was around thirty shows him determined, moody, and restless, in a dark rumpled suit, leaning against a brick

Henry Clay Frick, ca. 1880, age thirty-one. Already the Pittsburgh tycoon had earned the nickname "King of Coke."

wall, his arms crossed, glaring at the camera, not unaware of the worldly figure he cut with a drooping mustache, a bowler hat, and

heavy gold watch chain strung across his vest. At fifty, he had grown more solid and his neatly trimmed brown beard was turning white. His appearance was deliberately crisp and polished. He wore well-made dark suits, stiff collars, and always, a gold watch chain. He was among the best looking of American industrialists, and portrait painters easily smoothed out the intensity and confidence that comes through in photographs. In one photograph, taken of his family and friends together on a lawn, he alone casts an almost swaggering pose, putting his leg up on the chair, his arm on his knee, one hand in a pocket, the other holding a cigar, his hat jauntily tilted back.

In Frick, Carnegie had found a sharp-eyed accountant. He was a *"thinking machine, methodical as a comptometer, accurate, cutting straight to the point . . .* the most methodical thinking machine I have ever known," observed Charles M. Schwab, another Carnegie partner. He "had no instinct for books or learning; was cold-blooded, ignorant of everything except the steel and coke business. . . . ruthless, domineering, icy." According to James H. Bridge, who worked for both Carnegie and Frick, the latter had a "singularly charming, humane and charitable side," which he revealed to his family, particularly to his daughter Helen whom he adored. Disciplined and relentlessly driven, Frick worked long hours and at a fast pace, wanting above all to prove to himself and to the watchful Carnegie that he was capable of single-handedly managing Carnegie Steel under even the most adverse conditions. He often commuted between Pittsburgh and New York by train, arriving in the morning and returning the same night, his day filled with appointments. Frick seemed "more refined than the Carnegie partners, who often came to the Windsor [Hotel] for dinner, and had the rough friendliness of Western men who do big things," recalled Bridge. "He spoke little, his smile serving as an answer to, or acknowledgement of, Carnegie's jests and habitual enthusiasms." From himself, and those who worked for him, Frick demanded perfection.

To orchestrate a vast industrial complex, Frick kept his gaze trained on myriad details. His insistence on order, structure, and control was not simply a management tactic but an integral part of his personality. He loved figures and ledgers and clearly understood their power. His almost daily letters to Carnegie are long, rational reports, logically and

Anthony van Dyck, *James Stuart, Duke of Richmond and Lennox,* ca. 1634–35. The Metropolitan Museum of Art, New York. Searching in England for Old Masters for the Metropolitan, Henry G. Marquand first saw the portrait in 1886 at Corsham Court.

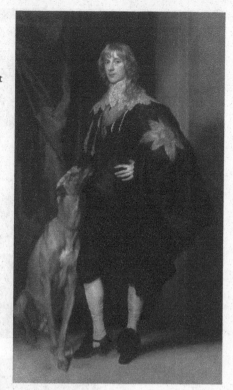

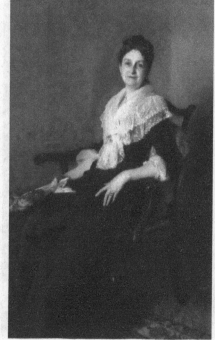

John Singer Sargent, *Elizabeth Allen Marquand,* 1887. Princeton University Art Museum. Sargent painted the portrait a year after he had encouraged Henry Marquand to acquire van Dyck's *James Stuart.*

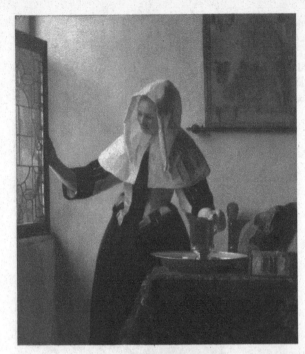

Johannes Vermeer, *Young Woman with a Water Pitcher,* ca. 1662. The Metropolitan Museum of Art, New York. In 1887, Henry Marquand spent $800 on this canvas—the first Vermeer to arrive in America.

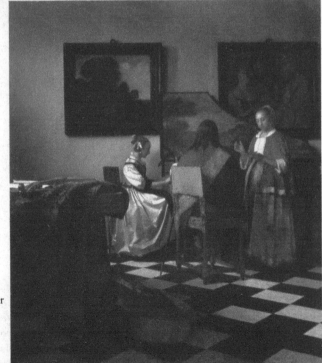

Johannes Vermeer, *The Concert,* ca. 1665. Isabella Stewart Gardner Museum, Boston. Gardner won the Vermeer at a Paris auction in 1892.

John Singer Sargent's *Portrait of Isabella Stewart Gardner*, 1888. Isabella Stewart Gardner Museum, Boston. Portraying Gardner as a symmetrical figure set against Venetian fabric, Sargent paid tribute to her as a patron of art.

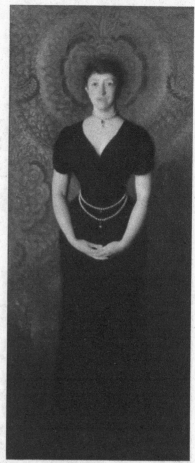

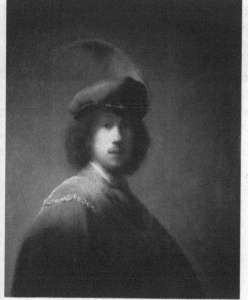

Rembrandt Harmensz. van Rijn, *Self-Portrait, Aged 23*, 1629. Isabella Stewart Gardner Museum, Boston. "I am bitten by the Rembrandt," Gardner wrote Bernard Berenson in February 1896, "and today being Sunday, I wait until tomorrow and then cable 'Yes Rembrandt!'"

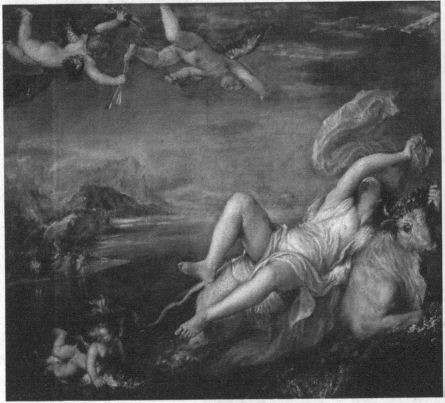

Titian, *Europa*, 1560–62. Isabella Stewart Gardner Museum, Boston. "Lord Darnley's Titian: *Europa*" is a "picture for a great 'coup,'" the dealer Otto Gutekunst wrote Bernard Berenson in 1896, and "one of the finest & most important Titians in existence."

Raphael, *Madonna and Child Enthroned with Saints* (*Colonna Madonna*), ca. 1504. The Metropolitan Museum of Art, New York. Paying $400,000 in 1901, J. Pierpont Morgan made the altarpiece the world's most expensive painting.

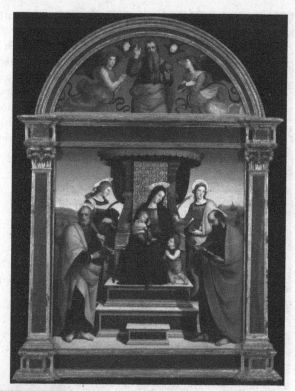

Sir Joshua Reynolds, *Lady Elizabeth Delmé and Her Children,* 1777–79. National Gallery of Art, Washington, D.C. Pierpont Morgan's purchases established a taste for eighteenth-century English beauties among American tycoons.

El Greco (Domenikos Theotokopoulos), *Portrait of a Cardinal. Probably Don Fernando Niño de Guevara* (The Grand Inquisitor), ca. 1600. The Metropolitan Museum of Art, New York. In 1901, an El Greco expert alerted Mary Cassatt to the rare full-length portrait, which he had recently discovered in a palace in Madrid.

Edgar Degas, *At the Louvre,* ca. 1879. Private Collection. Degas portrayed his American friend Mary Cassatt not as a painter but as a connoisseur, looking at pictures.

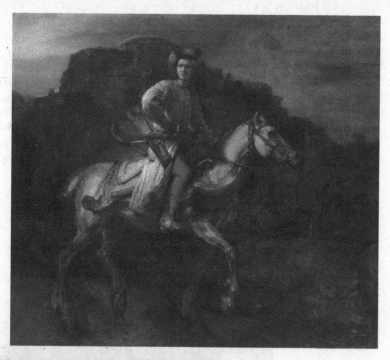

(*above*) Rembrandt Harmensz. van Rijn, *The Polish Rider,* ca. 1655. The Frick Collection, New York. Scouting for canvases for the 1898 Rembrandt retrospective in Amsterdam, a Dutch scholar found the painting in a castle in Poland.

Rembrandt Harmensz. van Rijn, *Self-Portrait,* 1658. The Frick Collection, New York. The Ilchester Rembrandt was the sort of picture that the dealer Otto Gutekunst called "Angel's food" or "Big-big, big game."

Giovanni Bellini, *St. Francis in the Desert,* 1480. The Frick Collection, New York. When the ravishing Bellini was first exhibited in London in 1912, it created "a sensation."

Giovanni Bellini and Titian, *The Feast of the Gods,* 1514/1529. National Gallery of Art, Washington, D.C. "Bless the war that you have the chance [to buy]," Bernard Berenson wrote Isabella Stewart Gardner in 1917, delivering the news that the Renaissance masterpiece was for sale.

carefully argued, and filled with specifics on all aspects of the business. One day he discussed railroad rates: "Would not be at all surprised but what we could get $1.00 a ton on all export business from Baltimore & Ohio [Railroad]." Two days later, he outlined a plan for a corporate restructuring: "My idea is that the stock in the Coke Company is to-day cheap at $150.00 per share.... It is only giving holders ... about $1,000.00 per acre for unmined coal alone, with all surface land, ovens, improvements, cares, etc., etc., thrown in." He was sensitive to the nuances of the operation and to his colleagues who ran it. "[I] do not think it quite fair that you should be so severe on McCague.... No one knows better than you the immense freight business of Carnegie Steel Company, but I doubt whether you are fully aware of the many deals the Freight Agent has to make of one kind or another to secure best rates, which he really takes great risks in doing. McCague is an exceedingly sensitive man, and it unfits him for business." Frick reminded the distant Carnegie that he was "on the ground, and keeping the run of matters pretty closely, I am in [a] position to speak on these matters, and am satisfied, if you could view the whole situation as I do, you would thoroughly agree with me." Although he wrote hundreds of business letters, he composed few to family members and friends, and in these he rarely expressed emotion.

The vigilance with which Frick oversaw the steel corporation he also applied to the operations of his private life, where he employed his own method of accounting to keep track of his structured extravagance. Starting in 1892, he put in place an ornate bookkeeping system with which he recorded every dollar that left his bank accounts. He printed up his own vouchers, engraved self-importantly in large black lettering—"H. C. Frick"—which his bookkeepers mailed out to merchants and tradesmen to document his purchases. When the vouchers were returned, the bookkeepers stamped them and filed them in steel drawers. With two and then three enormous houses, which were manned by dozens of servants, filled with furniture and paintings, and equipped with horses, carriages, and cars, the Fricks spent millions and generated some 23,000 vouchers. (Nine decades after Frick's death, these vouchers, cataloged in dozens of metal file cabinets in the basement of his museum, remain a testament to his obsession with order.)

Reticent as he was, Frick revealed much about himself when he spoke about those he considered worthy of respect, including his fellow collectors. Making the case that the late Pierpont Morgan deserved to be memorialized in a portrait bust, he argued that the banker's true monument was "the Steel Corporation itself . . . the greatest and most beneficent industrial organization conceived by the brain of man." But, he added: "Those of us who knew him best like to think of Mr. Morgan as a man—as a human personality, strong, self-contained, dignified; and that is the aspect which the sculptor has so skillfully presented in the enduring bronze of his art." When he met Isabella Stewart Gardner, she was sixty-eight and he a decade younger. He described her as "remarkable in many ways," noting with a sense of detachment and perhaps regret that she "has the energy of youth."

The fortunes Carnegie and Frick had made in steel came at a price. When they could, they saw to it that other people paid it. In their drive to boost profitability, they had broken strikes and driven out unions, most famously at the steel mill in Homestead, Pennsylvania, where a gun battle between strikers and hired guards left more than ten dead and many others wounded. Although Carnegie had been in Scotland during the strike and had left Frick in Pittsburgh to handle the situation, their brutal tactics in dealing with the union damaged the reputations of both men. In the public mind, Frick came not undeservedly to represent the most ruthless of American capitalists and Carnegie a hypocrite, whose practices were awkwardly at odds with his public preaching on capital and labor. In an 1886 article in *Forum*, he had defended the "the right of the working-men to combine and to form trades-unions," and argued that wage disputes should be settled by arbitration rather than strikes. Soon after, he advised against the hiring of strikebreakers.

If Frick's life had been a triumph of industrial entrepreneurship, his dependence on Carnegie had frustrated his ambition and clouded his achievements. From the start, the Frick-Carnegie collaboration had been strained by the rivalry of two titanic clashing personalities who needed each other but often failed to see eye to eye. Even as chairman of Carnegie Steel, Frick had to defer to his senior partner, who had the power to dismiss him at any time. "While Carnegie was leading the

high life in New York, London, and his Scottish estates, Frick stood at his post in Pittsburgh through fair weather and foul," writes Carnegie's biographer David Nasaw. "As long as Carnegie remained the majority stockholder in Carnegie Steel and the controlling stockholder in H. C. Frick Coke, there was no way Frick was going to win a battle with him."

Frick had come to Europe in June 1899 trying to avoid such a battle. Recently deciding that he wanted to "retire," Carnegie had given Frick his blessing to organize a buyout of the steel company. Over the past few months Frick had put together a syndicate to raise $320 million for the purchase. His partner in the scheme was William Moore, whose identity he kept from Carnegie because Moore was well known as a stock manipulator. Carnegie insisted Frick's syndicate pay a $2-million option on Carnegie Steel to demonstrate their ability to complete the purchase—essentially a "break-up fee" put down in advance. He gave Frick until August 4 to get the deal done. Carnegie's share of the fee was $1,170,000. When Moore produced only $1 million of that fee, and Frick and his partner Henry Phipps had to come up with the rest, they surely sensed trouble. Then in early May, Moore acknowledged he didn't have the $320 million promised Carnegie. Refusing defeat, Frick proposed to raise the funds through a public offering, but needed time to organize it. The first challenge was to persuade Carnegie to extend the option beyond August 4. Wanting to present his case in person, Frick decided to make the trek to Skibo Castle in Scotland where Carnegie was spending the summer. It would demand all of Frick's considerable business experience to complete the deal, but fortunately he had prepared himself well for the task.

"King of Coke": Henry Clay Frick

Frick attempted to order his life with the regularity of ledgers and graph paper, but it was, in fact, the stuff of melodrama. Although he had not lived Carnegie's rags-to-riches American fable, he engineered his rise to the top of American industry by means of ruthless drive and he outmaneuvered any competition by exceeding it with brains, talent, and incessant work.

Named for the admired statesman Henry Clay, Frick had been born in 1849 into a prosperous family in Western Pennsylvania on the Allegheny plateau, where rich seams of coal would later provide the raw material for his fortune. Frick grew up on the farm of his grandfather Abraham Overholt, whose brick distillery across from his house produced Old Overholt rye whiskey and made him among the wealthiest men in the county. In contrast, Frick's father struggled as a farmer and his shortcomings as a provider were clear to his son (not unlike Carnegie's view of his own father). Thus Frick took his cues from Abraham Overholt, who hung black-and-white prints of American statesmen in his parlor and ran the distillery with coal that he mined from his own land. Finishing his formal education by the time he was seventeen, Frick went to work first as a clerk in an uncle's store and then kept the books at the distillery.

Early on, Frick demonstrated his appetite for calculated risk. At twenty, he borrowed $75,000 to invest in a "coke" firm started by two cousins and a friend. They had bought land and mined coal, firing it in bee-hive ovens to produce coke, which they hauled to the iron and steel mills in and around Pittsburgh. The sooty, industrial city, located where the Allegheny and the Monongahela rivers converged into the Ohio River, was already a center of iron milling and iron rail production. By the mid-1870s, the city's iron makers, including Carnegie, began to produce steel.

To expand his business, Frick approached Thomas Mellon, a childhood friend of his mother's, who with his sons, Andrew and Richard, had recently started a Pittsburgh bank. Mellon obliged Frick with the loan. Six months later, Frick requested a second. When Mellon dispatched a colleague to inspect the coke operation, he reported that Frick "knows his business down to the ground," and he advised the bank to extend the loan. "Lands good, ovens well built, manager on job all day, keeps books evening." He also observed even then that Frick "maybe a little too enthusiastic about pictures," adding "but not enough to hurt."

Soon after, in 1873, when the collapse of Jay Cooke's Philadelphia bank set off a depression, Frick snapped up his struggling competitors. Two years later, he bought out his partners. By 1882, the H. C. Frick Coke Company had over 1,000 coke ovens, produced over 75 percent of

the region's coke, and was valued at $1 million. Meanwhile, Andrew Carnegie and his brother, Thomas, were seeking a steady supply of high-grade coke for their steel mills, and Tom approached Frick. Looking for capital to further expand, Frick agreed to sell Carnegie 11 percent of his coke company.

By 1881 Frick had moved to Pittsburgh, and that spring he and Andrew Mellon, with two other friends, took a "grand tour" to Europe, stopping in England, Scotland, Italy, and France. In a photograph of the four young men, Frick stands out from the others by casting a skeptical

Adelaide Childs Frick, age forty-one, taken at the Falk Studio at the Waldorf-Astoria Hotel, in 1901. She had married Henry Clay Frick in Pittsburgh in 1882, and remained in his shadow.

look and striking a sophisticated pose with a walking stick and a hand on his hip. The following year, he elevated himself to a social class commensurate with his wealth when he married Adelaide Howard Childs, the twenty-two-year-old daughter of a Pittsburgh boot manufacturer. Adelaide had understated beauty with an innocent open face. She would remain an obscure, reclusive figure, her life centered at home, in the shadow of her husband.

On their honeymoon, Frick took Adelaide to New York, where for the first time he met Carnegie, who had moved to the city in 1870 and now invited the Fricks to celebrate the new steel and coke alliance by joining him and his indomitable mother for dinner at the Windsor Hotel. By 1883, Frick, always bent on expansion, had sold Carnegie more than 50 percent of the coke firm, along the way effectively ceding control of his company to the steel magnate. Three years later, Carnegie warned Frick against selling out his firm. It will be "the mistake of your life," he bluntly predicted. "Your career must be identified with the Frick Coke Co. You never could become the *Creator* of CB and Co. Twenty years from now you might be a large owner in it, perhaps the principal, still the concern would not be *your work and you could not be proud of it*." Within two years, Frick had reduced his share of coke company stock to only 21 percent, while Carnegie held more than three times that much.

In January 1887, Frick had accepted Carnegie's invitation to join Carnegie Brothers' board and take $100,000 (or 2 percent) of its stock, for which he could pay with the company's future profits. But within months, when Frick's coke workers went on strike, Carnegie forced the reluctant Frick (not for the first time) to settle. Frick fired off a protest to Henry Phipps, chairman of Carnegie Brothers, against "so manifest a prostitution of the Coke Company's interests in order to promote your steel interests," and resigned as the coke company's president. That summer, after persuading Frick to visit him in Scotland, Carnegie wooed him back to the coke firm, and in a year and a half named him chairman of Carnegie Brothers steel.

Frick was pleased with his new appointment. "As I become familiar with the Steel business, it becomes more interesting; always something that can be done to reduce cost," he wrote Carnegie in Scotland

on July 25, 1889. "I am nothing of a 'literary cuss' any way, which is probably as well, as we have no lacking of it in our concerns. Glad you are enjoying yourself. When I get to be 50 I want to retire and do the same." Carnegie replied: "I am so glad the steel business is fascinating you. It is the greatest of investments in the U.S. in my opinion *managed as it can be.*" Frick shot back that he more than understood. "I could not and would not remain the official head of any concern that was not well managed. I cannot stand fault-finding and I must feel that I have the entire confidence of the power that put me where I am, in a place I did not seek. With all that, I know that I can manage both Carnegie Brothers and Co. and Frick Coke Co. successfully." By September, Carnegie told Frick to "take supreme care of that head of yours. It is wanted. Again expressing my thankfulness that I have found the *man.*" Frick helped Carnegie by buying steel mills, building a railroad, and constantly driving down costs. Frick viewed labor as nothing more complicated than a "factor of production," writes the historian Kenneth Warren, "wages being regarded as a cost consideration on a par with charges for raw materials, energy, or transportation."

Carnegie had already begun to meet the challenge he threw out to himself and other tycoons to redistribute their fortunes. In his 1890 *Gospel of Wealth,* he wrote that "the duty of the man of wealth" was "to consider all surplus revenues which come to him simply as trust funds," and to administer them for society "in the manner . . . best calculated to produce the most beneficial results." In 1879, he gave his first library to Dunfermline, the Scottish village where he was born; eventually, he would spend some $50 million to fund over 2,800 other libraries and would give away his entire fortune.

With Frick's grip on the steel empire, Carnegie could supervise from afar, and move about on an international stage, distanced and detached from the city that continued to generate his fortune but that he had long ago escaped. Famously described as "Hell with the lid taken off," Pittsburgh now produced more steel than any other city in the nation—a gargantuan industrial landscape with mills, foundries, and factories, darkening sky and water. Commentators cringed at the inhuman scale, the ugliness, and the contrast between the ever richer

capitalists and the workers, increasingly unskilled immigrants from Eastern Europe, many of whom made less than two dollars a day.

By 1890 Clay and Adelaide Frick had three children, Childs (b. 1883), who was seven, Martha (b. 1885), five, and Helen Clay (b. 1888), who was only two. Although they were raised in extraordinary luxury, the Frick children were not spared the dangers of a nineteenth-century childhood. Several years before, Martha had contracted an illness that continued to grow worse. On June 30, 1891, Frick cabled Carnegie who was in London: "We have had a very sick little girl for two weeks past." On July 14, he telegraphed again. "I have decided positively not to go to Europe this year. The future of business is too uncertain, and matters here need close attention." Sadly, Martha's condition worsened, and on July 29 she died. Both parents were devastated. "Knowing just what the blow means to you, I can find no words to write . . . I have *no consolation* to offer you," Carnegie confessed in a thoughtful letter addressed to "Mr. & Mrs. Frick" on August 3. "All I have found serviceable is to resolve to forget & busy myself with the duties that surround me." To memorialize Martha, Frick not only commissioned a posthumous portrait, but also, in a strange tribute, the tycoon had the image of her young face printed on his checks. But grief did not paralyze the pragmatic industrialist; within six months he began a $131,000 renovation of his large gray stone house, which he had named "Clayton," after himself.

The following year, the ongoing conflicts between Frick and Carnegie reached a climax when the strike by the Amalgamated Steel Workers union at the mill in Homestead, a bleak industrial town on the Monongahela River, brought to light the brutal underpinnings of their moneymaking empire. In April 1892, when steel prices were falling and the union contract at Homestead was about to expire, Carnegie sailed for Europe. He left Frick to execute their agreed-upon strategy to slash wages, lengthen shifts, and break the union—he would refuse to negotiate, shut down the steel works, send guards to occupy it, and start up again with workers who would accept the Carnegie terms. In preparation, Frick encircled the mill with an eleven-foot fence and ordered it to close. Then he dispatched a force of Pinkerton guards to take over the plant, sending them by barge up the river into Homestead in the early hours of June 6. But idled workers, stationed as look-

outs, spotted the approaching Pinkertons. Gunshots (from one side or the other) started a fight, which raged throughout the day, until the guards surrendered. Within days, Pennsylvania's governor dispatched eight thousand National Guardsmen to Homestead, and the Carnegie management regained control of the plant.

Meanwhile, on July 8, Adelaide Frick gave birth to a premature baby. The parents named him after his father, who at that moment had little time to spend with his new son.

Three days later a committee from the House of Representatives arrived in Pittsburgh to investigate the Homestead fight. Their report faulted the officers of Carnegie Steel for not having "exercised that degree of patience, indulgence and solicitude which they should have done," and argued that Mr. Frick, who is "a businessman of great energy and intelligence, seems to have been too stern, brusque and somewhat autocratic."

To Carnegie, Frick assessed the situation with a fanatically detached optimism and took no account of human cost. "Looking back over the transaction of this month so far, or previous to that, I cannot see where we have made any serious blunders," he wrote on July 18. "It will all blow over before long, and when we do get started at our several works they will be all non-union, and if we treat the men as we always have done, or desired to do, it certainly will be a long while before we will have any more labor trouble."

But Carnegie attempted to distance himself from Homestead. "I have given up all active control of the business, and I do not care to interfere in any way with the present management's conduct of this affair," he told a reporter who tracked him down in Scotland. To another partner, he wrote on July 17, "matters at home *bad*, such a fiasco trying to send guards by Boat and then leaving space between River and fences for the men to get opposite landing and fire—still we must keep quiet and do all we can to support Frick and those at seat of war." No doubt Frick was aware that behind his back, Carnegie blamed him for the crisis and its toxic public relations fallout. "For as long as he [Carnegie] lived, and longer," writes Nasaw, "Homestead would remain a symbol of all that was wrong with industrial America."

Then suddenly violence of the sort that Frick had set in motion in the

troubled steel town arrived at his own door. On July 23, a twenty-five-year-old self-proclaimed anarchist (who had no ties to the union) named Alexander Berkman barged his way into Frick's Pittsburgh office, pulled a gun on the coke tycoon, who was standing at a table, and shot him twice. John Leishman, Carnegie's vice-chairman, who was meeting with Frick, jumped on Berkman, who had meanwhile pulled out a knife and stabbed Frick in the right hip and left leg. Although wounded, Frick helped Leishman subdue the gunman. Later a doctor removed the bullets from Frick, and he was transported to the hospital. Before he left the office, the self-possessed industrialist courageously cabled Carnegie: "Was shot twice but not dangerously. There is no necessity for you to come home. I am still in shape to fight the battle out."

For several weeks, Frick rested at home, although he continued to work. A visitor recalled seeing him in bed with his head bandaged, arguing, "I will fight this thing to the bitter end. I will never recognize the union, never, never!" Eventually, Frick recovered. Meanwhile, he could do little to help his struggling son. On Wednesday, August 3, the baby, only weeks old, died. Two days later, Frick took the trolley back to work. At one point, he wrote Carnegie about the heartbreaking situation of witnessing a child die for the second year in a row. Carnegie replied: "I don't see how you can stand [your home agonies]. If you are like me you will stand until all is quiet and you are out of it and then give way."

Carnegie's vocal concern only provoked Frick's anxiety. Frick encouraged Carnegie to stay where he was but defensively told Carnegie that if he found a better manager, "the position is open for him." Even when sympathetic, Carnegie's messages seemed double-edged. "This fight . . . is very bad indeed for you—very, and also bad for the interests of the firm. . . . You don't deserve a bad name, but then one is sometimes wrongly got."

Although the strike cut profits in 1892, in the long run Carnegie enjoyed the reduced costs of a weakened labor force. By early August one thousand workers restarted the Homestead mill and by mid-November the union called off the strike. "Events were to show that his [Frick's] firmness had indeed set in train a wholesale and irreversible decline in the union," argues Kenneth Warren. Frick only grew more arrogant,

volatile, and certain of himself and his decisions. By 1897, Carnegie Steel manufactured almost 50 percent of America's structural steel, and its profits, climbing steadily since 1894, reached $7 million.

Fall 1899

After the Fricks docked in Le Havre in June 1899, Adelaide and the children settled into a Paris hotel, and Frick and Henry Phipps crossed the channel and headed to Scotland for their fateful meeting with Carnegie. By now, Carnegie was furious; he had learned Moore's identity, and that Frick, whom he entrusted to negotiate on his behalf, had structured the deal to shower himself, Phipps, and Moore with a $5 million bonus if it went through. Although Carnegie played the host to Frick and Phipps, taking them on walks and carriage rides, he made it clear he would not extend the option: "Not one hour." For the moment, Frick's dream of wresting control of Carnegie Steel had collapsed. Carnegie's doubts about Moore had proved true and Frick, who rarely, if ever, admitted to error, had been humiliated.

Frick remained with his family in Europe for the rest of the summer. They went south to Aix-les-Bains and later returned to Paris. There at the French branch of Arthur Tooth's gallery, Frick agreed to buy portraits by the eighteenth-century French artists Greuze and Nattier; soon after, in London, also from Tooth at Five and Six Haymarket Street, he bought a second Nattier—an emphatically aristocratic image of an English countess, with a long neck, creamy skin, and a fancy dress, whose arms are resting on a balustrade as she gazes at the viewer. Then only days before setting sail from Liverpool, he told Arthur Tooth he had made the decision to buy the Rembrandt—*Portrait of a Young Artist*—for $38,000 and asked the dealer to ship the painting (already in New York) to Pittsburgh.

For Frick, art collecting, like all other aspects of his life, involved careful calculation. In accumulating pictures, he could translate the vast capital he had amassed into something magnificent, concrete and fixed, which gave him pleasure, gained him recognition, and over which he could exert complete control.

Anticipating the discomfiture of returning to Pittsburgh without

any prospect of escaping Carnegie's shadow, he would now enter trium-
phantly with a magnificent work of art, a picture of unassailable value,
which even as a private possession would enhance the cultural assets of
the city. At the very least, the Rembrandt underscored Frick's financial
clout and his appreciation of genius. It spoke with the authority of ages,
an artifact of Dutch art's Golden Age, when the practice of painting
thrived and the bourgeois society measured itself in its abundance of
pictures. Despite ups and downs, its value as a work of art and as a com-
modity had held for over 250 years. In his lifetime, Rembrandt had en-
joyed international fame and success, and in the eighteenth century,
such illustrious figures as Catherine the Great numbered among the
collectors of his pictures. Yet, in the course of the nineteenth century, his
reputation had soared and was reaching its zenith. As the American
artist and critic Kenyon Cox put it: "Of all the great masters of painting
none is more popular today than Rembrandt." Extraordinarily prolific
and versatile, he wore the label of genius with ease. He had produced
over 350 canvases, some 1,000 drawings, and close to 300 prints. While
he concentrated on portraits, which brought a steady income, he also
painted (and drew) landscapes, in addition to subjects from history, my-
thology, and the Bible. Ironically, historical evidence of the artist's worldly
success—that he had operated a large workshop and earned enough to
become a collector himself—was ignored by the pioneering French crit-
ics who had in the mid-nineteenth century rediscovered him as the most
up-to-date of Old Masters, the one who spoke most eloquently to the
modern age—his dark, mysterious, psychologically penetrating canvases
aiming not to idealize but to capture nature and "truth."

So popular was Rembrandt that the nations of northern Europe
fought over the artist's legacy. Germany first advanced its claim with
Wilhelm von Bode's scholarship. But Holland celebrated its native son
when Bode and the art historian Cornelis Hofstede de Groot organized
the 1898 Rembrandt retrospective (with over 124 canvases and 350 draw-
ings). Staged to coincide with the coronation of Queen Wilhelmina, this
first modern "blockbuster" was groundbreaking on many counts. There
for the first time "the general public could see . . . the chronological evo-
lution of Rembrandt's style," explains the art historian Catherine Scallen.
Canvases never before on exhibition appeared from far-flung points of

Europe. A pair of portraits—*A Gentleman with a Tall Hat and Gloves* and *Lady with an Ostrich-Feather Fan*—came from the legendary Youssoupoff collection in Saint Petersburg, and a canvas called *The Polish Rider*, from Silesia, recently discovered by the Dutch art historian Abraham Bredius. The Dutch borrowed forty of the Rembrandts from England and twenty-four from France. Three months later, not to be outdone, the English staged their own Rembrandt exhibition in London. "It is as though we had regarded the Amsterdam exhibition of Rembrandt as a challenge," wrote a critic in the London *Times*, "and had replied to it, 'This is all very well but we can do it better in England.'"

Relative newcomers in the Rembrandt market, Americans had been making up for lost time. In the decade and a half since Henry Marquand imported *Portrait of a Man*, his compatriots had bought Rembrandts at a rapid clip, accumulating some thirty canvases. With the exception of the landscape and the seascape owned by Isabella Gardner, all the American Rembrandts were portraits.

Although a novice in the Old Master market, Frick could be certain that the *Portrait of a Young Artist*, if not one of the artist's most famous pictures, was deemed genuine by Rembrandt scholars and fine enough to go into the Amsterdam exhibition. Indeed, not all Rembrandts were of equal quality. Problematically, his extraordinary manner of painting had encouraged imitators whose works were often taken as his own; exactly how many pictures Rembrandt painted was a matter of dispute. Bode's first catalog published in 1883 identified 350 canvases; his multivolume catalog (completed in 1906) named 595 paintings. Two years later, Wilhelm Valentiner, another German scholar, boosted the number of Rembrandt pictures to over 640. Although scholars later attributed the *Portrait of a Young Artist* to one of Rembrandt's contemporaries, at the time no one questioned the authenticity of the canvas. In early October, Arthur Tooth asked Colnaghi to write Frick a letter about the history of the Rembrandt he had just bought. In this letter, the London dealers strategically dropped the name of "our friend Dr. Bode" and bragged that the Berlin museum director had "strongly recommended it [Frick's new Rembrandt] to one of his intimate friends who, however was not at the time quite rich enough to treat himself to such a high priced picture."

By October 7, Arthur Tooth delivered the painting to Frick's Pitts-burgh mansion. The house was a Victorian clutter of ornate, stuffed furniture, encased in busily wall-papered rooms jammed mostly with small, sentimental pictures, overwhelmed by elaborate gold frames. Both literally and figuratively, the dark, brooding Rembrandt portrait didn't fit. Frick wanted to put up the canvas in his music room, but the walls were full, and he hung the painting against a window, covered with velvet curtains. The large, somber Old Master picture swept into the late-nineteenth-century assemblage like a bracing draft. Until re-cently the painting had resided at the Earl of Carlisle's vast Castle Howard in Yorkshire; now in Pittsburgh, it was an aristocratic visitor from the old world—the young man in the broad-brimmed hat ap-pearing prosperous and confident, and holding the tools of his trade in his hands. With the figure dramatically highlighted against the rectan-gular field of darkness, the portrait was mysterious, and slightly melan-choly, but also serene. In its plain black Dutch frame, Rembrandt's *Portrait of a Young Artist* established a sense of order, history, and per-manence. For Frick, the purchase of an Old Master was a turning point. Frick had observed Carnegie's success at using his writings to mold his public image and to counteract the damage inflicted by Homestead. Even if "nothing of a 'literary cuss,'" Frick was proving himself as a collector and harnessing the visual arts to create an al-ternate image to the dark figure who coolly masterminded labor's defeat.

The Rembrandt's $38,000 price probably seemed reasonable to Frick—only $12,000 more than he had paid for his most expensive Corot. Making his way for the first time in the Old Master trade, the Pittsburgh collector didn't know that since Gardner rejected the Earl of Carlisle's Rembrandt portrait the canvas had languished on the mar-ket. Soon he would recognize that to land in the company of major collectors demanded he buy Old Masters for which he would have to compete.

When in the summer of 1899 news reached Charles Stewart Carstairs that Clay Frick had bought Rembrandt's *Portrait of a Young Artist* from a rival in London, he bolted to attention. Carstairs was in his early thirties, a tall, gregarious art dealer from an old-line Philadel-

phia family in both the art and whiskey trades. He worked for M. Knoedler & Co., a New York gallery, where up until now Frick had bought most of his paintings. Carstairs had been promoting Old Masters in Pittsburgh and he had sold the city its first Rembrandt. The dealer had been urging Frick to trade up to Old Masters and now, much to his consternation, the steel tycoon, one of his best clients, had bought the Dutch portrait from another dealer and had lavished significantly more on it than he ever had on any other picture. "How do you like your new pictures?" the dealer Roland Knoedler asked Frick after the Rembrandt arrived in Pittsburgh. "I am anxious to see them & to hear that you are pleased with all even if they did not come through M.K & Co."

Charles Carstairs was involved in the creation of Frick's collection from the beginning. In 1894, Carstairs, then twenty-nine, had sold Frick a small, sentimental, genre scene of a young woman walking in a garden by Daniel Ridgway Knight, a quickly forgotten American artist working in Paris. Frick had paid $1,350, which was for him a negligible sum. Roland Knoedler "must have been relieved" because two months before the dealer had told his partner in Paris he had "enough paintings by Knight in stock for the moment," observes the art historian DeCourcy E. McIntosh. In gaining the confidence of Frick, Charles Carstairs had secured a collector who immediately stood out for the scale of his purchases, if not the singularity of his taste.

In 1895, the year after making his first Knoedler purchase, Frick spent eight weeks in Europe; he and his family paid the requisite visit to Carnegie in Scotland but for the first time they also traveled with Roland Knoedler in France. Photographs show the Americans seated at tables under striped umbrellas on a sunny terrace in Aix-les-Bains. (Over the next decade, Frick would take eight trips to Europe, each lasting at least several weeks and some as long as three months.)

Roland Knoedler

Knoedler (whose mother was French and who spent summers in Switzerland and France) introduced Frick to some of the pleasures of

vacationing in Europe while making certain to encourage his buying of art. In the summer of 1895, Knoedler took Frick to meet the artists Rosa Bonheur and William Bouguereau in their studios in Paris. As the dealer hoped, when Frick visited Knoedler's Paris gallery, at 2 rue de Gluck, he bought pictures in bulk for the first time—seven contemporary French canvases on which he spent over $32,000. For one picture alone—a melancholy landscape by Jules Breton called *The Last Gleanings*—Frick paid $14,000, the highest sum he had yet spent for a canvas. On August 9, his last day in the French capital, Frick snapped up three more paintings—landscapes by the French Jean-Charles Cazin. Soon after, he hammered home to Knoedler his desire to improve his collection: "I am relying on you to see that I get the first opportunity at any of Mr. Cazin's pictures which you might consider masterpieces, and also anything else that may come up of any other first class artists which you think particularly fine." By the end of 1895, Frick had spent $67,250 on eighteen pictures and become one of Knoedler's major customers.

An immediate impetus behind Frick's frenetic picture buying came from Andrew Carnegie, who had given $1 million to Pittsburgh to construct the city's first major cultural institution, which would combine a library and a concert hall as well as a museum. His hope was that "not only our own country, but the civilized world will take note of the fact that our Dear Old Smoky Pittsburgh . . . has entered upon the path to higher things, and is before long, as we thoroughly believe, also to be noted for her preeminence in the Arts and Sciences." Frick made certain that when the Carnegie Institute opened in September 1895 with an exhibition of some two hundred pictures borrowed from Pittsburgh collectors, he appeared to be one of the most important with twelve paintings in the show.

But Frick's appetite for pictures needed no outside stimulus. In 1898, he put down $100,000 for twenty paintings. Most were Barbizon landscapes. He bought fifteen from Knoedler, including Camille Corot's *Ville D'Avray*, which cost $25,000; he boasted to Carnegie that it was "the gem" of his collection. The following year he went back for a second, more expensive Corot, a misty gray scene with trees silhouetted against water and sky, called *The Pond*.

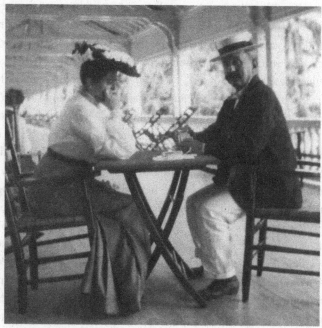

Adelaide Frick playing cards with Roland Knoedler in Palm Beach in 1904. The dealer also traveled with the Fricks in France.

When Frick was in Pittsburgh, Knoedler kept him informed. "The Vever collection is to be sold in Paris next Monday," he wrote in 1897. "There are some good things in it but I think they will bring very high prices." When Frick inquired about a Corot coming up at auction, the dealer replied: "[It] is very fine, though it might not suit a person who was in search of a silvery picture."

Frick began to rely on the unprepossessing Roland Knoedler not only for art advice but for companionship. More a salesman than a connoisseur, Knoedler (seven years younger than Frick) put the tycoon at ease. At forty, Knoedler had a round face, lively eyes, and a gray handlebar mustache that gave him a look of joviality and optimism. Together the dealer and the steel magnate challenged each other to golf and gratified their taste for cigars. One year they made a pact to smoke less, reducing their consumption "to not over three cigars" a day.

When Knoedler proposed extending the commitment into the new year, Frick responded with mock exactitude and formality: "I am getting along very comfortably on the three daily, but find occasionally that I have reached the maximum by about three PM so that I cannot indulge myself after dinner. . . . I shall take this matter up with you later, and have no doubt we can reach an understanding." In the same letter, Frick joked that his eight-year-old daughter, Helen, had sold him some of her own drawings, insisting that her father pay her in gold. The silver controversy was raging, and "she understood that [gold] was what people generally demanded and what I was in favor of . . . and would accept nothing else. So I have discontinued purchasing her pictures for the present." He advised Knoedler: "Here is a great opportunity for you."

Roland Knoedler had grown up in the art trade, inheriting the gallery at 170 Fifth Avenue (on the corner of Twenty-second Street) in 1878 from his father, Michael Knoedler, one of New York's leading art merchants. The elder Knoedler had emigrated from France in 1852 to work at the New York branch of Goupil (Goupil & Cie), the famous Paris gallery that later employed Theo van Gogh as a dealer, and also briefly his brother, Vincent. Goupil's had started as a publisher of prints and had at first only acquired paintings in order to obtain the rights to publish engraved or lithographic reproductions that it would sell to a mass market. Tellingly, Roland Knoedler referred to the gallery as the "store." His staff kept fastidious records of purchases and sales, which they wrote out by hand on the lined pages of large leather-bound books, records that suggest the well-established pattern of a high-volume retail business. Frick was customer "No. 51." While prints made up the bulk of Knoedler's sales, canvases by then-famous living artists, who had made their reputations in the European art establishment, generated an increasing amount of the profits. From Paris, Knoedler obtained a steady supply of French paintings for the American market. In 1895, the gallery moved up Fifth Avenue, to Thirty-fourth Street. Later the Paris dealer René Gimpel mocked the mercantile atmosphere of the gallery which sold prints for five dollars along with fine paintings, but acknowledged Knoedler had "an old name, a long reputation for honesty."

By 1897, thanks largely to Frick, Pittsburgh's demand for pictures was so strong that Roland Knoedler opened a branch of the gallery in the industrial city and dispatched Charles Carstairs to run it. By birth and temperament, Carstairs was well suited to selling art to America's new industrial tycoons. Born in 1865, Carstairs went to work at age twenty for Charles Haseltine, his mother's first cousin, who owned an art gallery in Philadelphia. That same year, he married Esther Haseltine, the dealer's daughter. Roland Knoedler did business with Haseltine's and, by 1894, he had hired Carstairs to work for him in New York. That Carstairs's father and brother operated the family's Pennsylvania whiskey firm may have helped him develop a rapport with Frick, who had held on to his grandfather's Old Overholt distillery.

Charles Carstairs

A gentleman, Carstairs brought an old-fashioned sense of honor and loyalty to the art trade. In his thirties, he had a long, open face that looked boyish and innocent even with a mustache. He was calm, organized, articulate, and frank, and he carried on his work with an easy-going professionalism. Later, his Knoedler colleagues described his touch as "light" and his grip as "firm." When Otto Gutekunst expressed outrage that Joseph Duveen had sold a painting of "an ugly old woman & early & flat," which happened to be by Rembrandt, for a very high price ($110,000), Carstairs brushed it off: "Don't be alarmed about the Duveens. They ask high prices and that's the competition we want. They are smart, active people. We must be the same." To his Knoedler colleagues, Carstairs preached the wisdom of going out of the way to secure clients who had the means to pay high prices by offering them the choicest pictures, and giving them price breaks. When a subordinate promised Philip Sassoon, one of the richest men in England, "any Sargent of ours he likes," he apologized to Carstairs but explained he was simply following the latter's advice. "I may in this way have sacrificed the difference between an English and a [higher] American price for a Sargent, but this is my interpretation of what you have often told me about taking a big view of a small matter in order to make a very important customer."

With this strategy, the socially confident and sophisticated Carstairs,

who was sixteen years younger than Frick, learned to handle the formidable and moody collector. The dealer enjoyed the company of the magnate and became one of his few close friends. Carstairs played golf with Frick, in England drove him to see some of the collections in the countryside, and they had, as he put it, "numerous picture talks." Later, in 1910, when Frick loaned his collection to the Museum of Fine Arts in Boston, he assigned Carstairs to supervise the hanging of the pictures. Two years before, Frick wrote the dealer: "There is no one whose judgment of the beautiful I have more confidence in than yours."

For Carstairs, paintings were objects of beauty and pleasure, and a means to make a substantial income. He himself liked to live in the style of his clients. Eventually he had houses in London (on Chesterfield Street) and Paris (on the rue de Grenelle), as well as in the English countryside, and he filled them with fresh flowers, Old Masters and Impressionist paintings, including a Pissarro and a Berthe Morisot. Knowing Frick loved fine cars, Carstairs reported he had bought a twelve-horse Panhard. "I never knew so much about the suburbs of London and have enjoyed having it tremendously," he wrote Frick. "Sunday I left at 10:20 with my mother & sister & went to Brighton, spent 4 hours there & was back at Carlton by 6:50. I have often wished you and Mrs. Frick were here."

Not surprisingly, Carstairs despised his assignment in the sooty and provincial Pittsburgh. Not one to complain, he didn't let on. But, later, when Gutekunst grumbled about having to travel to Berlin, the American dealer commiserated: "I have done so much similar waiting in my past life in beastly places like Pittsburgh. It is a horrible existence." Nevertheless, Carstairs saw the stupendous wealth accumulating in Pittsburgh as an art market opportunity. Conveniently for the Knoedler dealers, Pittsburgh lagged behind the East Coast in its taste for pictures, and to the western Pennsylvania industrialists they could continue to market Barbizon landscapes, which Boston collectors had first bought thirty years before and now considered almost passé. Yet, Carstairs recognized that Frick was ambitious, and attempted to direct him toward the increasingly expensive Old Masters. In 1898 and 1899, he sold Frick three half-length eighteenth-century English portraits—examples of prettily clothed, high-born women with powdered hair:

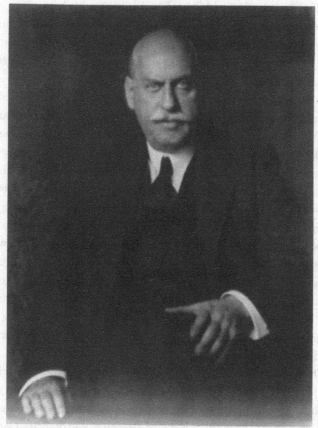

Charles Carstairs (ca. 1928) headed the London branch of the New York gallery M. Knoedler & Co. "Don't be alarmed about the Duveens," he told Otto Gutekunst. "They are smart, active people. We must be the same."

George Romney's *Miss Mary Finch Hatton*, John Hoppner's *The Hon. Lucy Byng*, and Sir Joshua Reynolds's *Miss Puyeau*. He constantly encouraged Frick to trade up, arguing in 1902 that the collector should let go of a painting acquired only four years before, "as it is not up to the high standard you have established *since its purchase*."

Immediately on learning that Frick bought a Rembrandt, Carstairs tried to persuade him to acquire a second. When the collector declined, the dealer argued that he had lost an opportunity. "The Rembrandt is

sold [for] $55, 000," he told Frick. "And others are likely to go any time. I don't suppose you are interested, but if you are, don't delay acquiring masterpieces that would be a glory to any museum." Soon after, Roland Knoedler told Lockett Agnew that he was "desirous of getting first class pictures by the masters."

Indeed, Charles Carstairs soon began to reorient Knoedler gallery, changing its focus from canvases recently painted by artists in Paris to Old Master pictures, which he found readily on the market in London. There, in 1902, Carstairs opened a branch of Knoedler, taking over the wood-paneled space at 15 Old Bond Street, which had housed Lawrie & Co., and slipping an American firm into the shoes of the now-dissolved British gallery. In London, Carstairs sold paintings to Americans who liked to shop for art when they traveled abroad. By establishing the presence of the New York gallery in the city to which British aristocrats looked when they wanted to sell their pictures, he hoped to compete with English firms. He also had ready access to collections in Europe. "I have just returned from the continent where I have been a week picture hunting," he wrote the banker Andrew Mellon in December 1906. Nevertheless, the American dealer depended upon London dealers to provide most of his merchandise.

One of those dealers was Otto Gutekunst at Colnaghi. After Henry Clay Frick bought Colnaghi's Rembrandt *Portrait of a Young Artist* through Arthur Tooth, Gutekunst hoped to secure the Pittsburgh tycoon as a client. Ever since Bernard Berenson and Isabella Gardner had severed their ties to the London dealer, he had searched for Americans to replace them. Early in 1900, Gutekunst's partner, Edmond Deprez, traveled to New York "with a view to extending our connection among art collectors in America." Armed with a letter of introduction from Pierpont Morgan, Deprez attempted to get directly in touch with Frick, and sent him photographs of a "Rembrandt picture which we think might be of interest to you and possibly of taking a place in your collection by the side of the fine Rembrandt portrait already hanging there." Making no headway with Frick, Deprez wrote Knoedler: "Should you be able to assist us in effecting a sale to Mr. Frick we will of course make it a matter of business with you." Within a year, Colnaghi's William McKay assured Roland Knoedler he had

"other pictures in view," and asked if "you are still willing to buy fine English pictures with us???" Soon Otto Gutekunst was addressing Carstairs as "Charlie" and wishing him well as he was about to sail from Liverpool to New York. "May you find things favorable over there and Clay in a good mood." Still, it took time for the dealers at Colnaghi and Knoedler to launch the team that together combed Europe for extraordinary examples of the Western tradition with which to tempt Clay Frick.

In the fall of 1899, following his failed campaign to buy Carnegie Steel, Frick had many business distractions, most importantly the fraying partnership with Carnegie. At first, the two partners fought over the price the steel company had contracted to pay for its supply of Frick coke. At a Carnegie Steel board meeting on November 20, Frick claimed that the absent Carnegie had accused him of "cowardice in not bringing up [the] question of [the] price of coke" directly to Carnegie himself. "I have stood a great many insults from Mr. Carnegie in the past, but I will submit to no further insults in the future." Almost immediately Carnegie decided to fire Frick, but before he could, on December 5, Frick resigned. At a famous meeting a month later, Carnegie confronted Frick face-to-face in Pittsburgh. "He came to my office and endeavored to frighten me into selling my interests in the Steel company at much below their value," Frick later wrote. According to Charles Schwab, Frick flew into a rage, screaming that Carnegie was "a god damned thief." Carnegie himself claimed that Frick "became wilder and I was forced to leave."

Carnegie then persuaded thirty-two of his steel partners (all but two) to strip Frick of his investment, and pay him less than $5 million for his share of the firm, which was, in fact, worth between $15 and $30 million.

By then, Frick had hired the attorney John G. Johnson, and in February 1900, he sued Carnegie Steel for the profit he believed was rightfully his. In court papers, Frick exposed to public scrutiny the steel firm's rancorous civil war, but also its profits, which in 1899 amounted to $21 million and would probably rise to $40 million that year.

In response, Carnegie and his board denounced Frick as "a man of imperious temper, impatient of opposition, and disposed to make a personal matter of any difference of opinion. . . . He demands absolute power and without it is not satisfied." Nonetheless, by March, Carnegie and his partners settled with Frick, recapitalizing the steel company and alotting him a $31.6 million share.

When, only a year later, Pierpont Morgan created United States Steel, he bought Carnegie Steel for $480 million, paying Andrew Carnegie $226 million. Frick's share of stock and bonds in the new steel giant doubled his fortune to some $60 million—or close to $1.5 billion today. If Carnegie was now "the richest man in the world," Frick was a member of the same circle. Nevertheless, he had continued to accrue intangible costs. He had lost his job, broken from the coke and steel industries, which he had done so much to shape, and further damaged his reputation. Carnegie's denunciation of Frick "was to contribute to the creation and confirmation—over many decades in the future—of the myth that Carnegie was a benevolent gentleman," argues Kenneth Warren, "the head of a generally happy brotherhood of industrial leaders from whom a persistently uncooperative member had been expelled for the general good."

Frick never saw Carnegie again. If Carnegie had failed to keep his reputation spotless, he had nonetheless persisted in besting Frick, who had been forced again and again to recognize his senior partner's masterful abilities in controlling his own fate and shaping his public image. Finally, on his own, Frick would put those lessons fully to use.

Never one to stay still, Frick summoned his new fortune to focus on investing and to recast his life and his legacy. Although by 1903 he had divested his stock in U.S. Steel, he sat on its board and played a part as an adviser. Soon, he diversified his portfolio, putting his assets (sometimes with Andrew Mellon) into banking, insurance, and railroads. The taciturn Mellon remained his closest friend.

Frick also turned his attention east—to New York, which continued to outdistance any rivals as the nation's financial and cultural capital and where he spent increasing amounts of time. In 1902, he rented an apartment at Sherry's hotel, and, three years later, deciding to move his family, he leased (for $50,000 a year) one of the late William H.

Vanderbilt's two enormous brownstones, at 640 Fifth Avenue. (Edith Wharton famously dubbed Vanderbilt's style as a "Thermopylae of bad taste.") The Fricks now basked in a new scale of architecture and luxury, with nine bedrooms, a library, a boudoir upholstered in gold silk and satin, and sixteen rooms on the uppermost floor for servants. The house came equipped with "furniture, rugs, carpets, bronzes, bric-a-brac, tapestries, curtaining, oil paintings and their frames," and a cabinet with 385 pieces of blue and white china. Frick selected the mansion in part because it had a fifty-foot picture gallery. "From that time on, he [Frick] collected intensively and did not have to restrict himself as to the size of the paintings," his daughter Helen later wrote. Certainly, he planned it that way.

The move to New York thrust Frick into the most competitive field of Old Master collectors. To the south at Thirty-sixth Street and Madison Avenue was Pierpont Morgan, whose Renaissance Madonnas looked down from the red damask walls of his Library. To the north, at Sixty-sixth Street and Fifth Avenue, were Harry and Louisine Havemeyer, with eight Rembrandt portraits, several Goyas, and the full-length El Greco *Cardinal*. At 626 Fifth Avenue, the department store magnate Benjamin Altman was constructing a mansion where he would hang a Rembrandt and a Hals he had bought earlier that year.

At the Vanderbilt house, Frick had the walls of a picture gallery and many others to fill. Before moving in, Frick had asked George Vanderbilt if he might borrow some of the pictures from his late father's collection, now on loan to the Metropolitan Museum. But in a letter enclosing the key to the house, Vanderbilt declined.

Fortunately, Charles Carstairs had already provided Frick with enough Old Masters to make a respectable showing in New York. Compared to Isabella Stewart Gardner, Frick had conventional taste. Following the Anglophile pattern established by Henry Marquand and Pierpont Morgan, he concentrated on Dutch landscapes and English portraits. He spent $75,000 on Meyndert Hobbema's moody *Village Among Trees* and $91,000 on Aelbert Cuyp's five-foot *Dordrecht: Sunrise*—a view of a glassy river with ships under sail as the sun is rising. His finest Dutch picture was a Vermeer—a corner of a room with light streaming through a window catching a pair of figures—a woman

in a red jacket, seated in a chair, and a man in gray standing behind her. He seems to be taking a sheet of music out of her hands and she is staring straight out of the canvas, as though the viewer had just entered the room. Entitled *Girl Interrupted at Her Music*, the small picture was the fourth Vermeer to reach America. Frick had bought it from Carstairs and paid $26,000. Although four times the price Gardner paid for her Vermeer nine years before, the canvas was nevertheless relatively cheap. That the art world didn't yet fully appreciate the Dutch artist's genius is evident in the Knoedler ledger book, where the painting is listed among eight that Frick bought on September 18, 1901.

Two years later, for the first time Frick spent over $100,000 for a single picture—a half-length Gainsborough portrait of a delicate, heavy-lidded young woman named Mrs. Charles Hatchett. Soon after, he returned eight pictures to Knoedler, most of them Barbizon landscapes. In 1904 he paid $200,000 for both George Romney's *Lady Hamilton as "Nature"* and Thomas Lawrence's *Julia, Lady Peel*—"2 of the best known of the English school," as Carstairs put it, each only a half-length but each expensive. A subject's fame, as well as the beauty of his or her face and figure, factored into a portrait's price. As a notorious femme fatale and the mistress of Lord Nelson, Emma Hamilton herself (painted at the age of eighteen) made the Romney desirable. But more complex and interesting was the glossy portrait of Lady Peel, the dark-haired wife of the prime minister Robert Peel, based upon Rubens's famous portrait of Suzanne Fourment. Lawrence had painted Lady Peel straight on, underlining her bold sophistication and glamour, and enabling her strong classic features and sultry gaze to carry off an elaborate costume that ran down from a large black hat with a waterfall of red plumes to a row of gold bracelets inlaid with green and red gemstones encircling a white satin sleeve.

Eighteenth-century English portraits, redolent of wealth and nobility, suited Frick's sense of order and optimism, and reflected his desire to view things as he wanted to, rather than as they were. As their numbers mounted, these portraits infused Frick's collection with a current of well-bred hedonism, its atmosphere tilting more toward the garden party than the museum. Well aware of the social prestige attached to aristocratic portraits, Carstairs underlined Thomas Lawrence's con-

nections to European royalty, when he offered Frick the *Marquise de Blaizel*, dropping the fact that she sat for the portrait in the artist's "studio [on the] Rue Royale, Paris, the year in which he received from the king of France, Chas. X. a set of Sevres China & the Cross of the Legion of Honor."

Frick planned to occupy the Vanderbilt house in October 1905, and in June he sailed to Europe on the *Kaiser Wilhelm II*. In London, Carstairs had lined up several portraits, most importantly an El Greco portrait of a cardinal (*St. Jerome*). A far cry from Reynolds and Gainsborough, the formidable sixteenth-century Spanish portrait described the head and torso of an older man with an elongated, skeptical face and a pointed white beard. He is wearing a cardinal's red robe, which armors him in a pyramid of chalky crimson, and his black eyes look off to the left. Before him is a large open book (presumably the Bible) on which his long-fingered hands point to black lines of text. Never before on the market, the portrait was one of the two El Grecos from the cathedral in Valladolid that had recently made their way to Paris. Its voyage from the Spanish church to a Paris gallery (Trotti & Cie) had stripped the Mannerist painting of its religious past and transformed it into an aesthetic object, which conjured a powerful presence.

In London, Otto Gutekunst also had a painting for Frick to see. That July he had acquired a Titian portrait, *Pietro Aretino*, from the illustrious Chigi family in Rome. Aretino was an influential satirist who made himself wealthy by extorting money from public figures fearful of his pen. Titian paints him as an older man with a sharp-eyed gaze, his brilliance and worldly success translated into the glinting orange satin of his sleeves, set off by a wide collar of rich fur and a heavy gold chain. The rare Renaissance picture was "comparatively little known up to now, having been kept in the private apartments of the palace," Gutekunst explained, and he immediately hung it at Colnaghi. That August, in *Burlington Magazine*, Roger Fry described the Titian as a masterpiece—one of the "few portraits left to us by the greatest masters in which the relation of artist and sitter was as intimate." He said he hoped that it would be purchased "for the nation." By September, Frick agreed to buy El Greco's portrait *St. Jerome*, along with two more conventional portraits—van Dyck's *Ottaviano Canevari* and *Mrs.*

James Cruikshank, by the Scottish Henry Raeburn, an heir to Joshua Reynolds. But Frick did not acquire Titian's *Pietro Aretino*.

Meanwhile, Carstairs and Knoedler went to extraordinary lengths to prepare the Vanderbilt house for Frick's arrival. They dispatched Thomas Gerrity, a Knoedler employee, to Pittsburgh to supervise the packing of Frick's pictures and to organize their shipping to New York. Gerrity kept Carstairs, who was in London, informed of the progress of the move. Accompanying the paintings east, he reported that on September 15 Knoedler's handlers delivered the crates to 640 Fifth Avenue. The dealers had a month to unpack and hang the paintings before Clay and Adelaide Frick moved in.

"We had gilders working night and day on all his frames," Gerrity wrote Carstairs on October 4, "as the time was very short to get them ready, and a great many of them were in very bad condition." He asked Frick if he wanted an estimate of the cost of the new frames and the repairs, but Frick had said, "No, not to waste time and go ahead and finish as quickly as possible." Carstairs had sketched out a blueprint for the arrangement of the paintings. "There have been several changes in the hanging from the plan you sent me, chiefly on the north wall," Gerrity reported. "The Grecho [*sic*] was hung over the mantel instead of the Rembrandt." And the collector placed his other new acquisitions on either side: "the Raeburn to the right of the mantel . . . and the van Dyck on the left." By October 6, Gerrity cabled: "GALLERY HUNG."

Frick "had several friends there [for] the evening," Gerrity wrote Knoedler. "We got through hanging and [he] seems to me to take a great deal of pleasure in them, *the Greco especially*." He concluded: "Everything looks well in the gallery and there is certainly room for a lot more." The presence of the El Greco, now the crown jewel of the collection, caused its new American owner to recalibrate. On November 16, Knoedler spent the evening with the steel tycoon. Frick's pictures "look very well," he wrote Carstairs, "but he says he needs a few things to *key* up the collection—that is the way we want him to feel." (Knoedler noticed on the floor, resting against a wall, another El Greco portrait that some other dealer had delivered to Frick. "He said he did not like it. Mrs. F. said it looked like [the millionaire] James H. Hyde, which was enough to settle it.") Two weeks later, Charles Carstairs

arrived from London and he immediately saw the Vanderbilt house as a market ally, its extensive wall space fueling Frick's picture demand. To Thomas Robinson, his London assistant, he gave an assignment: "We must also find four splendid full-lengths for Mr. F's dining room. Although," he added, "we don't want to talk about it."

Not long after, Carstairs urged Gutekunst to send Titian's portrait of Pietro Aretino to New York. "I am delighted to learn that the prospects of business are so good," Gutekunst replied. "Also I hope, that Mr. Frick will keep the Aretino! What a grand thing to have him so interested in paintings just now; I will do my utmost to assist you in getting the right things for him, you may be sure." He joked about the difficulty of marketing paintings in England. "I am sick not because I fear the thing may not sell readily but simply because I had hoped & wished to place it, before you wanted it over there & to show you that I also can sell sometimes." As he put it: "The only market just now seems America."

As the dealers hoped, Frick kept the Titian and paid Knoedler $90,000 for it. Gutekunst had wanted more money for the magnificent painting. But Carstairs reassured him that Frick was a long-term and potentially fabulous client, who might even fund major purchases. "We will no doubt sell him some more things. . . . He always told us he would help us finance any big thing that might come our way & what can one do with such a good friend but accede to his wishes and he is always so charming about it. The gallery looks stunning & he will unquestionably have the greatest collection in the country." If Frick accumulated the "greatest" collection, Carstairs knew he needed to set himself to the task.

"I am not only satisfied; I am delighted!" Gutekunst replied. "You have done very well my son & we can do with this money, by Jove! Frick will never regret *that* purchase!" To this he added: "*Do* make him buy the Hoppner & Bembo. When those 2 are gone I shall get drunk twice over!!" He understood Carstairs's strategy. "I am delighted at Frick's interest in such a case & the nice way in which he seems willing to assist you & you us. It is most valuable, it is everything to have such a man."

Yet Frick was a temperamental and difficult client, who made his

own decisions about each painting he purchased, sometimes after borrowing a picture for months. "I look on you as a great expert," he told Roger Fry, but "prefer to make up my own mind as to what I want in my collection."

Nevertheless, Frick's collection depended upon the collaboration between the collector and the dealers Charles Carstairs and Otto Gutekunst, who sought out pictures, acquired them, and persuaded him to buy them. Replacing Berenson, Carstairs became Gutekunst's conduit to the American market, and together they proved a shrewd and stable team, bound by mutual trust and respect, who risked their capital to acquire masterpieces. Frick's collection reflected not only his own taste, but the taste and entrepreneurship of his friend Carstairs and also of Gutekunst, who deliberately stayed in the background. Where Berenson shrank from acknowledging to Gardner any debt to Colnaghi, Carstairs treated the London dealer as an equal and revealed to Frick he was a partner in many transactions. At one point in 1911, Carstairs and Gutekunst (who seems never to have visited the United States) talked about merging the London and the New York galleries.

Inside information on the buying and selling of pictures was critical to a dealer's success, and Carstairs and Gutekunst traded it freely. When Carstairs was in New York, Gutekunst jammed his letters with news of the London market. "Sulley sold his Vermeer which belonged to him with Wertheimer to a friend of ours in Berlin [for] 16,000 through Bode)!!" he wrote in February 1906. "I have been pondering over the Ashburton pictures," he reported the following year. "I do not know of course what is now remaining but the collection has been I hear more or less picked over here & at Berlin." He ran matter-of-factly through their accounts. "I sincerely trust & hope with you, that the March and subsequent bills will be paid, for the monies now & later due by your firm represents practically all the funds from which we can meet our forthcoming liabilities." In addition, "we have had to miss a number of very tempting purchases which presented themselves lately." He often gave advice. "I find that unless a picture is well set before the public and well written up the amateur [collector] is so ignorant that he is not impressed or sufficiently artistically warmed up."

More and more, the dealers felt the pressure of time. If Gutekunst learned of a picture that might be for sale, he wanted to get ahold of it before word leaked out to rivals. Once they purchased a canvas, they sought to unload it as quickly as possible, as the amount of capital at risk kept rising. The Old Master trade began to operate at a quickened pace, driven by the volatile and cutthroat nature of business in the industrial age—a rapid tempo to which the veterans of American industry like Frick were more than accustomed.

The Knoedler dealers kept up constant correspondence among their branches in London, Paris, and New York. And at the top of the first page of each letter, they wrote the name of the steamship on which they planned to send the mail across the Atlantic. These evocative names—*Mauretania, Lusitania, Umbria, Campania, Baltic, Olympic, St. Louis, La Lorraine, Kaiser Wilhelm der Grosse*—gave their international communication not only a sense of urgency but also glamour. "It is nearly 6 o'clock, but I must write you a line by this steamer," Carstairs told Gutekunst, on January 10, 1911. (From London, letters were rushed to the ports of Southampton or Liverpool; from Paris to Le Havre.) Often in even greater haste, they communicated by cable, ensuring that news would cross the Atlantic overnight. Cables to collectors about paintings pressed the case for their artistic importance and for the fleeting opportunity to possess them.

By 1905, Gutekunst had set his sights on finding Frick a major Rembrandt. He hadn't given up on Lord Lansdowne's *The Mill*, for which he thought even Bode's budget-conscious German museum would give $300,000. ("Before I speak to anyone do you want it?" Carstairs asked Frick.) Meanwhile, Gutekunst went after the equally legendary "Youssoupoff Rembrandts," the pair of portraits—*A Gentleman with a Tall Hat and Gloves* and *A Lady with an Ostrich-Feather Fan*—that had been among the revelations of the 1898 Amsterdam Rembrandt retrospective and the London *Times* described as "of immortal, unchanging interest." At that moment Edmond Deprez had just returned from Saint Petersburg, where he had tried to buy them. "We would stamp F's collection for once & all," Gutekunst wrote. Characteristically, he

gave Carstairs a rundown of paintings that Deprez had seen in Saint Petersburg. "2 Rembrandts, a fine Boucher worth 4000–5000 pounds & a van Dyck of the *supremest* Genoese quality & period: a full length lady in blue!!!"

But soon after, Gutekunst began to fret about the risk involved in purchasing the far-off and high-priced Russian Rembrandts. "Naturally if he [Frick] takes them and pays us a commission, we will have to stand back of him in event of the pictures not being as fine as recommended or as in good condition as they should be and we would have to be justly responsible to him for the money." He needn't have worried. Deprez returned empty-handed. Soon, however, as Gutekunst cast his telescope about the European landscape, another Rembrandt came into his view.

The Ilchester Rembrandt

On November 5, 1906, Charles Carstairs cabled Henry Clay Frick from London:

JUST CONCLUDED PURCHASE GREATEST REMBRANDT PORTRAIT OF HIMSELF EXISTING SEE ROLAND FOR PARTICULARS AND CABLE DECISION CARSTAIRS.

The "greatest Rembrandt" was a large, late self-portrait, signed and dated 1658, when the artist was fifty-two, and at what many believed to be the height of his powers. For almost one hundred years, the portrait had been in the collections of the Earls of Ilchester, who had hung the canvas in its gilded frame over the mantel in the drawing room of their vast house at Melbury Park, their countryseat in Dorset, one hundred miles southwest of London.

For four months Otto Gutekunst had been negotiating with Giles Fox-Strangways, the 6th Earl of Ilchester, to acquire the Rembrandt portrait and completed the transaction that day. Gutekunst and Carstairs had agreed to invest in the picture together—as they often did with canvases that they otherwise could not afford. Together they paid 31,000 pounds or $155,000, a substantial sum, exactly equivalent to the

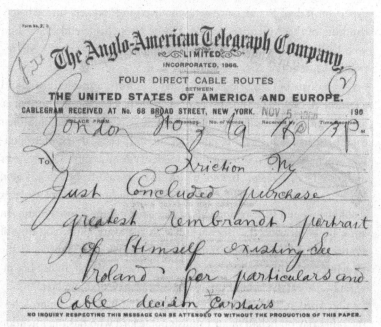

The Anglo-American Telegraph Company
LIMITED
INCORPORATED, 1866.
FOUR DIRECT CABLE ROUTES
BETWEEN
THE UNITED STATES OF AMERICA AND EUROPE.
CABLEGRAM RECEIVED AT No. 68 BROAD STREET, NEW YORK. NOV 5

Just Concluded purchase greatest Rembrandt portrait of Himself existing See Roland for particulars and Cable decision Carstairs

NO INQUIRY RESPECTING THIS MESSAGE CAN BE ATTENDED TO WITHOUT THE PRODUCTION OF THIS PAPER.

Charles Carstairs in London cabled Henry Clay Frick in New York about the Ilchester Rembrandt immediately after acquiring it with Colnaghi's.

1904 operating budget of the Metropolitan Museum of Art. The dealers risked their own capital, certain of the Rembrandt's market value and betting on a high financial reward.

Immediately after cabling Frick, Carstairs telegraphed instructions to Knoedler in New York: "REMBRANDT SURE. GIVE CLAY FIRST OFFER." He also advised Knoedler to ask Frick for $225,000, a sum more than twice the $100,000 that Isabella Stewart Gardner had spent on Titian's *Europa* a decade before.

For Carstairs and Gutekunst, gaining possession of the famous Rembrandt was in itself an entrepreneurial feat. Henry Fox-Strangways, the 5th Earl of Ilchester, had died in December 1905, and his son Giles faced steep inheritance taxes, which the British government began to levy in the 1890s. Aware of high prices recently fetched by Old Master pictures, the earl rightly saw the family's Rembrandt as a major asset, which might quickly generate cash. Early in 1906, Fox-Strangways got in touch with Herbert P. Horne, an English architect, designer, and

expert on Italian Renaissance art, who lived in Florence. Immediately thinking of the American market, Horne wrote his friend Roger Fry, who had recently been appointed Curator of Paintings at the Metropolitan Museum of Art.

A graduate of Cambridge, Roger Fry was forty, a painter, critic, and a leading figure in the Bloomsbury circle. He had established himself as an expert on Renaissance art with a book on Giovanni Bellini. That month, he had launched his gallery of "masterpieces," at the Metropolitan, where he hung several of the late Henry Marquand's Old Masters and also Titian's *Pietro Aretino*, which he borrowed from Frick. Later, Fry's fluent and persuasive writings on Cézanne and other modernists would help build their reputations in England and the United States. In 1910, he introduced the British public to the avant-garde painting of France with the groundbreaking London exhibition "Manet and the Post-Impressionists," which, according to Virginia Woolf, in her Fry biography, threw the public "into paroxysms of rage and laughter."

On April 19, Horne informed Fry that he had been "approached the other day on behalf of an English noble lord who has the intention to apply to the courts for permission to sell a certain famous Rembrandt (a portrait of the painter by himself)." He asked: "Is it likely that you would care to consider it for the Museum, or for one of your collectors in America?" He also requested that Fry "not speak of this matter to any one." But Fry, who was in New York through mid-April, didn't answer Horne's letter.

A month later, on May 14, Horne wrote to Fry again. This time he identified the Rembrandt's owner as Lord Ilchester, "who has just succeeded to Holland House, Melbury, & c. It is he, who wishes to sell his Rembrandt, in order to pay death duties. The picture—a portrait of Rembrandt by himself—has been reproduced in the big German book on Rembrandt, and elsewhere. I have never seen it, but am told on good authority that it is very fine." By now, Horne learned that Fox-Strangways had given the London collector Herbert Cook the right of first refusal on the Rembrandt, and "has already said something about it to Agnew, and another dealer." Horne continued to press his own case: "You would no doubt do much better dealing with him [Fox-Strangways] direct, or thro' your own agent, than by waiting till it gets into Agnew's hands,—

should it prove a picture which you might care to buy. If you would let me know by return, I could arrange the matter with Lord Ilchester before he leaves here at the end of next week."

On May 17, Fry replied, but with little enthusiasm: "Although our funds are not likely to enable us to purchase the picture immediately, it would certainly be worth while for you to meet Lord Ilchester and discuss the matter." (Fry had purchased fifty-six pictures for the Metropolitan in 1906 and reported to his wife on April 13, "I've spent all my allowance on pictures for the whole year.") Could it wait until the end of June, Fry wanted to know. Even if he had exhausted the Metropolitan's picture budget, the curator realized he could try to interest the museum's president, Pierpont Morgan, in acquiring the painting. The following week, Horne met with Fox-Strangways and his wife, who had come to Florence. To keep his hand in the fire, he persuaded the earl not to "turn over the picture to the tender mercies of Agnew." Soon after, Fry told Morgan that Lord Ilchester would be willing to sell the Rembrandt for £30,000. The banker had countered with a lower bid, which was refused. "I showed Mr. Morgan . . . [the Ilchester] Rembrandt and told him that it was of the highest importance to the museum," Fry later wrote, "and that now was the time to redeem the promise that when I found something really big he would raise a subscription. The only result was that Mr. Morgan tried . . . to acquire it himself."

At this point, Otto Gutekunst jumped into the fray. Failing to get the price he wanted from Fry and Morgan, Fox-Strangways now gave Gutekunst and Carstairs permission to see his celebrated Rembrandt. Carstairs arranged to visit Melbury on July 17. He was excited. According to a catalog, the Dorset house had over 150 paintings lining its two drawing rooms, dining room, morning room, smoking room, library, bedrooms, sitting rooms, and dressing rooms, as well as its pantry, saddle room, harness room, and the passages between.

On paper, the Ilchester Rembrandt had attributes that Carstairs knew would appeal to Clay Frick, including an aristocratic provenance running back to the 1730s when Stephen Fox, the 1st Earl of Ilchester and a Whig member of Parliament, acquired the picture. Although it was not clear what had happened to the *Self-Portrait* in the seven decades between the time it had left Rembrandt's Amsterdam studio and

the time it reached Fox, Bode and other Rembrandt scholars did (and would) not question its authenticity.

At first glance Carstairs understood why. He recognized the *Self-Portrait* as of a totally different order than the lackluster example of Rembrandt that Frick already owned. Bode's complimentary appraisal of the portrait as the "the most dignified of all Rembrandt portraits of himself" only hinted at the painting's extraordinary power. At Melbury House, Carstairs found the painting in the drawing room—high on the wall over the fireplace—facing French doors opening onto a lawn that descended to a lake.

The dark *Self-Portrait* dominated the light-filled room. It is an atmospheric picture of rich blacks, deep browns, and effects of chiaroscuro. The artist is wearing a round, black velvet cap and a robe with shimmering pleats of gold, the vertical strands of paint running across his chest evoking the fabric and arming him as though with a breastplate. His massive pyramidal presence fills most of the canvas. He portrays himself not as a painter, but as a ruler, or elder statesman, seated on a wooden chair, as though on a throne, and holding a staff, or scepter—a man of weight, wisdom, and power, ideas conveyed also in the seriousness of his inelegant, aging, worldly face. Although measuring only three feet by four feet, the three-quarter-length portrait seems, with its ornately carved, gilded frame, much larger—and the artist seems larger than life. He has placed himself against a background of black that envelops the upper half of the canvas. Gold light rakes down, illuminating his face and hands, as well as the painted architecture of his garments. A sash of china red crosses twice over the torso, igniting the ornamental glory of the costume, signaling the sense of force that comes through in the hands thrust into the foreground, one in each of the lower corners of the picture. The right hand emerges from a sleeve composed of bold brushstrokes of white. The left hand holds the staff, its long capable fingers pulling slightly to keep it in place. The artist painted this portrait the year he declared bankruptcy; the virtuosity of the painting technique embodies and announces his resilient genius, through the sheer lushness and melancholy grandeur of his creation.

Returning to London, Carstairs immediately sat down and wrote

Roland Knoedler. By then Otto Gutekunst had agreed to pay 31,000 pounds for the Rembrandt and the earl had tentatively accepted Colnaghi's offer. "I have just been this morning to see Lord Ilchester's great portrait of Rembrandt by himself. . . . It looks as though we ought to get it," Carstairs told Knoedler. "We will have to deposit tomorrow morning 31,000 pounds to her ladyship's account." Carstairs referred Knoedler to the painting's entry in Bode's catalog, to identify the picture. "This Rembrandt appears to me as monumental, much greater than the Russian pictures [the Youssoupoff Rembrandts] & a picture for a big price."

Carstairs had been cultivating Frick's taste for "masterpieces," and the Ilchester Rembrandt more than embodied the sort of painting he had in mind—what Gutekunst irreverently called "Angel's food," or "Big-big, big game." The purchase of this well-known English Rembrandt would remove any question of Frick's Pittsburgh provincialism and put him on an equal footing even with Isabella Stewart Gardner and Pierpont Morgan, as a player with not only the money but also the discrimination to compete for the most highly esteemed Old Masters—the canvases at the very top.

Carstairs and Gutekunst now tried to persuade Fry to leave the Rembrandt to them: "CAN YOU COME LUNCH TOMORROW. IF NOT WHEN WILL YOU CALL. VERY IMPORTANT," Gutekunst cabled Fry on July 17. That same day, Fry explained to Gutekunst that he "had Lord I's verbal promise not to sell without letting me know." Learning that Colnaghi had offered £31,000 for the Rembrandt, Fry gave Morgan another shot.

HAVE BECOME CERTAIN THAT THERE IS NO CHANCE OF GETTING THE REMBRANDT AT PRICE YOU MENTIONED. UNDER THE CIRCUMSTANCES I SUPPOSE THERE IS NO HARM IN MY BRINGING IT TO NOTICE OF A POSSIBLE AMERICAN PURCHASER.

Fry either knew or guessed that Frick was Knoedler's client, and may have hoped to persuade the tycoon to purchase the painting for the museum.

But, now Morgan suddenly decided he did in fact want the picture. "WILL TAKE THE REMBRANDT AT PRICE YOU MENTIONED PAYABLE AFTER MY ARRIVAL IN NEW YORK. NO TIME TO ARRANGE NOW," he cabled Fry from London on the seventeenth.

The following day, Fry met with Carstairs, Gutekunst, and Deprez at Knoedler's gallery at 15 Old Bond Street. His aim was to acquire the Rembrandt for the Metropolitan. For their part, the Colnaghi and Knoedler dealers wanted neither to give the painting up to Fry and Morgan nor be forced to pay more than they had negotiated. Compromising, they agreed that if Fry matched their offer, they would sell it to the Metropolitan and forfeit their regular commission. On July 18, Fry cabled Morgan that he and the London dealers had reached a settlement that effectively left the banker out:

IT WAS AGREED BETWEEN GUTEKUNST, CARSTAIRS, DEPREZ AND MY-
SELF AT KNOEDLERS AT 6 PM THAT THEY WOULD LET THE MUSEUM
HAVE IT FOR THEIR COST PRICE £31,000. *BUT THE MUSEUM ONLY.*

They telegrammed this information to Ilchester.

That same day Fry sent Morgan a second cable, explaining more fully the circumstances, which might still enable them to obtain the Rembrandt for the museum.

YOUR WIRE CAME TOO LATE YESTERDAY EVENING. A FIRM OF
DEALERS OFFERED THIRTY THOUSAND FOR REMBRANDT. LORD
ILCHESTER ACCEPTED VERBALLY.

Fry reported he had seen the dealers that day:

THEY ARE WILLING OUT OF CONSIDERATION OF THE MUSEUM TO
HAND IT ON WITHOUT PROFIT PROVIDED IT IS FOR THE MUSEUM
AND NOT FOR ANY PRIVATE BUYERS. THEY ALSO HAVE TO REALIZE
ONE THOUSAND PAID AS COMMISSION. I ASSURE YOU THAT COM-
PARED WITH OTHER IMPORTANT REMBRANDTS THIS IS STILL REA-
SONABLE AND THINK THE MUSEUM OUGHT THR' YOU TO ACCEPT
OFFER. MONEY MUST BE PAID QUICKLY AS THE DEALERS WILL BE
OUT OF POCKET.

On July 19, Carstairs acknowledged to Roland Knoedler, in New York, that their purchase of the Ilchester portrait was far from certain.

"There are a great many complications about the Rembrandt. They have agreed to sell it to us but have to get an order of court & are certain someone may overbid us and we may lose it," he explained. He kept the details of the complications from Knoedler and only mentioned that Pierpont Morgan and Roger Fry were "after" the painting. Carstairs downplayed his worries over the deal he had struck with the Metropolitan's curator. Morgan and Fry "have withdrawn in order not to run the price up and we on the other hand have promised to hand [it] on to the Metropolitan without profit," he reported. "We will merely get a little glory. There was nothing else we could do." Nevertheless, he noted, "the Metropolitan may not be able to arrange [it]. This is our only hope."

About a week later, that hope was realized when Fry cabled Deprez at Colnaghi's:

MR. MORGAN WIRES ME THAT HE WILL DO NOTHING FURTHER IN
THE MATTER OF THE REMBRANDT. I REGRET THIS BUT IT LEAVES
YOU ENTIRELY FREE.

"Their chance disappeared & one can have the picture," Carstairs later told Knoedler. Morgan is "unfortunately a man of many moods," he added. But, it took months before he heard any news from Ilchester. "The Rembrandt matter comes up Monday next for decision and I think before you get this letter the picture will be ours," Carstairs wrote Knoedler on November 2. He conveyed his certainty about the picture's value, claiming he "would not have hesitated a moment at [paying] 40,000 pounds ($200,000)" for it. Problematically, Morgan had returned to New York. "I don't think it matters that Morgan has spoken to Frick." But he knew it might, as the banker probably told his friend that the dealers had paid 31,000 pounds ($155,000) for the Rembrandt. (To that they added the 20 percent tariff, bringing the picture's cost to $186,000. If the painting had gone directly to the Metropolitan Museum, the tariff would not have applied.)

"We [Colnaghi and Knoedler] must have "$15,000 each," he explained to Knoedler. If they charged Frick $215,000, "prompt cash.

Money cable," he reasoned then Knoedler could make close to the $15,000 and avoid the added cost of borrowing from a bank at "8% about." But, if Frick refused to pay immediately, "we must have $225,000." Only two months before, the collector had spent $275,000 on two English portraits—*Lady Harcourt* and *Selina, Lady Skipwith*—by Sir Joshua Reynolds. Even at $250,000, Carstairs asserted, this Rembrandt would be "cheap," and he sniped, "less than Morgan paid (if duty is considered) for his Lawrence 'Miss Farren.'" That the banker recently spent $200,000 for the full-length English portrait but lost interest in the Rembrandt mystified the American dealer. "I don't think anything further need be said about his judgment, for the Rembrandt is certainly worth 3 times as much." Finally, on November 5, Carstairs learned that he and Gutekunst had won the picture and immediately told Knoedler that the Rembrandt was theirs.

A day later, Frick received Carstairs's cable about the Ilchester portrait in New York. Following Carstairs's instructions "to see Roland for particulars," Frick telephoned the dealer at the Fifth Avenue gallery. On the phone, Knoedler repeated to Frick the figure Carstairs had named in the cable: $225,000. Frick's response was blunt and dismissive; he snapped that he did "not want to be bothered with pictures at these times."

Well acquainted with his volatile client, Roland Knoedler stopped by the Vanderbilt house the next day. "He was very nice, but looking around, said he had bought sufficiently, & that *even at cost* he would not be interested in it," Knoedler reported to Carstairs.

"I am sorry Clay is not in the mood," Carstairs calmly replied from London. "It is a great picture and one that he will regret not owning in years to come." He added, "I realize he has bought a great deal." Characteristically, Carstairs resolutely refused to acknowledge that Frick had dealt a blow, and M. Knoedler & Co. didn't have enough capital to hold on to the picture until the tycoon changed his mind. Works of art had their highest value when fresh to the market. If it became widely known that Frick had rejected the Rembrandt, the dealer might have difficulty selling it to someone else. In the small, overheated art world, news spread faster than in the past. Even a nearly perfect Rembrandt could become damaged goods. "Mr. F must keep the price absolutely

secret as we may conclude to ask much more for it. It is a wonderful purchase. I think the Berlin Museum might give a great deal for it."

Already rumors were flying. Bernard Berenson had heard that the portrait's buyer was Isabella Stewart Gardner. "I told you I was going to find out whether you had bought the Ilchester Rembrandt," he wrote Gardner. "The scandal regarding it almost rivals the Marlborough affair. It seems Ilchester sold the picture on the assurance it would not go to America. And he has heard that you said to somebody in Italy that you were stony broke because you had just bought his Rembrandt. . . . It looks as if you had bought it—and I heartily congratulate you, for it is one of the crack pictures of that over-admired Dutchman."

At some point, Carstairs had promised a right of second refusal on the Rembrandt *Self-Portrait* to Scott & Fowles, a gallery in New York, but he waited two weeks for Frick to come around. Finally, on November 23, Carstairs cabled Scott & Fowles: "Am in position to offer you Ilchester Rembrandt are you interested." He held to the $225,000 price, and agreed to give them "four months" to pay. That same day, Scott & Fowles dealers declined the picture.

Even now, Carstairs and Knoedler refused to give up on Frick, hoping he would purchase the Rembrandt and pay full price. Knoedler wrote him a letter. Although Frick seems not to have answered, he did invite the dealer to come and see the mansion he had just finished building on a bluff over the Atlantic, in Prides Crossing, the New England watering place on Boston's North Shore where Isabella Gardner had a house. The "trip to Prides was delightful. Beautiful weather-golf-walking-driving, fine bracing air," Knoedler reported to Carstairs on November 23. And, at some point, "Frick asked what had become of the Rembrandt."

Not long after, back in New York, Frick stopped by Knoedler's, wanting to see Bode's Rembrandt book, so he could study the black-and-white photograph of what he referred to as "that ridiculous priced picture." The five-by-eight-inch grayish photograph gave a ghostly and diminutive glimpse of the Rembrandt; but the tycoon offered Knoedler $200,000 for it—"one hundred thousand cash & one hundred, delivery of picture." Frick had confessed that he never thought that "he would have made the offer."

Relieved and delighted, Carstairs and Knoedler wanted to accept Frick's $200,000 in cash. But in London, Gutekunst disagreed, arguing that he could get the same sum from his own client in Berlin and expected more from the American market. Gutekunst's rebuff strengthened Carstairs's resolve. "Colnaghi refuse," he wrote Knoedler. "Will consent sell Clay 225,000. Otherwise . . . advise holding for $250,000."

In fact, Carstairs was of two minds: "I did my best to influence them [Gutekunst and Deprez] to accept it," he told Knoedler, "but I can't help but think it absurd to sell this great picture for so little profit & I would love dearly to see our good friend F have it but . . . it is not beyond the bounds of chance to have such [a] picture sell for 300 or even 4 hundred thousand dollars."

Problematically, the Rembrandt was still hanging at Colnaghi's in London, and Frick had yet to lay eyes on it. On November 23, Carstairs himself launched an assault on behalf of the Rembrandt, in a letter he tailored to change the mind of the stubborn Frick. He began by stating simply that the *Self-Portrait* represented "Rembrandt at the zenith of his powers." He claimed to regret "having been unsuccessful in arranging the purchase of the Rembrandt for you at $200,000." Mostly, however, the art dealer focused on the painting's monetary value, citing evidence that this particular Rembrandt canvas was worth considerably more than the $225,000 he was asking. "I should imagine . . . you consider it expensive," he wrote Frick. "In this you are mistaken, for it is the greatest single portrait existing."

Carstairs cited rising prices. The Rembrandt that Frick had turned down in 1900 for $55,000, the dealer now claimed was worth $150,000. In Amsterdam, the owners of the famous *Jan Six*, a "somewhat smaller picture than ours," had been offered 80,000 pounds ($400,000). "This," he asserted "is the value of our picture." With characteristic candor, he spelled out the financial situation the gallery faced:

"We must have a profit out of such a picture for after all a fine Rembrandt is the rarest and most saleable thing in the world & we have done no end of work getting it and had to keep the payment of it for over 4 months in mind when we might have used our money more advantageously from the standpoint of profit. I recognize my duty toward you & am trying to fulfill it and in advising you to take this

picture at $225,000. I put myself on record and want you to remember my advice in the future."

Finally, he turned to the substance of the painting, and what it would mean to Frick: "If you could only see the picture over your mantel dominating the entire gallery just as you dominate those you come in contact with, you wouldn't let it pass for $500,000." He concluded, "I can't imagine a more suitable picture for you." Shrewdly he invoked Wilhelm von Bode, explaining that Gutekunst was "wiring to send the picture to Berlin where he thinks he can sell it for £40,000—probably to the Berlin gallery." Nonetheless, he promised to reserve the Rembrandt for Frick until Wednesday, December 5.

On Monday, Frick telephoned Knoedler and asked to see him. Frick mentioned that "Fry had praised" the Rembrandt, and stated to the dealer that "for such a fine work, the question of price for a man like him was a secondary matter, etc." Nevertheless, he still refused to pay $225,000. Knoedler stood his ground: "I said no," he told Carstairs.

"Well," Frick replied, "I suppose I ought to have the picture."

Roland Knoedler was jubilant. They had battled with Henry Clay Frick and had won. But within days the dealers realized that Frick in fact had not ended negotiations: he wasn't going to pay for the picture now. Instead, he would wait until June 30, six months away. Knoedler requested Frick to compromise, asking if he would pay on "April 30," the day the gallery closed its books. Frick shot back: "It depends on how much I like the picture."

Beholden to the steel tycoon, Knoedler had little choice but to accept Frick's terms. On December 6, Roland wrote: "The Ilchester Rembrandt sold to you for Two hundred & twenty five thousand dollars payable June 20th next." Ever hopeful, he added "or April 30th if you wish." By December 15, the Colnaghi handlers packed the picture in a crate and shipped it to Le Havre, where it was to sail for New York. By Christmas, the canvas took its place in the Vanderbilt mansion.

Suddenly, Frick began negotiating again. To pay for part of the Rembrandt, he would return Jules Breton's *Last Gleanings*. Although he had paid $14,000 for the French picture eleven years before, he calculated it was now worth $25,000. Thus Frick knocked down the cost of the Rembrandt to exactly as much as he had originally wanted to pay.

In his mind, he had prevailed. That, in fact, the collector paid the $200,000 for the painting on January 16, well before the June 20 date he had negotiated, suggests just how pleased he was. Face-to-face with the extraordinary canvas, Frick recognized that Carstairs in his effusive praise had hardly exaggerated.

In the end, Frick paid Knoedler a commission of only $7,500, or half the minimum that Carstairs had hoped for. Nevertheless, Carstairs insisted on taking the long view and saw the Rembrandt sale as a triumph. "I was delighted to get your cable & to know Frick was pleased with the Rembrandt but how could he be otherwise. He certainly has one of the great pictures of the world. & I should say the greatest in America all things considered."

But the Knoedler dealers struggled to cope with financial problems caused by their best client, who saw paintings as investments. They quickly became familiar with Frick's tactics. When Gutekunst was negotiating for the Youssoupoff Rembrandts, Carstairs warned him not to reveal in his correspondence how much he would actually pay for the pictures: "If you cable cost of Rembrandts, include the commissions so I can show him the cable & ask him [Frick] for 20% above that." In February 1906, Carstairs was pressing Frick to buy Joshua Reynolds's *Lady Harcourt* for $110,000. "Frick is very much interested and offered $100,000 which I of course refused," he told the dealer W. D. Lawrie. "He says nothing more and asks all sorts of questions. I told him we bought it. A/C [joint account] with you. He is not an easy man to sell & has many moods." When earlier Knoedler offered Frick Turner's seascape *Antwerp: Van Goyen Looking Out for a Subject* for $90,000, the dealer felt compelled to explain: "I know that you would approve of our profit. In fact I am inclined to think that you would say that we are entitled to a larger percentage on such an exceptionally fine work." Nevertheless, for the Turner, Frick paid only $80,000. After Frick agreed to buy a pair of pictures at what Carstairs believed was below the market, he fretted that the collector would manipulate the price down further. "These were my prices to him at which he took them without making an offer," he told Knoedler. "Therefore, I cannot tell just when we will be paid, as sometimes when I refuse to accept his offers he takes it out by keeping us waiting."

M. Knoedler & Co., like many galleries, was undercapitalized and struggled against a chronic shortage of liquid assets. The dealers sold most of their paintings in the summer "principally to Americans" and delivered the pictures in the fall, when they were paid. "The nature of our business, owing to the character of our clients, is such that we cannot ask for money owed us, neither can we force sales," Knoedler explained to a banker. The dealers constantly searched for sources of capital and periodically went into debt. "Money is scarce and coming in very slowly," Knoedler's Henry Thole wrote Carstairs. On July 10, 1906, three days before a $49,000 payment to the French dealer Trotti was due, Carstairs asked Frick if he would pay the $65,000 he owed the gallery. Two days later, the Knoedler dealers anxiously awaited the check but "were disappointed." The next morning they arranged to borrow $150,000 from First National Bank. By the "second mail," Frick's check arrived.

The Knoedler dealers also depended upon Frick for capital. In 1902, he loaned the gallery $100,000 at 6 percent for 90 days, a note which was renewed in January 1903 for four months. In March, the dealers repaid him. "I have been kept very busy and have already been to Holland & to England & find good pictures very scarce and higher than ever," Knoedler wrote. A month later, he again borrowed money from Frick. "I do not like to miss opportunities of gathering good things which is the reason I trouble you as my capital is not large enough for the business we are doing."

By January 1, 1907, Frick had moved the Rembrandt *Self-Portrait* to his dining room, where, Knoedler told Carstairs, "it looks superb." When added to El Greco's *St. Jerome* and Titian's *Pietro Aretino*, the Dutch portrait gave Frick a small gallery of "Great Men," befitting a collector who believed himself and wanted others to see him in such a company. In fulfilling Frick's ambitions for masterpieces, the Dutch painting tightened his partnership with Charles Carstairs and secured the dealer's place as the collector's most trusted art adviser.

On February 18, Carstairs wrote Frick from the Hermitage Hotel in Monte Carlo. "I appreciated your cable New Year's time & I am

delighted you are so pleased with the great Rembrandt, it will always be a great joy to you & we were all very lucky to have it." The Rembrandt sharpened the dealers' focus. "Carstairs' recent remark that it was much better to confine ourselves to fine pictures is absolutely true," Roland Knoedler wrote to a colleague in Paris. "For instance, we have just now too many small Diazs and it seems difficult to get people interested in them."

Frick did not have to wait long for tributes to start pouring in. To announce his new acquisition, he put it on public display—loaning it to the Metropolitan Museum of Art for the summer. Two years later, he seized the chance to place it center stage, at the New York museum, in a major exhibition of Dutch art organized by Wilhelm Valentiner, a Rembrandt expert and Bode protégé from Germany, whom Morgan appointed as the museum's curator of decorative arts. The Dutch paintings show (along with an exhibition of American decorative arts) had a patriotic purpose—to celebrate the discovery of the Hudson River and also Robert Fulton's "first use of Steam in the Navigation of Said River." Intent on showing America's rich and recently gotten holdings of Dutch paintings, Valentiner borrowed 6 Vermeers, 20 Frans Hals, and 37 Rembrandts from private collections. He estimated that there were now 70 Rembrandts in the United States, of which 65 were portraits. "No such resplendent show has hitherto been made in this country, and in all probability it will be many a year before anything like it is organized again," wrote the critic Royal Cortissoz in the *Tribune*.

Valentiner described Frick's Rembrandt as "supreme," gave it a prominent place in the Metropolitan, and reproduced it on the cover of the museum's *Bulletin*. Now Frick ranked with Morgan and Benjamin Altman as collectors of Rembrandt, singled out even in this enviable company as possessing one of the artist's very best pictures. "If there are two Rembrandts here which more than any others might be chosen as revealing the full height of his genius, they are the 'Portrait of Himself,' the majestic canvas of 1658 lent by Mr. Frick, and Mrs. Huntington's solemn 'Savant' [*Aristotle with the Bust of Homer*]," Valentiner wrote. "One thinks of Michelangelo in the presence of the two portraits, of his largeness of form, his way of lifting the human body on to a plane of high imaginative significance."

If this was the first time Frick was lauded for his fabulous taste, his sense of discrimination, his ability to choose fine paintings, it would not be the last. As years went by and the canvases heaped up, Frick's pattern of buying only portraits and landscapes would never change. He had little interest in subjects from history, mythology, or religion. He never acquired a picture of a nude. In 1911, Carstairs left two Veronese allegories, *Virtue and Vice* and *Wisdom and Strength*, in Frick's house for weeks, waiting for the collector to decide whether to buy them. The figures are dressed in Renaissance costume and one of the women (Wisdom) has a bare breast. Finally, after Roger Fry endorsed the paintings, Frick agreed to their purchase.

If in matters of taste Frick followed other collectors, rather than lead, he was a follower with the keenest gaze and he learned fast. He watched what others were buying and refused to be bested. Where Isabella Stewart Gardner dreamed of owning certain paintings and sent Berenson on their trail, Frick rarely asked dealers to go after a particular picture. He could afford to wait. Like all influential collectors, he fielded constant offers. Once he began amassing visible, expensive pictures, dealers gave him chances to buy others of the same caliber. Some of Frick's outstanding pictures came to him because circumstances sent them his way and eventually he bought them. He insisted that the process of selecting pictures be measured and deliberate. Dealers hung paintings on his walls and let him live with them, as he stood back and considered whether to purchase. "He seemed to lavish on art all the passion that he might have bestowed on human beings," Charles Schwab observed.

The character of Frick's collection reflected in various ways his brilliance as a businessman, evolving from his method of buying and his shrewdness as a negotiator. While he spent millions on art, he constantly tried to acquire as cheaply as possible. Famous for cutting production costs at Carnegie Steel, Frick haggled over the prices of pictures, consistently refused to pay what the Knoedler dealers asked, and seems never to have paid a record price. Without fail, Frick based much of his final decision to purchase a painting upon what it cost. "He is really taking a very great interest in Art," Charles Carstairs wrote Otto Gutekunst in 1905, "but has an idea that picture dealers want too much money or rather too much profit & he is a born trader

and a close buyer & a d——— smart man, much more so in that way than Morgan."

In contrast to Gardner, who disliked discussing art and money in the same breath, Frick wanted to know the financial details of a transaction. A victor in the pitiless environment of coke and steel, Frick was competitive as a collector. He watched the art market closely. Trying to persuade him to purchase a van Dyck, Carstairs noted that the collector "needs the inspiration of a rising [stock] market." He understood as well as anyone that even celebrated works of art have no intrinsic value—their market value depending only upon what collectors are willing to pay. As able as he was as a financier, he looked to experts to advise him. Not surprisingly, at first he relied mostly on dealers, who, like him, were men of business.

Periodically, Frick made long lists of his paintings, sometimes on ledger paper. Beside each title he wrote the amount he had paid for the picture—a tally of his artistic fortune. By the beginning of 1905, Frick calculated that he had expended close to $1.4 million on more than thirty pictures, including eighteen Old Masters. Within a year he added the Ilchester Rembrandt and twelve more.

Early in 1907, Frick took the first step toward constructing an appropriate setting in which to hang his new art. He spent $2.25 million on a piece of property that ran between Seventieth and Seventy-first streets on Fifth Avenue, where the Lenox Library (whose books were headed for the New York Public Library) had stood for two decades. According to the *New York Times*, Frick planned "to build a home which shall rival, if not outclass, the Carnegie home, situated a mile further up Fifth Avenue."

Frick's buying of Old Masters became part of a methodical project to surround himself with goods of the highest quality—clothes bought in Paris, Renaissance bronzes, and a desk created by France's finest cabinetmaker for Marie Antoinette. He always loved pictures, but he also enlisted them into a campaign to shape and control his public legacy. He knew that a fabulous collection of art had the power to atone for sins, and to change the public's perception of who he was. If he had not succeeded in controlling the events that shaped his life as he had wanted to, he nevertheless would make his collection the final accounting.

PART TWO

The Painting Boom

"Octopus and Wrecker Duveen"

Joseph Duveen Enters the Old Master Market

By far the most threatening competitor Charles Carstairs and Otto Gutekunst faced was the driven, well-capitalized Joseph Duveen. "How can we stop the disastrous work of the . . . Octopus and wrecker Duveen? I don't know," Gutekunst wrote Bernard Berenson in 1909. Gutekunst did not realize that Duveen had already lured the connoisseur into his fold.

Joe Duveen dressed like a gentleman even if the roughness of his features jarred with the pristine cut of his starched white four-inch collar. His legendary optimism and energy comes through in a photograph, where his tight-lipped smile echoes the jaunty curve of the brim of his hat. He was "smooth, immaculate," and his "well oiled courage knows no defeat," wrote the collector Archer Huntington, who resented the dealer's ability to persuade his mother, Arabella (widow of Collis Huntington, who ran the Central Pacific Railroad), to spend so much on paintings.

Duveen was only a recent entrant into the Old Master market. Other dealers had tried to keep him out; in 1901 when he bought Hoppner's *Miss Manners* at a London auction, they bid it up and forced him to pay a high price for a run-of-the-mill English portrait. Within six years he had put himself in a position to dominate the market—thanks to his high levels of energy and ambition, and to the funds generated by his family's decorative arts firm.

Duveen signaled his willingness to raise capital and risk it in 1907, when he purchased the collection of the late Rodolphe Kann, a German merchant banker, who had made a fortune in South African mining and lived on the avenue d'Iena in Paris. Next door was his brother Maurice, also a collector, and a picture gallery linked the Kann mansions. Rodolphe Kann's collection contained "more stock . . . than in the whole of the [Duveen] London inventory, and it included some of the greatest pictures in the world," explained Edward Fowles, who ran the firm's Paris gallery. There were over one hundred Italian, French, English, and Flemish paintings, and an extraordinary sequence of Dutch pictures: Vermeer's *A Maid Asleep*, Gabriel Metsu's *Visit to the Nursery*, ter Borch's *Young Woman at Her Toilet with a Maid*, and eleven Rembrandts, among them *Aristotle with the Bust of Homer*.

The Kann collection cost Duveen 21 million francs or $4.2 million, which he paid to Rodolphe Kann's son, Edouard. Duveen's partner in the transaction was the French dealer Nathan Wildenstein, who (with René Gimpel, also a Paris dealer) had bought an option on the collection in 1906, and then took one-quarter share (for $1 million). To help fund the Kann purchase, Duveen, according to Berenson, borrowed $2 million from the Morgan bank, and the dealer agreed to let the banker have his first choice of pictures.

Joe Duveen was born in 1869, the eldest of eight sons and four daughters of Rosetta Barnett and Joel Joseph Duveen, a Dutch Jew who the year before had emigrated from the Netherlands to Hull, a town on the English channel. By 1879, Joel Duveen had opened a gallery on Oxford Street in London and was dealing in all manner of decorative arts—from porcelain (imported from Holland), to bronzes, chandeliers, furniture, and tapestries. At the same time, Joel's younger brother Henry launched a branch of Duveen Brothers in New York, on Broadway and Nineteenth Street. "I like amerika [*sic*] very well," Henry wrote. "It is a first-class money-making country. It is a fine rich country. It beats England in everything."

Joe Duveen went to work for his father in London in 1887, when he was eighteen. By 1893, Joel had moved the London gallery to 21 Old Bond Street, and in 1897, he opened a branch in Paris, at 20 Place Vendome, near the Ritz. Henry Duveen had much to teach his nephew

Joseph Duveen ca. 1900. Jumping into the Old Master market a year later, the dealer soon became a dominant player.

about marketing decorative arts to affluent Americans who were building enormous houses with many large rooms to fill. In addition to original eighteenth-century furniture, Henry sold reproductions, churned out by craftsmen in Paris. By the 1890s, so great was the American appetite for the newly minted antiques imported from France that, according to Edward Fowles, to meet the demand, the Duveens agreed to place "annual orders worth not less than $500,000" with the firm of Carlhian and Beaumetz "to ensure first call on its artisans."

Henry Duveen's practical commercial approach had taken the firm far. He was shrewd at appraising both inventory and clients. "I think you are making a grave mistake in showing Mr. A. [Altman] too many things," he complained to Joe. "Let him be hungry and enquire for beautiful things, and he appreciates our things because we only show him the very finest." He freely talked to collectors about the market. He told Frick he wanted him to realize "the artistic pleasure of possessing fine objects of art" but also to "appreciate the important fact, that they are also in the nature of an investment." The dealer emphasized that he had Frick's financial interests at heart. "The spending of money is all very well, but to know that you have full value for your money, and that that value tends to enhance

rather than decrease, is bound to add a little to the pleasure of posses-
sion." He also grasped Frick's competitive ambitions, promising him
that "my efforts are devoted to securing the greatest things for you so,
that your collection of art treasures may, if not eclipse, at any rate equal,
others."

In the 1890s, the Duveens sold few Old Master paintings. "It had
long been Uncle Henry's dictum that pictures were the last thing a
man buys," explained Edward Fowles. When clients inquired about
paintings, the Duveens generally sent them to Agnew's in London, or
to Jacques Seligmann, or Wildenstein, in Paris. But, when Joe Du-
veen watched Old Masters become the most expensive works of art, he
insisted on getting into the market. He "fundamentally disagreed with
his father's business methods," notes Fowles. "He, quite rightly, saw
that the time and effort involved in selling an article for a few pounds
could be more fruitfully used if the article were worth one thousand
times this amount." The purchase of the extraordinary Kann collec-
tion allowed Joe to put his business plan into practice.

To take the Kann pictures, Duveen lined up not only Morgan but
also Arabella Huntington, and Benjamin Altman, the retailing mag-
nate. Each spent at least $1 million and covered more than three quar-
ters of the price Duveen paid for the entire collection. Duveen left
Rodolphe Kann's pictures in the late banker's Paris house for over a
year, inviting potential buyers (including Isabella Stewart Gardner) to
inspect them in sumptuous surroundings. Morgan selected eleven
paintings—three Memlings, the Metsu, a Solomon Ruysdael land-
scape, van der Weyden's *Annunciation*, Ghirlandaio's *Giovanna Tor-
nabuoni*, and *Portrait of a Young Man* by Andrea del Castagno, which
Isabella Gardner had wanted to buy. Arabella Huntington acquired
five canvases, most importantly Rembrandt's *Aristotle with the Bust of
Homer*, for which she paid $315,000, making it the second most expen-
sive painting on record. She also bought a second Rembrandt as well
as Chinese vases, a Beauvais tapestry, a Louis XV desk, a sofa, tables,
footstools, a clock, and other decorative arts. Altman got three Rem-
brandts (*Titus*, *Pilate Washing His Hands*, and *Old Woman Cutting Her
Nails*), and a Pieter de Hooch, as well as landscapes by Hobbema and
Cuyp, and Vermeer's *A Maid Asleep*.

Altman, the son of a German Jewish immigrant who ran a dry goods store on the Lower East Side, was building one of the most important collections in New York. By the age of twenty-five, he had founded his own "Dry goods and Fancy Store," and eventually expanded the business into a large department store at Nineteenth Street and Sixth Avenue, which happened to be a block from Henry Duveen's first gallery. As affluent New Yorkers moved their residences north, Altman followed. At the turn of the century, he quietly accumulated parcels of land on Thirty-fourth and Fifth; his new store, well-positioned between New York's Grand Central and Pennsylvania stations, would eventually take up an entire block. The neo-Renaissance building that he opened in 1905 would become the first in a line of New York department stores running north along Fifth Avenue to Central Park. Altman was unmarried and spent most of his waking hours working at his store. He began collecting by buying Chinese porcelain from Henry Duveen—antique versions of the decorative pieces he himself imported from China and sold. In 1905, the year he built his Fifth Avenue mansion, the retailer, then sixty-five, bought his first Old Masters—Rembrandt's *Man with a Steel Gorget* and Frans Hals's *Young Man and Woman in an Inn* (*"Yonker Ramp and His Sweetheart"*).

From the start, Altman focused on seventeenth-century Dutch portraits and landscapes. This taste was reflected in Henry Duveen's comments to him, dismissing certain French pictures as "only fit for French taste, being all of a class which we call 'finicky' and effeminate, so much sought after by French people." Similarly, the dealer assured Altman he would have no interest in a canvas by the Italian Mannerist Bronzino: It is "a very fine and striking picture, but after all it is Bronzino and therefore decadent." Bronzino, Duveen instructed, "as you know is rather late as far as 'great art' is concerned, and he is not an artist whom we should consider of any very great degree of importance." Recognizing that his clients wanted paintings to decorate their houses, Henry Duveen shied away from paintings even by the most celebrated masters if they had what he considered "unpleasant subjects," such as "an ugly man with a knife in his hand," or "an interior with a woman nursing a child."

The purchase of the Kann collection in 1907 was a watershed in the

Old Master market, importing a group of major pictures to the United States and instantly elevating three American collectors to a new level of quality and spending.

Otto Gutekunst had tried to organize a syndicate to buy the Kann collection, but after losing to Duveen, he and Carstairs countered with the purchase of a spectacular group of seven Genoese van Dycks, painted in the 1620s for the Cattaneo family and left untouched in a palace in Genoa for close to four centuries. The reputation of the paintings had grown as information leaked out—"Eight beautiful van Dycks in a billiard room," as one dealer put it. Then, in 1900, Wilhelm von Bode confirmed to Colnaghi that the Cattaneo portraits were in fact masterpieces. He had found them "hanging much too high & partly in the dark. They are all very much obscured by . . . varnish and dirt. Disfigured by additions . . . and some are badly repainted," he wrote. But, several he found "extraordinarily beautiful and attractive." He declared eleven pictures "unquestionably genuine," and warned that "half a dozen Paris and London dealers" were "lying in wait." Recently, William McKay discovered that the van Dycks had been moved to an apartment that was empty most of the year: "In the absence of the family, the rooms are left in charge of a servant who for a tip will show the van Dycks." They should "be visited in the morning early," he wrote. "The light is 1/4 bad especially in the last room where some of the most important pictures are."

The most dazzling of the portraits was an eight-foot full-length portrait of Marchesa Elena Grimaldi Cattaneo, which in its scale, colors, artifice, and sense of movement and life demonstrated exactly how van Dyck had taken the lead in constructing the image of confident beauty and grandeur that Europe's aristocracy sought to achieve. *Elena Grimaldi Cattaneo* depicts a tall, magisterial figure in a long black dress that is set off by a large red parasol above her head. She seems to have just stepped onto a terrace from a portico whose fluted stone columns shoot up to the top of the frame, and she is looking out, slightly warily and downward at us. Following her is a page, who is black and dressed in a gold silk jacket, his eyes gazing up at the parasol he holds dramatically over her head. In the distance, a cultivated green landscape, below a blue sky with a tumult of

gray clouds, fills the upper-left-hand corner of the canvas. In the elongated proportions of her figure, in the assurance of her carriage and stride, and even in the graceful line of twenty-one gold buttons that delineates the curve of her torso, van Dyck conspired to convey her nobility.

In 1907, Carstairs, Gutekunst, and the Paris dealer Trotti risked close to half a million dollars to acquire the Genoese portraits, a purchase negotiated by the Colnaghi partner Edmond Deprez. It was Trotti who had removed the canvases from their frames and rolled them into a tube underneath his car to smuggle them out of Italy. He drove the pictures to Monte Carlo and then Le Havre, where Carstairs saw them and then arranged to have a conservator reline them, remove the old varnish and replace it with new. He had high hopes for the van Dycks. "If Frick took these 5 it would make them all sit up and even the National Gallery, Wallace Museum & Continental museums would have to bow down to him," Carstairs wrote Roland Knoedler. "The question is will he give the price?" On February 18, he invited Frick to be the first to have an audience with the "superb 7 Van Dycks," and the first to have the chance to buy them. "They are being photographed & in 3 weeks by the time they have thoroughly dried the frames will be ready." He tried to convince Frick to come to Paris. "They are all being held for your inspection, approval or rejection. Will you come over and see them?"

Carstairs answered his own question. "I presume not." Therefore, he explained, "my present plan is to ship them from Havre Mch 23!" "Sail for Naples," he urged. "I will motor you 1 day to Rome, 1 day to Florence. Magnificent trip. 1 day to Genoa & one to Monte Carlo & then we will take the train to Paris." Carstairs singled out the *Elena Grimaldi* portrait. "There is no question, no argument, from every standpoint it is Van Dyck's masterpiece. . . . Just think[,] they were painted for the family in 1623 to 5 and have never been out of Genoa." The price the dealer asked for the portrait was $490,000—or more than twice what the collector had paid for his Rembrandt, and higher than the record $400,000 that Morgan had paid for the Colonna Madonna. Berenson told Isabella Gardner what he knew about the van Dycks. "The Colnaghis and Knoedler bought them together. They have sold the bust of the man to the National Gallery for £13,500 [$67,500]. That

gives you some measure of the prices. They expect Frick to pay them £100,000 [$500,000] for the *Woman with the Umbrella*, and I dare say they have sold it [to] him already."

But Berenson was misinformed. Although the van Dyck certainly suited Frick's taste, he declined it. The timing was terrible. The financial markets had been in trouble and he was one of the financiers Morgan recruited to help stabilize them. He agreed to take a small three-quarter-length portrait of Marchesa Giovanna Cattaneo. London's National Gallery in fact bought two portraits. Carstairs would take a year to sell *Elena Grimaldi*. In July 1908, he showed the Philadelphia traction magnate Peter Widener and his son Joseph the portrait, and two smaller paintings of Grimaldi's children, *Filippo Cattaneo* and *Maddalena Cattaneo*. (They had hung together in Genoa.) He lowered the price of *Elena Grimaldi* from $490,000 to $450,000, a sum that Widener agreed to pay, but for three pictures, instead of one, and he gave less than half in cash.

The son of a bricklayer, Widener had begun working at his brother's Philadelphia butcher shop and translated his experience into a chain of meat markets. Meanwhile, he had gotten into politics, holding several offices in the city and building connections that assisted him in winning a contract to supply the Union Army with mutton during the Civil War. After failing to get the nomination for mayor of Philadelphia, he and his friend William L. Elkins began investing in horse cars, then cable and trolley cars, in Philadelphia. By the mid-1890s, they had built transportation systems not only there but also in Baltimore, Chicago, Pittsburgh, and New York. Widener lived in a mansion he called Lynnewood Hall, in Elkins Park, on the northern outskirts of Philadelphia.

Widener's picture-buying had been encouraged by his friend the attorney John G. Johnson, who sought out expert advice from Berenson, Wilhelm Valentiner, and others, and prided himself on discovering pictures that had been overlooked by his wealthy clients. Widener played in a regular poker game with Johnson and Elkins, also a collector, when they talked about buying art.

Even though Frick squandered his chance with *Elena Grimaldi*, Carstairs knew the collector would not be happy to learn that his dealer

had sold it and two other Cattaneo paintings to Widener. He broke the news to Frick from London on July 2, 1908. "My feelings on the subject are somewhat mixed. I always expected you to take this great picture," Carstairs wrote. "[I] longed to see it in your gallery & in your possession." The Wideners were "very keen on all 3 from the first moment & bought them immediately," he explained. Frick quizzed Carstairs on the terms of the purchase. "Mr. Widener gave us $450,000 and fifty-two pictures which cost him $250,000," he replied, revealing the favorable deal Widener had negotiated. More willing to spend freely on pictures than Frick, the traction tycoon would become the steel tycoon's most formidable collecting rival.

Duveen and Berenson

When plotting to buy the Rodolphe Kann collection, Joe Duveen worked with his uncle Henry and left his father out. Learning of this maneuver, Joel reasserted himself as the head of the firm, but the family's conflict led to its reorganization, and Joe and Henry became partners in Duveen Brothers. Joe's younger brothers Ernest, Louis, and Benjamin remained in the business but were simply employees. Soon after, Joe Duveen established an alliance with Bernard Berenson that proved one of the most lucrative in the history of the art trade. Apparently Duveen heard that Berenson had questioned some of the attributions of the Italian paintings in the Hainauer Collection, which he had bought in 1906, and hired the connoisseur to examine the pictures. Soon he enlisted Berenson to expand his trade in Old Masters. In 1909, Duveen gave Berenson a secret contract promising him 25 percent of the profits of every picture he authenticated. For the Duveens, Berenson provided invaluable services, in both buying and selling pictures. He scouted for Old Masters (mostly but not exclusively Italian pictures) and advised their "various houses [branches] about things proposed" to them. He also spent much of his time "working up" eloquent letters promoting paintings the Duveens had purchased, posing as the disinterested scholar writing about a particular picture strictly for the art historical record. As a means of marketing Old Masters, Berenson's letters were hard to surpass.

About Italian paintings that the Duveens wanted to buy, Berenson spoke frankly: When Louis Duveen asked about a Giovanni Bellini *Madonna*, Berenson spelled out the problems:

"The face of the Madonna is made over entirely, the Child rather less, all the hands considerably. The Child's body on the other hand and his legs especially are in good condition. The landscape has been over-cleaned. The blue of the Virgin's mantle is crude. Nevertheless, I would advise you to buy the picture for it is a very grand Bellini and a perfectly authentic one."

Berenson specified exactly what the dealer should pay. "You must try and get the picture for £4,000 or less, because although it is a very great work of art, you yet are taking considerable risks owing to its condition." Nine months later on the subject of the same Bellini, Berenson produced a very different sort of letter, and one that the Duveens could show to their clients. He thanked them for granting him a glimpse of the *Madonna*, declared it a "masterpiece," claimed he would "speak of your picture in the course of further studies," and asked for a photograph. Accompanying the official letter was a note verifying that he had written on the right picture—"presumably on the one that came from the Rev. Langton Douglas."

The Berenson-Duveen partnership worked well for both parties, as Mary Berenson candidly explained to her family in 1913. Joe and Ernest Duveen had just visited I Tatti. They "have an immense satisfaction as a Firm in the first rate 'goods they have handled' since they began to take B.B.'s advice," she wrote. She named the Italian works Berenson had found for the Duveens to sell: "Two Titians, a Giorgione, a Donatello, a Crivelli (what a jewel!), two Bellinis, various Tintorettos, a Perugino, a Pinturicchio, a Fra Filippo, a Botticelli, a Filippino and I can't tell how many others."

Berenson feared that by stealing too much of his time, the Duveens would undermine his own ability to stay at the forefront of his field and to maintain his public image as the independent connoisseur, a fiction in which his employer had a vested interest. Even to Henry Duveen, he pretended to be commercially detached from art: "So you may be grateful that I am only a scholar and not a salesman in disguise," he wrote

on February 25, 1913. "Not that I object to making money. Far from it. But I want to make it with scrupulous honesty and absolutely above board." He wanted to make it "only as a scholar and a gentleman can. . . . I cannot afford to let it take up too much of my time." If he stopped writing, he warned, he would lose his "reputation and authority," and the cost would be steep not only to himself but to the Duveens. But Berenson knew as well as anyone the market value of Italian pictures and two months later, on April 7, when he learned what the Duveens had spent on a Bellini, he chastised his "dear Friends." "This seems to me a very foolish transaction, and I have every reason for being seriously dissatisfied with it as a business proposition." He reminded them of his value: "That I can look at art with the commercial eye should be potent to you." Problematically, as he explained, by overpaying for a lackluster picture, the Duveens would drive up prices of really fine paintings by the same artist.

For the Berensons, the steady income from Duveen allowed them to pay for traveling, renovations, a car, and Bernard's enormous library. "I *loved* hearing them boast," Mary wrote, for each picture "means some fun for us all—motor-trips, house-furnishings, B.B.'s *ogetti*, opera-boxes (!) and so on." She described the Duveens as "notoriously fickle," and depicted Berenson bridling at the dealers' demands. "They are continually at him to make him say pictures are different from what he thinks," she explained, "and are very cross with him for not giving way and 'just letting us have your authority for calling this a Cossa instead of a school of Jura.'"

Otto Gutekunst was rightly worried about Joe Duveen's designs on Henry Clay Frick. Recently, Frick had paid Duveen $138,000 to fill his Prides Crossing house with furniture and decorative arts, but he had yet to buy a painting from the dealer. (Duveen never abandoned the decorative arts, recognizing that his influence depended in part upon his control over the design of his clients' houses.) In November 1906, Roland Knoedler informed Charles Carstairs that Duveen had "left two Italian pictures" (a Fra Filippo Lippi and a Pollaiuolo) at the Fricks'. At that point Frick seemed indifferent to Renaissance pictures and he had Duveen take them back. (The Pollaiuolo proved difficult to sell. Joe asked

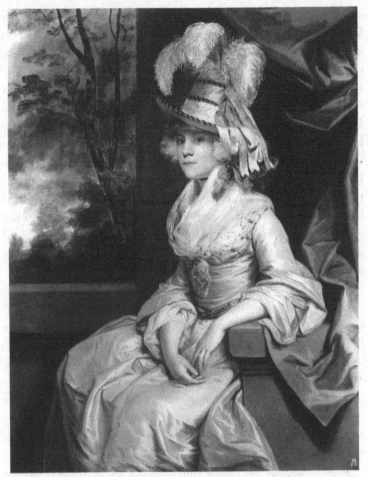

Sir Joshua Reynolds's *Elizabeth, Lady Taylor*, ca. 1780. Joseph Duveen sold the portrait to Henry Clay Frick in 1910 for $190,000.

Henry to get Altman to take it, but Henry refused: "I cannot pronounce the name of the artist. . . . I would stutter and look foolish. Don't insist. Let BB sell it to Mrs Jack Gardner," which he proceeded to do.)

Some three years later, on February 1, 1910, Duveen finally succeeded in selling an Old Masters painting to Frick: Joshua Reynolds's portrait of Elizabeth, Lady Taylor, a young woman with powdered hair and ostrich plumes on her hat. Duveen's coup rattled even the noncha-

lant Roland Knoedler. Two months later, Knoedler anticipated that at the Charles Yerkes auction, Duveen would strike again and go after a Frans Hals portrait for Frick. "I made up my mind that we ought not to let Duveen get this picture at any price within reason," he told Carstairs. Bidding for the portrait soared past $100,000 and Knoedler won it for $137,000. Soon after, Frick acquired the picture for the auction price, plus 10 percent, or some $150,000. Only five months later, Duveen got Frick to pay $194,000 for another Hals—*Portrait of an Elderly Man*. With Reynolds's *Elizabeth, Lady Taylor,* Duveen maneuvered himself into a position alongside Carstairs and Roland Knoedler as a principal supplier to Frick of Old Master pictures. He followed the pattern Carstairs had established, selling portraits and landscapes, most of them Dutch and English pictures. A year later, Duveen persuaded Frick to spend $550,000 on two full-length English portraits, each over seven feet tall: Gainsborough's *The Hon. Frances Duncombe* and Romney's *Charlotte, Lady Milnes*. At $225,000 a piece, the English full-lengths were among Frick's most expensive pictures.

Frick was clearly wary of Duveen. When, in May 1911, he agreed to buy the English portraits, he himself (in his blunt, choppy handwriting) wrote out a contract and a schedule of payments for the dealer and had Duveen sign it.

"Highest Prizes of the Game of Civilization"

Holbein's *Christina of Denmark*, Rembrandt's *Polish Rider*,
Velázquez's *Philip IV*, Three Vermeers, and Record Prices

With Henry Clay Frick's purchase of the Ilchester Rembrandt, the heyday of his collecting began. Settled in the Vanderbilt house, the magisterial portrait demanded paintings of equal caliber. "Is there anything else of great importance that you have in the picture line?" Frick asked Charles Carstairs in the summer of 1908. "I feel rather in the humor of buying some more this summer, but, it must be very important." When Roger Fry persuaded Frick to take a Rubens portrait (sight unseen) that cost only $15,000, the collector was skeptical of the worthiness of a picture that came so cheap, and voiced his displeasure: "I do not wish to purchase anything unless it ranks with the Rembrandts I have and the Velasquez [*sic*]."

The ambition to acquire "important" pictures also infected Frick's competitors—Pierpont Morgan, Peter Widener, Benjamin Altman, and Arabella Huntington. Now in their sixties and seventies, they had years of experience buying pictures and limited time left. Already possessing substantial collections, they sought to upgrade and round them out. They wanted paintings that were famous, costly—the envy of the world and of one another. Contriving to be given first refusal of every major Old Master to appear on the market, they observed each other's moves.

The dealers encouraged their clients' appetite for masterpieces. "We can only approach you when we have something really and utterly

great," Henry Duveen told Altman. For his part, Roland Knoedler gladly arranged to take Frick to visit the ninety-foot picture gallery behind Altman's new house. Already Frick had asked the dealer to get him the dimensions of the Altman gallery and also of Widener's, which was ten feet longer. After taking stock of Altman's collection, Frick, Knoedler noticed, was "more anxious than ever to add to his present holdings something exceptional, fine."

At the turn of the twentieth century, Wilhelm von Bode had dismissed the American threat to Europe's Old Masters. As long as Americans bought in a haphazard way, their occasional triumphs in the Old Master market didn't alarm him. But by 1906, Bode found to his dismay that Americans were beginning to organize and to collect "systematically and scientifically," employing the very principles he used to guide his purchasing for the museum in Berlin. Bode acknowledged that he and other German scholars had unwittingly promoted American picture-buying by publishing "large, scientific catalogues." Certainly, the drive for masterpieces reflected the influence of Bode and rival connoisseurs; more than ever, Americans leaned upon experts to guide them to the finest pictures and to purge their collections of everything not up to the mark.

Peter Widener hired the Metropolitan curator Wilhelm Valentiner to weed out his Dutch pictures and relegate any embarrassing examples to the scrap heap. To sort through his Italian paintings, he brought in Berenson. "I hear you're going to Philadelphia to bust up Widener's collection!" Morgan remarked to the connoisseur. Mary Berenson described the process to Isabella Stewart Gardner: "They [the Wideners] have really nothing of importance among their Italians, and their best other picture, outside of the Van Dyck, is a fine Frans Hals. But to stick to the Italians—we could not leave one single great name." Peter Widener was a widower in his midseventies, whom Mary Berenson described as "very broken," and deferential. He was "trotting round and saying meekly 'Mr. Berenson, is this a gallery picture, or a furniture picture, or must it go to the cellar?' (that is their formula and about 160 pictures *are* already in the cellar!) He was very much pleased whenever we would allow a picture to stay in the gallery, even if shorn of its great name. But we had to banish several."

Competition among the Americans caused Old Master prices to soar. In the two decades since Henry Marquand secured his van Dyck for $40,000, the Old Master market had been steadily rising. The 1907 sales of the Kann collection and the Cattaneo van Dycks marked a new level of American spending and launched a boom in Old Masters that would last almost until the First World War. By 1909, Bode estimated that "simple portraits by Frans Hals and Rembrandt, if of excellent quality" or landscapes by Cuyp and Ruisdael "sold on average for one million marks [$250,000]." Also in 1909, the habit of buying Old Masters became suddenly cheaper for Americans when the Payne-Aldrich Tariff Act eliminated the 20 percent customs duty on art over twenty years old. According to a New York customs collector, Senator Nelson Aldrich "put the free art paragraph in the tariff bill especially in the interest" of Morgan's collections, so the banker could transfer them from England to the United States without the tax penalty. In 1911, Morgan ordered the packing of his collections to begin.

America's unprecedented spending on Old Master pictures reflected the strength of the nation's economy and the concentration of wealth in the hands of industrialists and financiers. By 1914, the United States' national income climbed to $37 billion, more than triple the income of either Germany or Britain, the next two largest economies. America "was in fact an entire rival continent and growing so fast that it was coming close to the point of overtaking all of Europe," writes the historian Paul Kennedy. The major American art collectors, even if lacking the wealth of Andrew Carnegie or John D. Rockefeller, had a surfeit of money. After amassing large collections, they still ended up leaving substantial fortunes—Altman, some $35 million; Widener, $50 million; Morgan, $68 million; and Frick, $95 million.

News of Old Masters fetching record prices caused Europe's art heirs to survey their holdings; naturally the most celebrated canvases (often their proudest possessions) caught their attention, because they would generate the highest sums. The inflated values transformed canvases into fungible assets their owners could no longer afford to keep, as their opportunity cost—the income lost by not investing the money tied up in a picture—shot up. Masterpieces swept onto the market at

an ever-faster pace. How a particular painting ended up in a particular collection depended upon a web of finance and circumstance; a picture's path was rarely straight or smooth.

Holbein's *Christina of Denmark*, 1909

As higher taxes left the landholding nobility financially ever more pressed, England kept delivering major Old Masters to the market. For two decades, Hans Holbein's *Christina of Denmark, Duchess of Milan* had hung in the National Gallery on loan from the Duke of Norfolk. Hoping to keep the Holbein, Charles Holroyd, the gallery's director, warily asked the duke in 1909 if he would be willing to sell the painting. The reply, although affirmative, was not reassuring. The duke would be willing to sell the Holbein if offered a price "far in excess of its [the picture's] real value." He hoped to get as much as 60,000 pounds for the painting.

The Holbein was a full-length portrait of a sixteen-year-old princess that demonstrated the artist's genius in its gleaming, jewel-like realism, the precision of details, and a disarming sense of psychological truth. The German Holbein had served as court painter to Henry VIII, and like most of the pictures he painted in England, *Christina of Denmark* was an important document of English history. Henry VIII had commissioned it when he was considering taking its subject as a bride. (He had divorced Catherine of Aragon, executed Anne Boleyn, and Jane Seymour had recently died two weeks after giving birth to Edward, the crown prince.)

Christina, already a widow and officially in mourning, is wearing a long black velvet dress and a long, black silk coat with puffy sleeves and a dark fur lining that forms a collar around her neck and descends the edge of the coat to the floor until it is simply a glimmer of mahogany-colored paint. She has an expression of innocence and self-possession; bowing her head slightly, she glances up warily, as though she might be looking at the king.

Already, the English had taken defensive measures to prevent American millionaires from "stripping us of Art treasures more ruthlessly than Napoleon stripped Italy and Spain," as George Bernard

Shaw put it. In 1903, several critics, connoisseurs, and curators (among them Roger Fry) had organized the National Art Collection Fund (the "Art Fund") to raise money to purchase works of art for the National Gallery. In 1906, when Velázquez's only nude, *Toilet of Venus* (the *"Rokeby Venus"*), came on the market, the Art Fund spent 40,000 pounds and made its first major purchase.

Even before appealing to the Art Fund, Charles Holroyd shrewdly tried to keep the Holbein's price down by persuading Wilhelm von Bode and Pierpont Morgan not to go after the portrait. But the Duke of Norfolk "was receiving large offers for the picture," Holroyd told the National Gallery trustees. And "he might at any moment receive an offer which, in view of the anxious financial future for all landlords, he might feel obliged to accept." Already, the Duveens had bid 35,000 pounds. "What is your opinion of the picture itself?" Henry Duveen asked Berenson. "We should have your opinion before doing anything definite." On receiving Berenson's reply, they raised the offer to 50,000 pounds. But Otto Gutekunst, refusing to let Duveen have one of Holbein's masterpieces, trumped him on April 21, when the duke agreed to take 61,000 pounds from Colnaghi for the picture.

Holroyd now had to find 61,000 pounds to buy the Holbein for the National Gallery. Gutekunst gave him nine days. "This is, of course, the very worst conceivable moment for the question to have arisen," argued the London *Times*, "for a Government with a deficit of 16 million cannot think of buying pictures at this price, and all the rich men are hit so hard by the Budget that to raise £60,000 for the purchase even of a masterpiece will be a very difficult task." Unbeknownst to the paper, Charles Carstairs had agreed to sell the Holbein to Henry Clay Frick for 72,000 pounds ($360,000)—the sum that the Art Fund would now have to match. In letters to the *Times*, protesters denounced the Duke of Norfolk, Colnaghi, and the still secret buyer—presumed to be American. The artist Philip Burne-Jones hyperbolically warned that should the Holbein "find a home in America . . . its days are practically numbered. . . . No painting," he cried, "can survive many years in the overheated atmosphere of American rooms or galleries." The possible loss of the Holbein seemed to signify the threat posed by the United States to England's place as the frontrunner in the global hierarchy.

Under public pressure, Gutekunst extended Holroyd's deadline to May 31. Lloyd George promised the treasury would donate 10,000 pounds to the Holbein cause. To show their patriotism, the Colnaghi partners themselves contributed 2,000 pounds. Edward VII threw in 100 guineas and the Prince of Wales 125 pounds. By mid-May Otto Gutekunst was in a good mood. "These Americans are buoyant again," he told Berenson. "And the Holbein will be decided in 11 days." By Friday, May 29, the Art Fund had raised no more than 32,000 pounds and when the Bank of England closed that evening, Carstairs assumed Frick had won the painting.

But on Monday, June 1, an irate Frick cabled Knoedler's in London: "CONSIDER HAVE BEEN TRIFLED WITH. NO AUTHORITY [TO] EXTEND OPTION WHICH EXPIRED YESTERDAY." That same morning Carstairs responded, reassuring Frick that the Holbein was his, but by that afternoon he learned that on Saturday an anonymous donor had wired the money necessary to match Frick's price to the bank. "The Holbein Duchess has been saved—by a veiled lady who has bought her off for £40,000," Henry James wrote his friend Edmund Gosse. "Can you lift the veil?"

Carstairs tried to appease Frick, then acknowledged he appreciated "the nation saving it for the National Gallery where it has hung so long." Disagreeing, Frick chastised the dealer: "REGRET FAILURE. THOUGHT YOUR PARTNERS MIGHT HAVE TAKEN LIBERTIES. HAVE WRITTEN." Frick's loss of the Holbein shook his confidence in Charles Carstairs. By now, dealers and agents of every stripe were proposing pictures to Frick. Most he ignored. But he had long experience as a picture buyer and he began to welcome the new lines of supply. While Carstairs also found new clients, he remained overly dependent upon Frick, whose increasing power in the marketplace made him ever more difficult to deal with.

For Charles Holroyd, the Holbein was a victory, but only a momentary one. By 1907, fifty years after the Old Masters at the Manchester exhibition had dazzled Théophile Thoré, Great Britain had let almost half of the canvases go. In 1910, David Lloyd George, chancellor of the exchequer, proposed "The People's Budget," which, he argued, would

"wage implacable warfare against poverty and squalidness," and which he funded in part by increasing taxes on the landed rich, who, as David Cannadine points out, were "its principal target and victim." The death duties on estates worth over 1 million pounds climbed to 25 percent. In 1913, the government made a sobering count of the paintings England had recently lost: 50 Rembrandts, 21 Rubenses, 4 Velázquezes, 11 Holbeins, and 7 Vermeers.

Rembrandt's *The Polish Rider*, 1910

Word of the inflation in Old Masters spread far beyond London and Paris and drew out legendary canvases that experts and dealers had long pursued in vain. Early in 1910, in the hilltop village of Dzikow, in Poland, Count Zadislas Tarnowski received an unsolicited offer of 44,000 pounds for his Rembrandt—*The Polish Rider.* He reported the news to his brother, who happened to work in the Austrian embassy in London, and who asked Arthur Clifton, a dealer at Carfax gallery, for a second opinion on the Rembrandt's value. Uncertain what to say, Clifton turned to Roger Fry, who had exhibited his own paintings at Carfax. Fry was no longer working for the Metropolitan, but he still had ties to New York. (Pierpont Morgan had fired him after he had criticized the museum's president, in an inexplicable absence of tact, for purchasing a Fra Angelico that Fry was trying to buy for the museum.) Fry immediately understood the significance of the Rembrandt, told the Carfax dealers the painting was worth close to 60,000 pounds, and cabled Henry Clay Frick.

Abraham Bredius, director of the Mauritshuis in the Hague described discovering *The Polish Rider*: "One glance at the whole, an examination of several seconds of the technique was all that was necessary for me to be instantly convinced that here in this remote place one of Rembrandt's greatest masterpieces had hung for almost one hundred years!" Bredius failed to persuade Tarnowski to sell the painting, but wanted it for the Amsterdam exhibition. "Really, this picture *must* be among the 85 Rembrandts which Her Majesty, the Queen of England, the English Nobility, and all the great collectors of Europe have

promised to send to our exhibition," he argued, predicting the exhibition would witness "the apotheosis" of the picture. The count agreed to loan the painting to Amsterdam, but after the exhibition he recalled it to Poland.

The Polish Rider was as mysterious and Romantic as its history. A pale gray horse and young male rider trot through the darkness of a rocky landscape—caught at the center of the canvas as if they had just come into view and were about to pass. The rider is taut in the saddle and turns sideways toward the viewer, looking out of the canvas as though scanning the horizon for danger. He has an innocent face, but in one hand he holds the reins and in the other, which rests on his hip in a pose of princely confidence, he carries a weapon. Strapped to his back are a bow and a quiver of arrows. Both horse and rider are mostly in shadow, but gold light seems almost to pursue them, illuminating half the rider's face, the yellow of his quilted sleeve, his red pants, the horse's neck and haunches.

On April 15, 1910, Fry cabled Frick:

"CAN SECURE REMBRANDTS POLISH CAVALIER SIXTY THOUSAND POUNDS URGE ACCEPTANCE DECISION MUST REACH ME EIGHTEENTH."

The collector was unfamiliar with the painting: "Is it number four sixty-six in Bode volume six and in as fine condition as my Rembrandt?" he asked by wire.

"YES," Fry replied the following day. "BY ALL ACCOUNTS CONDITION EXCELLENT PICTURE NEVER REMOVED FROM OWNERS CHATEAU SINCE AMSTERDAM EXHIBITION."

While ambivalent about serving as picture broker to American millionaires, Fry desperately needed money, in part to pay for medical treatment for his wife, who was mentally ill. The Rembrandt's owner, he told Frick, "had always thought that if he could get 1½ million francs [60,000 pounds] he would sell." Fry hadn't yet seen the picture and proposed that Frick make his purchase dependent upon whether the critic would "approve" the painting's condition.

"PURCHASE," Frick cabled, adding characteristically, "BUT TRY FOR LOWER PRICE." He had never before spent $300,000 on a painting. So great was Frick's confidence in Fry that he gave the connoisseur a free hand. "Leave matter of condition of picture with you, payment should

be made on delivery here but you have authority to do as you think best in all matters."

Fry began by offering 55,000 pounds, but by April 19 he raised the bid to 60,000 pounds. "HAVE PROMISED THAT YOU WILL CABLE SIXTY THOUSAND TO YOUR LONDON BANK FOR TRANSFERENCE TO VIENNA," Fry wired. The count agreed to sell. On April 20, Frick cabled the sum to Fry's credit at Morgan Grenfell bank in London. He also asked that the Rembrandt "remain in Paris that my family may see it."

"Sale Concluded," Fry replied. "I start for Poland to-morrow night," he wrote Frick. The critic had expected the count to send the painting to Paris, but he had refused, demanding instead that Fry come to Poland. "The Count pays the expenses of my journey, and all expenses of packing, insurance, copying etc." Fry described Tarnowski to Frick as "a good natured rather rustic country gentleman with the obstinate suspicions of a peasant type quite unused to business and extremely difficult to deal with, especially as he only spoke bad French."

Fry flattered Frick as a connoisseur and assured him the Rembrandt was a bargain. "I know that you are able to appreciate the extraordinary imaginative intensity of this great picture and that your collection is one where it will find a fitting home, and you will have secured it for at least twenty thousand pounds less than any dealer would have asked you for it." He already argued that "at present prices" the famous painting was worth "anywhere between £80,000 and £100,000."

Fry complained to his mother about the trip. "The picture costs £60,000, so it is an important affair," he wrote. "It's tiresome and rather hateful work but I couldn't refuse to do it. I hope Mr Frick will be more decent to me than his fellow millionaire. At all events I ought to get handsomely paid for all I have done, and indeed it comes at a critical time, for I am just at the end of my resources." He also informed Frick that the trip caused him "extreme inconvenience," and was "a most agitating and difficult matter to transact."

By May 3, *The Polish Rider* arrived in Paris. From there the canvas went to London, where an artist made a copy for Tarnowski. "I am much pleased with the way you have handled this matter; of course, I have been governed entirely by you as to its value, as I have great confidence in your judgment," Frick wrote Fry on May 12. "I have no doubt

that in the future you will be able to secure many other important pictures for me." For the Rembrandt and a new frame, Frick ended up paying $308,651. As an agent, Fry charged little for his troubles—only $15,000—a commission of only about half the 10 percent dealers customarily made even for buying a picture at auction.

Charles Carstairs happened to be traveling with Adelaide Frick when he got the disturbing news that Frick had bought a major Rembrandt from Roger Fry. Immediately, Carstairs tried to take some advantage of the situation and asked if he could exhibit the Rembrandt at Knoedler's in London. Frick agreed and tried to console Roland Knoedler. "Would have preferred to have purchased this Rembrandt through you," he wrote. "But I did not want to lose the opportunity of securing it; while I paid a very high price, yet the picture is unique, being as I am told, one of two equestrian portraits by the artist." But Fry had promised the Carfax dealers they could display the painting, and ultimately Carstairs did not have the chance to hang it at Knoedler's. "I have seen the picture again and shown it to some of the leading critics and connoisseurs here," Fry told Frick from London.. "They are all unanimous as to its quite exceptional beauty—that it is the most romantic thing that Rembrandt ever did and stands quite alone."

By July 6, the copy of *The Polish Rider* was finished, and handlers at Knoedler packed the canvas and had it shipped to New York. From there, the Rembrandt sped by train to Prides Crossing, where Frick at his house overlooking the ocean saw it for the first time.

On July 22 the taciturn collector sent Roger Fry a telegram, and in one of the very few instances he ever recorded his feelings about a work of art, he summarized them in a single word: "ENCHANTED."

Basking in Frick's good graces, Roger Fry quickly squandered them. Ignoring Frick's charge to show him only "important" pictures, Fry persuaded him to take the inexpensive Rubens, which Bode told Frick looked like a work by Sutermans. It was the last canvas Fry ever sold to Frick.

In the course of 1910, Frick had spent $379,000 on Old Masters from Knoedler's, but close to twice as much ($647,000) on pictures from Fry and Duveen. Facing a more competitive market, Carstairs

and Gutekunst also contended with Agnew's and Arthur J. Sulley in London, and Wildenstein, Gimpel, Seligmann, and Sedelmeyer in Paris. Wanting to appear as accomplished as his rivals, Knoedler bought the Lotos Club (for $900,000) on Fifth Avenue and Forty-sixth Street, tore it down, and constructed a six-story limestone building, which cost some $500,000 more. The gallery occupied the first two floors. "We are drinking your health wishing the Lotos property will treble in value and will never contain any doubtful pictures," Frick cabled Knoedler in August 1910. By the end of the year, Carstairs fretted about Knoedler's financial position. "Prospects of business look very poor," he told Gutekunst. "I am afraid the country is in for a long period of quiet; some people think it will last a couple of years. . . . We must buy with great caution and utilize our money on obtaining the few things that are most salable to the few rich people that exist." Knoedler's troubles seemed to have less to do with the economy than with their expenditures and their most important client. Nevertheless, in 1911 the gallery opened a new Paris branch on the Place Vendôme.

Three Vermeers, 1910–11

In the fall of 1910, Otto Gutekunst bought one of Vermeer's most ravishing canvases, *Woman Holding a Balance.* "The Vermeer has come home & looks *magnificent,*" Gutekunst wrote Knoedler. The subject of the painting is a female figure in a dark blue jacket casting her eyes down at a delicate brass scale she holds up carefully in her right hand, as the long fingers of her left hand pause lightly on the edge of the table. She stands in a darkened room, light coming only from the top of a shuttered window, glimmering on a still life of pearls, a gold chain, and coins on a table in the foreground. On the wall behind her is a painting of the Last Judgment. The Vermeer had been discovered by the Dutch scholar Hofstede de Groot in the collection of Countess de Ségur-Périer in France, and Gutekunst decided to ask 40,000 pounds for it. To underline the painting's beauty and significance, Gutekunst had the firm of White Allom design a setting for the picture, which he

hung at Colnaghi's for two weeks. He also lined up photographs of Vermeer's thirty-four other pictures—"the whole of the known work of Vermeer together."

The Dutch painting caused a stir in London. "We are having from 100 to 200 people a day to see the Vermeer," Gutekunst reported to Carstairs on December 7, 1911. Ten days later at 5 o'clock in the afternoon, Queen Alexandra, wife of Edward VII, came to pay homage to the Dutch picture. "I talked to her for ½ an hour," Gutekunst said. "Also the Prince of Wales." "Nobody has considered 40,000 excessive up to now & everybody admits our picture as one of the finest V. painted," Gutekunst wrote Carstairs, who was in New York. In early December, the dealer had spent over a week in Prides Crossing with Frick. "He is very much interested in the Vermeer, but seems to think the price frightful, that however was to have been expected."

Days later, Carstairs asked Gutekunst to send the Vermeer to New York. If Frick wouldn't take it, Wilhelm Valentiner claimed he had a buyer. Carstairs guessed it was Altman who had "sent for Roland and told him he was very . . . interested in this artist." On Christmas Eve, workers at Colnaghi packed the Vermeer "with utmost care" and dispatched the small canvas to the United States.

When in early January *Woman Holding a Balance* arrived in New York, Carstairs showed the Vermeer first to Frick. Perhaps he still thought the painting too expensive, because he turned it down. Carstairs next invited Altman to inspect it. But the collector sniped that "he would have bought it a month ago if it hadn't been exhibited but that he wanted to be offered pictures first." Carstairs was losing patience: "They are a rare lot these picture buyers," he told Gutekunst. Widener was next in line and the following Sunday, Carstairs and Knoedler carried the Vermeer onto a train bound for Philadelphia. But the excursion did not go as planned. Widener's daughter-in-law "was ill & the interruptions (she fainted) interfered, & we had to run to catch our train," Carstairs reported. "I begin to feel tired of the millionaire & wish I could retire and associate with poor but humble folks."

Nevertheless, only a day later, on January 11, Widener decided he would in fact buy the Vermeer. Once again, he did not pay the asking

price, but instead only $175,000, a sum still 75 percent higher than
what Morgan had paid for his Vermeer only four years before.

Widener's acquisition of the Vermeer irritated Frick. When Altman
told Frick he too had seen the picture, the steel magnate became even
more annoyed. Two months later, Frick "repeated" to Roland Knoe-
dler, "that he had not been properly treated." "All of our dear friends
talk among themselves," Knoedler told Carstairs, "and forget that they
have been spoken to confidentially."

In May 1911, Carstairs and Gutekunst bought a second Vermeer,
Officer and Laughing Girl. This Vermeer had two figures rather than
one—an intimate, charged encounter between a soldier and a young
woman looking at each other across the corner of a table. The soldier is
seated in the foreground, a confident character with his hand on his
hip, seen mostly in shadow and in a bold silhouette—formed by the
contours of his large black hat and his bright red uniform set against
the light coming from a window. Illuminated by the same light are the
delicate features and the gold and blue dress of the woman who is the
subject of his gaze, and a delicately drawn blue and beige map of Hol-
land and West Friesland, which not only fills the top half of the paint-
ing but seems to open up the room.

Again, Carstairs gave Frick first refusal. "HCF was in and saw it.
He seemed to like it immensely and asked to have it sent up to Prides,"
Tom Robinson informed Carstairs in London. For the summer and
early fall, when Frick spent most of his time on the North Shore of
Boston, he brought his collection with him. The paintings made the
trip in Frick's private railroad car, the "Westmoreland." That Novem-
ber, when Wilhelm von Bode returned to the United States, Roland
Knoedler accompanied him to Massachusetts to see Frick's pictures.
The German scholar must have praised the Vermeer because immedi-
ately after he left, Frick made the decision to buy it for $225,000, close
to ten times what he had spent on Vermeer's *Girl Interrupted at Her
Music* in 1898. While Frick complained about skyrocketing prices, he
no doubt prided himself on the brilliance of his art investments and
mentally adjusted the value of his collection upward.

Pouring fortunes into Old Masters, Frick and his rivals now

wallowed in a burgeoning supply. Legendary pictures seemed available at every turn, almost glutting the tiny market. Collectors could pick and choose, the surfeit of masterpieces spoiling them. Before the end of 1911, Carstairs and Gutekunst invested in yet a third Vermeer, *Girl with a Flute*. (Knoedler took half a share in the painting, which Agnew's had acquired in Brussels.) In the spring of 1913, Carstairs planned to include the painting in an exhibition at Knoedler in London, and when Altman asked to see the painting for a second time in New York, Carstairs reluctantly agreed to send it. "Show it to Altman and bring it back with you on the steamer if he does not take it (which I am sure he will not. . . . I know Mr. Altman has some very great pictures and will undoubtedly continue to improve his collection, but we have had no hand in the formation of it, and I really almost resent selling him the exquisite little VERMEER." As predicted, Altman decided against buying the canvas, as did Frick. (Finally, at the end of 1916, Gutekunst sold the Vermeer to an Amsterdam industrialist.)

Already in 1911, the $400,000 record price paid by Pierpont Morgan for the Colonna Madonna had been broken after its reign of a decade. Not surprisingly, the painting to eclipse the Raphael was Rembrandt's *The Mill*, the legendary landscape that Otto Gutekunst had tried to extract from Lord Lansdowne for Isabella Stewart Gardner in the 1890s. Part of the dark and moody picture's allure was that its subject, silhouetted against a stormy sky, was supposed to be Rembrandt's father's mill. Early in 1911, Lord Lansdowne, a trustee of the National Gallery, announced that he had been offered 100,000 pounds ($500,000) for the Rembrandt. He gave the gallery, where it had been on loan, a chance to buy the painting, for 95,000 pounds, but Holroyd was unable to raise the necessary funds and by early March the Rembrandt had been sold. Soon after, Frick ate lunch with Roland Knoedler twice in one week and both times interrogated him about the celebrated picture. "I haven't any idea who is buying *The Mill*, but always imagine it was Altman," Carstairs told Knoedler from London. The dealer rationalized his failure to get the painting. "It seems to me it would have been foolish to have tied up our money even for so grand an advertisement."

"Could it be Duveen?" Carstairs asked Frick on April 4. Always the

gentleman, he even suggested that his client "might still have a chance to procure it." His next piece of advice sounded like the standard pitch delivered by dealers to clients, but in fact reflected his knowledge of Frick. "Don't let price stand in the way for it is *priceless.*"

As Frick no doubt suspected, the buyer was Peter Widener, who had seen *The Mill* with his son Joseph at the National Gallery in the summer of 1910 and had asked Arthur Sulley to negotiate its purchase. For the painting, Widener had indeed agreed to pay 100,000 pounds ($500,000).

Widener's acquisition of *The Mill* also riled Benjamin Altman and he informed Henry Duveen that he required his own Rembrandt landscape. As Rembrandt had painted very few landscapes, the ever-pragmatic dealer tried to discourage the collector: "I told you that we ourselves did not care overmuch for genre or landscape Rembrandts, but preferred portraits by that master, more saleable and more understandable." In a letter to Berenson, Gutekunst reported that *The Mill* was "still at the National Gallery, attracting thousands; not by nature of its merits but through the huge price & sensational press utterances." He wondered "if it is really by poor Rembrandt himself."

Velázquez's *King Philip IV of Spain*, 1911

Despite record prices, Charles Carstairs was so skittish of expensive pictures that when he and Gutekunst had the chance to invest in another one of the rarest and most desirable—a Velázquez portrait of King Philip IV of Spain—he balked. Appointed court painter, Velázquez had painted many portraits of the monarch, but this one was unusual—painted when he was camped at Fraga, shortly after a military victory. The Habsburg king was not a handsome man, but his awkward face with its long nose and boxy jaw made him an instantly recognizable character in the painting galleries of Europe. Here his brown eyes stare out with a combination of distance and contempt. And the red military coat in which he is dressed is unforgettable—a wide central passage of the canvas painted by Velázquez with complete mastery and freedom of touch.

On January 17, Carstairs wrote Gutekunst that he was "deeply

interested in the Velázquez." Morland Agnew had bought the picture from a Bourbon prince who lived in Vienna, and hung it in the gallery on Old Bond Street. (He had consulted the Velázquez expert A. Beruete, who had confirmed it was authentic and a masterpiece.) But Agnew seemed not to have a ready client for the Velázquez and showed Gutekunst the painting. The Colnaghi partner was ambivalent. By

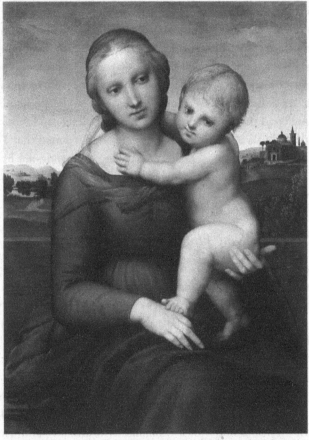

Raphael, *The Small Cowper Madonna*, ca. 1505. Descending from the 3rd Earl of Cowper, who bought it in the late eighteenth century, the Raphael was sold in 1913 by Lady Ethel Desborough to Duveen. Shortly afterward, the Philadelphia traction magnate Peter Widener paid a record $565,000 for it.

then, Carstairs was losing his nerve. "I fear you think we are neglecting you," he had told Gutekunst on January 10. "We have been working like dogs, trying to put some of the big things over the line. Unfortunately we have had many disappointments." They had sold Frick a pair of Rembrandts, but "only succeeded in getting $175,000 for them." Now, he cautioned Gutekunst about spending. "Naturally we must be careful on the money end of it as we are hard up and don't want to carry it. As you say Velázquez are scarce. We might jump in and make something of it, if it is really fine and not prohibitive in price." Still brooding, he dispatched Tom Robinson to Agnew's. "It is a striking picture," Robinson reported back. "The color of the dress is superb & the hands are fine. I didn't much care about the face . . . but the dress is almost enough to sell the picture. It is in old rose and white." Meanwhile, Gutekunst mused that if "supreme, the portrait wd. be worth 100,000–120,000 [pounds]."

Carstairs began to fret that Agnew's was trying to market the painting in New York. ("Charlie Williams has been here and has unquestionably talked to Widener and Altman.") Indeed, as he deliberated, Agnew's sold the Velázquez for $415,000 to Scott & Fowles, and one of the gallery's partners immediately invited Carstairs to invest in the expensive painting. Carstairs agreed to take half the picture, and sold Gutekunst half of his half. Eight days later, on February 20, Velázquez's *Philip IV* appeared at Knoedler in New York.

Frick "is very impressed," Carstairs wrote Gutekunst. "We are in great hopes of his buying it." That day the dealer delivered the portrait to the Vanderbilt mansion and gave Frick two days to consider its purchase. In a letter, he spelled out the terms. Straightforward as ever, Carstairs stated that he and his partners hoped to charge $515,000—and make "$100,000 profit," but confessed they would accept "$475,000 cash (say by March fifteenth)." Frick took no longer than the allotted two days to decide he wanted the Velázquez and would pay $475,000 cash, more than he had ever spent on a single painting and close to the record sum Widener gave for *The Mill*. Roger Fry had encouraged Frick to buy what he described as "quite the finest portrait of Philip IV which I have ever seen." That the subject of the painting had ruled Spain when its empire was at its apex no doubt figured into Frick's

own appraisal. The presence of Spain's absolute monarch enhanced Frick's already illustrious company of portraits. Carstairs had underestimated Frick's enthusiasm for the Spanish picture and the opportunity cost was high; he made only $12,000 on the near-record-breaking painting.

No doubt Frick took comfort in watching Old Master prices continue to advance. Only two years after paying $500,000 for *The Mill*, Widener set the record price again when he procured Raphael's *Small Cowper Madonna* from Duveen for $565,000. That same year Arabella Huntington gave Duveen $650,000 for Velázquez's *Count-Duke of Olivares*. The market was moving fast. By the time Widener paid for his Raphael in 1914, its record had been broken again, this time by Leonardo da Vinci's Benois *Madonna*. When Berenson confirmed that the painting (brought to Paris from Saint Petersburg by a member of the Benois family) was in fact a Leonardo, Duveen agreed to take it for one million pounds. At that moment, the Russian czar exercised an option he had on the picture, and acquired it for 310,000 pounds, or $1.5 million—a fraction of Duveen's offer and yet still a record sum. The extravagance of the czar in an art market driven to new heights by American industrialists marked the zenith of the Gilded Age's Old Master picture trade and was a fitting emblem of the final moments of the old order before the revolution cut down the Russian monarch and Europe was enveloped in the cataclysm of war.

"Thanks Not in [the] Market at Present"

Bellini's *St. Francis* and Falling Prices

In early 1912, Pierpont Morgan, Henry Clay Frick, and Peter Widener's son George Widener, his daughter-in-law Eleanor Elkins Widener, and his grandson Harry Elkins Widener, who was twenty-seven, booked passage on the maiden voyage of the White Star's *Titanic*. But Morgan, a principal investor in the shipping trust (the International Mercantile Marine) that owned the White Star Line, changed his plans. Clay and Adelaide Frick had sailed for France in January, and headed straight to Egypt—traveling from Alexandria to Cairo, and, as Frick wrote Philander Knox, "up the Nile, then to Syracuse on the Island of Sicily." They returned to Paris in April, still planning to take the *Titanic*, when Adelaide Frick sprained her ankle, and they postponed the transatlantic voyage home. But the Wideners sailed.

On April 15, news reached North America that in icy waters about four hundred miles south of Newfoundland the ship had gone down. "They say old man Widener was in an awful state, & was at the White Star office all day yesterday & would eat nothing," Dan Farr, at Knoedler in New York, wrote Charles Carstairs.

Peter Widener would learn that Eleanor and her maid had climbed into one of the lifeboats, but both George and Harry had drowned. Eleanor knew "nothing of the fate of her husband and Harry until informed of it on the dock," a Philadelphia book dealer told Morgan's librarian, Belle da Costa Greene. "The *Titanic* disaster is terrible,"

George Davey, at Knoedler in Paris, wrote Carstairs. "We passed icebergs last Saturday afternoon and our captain wired the *Titanic* that we had seen ice." About Widener, he wrote: "I hope the old gentleman will not die of grief." Within months Eleanor Elkins Widener decided to endow a library at Harvard University in memory of her son Harry, who was a collector of books. Erected in the middle of Harvard Yard, Widener would become Harvard's main library. Off the landing, halfway up the flight of stone stairs leading to the reading room and the stacks, Eleanor placed Harry's own book-lined study.

In January 1913, Pierpont Morgan traveled to Egypt. In December, the banker had testified at the hearings of the Pujo committee, a House of Representatives subcommittee named for Louisiana congressman Arsene Pujo, which was looking into New York's "money oligarchy." Morgan had not been well. In Egypt his condition grew worse, but on March 10, he went to Rome. "The ground floor of the Grand Hotel teemed with art dealers, antiquarians, foppish noblemen, shabby peddlers—all trying to unload a last painting or statue on the dying financier," writes Ron Chernow. Too sick to leave Rome, the banker died at the hotel on March 31, age seventy-five. Soon Morgan's legendary art extravagance became absolutely clear, when his collections, which he stored at the Metropolitan, were appraised at $50 million, or close to the value ($68 million) of the rest of his estate.

At one time, Morgan had suggested he would leave the collection to the Metropolitan Museum and hoped the City of New York would finance a new wing to house it. "This was a rich man's way of asking for a token of respect and gratitude," Chernow posits. After the press attacked the idea that the city would squander taxpayer money on galleries for Morgan's collections, the banker changed his mind. In November 1912, he had informed the museum's director Edward Robinson that he regarded his collections "as much too large an asset to take out of his estate in case it might ever be needed." In the end, he left his works of art to his son, Jack. Although Morgan's death did not set off a panic in the Old Master market, it signaled the end of the boom. When, seven months later, Benjamin Altman also died, the market further contracted. (In 1909, Altman had agreed to bequeath his collection to the Metropolitan.)

Another blow struck the Old Master market when on June 10,

1913, Arthur Morton Grenfell stopped in at Knoedler and told Carstairs he "must have 40,000 pounds by Friday" and needed to liquidate his entire collection. Grenfell, thirty-nine, was a London merchant banker who had made a fortune in South Africa and then in Canada, investing in mining and railroads. In the past two years, he had bought over seventy Old Masters—most importantly Giovanni Bellini's *St. Francis in the Desert* and Titian's *Portrait of a Man in a Red Cap*, which he hung in a house in Roehampton. If the financier appeared to be copying the Americans in his fast-paced art acquisitions, he was in fact resurrecting the English aristocratic tradition. His uncle George Holford had paintings ("a splendid van Dyck, a magnificent Cuyp landscape, a very fine Rembrandt of an old lady and three others," Grenfell wrote) at Dorchester House in London and also at his estate in Gloucestershire.

Arthur Grenfell already owed Knoedler 42,500 pounds. Lacking the capital to purchase Grenfell's pictures, Carstairs immediately made arrangements with Christie's to auction them and to advance the collector 40,000 pounds. But Carstairs bought three of Grenfell's pictures on "joint-account" with Agnew's, all at a deep discount—a Rembrandt, a Hals, and the Bellini *St. Francis in the Desert*. Carstairs had sold the Bellini for 45,000 pounds ($225,000) and spent only 30,000 pounds ($150,000) to get it back.

Although the subject of the Renaissance picture is Saint Francis, the painting is a landscape, close to five feet wide, bathed in the intense gold of slanting light. It begins with a blue ledge in the foreground and extends far into the distance, past fields, a shepherd with a flock, a stream, a bridge, the stone walls and towers of a town, and a small yellow castle on a hill, set against an azure sky. Saint Francis is an elongated figure in a brown friar's robe standing on a ledge, his arms outstretched, his palms open, looking to heaven. A gray cliff rises behind him. On the right, at the entrance to a cave cut into the cliff is a simple wooden desk, on which lie a red book and a skull. The saint seems to have just gotten up from the desk, leaving two wooden sandals beneath it. Bellini has painted rocks, plants, trees, a donkey, a rabbit, and the distant buildings with an exactness and attentive subtlety that suggests the gold sunlight is infusing the saint and his earthly surroundings with a sense of the divine.

The Bellini *St. Francis* was one of the most beautiful paintings to have emerged in the art market boom, discovered in a London suburb by the connoisseur and dealer R. Langton Douglas, along with a rare fifteenth-century Netherlandish *Deposition* by Gerard David. Both paintings were owned by Sarah Anne Driver, who inherited them from her brother-in-law, Thomas Holloway, a patent medicine tycoon. "The family had no idea of the importance of some of the pictures," Douglas later wrote. He began negotiations to buy them, but before he could raise the capital, Driver died. Douglas would have to relinquish his discovery as the trustees of Driver's estate demanded a price that was beyond his reach and then advertised the pictures by exhibiting them in 1912 at the Royal Academy in London, where Tom Robinson told Carstairs in New York that the Bellini was "creating a sensation." By the spring of 1912, Carstairs and Gutekunst bought the master-piece. "I have been so out of things that I have no gossip to give you, even of the art world," Mary Berenson wrote Isabella Stewart Gardner, on July 27, 1912. "Except that the most beautiful Bellini in exist-ence, the most profound and spiritual picture ever painted in the Renaissance, is now on view (and I believe on sale) at Colnaghi's—a *St. Francis Receiving the Stigmata*."

Carstairs told his colleague Charles Henschel not to reveal to anyone that Knoedler had bought back some of the Grenfell pictures. "It is often easier to sell them when [they are] someone else's property," he explained. He also had sympathy for his client. "I regret very much the unfortunate condition that Grenfell seems to have gotten into."

Only a month later, another Knoedler client, the financier, James Hamet Dunn, asked Carstairs for a loan of $50,000 against those Old Masters he had purchased from the gallery. Dunn was forty, a Cana-dian stockbroker who had moved to London. He consigned his entire collection to Knoedler—including a Bronzino, *Portrait of a Medici Prince (Lodovico Capponi)*, William Hogarth's *Miss Mary Edwards*, and Gainsborough's *Sarah, Lady Innes*. "He is very keen about his little col-lection and does not want to sell any of them if he can possibly avoid it," Carstairs explained, "but all their securities are very much depressed and to sell they have to suffer severe losses."

In August 1913 Frick was in London, searching for paintings. "Frick

takes up all my time and I haven't much time to write," Carstairs told George Davey. The dealer probably took Frick to inspect the Bellini *St. Francis*. (Earlier he had sent him a black-and-white photograph of the picture; Frick had made a half-hearted offer of $200,000, and Carstairs had refused it.) From London the dealer had piloted Frick to Longford Castle to inspect the Radnor pictures. With Colnaghi, Carstairs had recently bought seven paintings from the estate of Lord Taunton, including the full-length El Greco portrait *Vincenzo Anastagi* painted in Italy. "Frick is deeply interested in it," Carstairs wrote Knoedler. "I showed it to him in its dirty state and it was shipped yesterday for [the restorer] De Wild to put in order." In November, Frick bought the El Greco for $125,000.

Six months later, in May 1914, Frick sailed again to Europe. In London, Carstairs had plenty of pictures, including J. M. W. Turner's vast *Cologne: Arrival of a Packet Boat: Evening* (Frick bought it for $150,000) and a Holbein portrait of Thomas Cromwell, which the dealer Hugh Lane was anxious to sell. The thirty-eight-year-old Irish-born Lane had made enough money trading Old Masters in London to assemble a collection of modern French paintings, one of the first in Britain. The nephew of Lady Gregory, founder of Dublin's Abbey Theater, Lane was a thin, pale aesthete with large round eyes, dark brown hair, and a dark mustache. In a portrait commissioned by his friends, John Singer Sargent emphasized Lane's elegant fingers, holding a pair of gloves, while grasping the edge of his overcoat.

Lane's Holbein of Thomas Cromwell was dark and needed cleaning; the image of a scroll had been painted onto the blue background, and a restorer would have to remove it. Frick was "greatly impressed," Carstairs wrote on May 26, "but seems to be quite cross with me for not having cabled him about it last year. I suppose he regrets having to give any additional money." Frick already owned an arresting Holbein—*Sir Thomas More*—a half-length portrait of Henry VIII's chancellor and the Catholic martyr, which he had purchased two years before. By mid-June, Frick was back in New York. "The Holbein is coming out very beautifully," Carstairs wrote from London. "The table cloth is a beautiful emerald green, which places the man well behind the table, and that, together with the blue background, makes a wonderfully

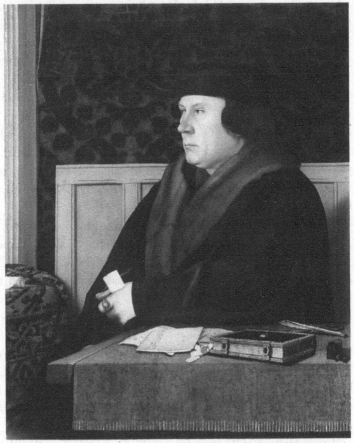

Hans Holbein, the Younger, *Thomas Cromwell*, 1532–33. "Have option on
Hugh Lane's Holbein sixty thousand pounds cash," Charles Carstairs cabled
Henry Clay Frick in June 1914.

brilliant effect." Lane, he claimed, now talked about asking 80,000
pounds (or $400,000) for the picture.

On June 28, Archduke Franz Ferdinand of Austria was assassi-
nated in Bosnia, and Europe seemed on the brink of war. Two days
before, sixty-seven of Arthur Grenfell's pictures came onto the block at
Christie's. Earlier, an English acquaintance sent Frick a list of the
Grenfell lots, explaining that his "City friends" had a lien on the pic-
tures and he was hoping they would "realize as much as they can." In

fact, Frick had met Arthur Grenfell several months before in New York, when he and a friend came to see his collection. Returning to England on the *Oceanic*, Grenfell sent Frick a letter of thanks and offered to let him know if he got wind of any "masterpieces" in London.

Hugh Lane had sold Arthur Grenfell most of his pictures, and at his auction the dealer spent 33,000 pounds on nine canvases, including Titian's *Man in a Red Cap*, to prop up the prices. Altogether, the sixty-seven pictures for which Grenfell had originally paid over 100,000 pounds went for less than half that sum. Later that year, Grenfell would declare bankruptcy, his debts running to over 1 million pounds. Suddenly pressed for cash himself, Hugh Lane quietly put some of his own paintings on the market, offering to Charles Carstairs *Man in a Red Cap* at cost, as well as Holbein's *Cromwell*. On June 6, Carstairs cabled Frick about the Holbein:

HAVE OPTION ON LANES HOLBEIN SIXTY THOUSAND POUNDS CASH UNTIL TOMORROW MORNING HE PAYING US COMMISSION TEN PERCENT THINK HE NEEDS MONEY TO PAY FOR HEAVY PURCHASES GRENFELL SALE.

Frick fired back: "THANKS NOT IN MARKET AT PRESENT."

By now, Europeans had begun to withdraw gold from America. At the end of July, the stock exchanges in London, Paris, Berlin, and New York were shut down.

The crisis in the markets drove James Dunn to let go of his pictures. On July 27 Dunn sent Frick a coded telegram asking if he would loan him 150,000 pounds against holdings of Lake Superior stock and paintings on which he had spent 100,000 pounds, with the right to "take any of [the] pictures at cost." Three days earlier, Carstairs also wrote Frick about Dunn—the steady dealer acting as though the collector's financial troubles were simply a matter of course: "I think our friend Dunn is hard-up. Would it interest you to give him £15,000 and a commission of 10% to us for his Bronzino?" The Bronzino was a three-quarter-length portrait of a pale young man in a doublet of black taffeta and velvet, looking every bit his part as a Medici prince. "It would certainly be an admirable picture for the mantel in your library," Carstairs wrote.

Before Frick replied, Carstairs and Gutekunst themselves bought the Bronzino and thirteen other Old Masters and modern canvases from Dunn.

"Very sorry indeed to hear of Dunn's condition," Frick wrote on August 1, 1914. "Conditions are such at present that I think it wiser to take up some good securities that are selling very low rather than add to my collection of pictures." Oblivious to the disaster about to befall Europe, he concluded with news about his game of golf: "Myopia is in fine shape and I am playing daily."

PART THREE

*The Great War and
the Picture Market*

"If This War Goes On, Many Things Will Be for Sale"

Old Master Spoils

On August 1, 1914, Germany declared war on Russia and, two days later, on France. On August 4, Britain, allied to Belgium and France, declared war on Germany. By August 6, when Austria joined Germany against Russia, World War I began.

From France, Mary Cassatt kept Louisine Havemeyer abreast of the deteriorating situation. "Here the days pass with leaden feet," she wrote on August 13. "May the battle in Belgium be a crushing defeat for Germany." She had heard that "bomb throwing from aeroplanes is to be spared us. Otherwise," she worried, "what would be left of the cities of Europe."

Three months later, from her beloved Paris, she continued: "This is the *saddest* place, war and all its horrors the only subject." Rumors flew. She had heard that "half the Brussels museum has been sent to Germany...a German Art Critic (!) has advised their stealing all works of Art. The Rubens' at Maline are burnt! It is too sickening." By December, Cassatt had moved south to a villa at Grasse, near Nice. "The great Russian victory I had so counted on is not to be. Yet, for the Germans have cut through that line & escaped."

Upon the outbreak of hostilities, Henry James fathomed what lay ahead, calling it "the plunge of civilization into this abyss of blood and darkness." He saw the war as shifting the perception of the recent past. It "is a thing that so gives away the whole long age during which we have supposed the world to be, with whatever abatement, gradually

bettering." Now, in James's view, the recent past revealed itself as the "treacherous years." Riding the crest of those years was the market for Old Master paintings.

With the war, communication and transportation between the combatant countries stopped, and international trade came to a halt. "Everything is at a stand still here—" Charles Carstairs reported from London. "Finances, exchange, and everything gone to pot. I don't know what will be the outcome." The Duveens shut their galleries in Paris and London. Without sales, the Knoedler dealers felt acute financial pressure and hoped that the British moratorium on payments would allow them to extend a large loan.

Otto Gutekunst and his partner Gustave Mayer, an American who had joined the firm in 1911, took steps to distance themselves from their German names and created a letterhead to prove their loyalty to Britain. On Colnaghi's stationary, below the name "O. C. H. Gutekunst," they printed the name of the German town where Gutekunst had been born and the details of his British citizenship: "Wertemberg—Denationalized 1889, Naturalized 1893." (Despite the nod to xenophobia, Gutekunst would later be interned in England as an enemy alien.) On September 23, Berenson, who was in Britain, begged Henry Duveen in New York to pay him 10,000 pounds the moment the moratorium was over, or he would "be threatened with bankruptcy." On October 10 he wrote again, filled with "despair," demanding that the Duveens send him money.

Fearing for the safety of fragile Old Master paintings in the London gallery, Carstairs decided to send Knoedler's most valuable canvases— two Goyas, the Bronzino *Medici Prince,* and the Bellini *St. Francis*—to New York. A month after the declaration of war, the National Gallery's director Charles Holroyd reported to the museum's board that he had put "50 pictures of supreme importance in the cellars for security."

Despite the art trade's slowdown, the war, like others before it, caused an upheaval in the possession of art—forcing paintings out of the hands of those trapped in the crossfire. In applying for a bank loan in 1915, Carstairs pointed out the disturbing truth that warfare had traditionally created a buyers' market for bystanders and victors. "England acquired her great Masterpieces during the French Revolution and Napoleonic Wars and now America's opportunity has come,"

In New York, Henry Clay Frick, by accident and planning, was positioned to capitalize on the paintings let loose by the European war. Frick was sixty-five and if his field of operation was now primarily the private realm (he was a member of several corporate boards), he was no less terrifying a figure and kept his dealers on their toes. The dealer René Gimpel who met him in New York thought he resembled "an old Scotsman, with a white beard, cut just so, to the fraction of an inch, and washed with white soap. His suit always looks new." His appearance was as immaculate as ever and his gaze as steady. "His features are so regular, his face so pleasant that he seems benevolent," wrote Gimpel, "but just at certain moments you see and comprehend that you are mistaken, that his head is there, placed on that body, for his triumph and your defeat." When in November 1915 the eighty-year-old Peter Widener died, Frick had the good fortune to be the last major American art collector of his generation left in the market.

A creature of habit, Frick spent long summers in his Prides Crossing mansion on a cliff overlooking the Atlantic. From there, he viewed the conflict on the other side of the ocean with detachment and malaise. Like many Americans, he thought the war inevitable and didn't envision the horror that would ensue. ("This war, of course, is a terrible thing, but I presume it is just as well to have this trouble in Europe.") He also had a distraction. In 1912, he hired the architect Thomas Hastings to design a mansion on the Lenox Library site, where he would display his stockpile of Old Masters and live out his life. By now, the Pittsburgh tycoon had learned his way in matters of taste, absorbing the lessons of restraint, old money, and aristocracy—lessons taught not only in Europe but in the neoclassical aesthetic of Morgan's new library. The limestone house rose three tall stories and ran the entire length of a Fifth Avenue block. Along Seventy-first Street, Frick erected a hundred-foot picture gallery. In 1913, the Armory Show rattled New York with the modernism of Cézanne, Gauguin, and van Gogh, but Frick's house with its round arches and fluted columns, its echoes of Ancient Greece and Rome and Renaissance Italy, kept the twentieth century at bay. The industrial-age palace triumphantly took shape in New York, against the distant backdrop of a Europe going up in flames.

Frick returned to New York from Paris on June 5, 1914, and

immediately went to see his new house. "I found [it] had progressed marvelously," he told Roland Knoedler. "The picture gallery is going to be a dream; I like its proportions immensely." Frick stayed in Prides Crossing waiting for the house to be finished; Charles Carstairs came from London to hang the collection. At the gallery's far end Carstairs placed the two Veronese allegories. Over the mantel, he set Frick's most expensive picture—the Velázquez *Philip IV* in his alluring red military jacket—and on either side other Spanish pictures: a Goya portrait and El Greco's *St. Jerome as a Cardinal*. In the hall, the dealer placed the enormous, luminous Turner *Cologne* and another Turner, *The Harbor of Dieppe*, one of James Dunn's paintings. Carstairs hoped that the empty wall space would prompt Frick to keep not only the Turner but five other Old Masters, which came from Dunn and Grenfell, including Bellini's *St. Francis*, for which the dealer found a "wonderful place." To Gutekunst, he expressed his thanks and acknowledged the contribution made by the London dealer to the New York collection. "The gallery looks superb," he wrote. "The far end is held up by the 2 fine Veronese and the other end has the Velasquez [*sic*] over the mantel. Do you see you were very much identified with its appearance and character? Mr. Frick as you know, is a smart man and thoroughly appreciated the traces and character of our band." Inextricably bound together, Frick's mansion and his art together would form a monument that reshaped his legacy, trumping the image in the public mind and perhaps in his own, of his brutal ascent in coke and steel, and securing his place in the line of artistocratic collectors that stretched back to the Medici.

Carstairs had still not persuaded Frick to take the Bellini, when he heard from London that the collector had competition. "I saw Lockett Agnew, who told me that the govs of the National Gallery had been asking about our Bellini," Knoedler's Frederick Menzies wrote on November 16. "He had talked it up to them and also told them he was interested in it." Carstairs replied by cable that Frick lacked enough enthusiasm to reserve the Bellini: "BELLINI FREE PRICE TO NG 55K POUNDS . . . THINK CLAY INTEREST."

In a matter of days, Menzies wrote back that Charles Holroyd "was going to put it before the governors who were having a meeting today." He asked Carstairs to return the Bellini to London. "He [Holroyd]

gave me to understand that the NG were quite in a financial position. . . . I am glad to hear Frick interested as the fact that the National Gallery contemplates buying the picture may influence him to close."

On November 16, 1914, his mansion still unfinished and furniture yet to arrive, Frick and the family moved in. Two days later, Carstairs explained to Lockett Agnew that he had decided to keep the *St. Francis* in New York. "The place where we want to hang this is not ready," Carstairs wrote. "He [Frick] is quite capable however of purchasing it [at] any moment, and I therefore cabled our London house not to tie it up."

Frick had always considered works of art as investments. Now, thanks to the war, he began to rake in the sort of bargains he had constantly sought, and these paintings would transform his collection. On December 4, 1914, from Carstairs, who noted things were "very quiet," he made a bulk purchase of six nineteenth-century pictures, including Turner's *The Harbor of Dieppe* and three others once owned by James Dunn. Carstairs had wanted $475,000, but Frick paid only $441,000, and in the form of 7,230 shares of Pennsylvania Railroad stock at $65.20 a share. Carstairs had little choice but to agree. He evaluated the pictures in the list he sent to Frick:

A Woman's Portrait by Goya for $45,000
The Forge by Goya for $125,000
The Bridge by Maris for $54,000
A View of Dieppe by Turner for $175,000
The Bull Fight by Manet for $13,500
The Dancers by Degas for $45,000

Frick acknowledged the railroad securities might fall. "It may probably look a little small that I could not concede your request to make this 7500 shares," he wrote. "But I really doubt the wisdom of making a purchase of pictures at this time, and do so rather reluctantly. It is most difficult to tell what the future has in store for us, and at present it seems to me that pictures will decline rather than advance in value." He protected Carstairs from total loss by agreeing to take back the railroad stock on January 20, 1916, at fifty dollars a share. Frick was articulate in his defense of the investment. "When business revives,

Pennsylvania will make enormous earnings; their rates are high enough, what they need is volume of business, and if you hold this stock it seems to me you are bound to realize ere long the full price for your pictures." The price of the Maris *Bridge*, which he had purchased in 1906 for $75,000 and returned to Knoedler two years later for a credit, fell by almost 30 percent.

With Goya's *The Forge*, Manet's *The Bull Fight*, and Degas's *Dancers (The Rehearsal)*, Frick broke from his usual pattern—these modern images adding substance and seriousness to a collection dominated by English portraits. *The Forge* was a six-foot canvas, painted in the early nineteenth century, where Goya focused on three laborers who struggle to work molten metal at an anvil. Seen from the back, the central figure swings a long hammer over his head, aiming for the anvil over which the two others bend. His gray and white shirt with its rolled-up sleeves is as complex and eloquent a passage of paint as any that Goya had applied to evoke the more sumptuous clothing of aristocrats. Certainly Frick saw steel-making as a heroic enterprise, but the respect for the iron workers conveyed by Goya's ennobling image seemed at odds with the history of the strikebreaking collector, who may not have seen the irony.

Frick quickly countered the avant-garde notes by adding three full-length van Dycks—*Paola Adorno* in 1914, *Anne, Countess of Clanbrassil* in 1917, and *Sir John Suckling* in 1918 to the four van Dycks he already owned. ("Owing to war losses" the Earl of Denbigh, who was serving in the British Army in Egypt, sought a "private purchaser" for *Anne, Countess of Clanbrassil*, according to the agent who wrote Frick about the painting in May 1916.) In 1917, Frick acquired his fourth (and second full-length) Gainsborough of Jane Clitherow, *Mrs. Peter William Baker*, a portrait of a young woman with towering powdered hair walking outdoors in a long gold satin dress.

During the course of the war, Frick also extended his line of grand-manner portraits into the industrial age by purchasing four full-lengths by James McNeill Whistler—*Arrangement in Brown and Black: Portrait of Miss Rosa Corder*; *Harmony in Pink and Grey: Portrait of Lady Meux*; *Symphony in Flesh Colour and Pink: Portrait of Mrs. Frances Leyland*, and *Arrangement in Black and Gold*—whose subject was the French dandy Comte Robert de Montesquiou-Fezensac,

dressed in white tie. Frick could now display 350 years of English por-traiture, starting with subjects from the reign of Henry VIII and ending with portraits of his own contemporaries. The presence of *Mrs. Frances Leyland*, depicting the dark-haired wife of a Liverpool shipowner, whom Whistler painted in the early 1870s when Frick was starting out in the coke industry, underlined the absence, among his two-dozen female portraits, of any image of the reclusive Adelaide Frick.

By the beginning of 1915, the Knoedler dealers needed capital. On February 11, they wrote to Lewis L. Clarke, president of the American Exchange Bank, explaining their intent to borrow $200,000 from each of three banks in order to weather the current depression, which had forced smaller galleries out of the market: "We feel that the present crisis will give us opportunities to buy abroad, and that this country will benefit tremendously in the pictures it will be able to acquire."

Even as he proposed building Knoedler's inventory, Carstairs had failed to sell two major paintings—Bellini's *St. Francis* and Hugh Lane's Holbein of Thomas Cromwell. Lane was struggling to stay afloat. He "was in here [at Knoedler] nearly every day worrying me to know if we were going to help him," and "very upset as he hadn't heard from you," a London assistant wrote Carstairs. Lane was planning to travel to New York soon to testify at a trial in a case involving the valu-ation of paintings. But meanwhile without Carstairs's knowledge, he authorized someone else in New York—Alice Creelman, the widow of the American journalist James Creelman—to sell his pictures. On the morning of April 2, Creelman visited Frick's house, and that afternoon she wrote him a note about "a small collection of wonderful paintings belonging to a little man . . . ruined by the war and [who] must part with them or go bankrupt." She mentioned a "beautiful Titian . . . and a superb Holbein." Soon after, she offered Frick the Holbein (*Thomas Cromwell*) for $300,000. A week later, she dropped the price to $290,000, and a day after that to $225,000, claiming that she would sell the canvas with the Titian together for $365,000. Before Creelman acknowledged that Hugh Lane owned the paintings, Frick must have already guessed. She failed to mention to Lane that her New York buyer was Frick.

If Lane betrayed Carstairs in turning to Creelman, Frick also went behind his dealer by agreeing to buy paintings from her. Across Creelman's April 10 letter, Frick scribbled a note: "Told her $215,000 net" to have the Holbein delivered to him in New York and to pay a commission of $10,000 (less than 5 percent) to "her & friend." Frick instructed Bankers Trust to pay her only after he had been shown the Holbein "in order that I may satisfy myself that it is the one I saw in London and which was cleaned by Dr. De Wilt [*sic*] of Knoedler & Company." Frick also agreed to buy Titian's *Portrait of a Man in a Red Cap*.

When Lane arrived in New York, he realized that his double-dealing had caught up to him. "I congratulate you on your bargains," he wrote Frick from the Saint Regis Hotel. "But I must confess that I am angry . . . as there is no reason why we should not have done the deal direct!"

Hugh Lane's brief visit to New York would have a tragic conclusion. He stayed only a week and a half, spending his last evening with Frick. On May 1, he headed back to England on the *Lusitania*. Six days later, a German torpedo struck the Cunard liner off the coast of Ireland and within eighteen minutes the ship had gone down. Hugh Lane was among the passengers lost. ("No news has been received of poor Sir Hugh. It looks hopeless," Creelman wrote Frick, immediately jumping to the subject of the pictures. "I hope you have received the Red Cap Titian.") Lane's death further slashed the prices of his Old Masters. In the end, for both the Holbein and the Titian, Frick paid $315,000. On May 14, Duveen cabled Berenson in Italy about Frick's Titian. "If Frick does not want to keep it, I would strongly urge you to take it for yourselves, if, as you tell me, he paid relatively little for it," Berenson replied. He was curious about the price: "Was it under £10, 000 [$50,000]?"

A year into the war, Carstairs in London told Frick that "business is absolutely stagnant here, but, curiously enough no one seems to have pictures of importance for sale." He concluded: "I presume everyone is waiting until the war is over."

In New York, Jack Morgan began to disperse his father's collection. Early in 1914, he agreed to let the Metropolitan Museum exhibit some 4,000 of Pierpont Morgan's acquisitions, including 39 tapestries, 260 Renaissance bronzes, 550 works of enamel, 900 miniatures, and over 50 Old Master pictures. The vast exhibition filled thirteen galleries and well

served to promote the parts of the art inheritance that Jack wanted to sell. "It may well be doubted whether even he [Pierpont Morgan] realized what a bewildering abundance of splendid objects he had accumulated," wrote the Metropolitan's director, Edward Robinson, "or what a display they were capable of making." In 1916, Jack Morgan gave the museum the Colonna Madonna. The following year, he turned over some 7,000 objects (from some 17,000) to the museum—most of them pieces of sculpture and decorative arts—including his father's Medieval collection. Morgan's gift would be one of the largest in the museum's history. Among the paintings he gave were Gerard ter Borch's *Young Woman at Her Toilet with a Maid* and Metsu's *The Visit to the Nursery*, from the Kann collection.

On January 10, 1915, Adelaide and Clay Frick met Joseph Duveen at the Morgan exhibition. If in the past Frick imitated Morgan as a collector, now he sought to acquire pieces that the banker had owned. According to René Gimpel, Duveen spotted the Knoedler dealers at the Morgan exhibition, standing in front of Fragonard's famous *Progress of Love*—ten panels depicting courtship. Made originally for a mistress of Louis XV, the pale paintings decorated a room at 13 Princes Gate. Duveen told Gimpel that he said to himself, "Aha," the Knoedler dealers "want to sell them to Frick." The following morning he "hurried around to Morgan's," and bought the Fragonard panels for around $1 million; by March 1, he sold them to Frick for $1.25 million—the highest price the tycoon ever paid for a work of art. (He would add $45,000 for frames and moldings required to install the Fragonards in a room in the new house.) By inserting an allegorical confection from France's ancien régime in the midst of English and Dutch portraits and landscapes, Frick refashioned his collection to more closely follow Morgan's aristocratic model.

Frick also asked Jack if he would sell his father's most celebrated English portraits—Reynolds's *Lady Delmé and Her Children* and Lawrence's *Elizabeth Farren*. "I would like very much to have two full-lengths for my dining room," Frick explained. Uncharacteristically, he didn't inquire about the price but volunteered "$500,000 prompt cash." The large sum suggested Frick's insatiable appetite for British art and his reluctance to treat a gentleman like Jack Morgan as he would have dealt with someone in the trade. Despite Frick's generous terms, Jack held on to the pictures.

The Morgan collection proved a windfall to the Duveens. "We have had a tremendous season here—in fact the greatest in the history of the firm," Joseph Duveen wrote Berenson from New York in July 1915. From the Duveens, Frick also bought quantities of Morgan's decorative arts—$4.7 million worth of Chinese porcelains, Italian bronzes, majolica, and eighteenth-century furniture. Duveen's sale of the eighteenth-century paintings to Frick was a cutting blow to Knoedler. "We were all very upset at seeing in all the papers that he [Frick] had bought the Morgan Fragonards from Duveen," Frederick Menzies wrote Carstairs, "as I am afraid it will be such a good advertisement for them."

By the spring of 1915, Carstairs had stored Bellini's *St. Francis in the Desert* for over a year at Knoedler in New York and he was increasingly anxious to turn the investment into cash. On May 14, 1915, Joseph Duveen cabled Berenson that Frick wanted his opinion on the Bellini landscape and that he had "advised Frick [to] purchase it saying you informed me it was great." He added, "Should like cable from you which I can show him in enthusiastic praise this would please him." Where twelve months earlier Carstairs had refused to let Frick have the Bellini for $200,000, he settled in early May for only $170,000, and then finally $168,000, because Frick paid with 367 shares of Columbia Trust Co. stock (at $460 a share). Since Arthur Grenfell had acquired the masterpiece in 1912, its price had fallen by a quarter. In a matter of days, Bernard Berenson got word that Frick had bought the Bellini. On May 16, from Settignano, he sent the cable that Duveen had requested.

CONGRATULATE *FRICK BELLINI* WHICH ONE MASTERPIECES ALL ITALIAN ART.

Arthur Grenfell had probably no idea that Frick had bought his Bellini and also his Titian—*Man in a Red Cap*. At the outbreak of the war, Grenfell, who was now forty-one and a father of five, had, like his brother Francis, joined the 9th Lancers, a cavalry division, which left for Belgium only weeks after the British mobilization. On November 1, 1915, after he had been in the trenches for over a year, he wrote Frick a

remarkable and moving letter. Earlier they had met as fellow financiers and collectors, when Grenfell visited Frick's collection in New York, but they no longer had much in common. To the English aristocrat trying to survive on a battlefield, New York must have seemed closer to the world he had once known in England than the wasteland where he found himself in Belgium. The reserved Englishman wrote with a disarming honesty that betrayed his despair. He recalled his visit to Frick: "I look back so often to the pleasure I had of meeting you & seeing your beautiful pictures that I felt I must write & tell you so. I suppose in times like these one's emotions get stirred up & big things appeal to one." Among these "big things" were "the really big pictures."

The letter conveyed the horror with which Grenfell and his English contemporaries had to cope. "Poor Newton has been killed. You may remember he was with me . . . ," he told Frick. So had one of Grenfell's brothers. In fact, he wrote, "Most of my friends have been killed or wounded. . . . One doesn't see any sign of this Armageddon coming to an end. It has been a terrible war—the most savage & cold-blooded killing machine versus human nerves & endurance."

Frick wrote back on November 29 a letter of some five sentences. He told Arthur Grenfell he "was aware of the sad loss" he had suffered and he extended his "deepest sympathy," but he was insistently optimistic, revealing he hadn't really understood the soldier's message. "You are certainly having a most difficult time, but it seems to me that things are shaping up so that you will be able to put an end to this war before many months."

By the end of 1915, Carstairs let Frick have two more paintings that once again expanded the dimensions of his collection—Bronzino's *Medici Prince* and the early Netherlandish *Deposition* by Gerard David. The Bronzino cost only $72,000 and the small, exquisite David even less.

In 1914, again the meticulous, record-keeping Frick took an accounting of his collection. He had a list drawn up of his fifty-nine most important paintings—their names hammered out by assistants on a typewriter onto long sheets of paper. Of these, he had bought forty-six from Knoedler and five from Duveen.

A later typewritten statement made immediately clear the extraordinary purchases he had made in the early part of the war. In just thirteen

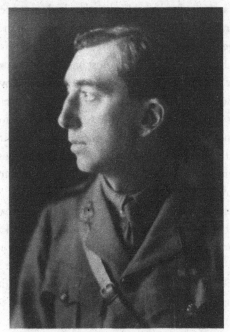

The London banker and collector Arthur Morton Grenfell, an officer in the 9th Lancers, fought in Belgium in World War I.

months, between July 1914 and August 1, 1915, he had spent $843,316 on paintings at Knoedler.

Three years later, in May 1918, Frick again tallied his paintings, now compiling the number he had bought since 1910, and their prices. In those eight years, he calculated he had spent over $9 million—some $190 million in 2006 dollars—on pictures.

In any accounting of Frick's collection, Charles Carstairs and Otto Gutekunst had an outstanding record. Of the dozens of Old Master pictures the dealers had persuaded him to buy, the identities of only a handful are questioned. Although neither had formal academic training in art, the dealers more than proved themselves as connoisseurs. Yet, the part they had played in forming Frick's collection, vividly recorded in the stock books and letters of their galleries, remained invisible to the public eye and was largely forgotten.

The Feast of the Gods

Bellini and Titian's Masterpiece Comes on the Market

In June 1916, Berenson sent a letter to Duveen in New York: "I write in tearing haste to tell you that I could procure you the Duke of Northumberland's *Bacchanal* (painted by Giovanni Bellini & Titian)." He added: "Only it must be done very quietly and discreetly." He warned the dealers to address their reply to him at Baring Bros. in London. "Italian censorship," he explained, "communicates every word contained in letters about works of art to people from whom we have every right & interest to keep it secret from."

What the Duveens replied isn't certain, but three months later, on September 30, they questioned Berenson about the painting and in a cable to the firm in London he explained its significance as a work of art: It "ranks with Botticelli's *Primavera* and *Birth of Venus* as among the few greatest imaginative creations of the Quattrocento and in my opinion America does not yet own [a] masterpiece comparable to it." He advised them not to let "such a work fall into other hands."

As Berenson knew, the Northumberland *Bacchanal*, or *The Feast of the Gods*, was legendary since its inception. Giorgio Vasari in his *Lives of the Artists* specifically mentioned the picture and claimed that Bellini had left it incomplete and that, after Bellini's death, Titian had finished it. (In fact, Titian had repainted the background.) Spread across the strange but ravishing painting (as though in a frieze) are seventeen carefully characterized figures—most of them classical gods and goddesses,

caught in distinctly human guise. They are dressed in greens, oranges, blues, reds, and countless other colors that Bellini created by spreading glazes, one upon another, and mixing ground glass into the paint to produce tones as luminous as stained glass. The subject is a bacchanal of classical divinities and a youthful company of male and female figures, eating and drinking and making erotic advances, some lost in their own thoughts and some gazing at the others. Bellini playfully signed the canvas by painting his name onto the image of a piece of paper stuck to a wine barrel in its lower right corner.

The Feast of the Gods depicts revelry, debauchery, and seduction. The central figure is a handsome, intoxicated, but contemplative Mercury seated on the ground, staring across the clearing at a young woman who has fallen asleep. Although her body is covered in a white robe, she is essentially a "nude," stretched out in the lower right of the canvas. The contours of her face are delicately inexact, breathing the airy atmosphere of the whole scene, which is full of movement, but oddly still. A young man leans over her, one of his hands raising the hem of her skirt. Between Mercury and the pale young woman are Jupiter, holding a cup to his mouth, a swarthy Pluto, and a peasantlike Apollo also imbibing. Besides the gods, who are identifiable by their traditional attributes (a helmet, an eagle, etc.), there are other figures—a child with a wreath on his head, two satyrs, and three standing young women, one carrying a blue and white porcelain bowl, from which to serve the feasting gods, yet also turning as though in the midst of a dance.

That the painting is difficult to read oddly increases the pleasure of looking. The eye moves from one figure to another, seeking clues, from a women in blue balancing a terra-cotta jar on her head, to the contoured blue stockings on the stretched-out legs of the youth in the foreground, to the glint on the silver rim of an overturned cup. Twilight and shadow, sky, trees, rocks, glass, metal, wood, grapes, a violin, drapery, flesh—Bellini showed he could paint them all.

On October 4, Berenson wrote Duveen again: "You will be not J. D. [Joe Duveen] but D. F. [Damned Fool], if you don't get the Bellini Bacchanal. From all I hear the price in New York can be almost anything you please and I shall not think it very bold of you if you don't dare."

But Duveen didn't dare. A shrewd assessor of the market, he may

have assumed that the canvas with its array of unfamiliar mythological characters was too complicated, remote, and sophisticated for the taste of most American tycoons. But over the past three decades that taste had evolved and expanded.

As Duveen hesitated, Lockett Agnew, Asher Wertheimer, and Arthur Sulley bought the painting together for 65,000 pounds ($325,000). A month later, on November 14, 1916, the art historian Robert Witt alerted the directors of the National Gallery in London about the "possible sale of the *famous Bacchanal at Alnwick*." On November 26, Bernard Berenson, knowing *The Feast of the Gods* would perfectly suit Isabella Stewart Gardner, tried to persuade her to draw on her capital and take the painting, which he only identified as a Renaissance masterpiece: "I am sure [it] is greater than any that has yet gone over to America. I won't say it is the greatest picture in the world, but I will say that the world has no greater—the only trouble is that even I could not get it for you under half a million dollars."

Berenson explained that Gardner could spread out the payment over two years. On January 7, he named the painting: "Nothing less than the world-renowned masterpiece, the *Bacchanal* which was painted for Alfonso d'Este Duke of Ferrara, in 1514 by Giovanni Bellini and Titian. The picture remained for generations at Ferrara, and finally after passing to the Aldobrandini family at Rome, it was bought within a hundred years by the Dukes of Northumberland. I saw it a number of times at Alnwick. Nobody but myself and one or two other outsiders are in on the secret of its present ownership." That day from Paris, Mary Berenson wrote Gardner a long description of the picture. "The poetry of Bellini's picture is so profound that you feel you could never exhaust or even entirely understand it; for the interpretation of the theme has an unexpectedness and originality that make you realize it is the result of the brooding and dreaming of a great mind."

Later in January, photographs were sent to Boston, although Arthur Sulley feared that they would put Gardner off. The varnish was cracking and worn, the background "dark and a little dirty," Mary Berenson wrote. But she added, "I scarcely know an old picture so well preserved—nor, as I wrote you—so mysterious and beautiful!"

Even before Isabella Gardner had seen a photograph of the painting,

she knew she wanted it. Her financial advisers cautioned she could only raise some $300,000. In March, she told Berenson that purchasing the painting was impossible. He refused to give up.

War taxes had reduced Gardner's income. She had closed down most of the rooms in the museum and was living in one on the top and

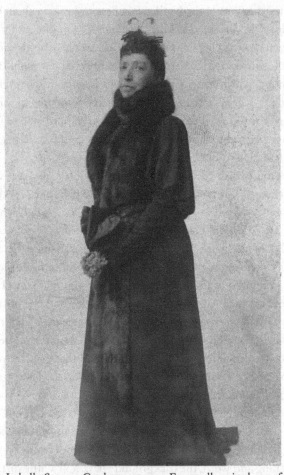

Isabella Stewart Gardner, ca. 1910. Eventually priced out of the Old Master market, she wrote: "Woe is me! Why am I not Morgan or Frick?" Image courtesy of the Boston Public Library, Print Department.

another on the ground floor. On May 18, she declared, "the *Feast* is put behind me!"

About a month before, on April 23, 1917, Arthur Sulley had written Peter Widener's son Joseph about the Bellini, asking him to "please treat it as an absolutely confidential communication as everyone has been trying to get at or find out about this picture," which had not been exhibited in "more than fifty years."

"Alnwick Castle is a long way from London and the Duke is not too fond of strangers, so the picture was overlooked by most people. . . . It is certainly the rarest picture of that time which can ever come into the market. There is at present a Bill before the House of Lords, here, to prevent masterpieces leaving this country and this is one of the chief pictures aimed at."

The dealer also attempted to communicate the painting's particular visual power. "The figures are beautiful, especially the two girls standing and the child with the jug at the barrel. I know nothing anywhere to equal these. . . . The sleeping woman is wonderful. The fact is the whole of the picture is so wonderful that it is difficult to write about."

He added that "there are things in the picture which do not show in the reproduction, for instance Titian wanted a spot of light in the middle distance and he has painted a faun holding a silver vase, and so gets his spot of light." The dealer rightly claimed, "It is a picture that if you sit and look at it absolutely fascinates you." The price was about 120,000 pounds, or $600,000. Widener made no move.

Throughout the war, *The Feast of the Gods* remained at Arthur Sulley's London gallery. Air-raids in 1917 persuaded the National Gallery's new director, Charles Holmes, that the museum's cellars would fail to protect the paintings from Germany's new missiles and he arranged to have an unused tube station turned into a "subterranean fortress," where, in January 1918, he sent some 900 of Britain's finest pictures. Later that year, Holmes finally received word that "Bellini's *Bacchanal* had been sold and was at Sulley's in Bond Street." Wearily he described the futile efforts to try to keep the painting in England. "Having been freshly cleaned it looked brilliant," he later wrote. "Every detail showed clearly." The Chancellor of the Exchequer went to examine the picture, but "with the Railway Strike and other signs of unrest about him,"

Holmes explained, "he did not feel justified in advancing the reduced, but still considerable, sum, which Mr. Wertheimer and Mr. Sulley had agreed with me to accept."

Some six months after the armistice in November 1918, Mary Berenson saw Bellini's *Feast of the Gods* again. She sent a copy of the letter she had written Isabella Gardner about the picture to Carl Hamilton, a former shoeshine boy now in his thirties who had found his way to Andover and Yale on a scholarship, and had made a quick fortune in oil during the war. An elusive character, Hamilton charmed Mary Berenson into thinking he was "the future source of untold wealth," and filled a New York apartment with paintings for which he owed Duveen 400,000 pounds. Hamilton agreed to buy *The Feast of the Gods*, but when he failed to pay for the picture, Arthur Sulley reclaimed it and asked Knoedler to store it in a bank vault in New York.

By September 1921, Sulley again approached Joseph Widener about *The Feast of the Gods*, and the collector agreed to purchase it. In early October Sulley asked Knoedler to deliver it to Lynnewood Hall. "As the Bellini is a good size when it is framed you might tell your servants where Knoedlers' people are to place it," Sulley wrote to Widener. Although Joseph Widener was heir to America's first Old Master collectors, his acquisition of *The Feast of the Gods* was the culmination of their ambitions, rivalries, spending, and tastes, and the painting's title emblematic of their entire collecting enterprise. Although more accessible than it was in a castle near England's border with Scotland, the canvas remained on Widener's estate in the Philadelphia suburbs for the next two decades.

Meanwhile, on December 2, 1919, Henry Clay Frick had died, at the age of sixty-nine. After a brief service at his house in New York, his body was taken in his railroad car to Pittsburgh to be buried. Charles Carstairs was among the honorary pallbearers. Frick left his house and his collection (valued at $50 million) to Adelaide Frick for her lifetime and then to the public.

Frick's death would seem to mark the end of an era, but his friend Andrew W. Mellon jumped into the fray, a dark horse who would end

up carrying the collecting ambitions of his generation to a fitting conclusion. In March 1921, the Pittsburgh banker became secretary of the Treasury and moved to Washington. A client of Knoedler's since the 1890s, Mellon only now with the field largely to himself started piling up major Old Masters (by Gainsborough, Vermeer, van Dyck, Reynolds, and Raphael) of the sort that appealed to his predecessors. "But though he denied the rumors that were circulating in Washington, it is clear that sometime during the mid-1920s Mellon did decide that he wanted to create his own national gallery," writes David Cannadine.

To that end, in 1930 and 1931, Andrew Mellon made arguably the twentieth century's most spectacular art purchase when $7 million persuaded the Soviet government to secretly sell some twenty paintings, including Raphael's *Alba Madonna* and Botticelli's *Adoration of the Magi*, from the Hermitage, the Leningrad museum that had been a palace of the czars. Colnaghi's Gustave Mayer, Knoedler's Charles Henschel, and a Berlin dealer negotiated the politically charged sale. The crash of the New York stock market in October 1929 had set off a worldwide depression, but financially Mellon remained largely unscathed.

In 1937, Andrew Mellon donated 125 Old Master paintings to launch the National Gallery of Art in Washington, D.C., arranging to give the United States government not only a picture collection but also the funds required to construct and endow the museum. By the time the handsome neoclassical five-acre gallery opened in early 1941, its founder had died and Europe was engulfed in another World War. A year later, the National Gallery received 101 pictures from Joseph Widener. Since Bernard Berenson had winnowed the Lynnewood Hall collection, the Wideners had kept up their pursuit of masterpieces, and to the museum they turned over 14 Rembrandts, 8 van Dycks, 2 Vermeers, Raphael's *Small Cowper Madonna*, and Bellini and Titian's *Feast of the Gods*.

Epilogue

In 1922, John Singer Sargent visited Isabella Stewart Gardner in Boston. She was eighty-two and partly paralyzed from a stroke. Nevertheless, Sargent painted her portrait. Once again he created an iconic image—this time in watercolor, capturing her mortality in the delicacy of his colored washes. She posed wrapped in white shawls—her face staring from the swaddling. She died two years later at the age of eighty-four, leaving her museum to the City of Boston. Her will made sure that the museum remain as it was in her lifetime. Frozen in time, Fenway Court with its extraordinary collection of Italian Renaissance paintings is an evocation of late-nineteenth-century taste and of Gardner's accumulative adventures in Europe.

In 1990, almost exactly a century after Gardner bought Vermeer's *Concert* at the Paris auction, thieves stole the canvas from her museum. They also took down the monumental Rembrandts (*Portrait of a Lady and a Gentleman in Black* and *Christ in the Storm on the Sea of Galilee*) obtained by Gutekunst from the Hope collection, cutting the canvases out of their frames. *Landscape with an Obelisk* (a panel painting, which Gardner had bought as a Rembrandt from Colnaghi) was also one of the thirteen works the robbers took. As of 2007, the museum had failed to recover any of them.

The year of Gardner's death, Jack Morgan established the Morgan Library as a public institution. Its collection of rare books and

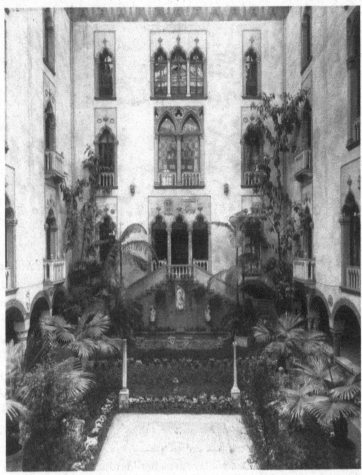

Central Courtyard, Isabella Stewart Gardner Museum, Boston. Gardner took inspiration from the Palazzo Barbaro in Venice in designing Fenway Court, which she completed in 1903.

manuscripts is one of the finest on the globe. In addition to the paintings left to the Metropolitan Museum of Art by Jack, several other of his father's canvases, including Fra Filippo Lippi's *Saint Lawrence Enthroned with Saints and Donors,* and Lawrence's *Elizabeth Farren* (both of which Jack sold in 1935), ended up there. Pierpont Morgan's daughter, Louisa Satterlee, kept Reynolds's *Lady Delmé and Her Children*

until 1930 when Duveen bought it. Throughout the twenties, thanks largely to Duveen, the American market for English portraits continued to rise. In 1921, he sold Gainsborough's *Blue Boy* to Henry Huntington (Collis Huntington's nephew and Arabella's second husband) for $728,000. Fifteen years later, the dealer sold Reynolds's *Lady Delmé* to Andrew Mellon, and the portrait went to the National Gallery, as did Morgan's Vermeer (*A Lady Writing*) and his Andrea del Castagno *Portrait of a Young Man* (with the red tunic and the piercing gaze), coveted by Isabella Stewart Gardner.

Louisine Havemeyer died at age seventy-three on January 6, 1929. With characteristic generosity, she bequeathed some two thousand works of art to the Metropolitan Museum as the H. O. Havemeyer collection. Her will named over one hundred paintings that she wanted the museum to have, among them the 8 Rembrandts, the 2 El Grecos, 15 Goyas, and many Impressionist canvases. In a codicil, she stipulated that her children could supplement the gift. Inviting the Metropolitan's curators to choose what they wanted, the Havemeyers added 111 more paintings, pastels, and drawings. The Havemeyer bequest transformed the Metropolitan, giving New York a collection of late nineteenth-century French canvases that is, according to one of the museum's curators, second "only to the collection of the French state at the Musée d'Orsay in Paris." Louisine left the house at 1 East Sixty-sixth Street with its Tiffany interior to her son Horace. A year later he tore it down. The contents that the children did not claim (including Cassatt's canvas *Mother and Child*) were auctioned in a series of sales, which ran for twelve days in April 1930. The Tiffany chandeliers (then out of fashion) went for no more than about $7 apiece.

The Frick Collection opened as a public museum in 1935, four years after Adelaide Frick's death. Like Gardner's Fenway Court, it maintained the character of a private house. In a sense, neither Gardner nor Frick ever relinquished control of their paintings, making certain they were seen forever as private possessions. With its marble floors, Oriental carpets, wood paneling, eighteenth-century furniture, and velvet walls, the Frick set its Old Master paintings in the sort of royal surroundings for which many had been painted. In the tradition of aristocratic collections, the canvases were hung not chronologically or by

school but where their owner (and later the collection's curators) thought they looked best. Frick allowed the trustees who ran the collection to expand it and by the year 2000 they had increased it by almost one-third. Interestingly, they added two more Pierpont Morgan paintings (Rembrandt's *Nicolaes Ruts* and Constable's *White Horse*). For visitors, the experience of the Frick Collection remains at once formal and intimate; they enter as though invited guests, find themselves in an opulent retreat from the din of Manhattan and momentarily in an American fantasy—where in a corridor they bump into two Vermeers.

Charles Carstairs never saw the Frick as a public collection. He died on July 9, 1928. Earlier that year, with his son Carroll Carstairs, Charles Henschel, and Carman Mesmore, he bought M. Knoedler & Co. from Roland Knoedler. Carstairs was "well known, indeed almost celebrated for his integrity," editors at *Burlington Magazine* wrote. "No one ever doubted his word or regretted an association with him, and when it first became known that he was seriously ill, even his keenest rivals in business expressed the deepest and most genuine regret."

At the start of the Second World War, Otto Gutekunst moved from England to Switzerland. In 1943, he wrote Berenson from the Hotel Montana in Lausanne. Still bitter that his old colleague and friend kept him at a distance, he mentioned that he hadn't visited I Tatti since 1902. He wondered if he would ever see England again. His house there had been "taken over by the Govt. & emptied of all . . . belongings, which are now distributed over a number of store houses in London." He died four years later.

Taking his cue from Isabella Gardner, Bernard Berenson attended to his legacy. For the American audience, he reigned in the field of Italian painting for more than half a century. "Worldwide adulation . . . marked his ninetieth birthday in 1955," observed Ernest Samuels. He died four years later, and was buried (beside Mary, who had died in 1945) in the chapel at I Tatti. As he wished, Harvard University turned the villa into a Center for Italian Renaissance Studies. Berenson remains controversial. "In writing and conversation he represented Culture as a disinterested striving for perfection, and withheld the fact that his own cultured way of life was made possible by the use of Culture as a commodity," wrote the art historian Meyer Schapiro. Looking back,

Berenson claimed that his mission had been "to send (to the United States) as many Italian works of art (and incidentally others too) as I could persuade collectors to acquire." By that measure, his life was more than successful.

A century after Henry Gurdon Marquand's death, Richard Morris Hunt's magnificent Fifth Avenue facade draws visitors to the Metro-

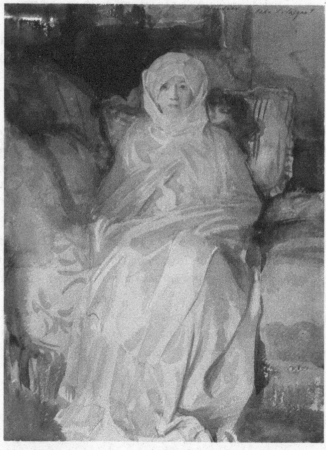

John Singer Sargent, *Mrs. Gardner in White*, 1922. Isabella Stewart Gardner Museum, Boston. Now eighty-two and partially paralyzed, Isabella Gardner posed wrapped in white shawls. "Did I tell you of Sargent's wonderful sketch in water-colour of me which keeps every one's tongue busy wagging?" she asked Berenson.

politan Museum of Art. The architecture still speaks of history and permanence, but since its completion, the museum has been in a constant state of expansion and change. It now stretches over eleven acres of Central Park and its encyclopedic collections contain over two million objects—paintings and sculpture, textiles, tombs, prints, drawings, photographs, vases, armor, and amulets.

But, immediately on entering the Metropolitan's great hall, the visitor's eye is carried across the vast space and up the grand staircase to red and yellow banners against an azure sky in the upper reaches of a fifteen-foot Tiepolo. To see the canvas demands a ceremonial climb up forty-six stone steps to a room of Tiepolos, which serve as prologue to some thirty galleries of Old Masters, including Morgan's Colonna Madonna, his *Elizabeth Farren*, Altman's Dutch and Italian pictures, and the Havemeyers' El Grecos. The Metropolitan boasts no less than seventeen Rembrandts—among them *Herman Doomer* and *Aristotle with the Bust of Homer*. (The museum has also accumulated more than fifteen other canvases reattributed to Rembrandt's contemporaries, imitators, and followers.) In a long gallery, Henry Marquand's van Dyck, *James Stuart, Duke of Richmond and Lennox,* faces Rubens's *Wolf and Fox Hunt*, a large version of the picture that the collector saw over the mantel in the picture gallery at Corsham Court. Since Marquand acquired a Vermeer in Paris in 1887, New York has added seven more, but the very first—*Young Woman with a Water Pitcher*—has, in its brilliance, yet to be outdone.

Despite the Metropolitan's new collections, galleries, and wings, the Old Masters still reign over the museum as they have for a century, enthroned at the top of the grand stairs.

Acknowledgments

In researching and writing this book, I depended on many people who generously gave their time and insights. Art collectors engage in mythmaking, and to break through those myths and unravel the actual buying and selling process that delivered Old Masters to America involved reading the letters of dealers and collectors—letters long stored and rarely, if ever, read. At the start, Konrad Bernheimer and Rachel Kaminsky gave me access to Colnaghi's archives, and I spent heady days going through letter books at a large table on the top floor of 15 Old Bond Street (once Knoedler's London branch), where I could hear the voice of Otto Gutekunst discussing his purchases with Berenson and Carstairs. The running commentary on the Old Master market brought the dealer, as well as his colleagues and clients, to life. In New York, Ann Freedman enabled me to understand the American side of the Colnaghi-Knoedler partnership by allowing me to work at Knoedler. Equally important were the Frick Collection and the Frick Art Reference Library, where from the beginning Patricia Barnett and Sally Brazil opened the doors and in countless ways supported my research. Throughout the project, Susan Chore and above all Julie Ludwig unfailingly responded to the steady stream of requests and questions.

The book could not have been written without these and other critical archives: At the Metropolitan Museum of Art, Alice Cooney Frelinghuysen led me to the Frances Weitzenhoffer files in the Department of American Decorative Arts, and Everett Fahy allowed me to read and quote from the letters of Henry G. Marquand and Roger E. Fry in the Department of European Paintings. Susan Alyson Stein guided me to important Havemeyer letters. Patrice Mattia responded to requests with consummate professionalism. In the Department of European Sculpture and Decorative Arts, Danielle Kisluk-Grosheide shared her files on Henry G. Marquand, and in the Archives Jeanie James guided me to the

Marquand and Cassatt correspondence. At the Isabella Stewart Gardner Museum in Boston, Kristin Parker helped me track down material from Henry James, John Singer Sargent, and others. At the Harvard Center for Italian Renaissance Studies at the Villa I Tatti in Florence, Fiorella Superbi navigated the Berenson correspondence and found a photograph of Otto Gutekunst. At the Galerie Durand-Ruel in Paris, Flavie Durand-Ruel and Paul-Louis Durand-Ruel went out of their way to answer questions about Paul Durand-Ruel's trips to Spain and his purchases of Spanish pictures. At the National Gallery of Art in Washington, D.C., Ann Halpern steered me to the Widener correspondence, and Nancy Yeide gave me permission to quote from the letters. At the Morgan Library & Museum, Christine Nelson directed me to the papers related to Morgan's collecting.

I am also tremendously grateful to the friends who contributed knowledge and expertise and read parts of the manuscript: Alice Cooney Frelinghuysen, Jonathan Galassi, Susan Galassi, Emily Kernan Rafferty, and Gail Winston. The origins of this book go back a long way—to courses at Harvard and at the University of California at Berkeley, and, in particular, to a seminar in seventeenth-century Dutch art, taught by Svetlana Alpers. Over the past several years in New York, she has given me invaluable help on this book, fielding questions, providing ideas, and then reading the entire manuscript. Also in recent years, Jon Galassi gave advice on many occasions.

If archives provided the foundation for my research, scholars helped me illuminate the material. Early on, Ron Chernow listened to my plans to write about collectors in the Gilded Age and urged me to go ahead. Alan Chong shared his knowledge of Isabella Gardner and her collecting. Nicholas Hall discussed his research on Colnaghi. David Nasaw added to my understanding of Carnegie and Frick. Flaminia Gennari Santori previewed her work on Pierpont Morgan. Dick McIntosh explained the early history of Knoedler. Jaynie Anderson put Morelli in the context of contemporary connoisseurs. Nancy Mowll Mathews pointed the way on Mary Cassatt and her role in American collecting. Barbara Weinberg talked about Marquand in the context of American art and introduced me to other scholars. Beth Carver Wees and Medill Higgins Harvey explained Marquand's history in American silver. In Berlin, Sven Kuhrau and Dr. Tanja Baensch described their research on Wilhelm von Bode, and Ulrike Goeschen translated correspondence between Bode and Colnaghi and tracked down answers to many questions.

I am also indebted to members of the families of the collectors and of other figures in the book: Townsend Burden and Helen Clay Chace, who encouraged me to research Henry Clay Frick; Allan Forsyth, who showed me an early portrait of Henry Gurdon Marquand; Harry W. Havemeyer, who explained the history of the sugar-refining industry and loaned me many books; Linden Havemeyer Wise, who shared her perspective on Louisine Havemeyer; and Blaikie Worth, who handed me Henry Gurdon Marquand's diary and gave me a place at a desk in her living room where I could read it. In England, George Fergusson introduced me

to his aunt Dame Frances Campbell-Preston, who gave me photographs of her father, Arthur Grenfell, and of his dining room, where he had hung Titian's *Man in a Red Cap*. Lady-Charlotte Townshend invited me to see the drawing room at Melbury, where the Frick's Rembrandt *Self-Portrait* had hung for over a hundred years. James Methuen-Campbell showed me Corsham's library and supplied a photograph of Frederick Methuen.

Others for whose help I am grateful are Julian Agnew, Jonathan Brown, and Colin Eisler (who each discussed aspects of collecting with me), Ronni Baer (who retrieved information about Sargent buying El Greco's *Fray Hortensio Félix Paravicino* for Boston), Martha Bograd, Keith Christiansen, Mitchell Codding, Philip Conisbee, Sharon Cott, Frederick Courtright, Alan Crookham, Stephanie Dieckvoss, Lydia Dufour, Barbara File, Françoise Forster-Hahn, Joseph Friedman, Isabel Galassi, Anne Guillemet, Donald Garstang, Evelyn Halpert, Harold Holzer, Bay James, Walter Liedtke, Peter Loring, Robert Maguire, Diana T. McNamara, Melissa de Medeiros, Katarina Meyer-Haunton, David Norman, Richard Ormond, Peter Paret, Inge Reist, Aaron Schmidt, James Sheehan, Amanda Smith, Rosemary Stewart, Elyse Topalian, Charles Towers, Jennifer Vanim, Edye Weissler, and Meg Winslow. Kate Daloz, Pamela Green, and Nicole Myers all contributed to the research. For over two decades, Christopher Burge, Michael Findlay, and Eugene V. Thaw have delivered clarifying perspectives on the art market. Timothy W. Guinnane, in the Department of Economics, Yale University, converted historical prices into 2006 dollars.

My thanks go to the staff of the following libraries and archives: The Sterling and Francine Clark Institute, Williamstown; The Research Library, The Getty Research Institute, Los Angeles; the John G. Johnson Collection Archive, Philadelphia Museum of Art; the Thomas J. Watson Reference Library, The Metropolitan Museum of Art, New York; The Reading Room, The Morgan Library & Museum, New York; the National Gallery Archive, London; Staatliche Museen zu Berlin, Zentralarchiv, Berlin; and above all, The Frick Art Reference Library, New York, and The New York Society Library.

At Viking, I would like to thank my editor, Carolyn Carlson, who championed the book from the start and, for the second time, contributed her excellent editing to the manuscript. Also at Viking, Ellen Garrison helped shepherd the manuscript through the editing process. Nancy Resnick created the book's elegant design and Greg Mollica its beautiful cover. Gina Anderson gave legal advice. Marlene Tungseth copyedited the manuscript and Kate Griggs masterfully managed the book's editorial production.

My greatest appreciation goes to Melanie Jackson, indeed the very best of agents and friends, for her astute counsel, bedrock support, and the brilliance she brings to all aspects of her work.

Among the friends whose spirits and advice encouraged me throughout the book were my Society Library companions—Benita Eisler, Ellen Feldman, Gayle Feldman, and Connie Roosevelt—as well as Lyn Chase, Wendy Chittenden,

Aileen Dodds-Parker, Anna Fels, Alida Messinger (who inadvertently introduced me to the subject of collecting), Emily Kernan Rafferty, Susan Restler, and Margret Stuffmann. Above all, over the course of years, in two Brooklyn kitchens, Susan Galassi has offered intellectual and culinary sustenance. And Joan Gardiner accompanied me to see the picture gallery at Corsham Court and helped sharpen the manuscript—more than once. In innumerable ways, members of my family also contributed—in particular, Penelope Saltzman; Katherine Motley Hinckley once again corrected the French translations; Katharine Pickering arranged for me to see Frick's property in Prides Crossing; and Elisabeth Motley did research on New York. Importantly too, in 1987, when *The Letters of Bernard Berenson and Isabella Stewart Gardner* was first published, my mother gave me a copy.

Incalculable thanks go to Matthew and William Motley for keeping me company on trips to London and Florence and for throwing doses of humor and realism into life lived during the course of this book, and to Warren Motley, who encouraged and endured my obsessive pursuit of Isabella Stewart Gardner, Henry Clay Frick, and the rest, and gave editing advice that got me to the point of the story.

Notes

ARCHIVE COLLECTIONS

Colnaghi—The P & D Colnaghi Archives, London
DBR—Duveen Brothers Records, Research Library, The Getty Research
 Institute, Los Angeles
TFC/FARL—The Frick Collection and Frick Art Reference Library Archives,
 New York
 HCFACF—Henry Clay Frick Art Collection Files
 HCFP—Henry Clay Frick Papers
 C—Correspondence
 GLB—General Letterpress Book
ISGMA—Isabella Stewart Gardner Museum Archives, Boston
Knoedler—Knoedler & Company, New York
MMA—The Metropolitan Museum of Art, New York
 EP—Department of European Paintings

INDIVIDUALS

BB—Bernard Berenson
MB—Mary Berenson
AC—Andrew Carnegie
CSC—Charles Stewart Carstairs
MC—Mary Cassatt
CWD—Charles W. Deschamps
PDR—Paul Durand-Ruel
HD—Henry Duveen
JD—Joseph Duveen
HCF—Henry Clay Frick
ISG— Isabella Stewart Gardner

OG—Otto Gutekunst
HOH—Henry Osborne Havemeyer
LWH—Louisine Waldron Elder Havemeyer
RK—Roland Knoedler
HGM—Henry Gurdon Marquand

NOTE ON PRICES

In the late nineteenth and early twentieth centuries, the pound sterling was worth $4.86 and the dollar worth 5.1 French francs. Throughout the text, in translating the value of the historical prices of works of art into 2006 dollars, the United States consumer price index was used. This index suggests how many dollars would have to be spent in 2006 to get the same "bundle" of goods in a particular year in the past. These figures are only approximations. In addition, the consumer price index measures the prices paid on goods bought by average households and not households of the rich, who buy expensive goods (wines, porcelain, silver, and so forth, in addition to paintings), which may have a different rate of inflation than the goods used in the index. Finally, the figures translated into 2006 dollars reflect inflation and not the time value of money.

INTRODUCTION

1 **"game of civilization":** Henry James, "The American Purchase of Meissonier's 'Friedland,'1876," in James, *The Painter's Eye*, ed. John L. Sweeney (London: Rupert Hart-Davis, 1956), 109.

1 **"quite left out":** Henry James to Mary Walsh James, October 13, 16, [17], 1869, Pierre A. Walker and Greg W. Zacharias, *The Complete Letters of Henry James, 1855–1872*, vol. 2 (Lincoln, NE, and London: University of Nebraska Press, 2006), 145.

1 **"no museums, no pictures":** Henry James, *Hawthorne* (Ithaca, NY, and London: Cornell University Press, 1997), 34.

2 **"no Raphael, no Michelangelo":** Roger E. Fry, "Ideals of a Picture Gallery," *MMA Bulletin*, 1, no. 4 (March 1906), 59.

3 **French Revolution:** Francis Haskell, *The Ephemeral Museum* (New Haven, CT, and London: Yale University Press, 2000), 4.

5 **to disguise it:** P. A. B. Widener, in Esmée Quodbach, "The Last of the American Versailles: The Widener Collection at Lynnewood Hall," *Simiolus*, 29, no. 1/2 (2002), 75.

5 **"most of them exquisite":** "The Travel Diaries of Otto Mündler," 1857, in *Fifty-First Volume of the Walpole Society,* ed. Carol Tagneri Dowd (Oxford: Walpole Society, 1985), 152.

5 **French capital:** MB to her family, January 12, 1913. *Mary Berenson: A Self-Portrait from Her Diaries and Letters*, ed. Barbara Strachey and Jayne Samuels (New York and London: W. W. Norton & Company, 1983), 186.

6 **"YOUR ADVICE":** JD to BB, February 9, 1910, in Ernest Samuels, *Bernard Berenson: The Making of a Legend* (Cambridge, MA, and London: The Belknap Press of Harvard University Press, 1987), 101.

6 **"VERMEER FORGOTTEN":** CSC to OG, December 5, 1911, Knoedler.

6 **"urge it upon you":** BB to ISG, April 24, 1917, *Letters of Bernard Berenson and Isabella Stewart Gardner, 1887–1924*, with correspondence by Mary Berenson, edited and annotated by Rollin van N. Hadley (Boston: Northeastern University Press, c. 1987), 601.

7 **"not Morgan or Frick":** ISG to BB, August 26 [1907], *Letters*, 405.

CHAPTER 1. "AMERICAN CITIZEN . . . PATRON OF ART"

12 **"solicit a bid":** HGM to CWD, September 26 and 16, 1886. MMA Archives.

14 *Betrayal of Christ:* See "Taking of Christ," Bristol Museum and Art Gallery, in Christopher Brown and Hans Vlieghe, *Van Dyck, 1599–1641* (London: Royal Academy Publications. Antwerp: Antwerpen Open, 1999), 144; *The Treasure Houses of Britain* (Washington, D.C.: National Gallery of Art, 1985), 338.

14 **350,000 visitors:** Calvin Tomkins, *Merchants and Masterpieces: The Story of the Metropolitan Museum of Art* (New York: Henry Holt and Company, 1970, 1989), 58.

15 **most important:** Winifred E. Howe, *A History of the Metropolitan Museum of Art* (New York: Metropolitan Museum of Art, c. 1913–46), I, 194.

15 **"artistically hardly any":** *New York Times*, February 22, 1880, in Elizabeth McFadden, *The Glitter and the Gold* (New York: Dial Press, 1971), 186–87.

15 **"first-rate genius":** Henry James, "The Metropolitan Museum's '1871 Purchase,' " 1872, in James, *The Painter's Eye*, 52.

16 **"bewildered the viewer":** William Cullen Bryant, in Howe, I, 107,108.

16 **"laborious people":** Joseph C. Choate, in Tomkins, *Merchants*, 16.

17 **"patron of the fine arts":** HGM, MMA Annual Report, 1888, 414.

17 **"pure and applied":** George Fiske Comfort, in Tomkins, *Merchants,* 30.

17 **treasures to come:** Ibid., 35.

17 **"world's masters":** Joseph C. Choate, ibid., 23.

18 **"of the High Renaissance":** Jaynie Anderson, "National Museums, the Art Market and Old Master Paintings," *Kunst und Kunsttheorie, 1400–1900*, ed. Peter Ganz (Wiesbaden, Germany: Harrossowitz, 1991), 375.

18 **Franco-Prussian War:** Katharine Baetjer, "Buying Pictures for New York: The Founding Purchase of 1871," *Metropolitan Museum Journal,* 39 (2004), 167, 177.

18 **gullible Americans:** Ibid., 163, 164.

18 **"other works of art":** MMA Annual Report, May 1872, 20.

18 **"nineteenth century painting":** Roger E. Fry, "Ideals," 58.

18 "acquire the *best*": HGM to CWD, August 16, 1882, MMA, EP.

19 "will be proud": J. Alden Weir, in Dorothy Weir Young, *The Life & Letters of J. Alden Weir* (New Haven, CT: Yale University Press, 1960), 159.

19 "I would get in time": HGM to J. Alden Weir, ibid., 160.

19 "than go to heaven": William Merritt Chase, quoted in H. Barbara Weinberg, "Late-Nineteenth-Century American Painting: Cosmopolitan Concerns and Critical Controversies," *Archives of American Art Journal*, 23, no. 4 (1983), 19.

19 "cultural arena": Ibid.

19 "should be encouraged": Richard Morris Hunt, in Elizabeth Hawes, *New York, New York* (New York: Alfred A. Knopf, 1993), 15.

20 American art: Ernest Knaufft, "Henry G. Marquand as an American Art Patron," *American Review of Reviews*, 27 (January–June, 1903), 172.

20 Henry Gurdon Marquand: For HGM biography, see: *The National Cyclopedia of American Biography VIII,* ed. Ainsworth R. Spofford (New York, 1898), 390. *Dictionary of American Biography XII,* ed. Dumas Malone (New York, 1933), 292–93.

20 their own ships: George Barton Cutten, *Silversmiths of Georgia* (Savannah, GA: Oglethorpe Press, 1998), 89. See Deborah Dependahl Waters, "Silver Ware in Great Perfection: The Precious Metal Trades in New York City," in *Art and the Empire City: New York, 1825–1861,* eds. Catherine Hoover Voorsanger and John K. Howat (New York: Metropolitan Museum of Art; New Haven, CT, and London: Yale University Press, 2000), 355–75.

20 rivers on either side: Edgar Allan Poe, "Doings in Gotham, Letters III and V," 1844, in *Empire City: New York Through the Centuries,* eds. Kenneth T. Jackson and David S. Dunbar (New York: Columbia University Press, 2002), 199.

20 "suburb": Alexis de Tocqueville, 1835, in Jackson and Dunbar, *Empire City,* 178.

21 "brother's store": Excerpts from HGM *Diary*, 1832, private collection.

21 "New England notions": HGM, 1891, in Tomkins, *Merchants,* 77–78.

21 "once in ten years": Philip Hone, May 1, 1939, in Ric Burns and James Sanders, *New York: An Illustrated History* (New York: Alfred A. Knopf, 1999), 76.

22 "farewell": Excerpts from HGM *Diary,* June 6, June 7, November 1842.

22 "aspirations": E. A. Alexander, "Mr. Henry G. Marquand," *Harper's New Monthly Magazine* 94 (March 1897), 563. For Henry Kirke Brown, see Thayer Tolles, "Modeling a Reputation: The American Sculptor and New York City," in Voorsanger and Howat, eds., *Art and the Empire City,* 135–67.

22 "suffer but to enjoy": Henry James, *Roderick Hudson* (first published 1875), ed. Geoffrey Moore (London: Penguin Group, 1986), 342.

23 larger than Europe's: Samuel Eliot Morison, *Oxford History of the American People* (New York: Oxford University Press, 1965), 743.

23 "New York he knew": *Harper's Monthly,* 1856, quoted in Burns and Sanders, 71.

23 **in the Western Hemisphere:** *The Encyclopedia of New York City,* ed. Kenneth T. Jackson (New Haven, CT: Yale University Press, 1995), 923.

25 **"under that head":** HGM to Richard Morris Hunt, October 7, 1885, Allan Marquand Papers, Princeton University Library.

25 **private "museums":** See Danielle O. Kisluk-Grosheide, "The Marquand Mansion," *Metropolitan Museum Journal,* 29 (1994), 151–81.

25 **"well-painted Madonna":** Max Liebermann, quoted in Peter Paret, *The Berlin Secession* (Cambridge, MA: The Belknap Press of Harvard University Press, 1980), 87.

26 **"ready to part with":** Frederick Methuen to H. Herbert Smith, May 12, 1886, MMA, EP.

26 **"in an embassy":** Voltaire, in *Corsham Court* (Wiltshire: privately printed, 1993), 25.

26 **relentless collectors of art:** Frank Herrmann, *The English as Collectors* (New York: W. W. Norton & Co., 1972), 3–5.

26 **rapid rate:** See Iain Pears, *The Discovery of Painting* (New Haven, CT: Yale University Press, 1988).

27 **Alnwick Castle:** Francis Haskell, "The British as Collectors," *Treasure Houses,* 51.

27 **"with their guineas":** Gustave Waagen, in Herrmann, 148.

27 **quantities of pictures:** Herrmann, 6, 365. Brian Allen, "England, XIII, Collecting and Dealing," *The Dictionary of Art* (New York: Grove's Dictionaries, 1996), 10, 365.

27 **"hottest time of the war":** Anna Jameson, "Companion to the Most Celebrated Private Galleries of Art," London, 1844, in Herrmann, 14n1.

27 **"price levels":** William N. Goetzmann, "Accounting for Taste," *American Economic Review,* 83, no. 5 (1993), 1373.

27 **"with the Louvre":** Théophile Thoré, in Brian Allen, "England," 10, 367.

28 **"painted for them":** Henry James, "The Picture Season in London," *Galaxy* 24, 24 (July 1877), in Haskell, *Ephemeral Museum,* 78.

28 **pair of Claudes:** Rembrandt's *Man in an Oriental Costume* was sold to William K. Vanderbilt, who bequeathed it to the Metropolitan in 1920. Rubens's *David and Abigail* ended up in the Detroit Institute of Arts.

28 **financial crisis:** David Cannadine, *The Decline and Fall of the British Aristocracy* (New York: Anchor Books, 1992), 8, 9, 92–93.

28 **political power:** Ibid., 39–43.

29 **[National Gallery's] board:** Methuen to Smith, May 12, 1886, MMA, EP.

29 **"do his best" for the paintings:** Ibid.

29 **"make me an offer":** Smith to CWD, May 16, 1886. MMA, EP.

30 **"sale in hand":** Lawrence Alma-Tadema to HGM, July 7, 1886, Allan Marquand Papers, Princeton University Library.

30 **Sargent:** See Richard Ormond and Elaine Kilmurray, *John Singer Sargent: The Early Portraits* (New Haven, CT, and London: Yale University Press, 1998).

30 **Frank Millet:** See H. Barbara Weinberg, "The Career of Francis Davis Millet," *Archives of American Art Journal,* 17, no. 1 (1977), 2–18.

31 **"necessity of selling":** CWD to HGM, July 16, 1886, MMA, EP.

31 **"care to sell":** Smith to CWD, July 21, 1886, MMA, EP.

31 **"put on it":** CWD to HGM, July 22, 1886, MMA, EP.

32 **for himself:** CWD to HGM, July 23, 1886, MMA, EP.

32 *James Stuart:* See Brown and Vlieghe, *Van Dyck,* 257–59. Arthur K. Wheelock, "James Stuart," in *Van Dyck* (Washington, D.C.: National Gallery of Art, 1990), 259–60.

34 **"superstition and despotism":** John Lothrop Motley, *History of the United Netherlands* (New York: Harper, 1866–68), vol. 1, xxii.

34 **"inexhaustible inventiveness":** Walter A. Liedtke, *Anthony van Dyck* (New York: Metropolitan Museum of Art, 1985), 37.

34 **American collectors:** Walter Liedtke, "The Havemeyer Rembrandts," in Alice Cooney Frelinghuysen, et al., *Splendid Legacy: The Havemeyer Collection* (New York: Metropolitan Museum of Art, 1993), 65.

34 **"any bargain":** HGM to CWD, October 5, 1886, MMA, EP.

35 **a commission:** Ibid.

35 **importing works of art:** Kimberly Orcutt, "Buy American? The Debate over the Art Tariff," *American Art,* 16, no. 3 (Autumn 2007), 82.

35 **"in funds":** Methuen to Smith, undated letter, 1886, MMA, EP.

35 **Masaccio:** These paintings have been reattributed: the Lucas van Leyden (*An Unidentified Scene*) to Jorg Breu the Younger; Rubens's *Portrait of a Man* to van Dyck; the Masaccio to Fra Filippo Lippi.

36 **"where they are going":** HGM to CWD, October 12, 1886, MMA, EP.

36 **"the country":** George Boughton to HGM, November 6, 1886, MMA Archives.

36 **"afternoons":** Frank T. Robinson, "Van Dyck's Masterpiece," *Boston Evening Transcript,* January 29, 1887.

36 **"intelligence":** Ibid.

37 **"2 or 3 days":** HGM to CWD, October 25, in Ormond and Kilmurray, *Early Portraits,* 199.

37 **"dignement":** Henry James to Henrietta Reubell, April 1, 1888, ibid.

37 **"van Dyck of the period":** Auguste Rodin from the *Daily Chronicle,* May 16, 1902, ibid., 150.

37 **"thank you":** John Singer Sargent to HGM, March 18, [no year given], Marquand papers, Princeton University Library, ibid., 199.

37 *Water Pitcher:* Alexander, "Mr. Henry G. Marquand," *Harper's,* 568. See Walter Liedtke, *Vermeer and the Delft School* (New York: Metropolitan Museum of Art; New Haven, CT, and London: Yale University Press, 2001), 379–81. *Dutch Paintings in the Metropolitan Museum of Art* (New York: Metropolitan Museum of Art; New Haven and London: Yale University Press, 2007), 877–80.

38 **Gabriel Metsu:** Ben Broos, "un celebre Peijntre nomme Verme[e]r," *Jo-*

hannes Vermeer, ed. Arthur K. Wheelock, Jr. (Washington, D.C.: National Gallery of Art and the Hague: Royal Cabinet of Paintings, Mauritshuis, 1995), 55, 56, 47. Lord Powerscourt had sold *Young Woman with a Water Pitcher* to Agnew's; it then went to the Paris dealers Stephan Bourgeois (of Bourgeois Frères), and Charles Pillet, 146–50.

38 **American collectors:** See Walter Liedtke, "Dutch Paintings in America: The Collectors and Their Ideals," B. P. J. Broos, *Great Dutch Paintings from America* (The Hague: Mauritshuis; San Francisco: Fine Arts Museums of San Francisco, 1990–1991), 14–59.

39 **"art of describing":** Svetlana Alpers, *The Art of Describing: Dutch Art in the Seventeenth Century* (Chicago: University of Chicago Press, 1983), xx.

39 **forebears:** John Lothrop Motley, in Oliver Holmes, *John Lothrop Motley* (Boston and New York: Houghton, Osgood and Co., 1879), 89.

40 **"without condition":** HGM to MMA trustees, January 10, 1889, MMA Archives.

40 **"whole country":** Alexander, "Mr. Henry G. Marquand," *Harper's,* 566, 562.

40 **"all the world":** Alfred Trumble, *The Collector,* III, February 15, 1892, 81.

40 **"fashion over there!":** Humphrey Ward to HGM, in Kisluk-Grosheide, "The Marquand Mansion," 176n8.

40 **academic discipline:** For early art history, see James J. Sheehan, *Museums in the German Art World* (New York: Oxford University Press, 2000), 90.

40 **Marquand's own son Allan:** See Marilyn Aronberg Lavin, *The Eye of the Tiger: The Founding and Development of the Department of Art and Archaeology, 1883–1923* (Princeton, NJ: Princeton University Press, 1983).

40 **"on the continent":** Wilhelm von Bode, "Alte Kunstwerke in den Sammlungen der Vereinigten Staaten," *Zeitschrift für bildende Kunst,* 6 (1895), 16, 17.

41 **"good taste":** Bode, in Quodbach, "Versailles," 60.

41 **"pictures systematically":** Bode, "Alte Kunstwerke," 13.

41 **"controls Mr. Marquand":** Hiram Hitchcock in Tomkins, *Merchants,* 81.

42 **"in the Museum":** Everett Fahy, "How the Pictures Got Here," in *From Van Eyck to Bruegel: Early Netherlandish Painting in the Metropolitan Museum of Art,* eds. Maryan W. Ainsworth and Keith Christiansen (New York: Metropolitan Museum of Art, 1998), 65.

42 **"double portrait":** Keith Christiansen, "Portrait of a Woman and a Man at a Casement," in *From Filippo Lippi to Piero della Francesca: Fra Carnevale and the Making of a Renaissance Master,* ed. Keith Christiansen (New York: Metropolitan Museum of Art; Milan: Edizioni Olivares; New Haven, CT, and London: Yale University Press, 2005), 150.

43 **"snatch his monument":** Morrison H. Heckscher, *The Metropolitan Museum of Art: An Architectural History, MMA Bulletin* (Summer 1995), 33.

43 **at the Louvre:** "Rearrangement of a Picture Gallery at the Museum," *MMA Bulletin* 1, no. 5 (April 1906), 69; and "Recent Changes in the Gallery," *MMA Bulletin,* 1, no. 6 (May 1906), 87.

43 **"serious attention"**: Roger E. Fry, "Ideals of a Picture Gallery," 59. For the plan, see Flaminia Gennari Santori, " 'European Masterpieces' for America," *Art Made Modern: Roger Fry's Vision of Art,* ed. Christopher Green (London: Courtauld Institute of Art in association with Merrell Holberton, 1999), 107–18.

43 **"Marquand Gallery"**: *MMA Bulletin,* 6, no. 1 (January 1911), 4.

CHAPTER II. "C'EST MON PLAISIR"

45 **"the best terms"**: BB to ISG, August 1, 1894, *Letters,* 39.

46 **"for fr. 29,000"**: John Lowell Gardner, *Diary,* Monday, December 5, 1892, ISGMA.

46 **"between 150 and 200 thousand!"**: Ralph W. Curtis to ISG, August 12, 1892, ISGMA.

47 **"only like him"**: ISG to BB, February 19, 1900, *Letters,* 205.

47 **"vulgar millionaire"**: BB to ISG, January 14, 1900, ibid., 201.

47 **"need apply"**: ISG to BB, December 2, 1895, ibid., 43.

49 **"private musicale"**: Greta, "Art in Boston: The Sargent Portrait Exhibition," *The Art Amateur: Devoted to Art in the Household* 18.5 (April 1888), 110, quoted in "Documents," Kathleen Weil-Garris Brandt, "Mrs. Gardner's Renaissance," *Fenway Court* (Boston: Isabella Stewart Gardner Museum, 1990–91), 26.

49 **"thin and shadowy"**: BB to MB, September 1897, in Ernest Samuels, *Bernard Berenson, The Making of a Connoisseur* (Cambridge, MA: The Belknap Press of Harvard University Press, 1979), 286.

49 **"New York foreigner"**: ISG to BB, December 19, 1904, *Letters,* 354.

49 **"Madonna with a Halo"**: Henry James to Miss Reubell, February 22, 1888, Houghton Library, Harvard University, b MS Am 1094 [1074], in Ormond and Kilmurray, *The Early Portraits,* 210.

49 **ropes of pearls**: See Brandt, "Mrs. Gardner's Renaissance," 25.

50 **as a collector**: Ibid., 10. "Mrs. Gardner's Venetian palace was and remains her self-image in the persona of a great Renaissance patroness of the arts," 11.

50 **"models to have enjoyed"**: Ibid., 12.

50 **"her every action"**: Morris Carter, *Isabella Stewart Gardner and Fenway Court* (Boston: Houghton Mifflin, 1925), 188. Kathleen D. McCarthy observes that "her motto . . . flew in the face of the notion of female self-sacrifice," *Women's Culture: American Philanthropy and Art, 1830–1930* (Chicago and London: University of Chicago Press, 1991), 161.

50 **cosmopolitanism**: For ISG, see Carter, *Gardner*; Louise Hall Tharp, *Mrs. Jack: A Biography of Isabella Stewart Gardner* (Boston and Toronto: Little, Brown and Company, 1965).

51 **"comfort and luxury"**: Julia Gardner to Mrs. Catherine Gardner, October 8, 1859, in Carter, *Gardner,* 19–20.

51 **"people condemned to them"**: Henry James to ISG, from Lamb House, Rye, February 2, 1899, ISGMA.

51 **"health & gaiety as I last saw him"**: Ibid.

51 **"the natural result"**: Henry Higginson to ISG, May 28, 1919, ISGMA.

51 **"to rejoice as myself"**: ISG to Julia Gardner, February 28, 1859, in Carter, *Gardner,* 17.

51 **"visits to the seals"**: ISG to BB, August 14, 1896, *Letters,* 62.

51 **stillborn baby boy:** Orders for Internment, Mount Auburn Cemetery Historical Collections, Cambridge, MA.

52 **"inward fire"**: ISG Journal, in Carter, *Gardner,* 38.

52 **"poor dear Joe"**: ISG Journal, July 16, 1874, ibid., 45.

52 **"wittiest man"**: Class of 1882. Harvard College, Sixth Report of the Secretary, 1882–1907 (Cambridge, MA: Privately Published, 1890), 75–76. John Jay Chapman in Tharp, *Mrs. Jack,* 120.

53 **"immortalize you"**: Henry James to ISG, January 29, [1880], ISGMA.

53 **"her motto of *C'est mon Plaisir*"**: Leon Edel, *Henry James, A Life* (New York: Harper & Row, 1985), 258.

53 **"a palace of art"**: Henry James, *The Golden Bowl* (London and New York: Penguin Books, 1985), 143.

53 **"of the Roman Empire"**: Henry James, notebook, July 15, 1895, in Clara Kozol, "Henry James and Mrs. Gardner: A New Perspective," *Fenway Court* (Boston: Isabella Stewart Gardner Museum, 1972), 9.

53 **"in the public's face"**: John Ruskin, *Fors Clavigera* (1871–84), ed. Dina Birch (Edinburgh: Edinburgh University Press, 2000), 265.

53 **"outside anecdotal interest"**: James McNeill Whistler, in Margaret F. MacDonald, "Whistler: Painting the Man," Margaret F. MacDonald, Susan Grace Galassi, and Aileen Ribeiro, *Whistler, Women, & Fashion* (New York: The Frick Collection, 2003), 8.

53 **"to be signed, you know!"**: ISG to Whistler, December 4, 1892, in *Eye of the Beholder: Masterpieces from the Isabella Stewart Gardner Museum,* eds. Alan Chong, Richard Lingner, and Carl Zahn (Boston: Isabella Stewart Gardner Museum, 2003), 199.

54 **promote himself and his work:** MacDonald, "Painting the Man," 5–14.

54 **"to anybody else!"** John Singer Sargent to ISG, August 29, 1895, in Chong, et al., *Eye,* 196.

54 **"summer afternoon!"**: Whistler to ISG, December [1892], ISGMA.

54 **"in all times"**: "Mr. Whistler's Ten O'Clock Lecture," February 20, 1895, *The Correspondence of James McNeill Whistler 1855–1903*, eds. Margaret F. MacDonald, Patricia de Montfort, and Nigel Thorp (University of Glasgow, online edition, 2003–07).

54 **"a good beginning"**: ISG to Charles Eliot Norton, July 12, 1888, M S Am 1088 (2494), Houghton Library, Harvard University.

55 **"off we started again"**: ISG Journal, in Carter, *Gardner,* 70.

55 **"portraits of Doges"**: Henry James to Catherine Walsh, (Venice), June 16,

[1887], in Henry James, *Letters from the Palazzo Barbaro,* ed. Rosella Mamoli Zorzi (London: Pushkin Press, 1998), 95.

55 **"sinking into the lagoon":** John Lowell Gardner to Theodore F. Dwight, July 5, 1892, in Carter, *Gardner,* 128.

55 **"Exactly like me":** ISG to Joseph Linden Smith, November 4, 1894, in Chong et al., *Eye,* 215.

55 **in the library:** Henry James to Ariana Curtis, July 10, 1892, in James, *Barbaro,* 121.

56 **"Venetian slave":** Henry James to ISG, September 3, 1892, ISGMA.

56 **"splendid ceilings":** Henry James, *The Wings of the Dove* (Middlesex, England: Penguin Books, 1977), 282.

57 **"for household expenses":** ISG to BB, May 25, 1900, *Letters,* 217.

57 **paid for the Vermeer:** Samuels, *Connoisseur,* 207.

57 **"of the fifteenth century":** Laurence Kanter in Chong et al., *Eye,* 69.

58 **fellow students and friends:** See Samuels, *Connoisseur:* "Wanting social position and wealth, he had only one resource, intellect, cerebral power, and he learned to flaunt it as others did their wealth," 169.

58 **reverence for beauty:** Denys Sutton makes a similar observation, in a review of *The Letters of Bernard Berenson and Isabella Stewart Gardner, 1887–1924, Burlington Magazine,* 130, no. 1026 (September 1988), 710.

58 **"I wish you to buy":** BB to ISG, August 1, 1895, *Letters,* 42.

58 **"for the Guardi":** ISG to BB, February 2, 1896, ibid., 48.

59 **"invented tone":** BB to ISG, May 12, 1895, ibid., 41.

60 **permitted to live:** Samuels, *Connoisseur,* 2–3.

60 **"life of the village":** Ibid., 3.

60 **"you and your friends":** Ibid., 16.

61 **"a Previtali":** Bernard Berenson, *Sketch for a Self Portrait* (New York: Pantheon, 1949), 60.

61 **"tender melody":** BB to ISG, July 4, 1888, *Letters,* 24.

61 **"next two years":** BB to ISG, March 11, 1894, ibid., 38.

62 **"in fact many things":** ISG to BB, March 15, 1894, ibid., 38.

62 **"is almost everything":** Bernhard Berenson, *The Venetian Painters of the Renaissance* (New York and London: G. P. Putnam's Sons, 1894), ix, x, 13, 61.

63 **"all over Europe":** Berenson, *Venetian Painters,* xii–xiii.

63 **"scientific connoisseurship":** Morelli introduced his theories in 1874 in a German journal, *Zeitschrift für bildende Kunst,* under the pseudonym Ivan Lermolieff.

63 **"air of infallibility":** Bode, *The Fortnightly Review* (October 1891), 119, in Jaynie Anderson, "The Political Power of Connoisseurship in Nineteenth-Century Europe," *Jahrbuch der Berliner Museen* (Berlin: Gebr. Mann, 1996), 118.

63 **"national museums":** Anderson, *Connoisseurship,* 107.

63 **fluid and controversial:** David Alan Brown, *Bernard Berenson and the*

Connoisseurship of Italian Painting (Washington, D.C.: National Gallery of Art, 1979), 15. "While many of Berenson's attributions have been overturned, many others were perceptive, given what was known about the artist at the time."

64 **"an Eliot":** BB to Senda Berenson, 1889, in Samuels, *Connoisseur,* 91.

64 **"an honest penny":** BB to ISG, April 28, 1889, *Letters,* 31.

64 **buying and selling of art:** Brown, *Berenson,* 17. "Scholarship always went together with collecting and dealing until the relatively recent time when art history became a well-established academic discipline."

64 **glamorous expatriate:** Meyer Schapiro called him "an aristocratic preeminence as an arbiter of taste" in, "Mr. Berenson's Values," *Theory and Philosophy of Art: Style, Artist and Society* (New York: George Braziller, 1994), 214.

65 **"in classifying plants":** "The New Art Criticism," *Atlantic* (August 1895), in Samuels, *Connoisseur,* 214.

65 **coauthor:** Samuels, *Connoisseur,* 169.

67 **"Giorgione":** Bernhard Berenson, February 7, 1895, *Venetian Painting Chiefly Before Titian at the Exhibition of Venetian Art, The New Gallery,* 1895, 2, 35.

67 **Otto Gutekunst:** See Nicholas H. J. Hall, "Old Masters in a New World: Colnaghi and Collecting in America, 1860–1940," in *Colnaghi in America* (New York: Colnaghi USA, 1992), 9–18; Donald Garstang, "Colnaghi" in *Art, Commerce, Scholarship: A Window into the Art World—Colnaghi 1760 to 1984* (London: P. & D. Colnaghi & Co., 1984), 21.

67 **extraordinary European pictures:** Patricia Rubin notes that Otto Gutekunst "was responsible for finding many of the important paintings Berenson proposed to Mrs. Gardner . . . A fact that remained largely or totally unknown to her" in, "Portrait of a Lady: Isabella Stewart Gardner, Bernard Berenson and the Market for Renaissance Art in America," *Apollo,* 152, no. 463 (September 2000), 37–44.

68 **"feathery trees":** BB to ISG, October 25, 1900, in *Letters,* 231.

68 **"little gem!":** OG to BB, November 1, 1900, Colnaghi. Hall observes that "frequently Berenson's letters of recommendation follow, almost word for word, Gutekunst's own letters to Berenson" in "Old Masters," 13.

68 **"self-indulgence and credulity":** Colin Simpson, *Artful Partners, Bernard Berenson and Joseph Duveen* (New York: Macmillan Publishing, 1986), 74.

68 **Correggio:** OG to BB, July 11, 1900, Colnaghi.

68 **Amberger:** OG to BB, March 15, 1901, Colnaghi.

68 **"fancy & longing":** OG to BB, December 15, 1897, Colnaghi.

69 **"common life":** William Hazlitt, *Picture Galleries of England, 1824,* in *Art, Commerce,* P. & D. Colnaghi, 16.

69 **"credit could supply":** William Makepeace Thackeray, *Vanity Fair* (New York: Random House, 2001), 506.

69 **pieces he wanted:** See Stephanie M. Dieckvoss, *Wilhelm von Bode and the*

English Art World, M.A. Thesis, Courtauld Institute of Art, University of London, 1995.

70 **"schemes and plans of battle":** OG to BB, March 29, 1897, Colnaghi.

70 **"at least interest them":** OG to BB, May 6, 1896, Colnaghi.

70 **"scarcely write":** OG to BB, March 7, 1901, Colnaghi.

70 **"beast & a liar":** Ibid.

70 **"not touch it":** OG to BB, February 20, 1901, Colnaghi.

71 **"into trouble":** OG to BB, May 5, 1896, Colnaghi.

71 **"Mssrs. P. & D. Colnaghi":** C. J. Holmes, *Pictures and Picture Collecting* in *Art, Commerce,* P. & D. Colnaghi, 16.

71 **"masterpieces only":** BB to ISG, December 18, 1895, *Letters,* 45.

71 **"fun with my Museum":** ISG to BB, July 19, 1896, ibid., 59.

71 **"last time":** OG to BB, December 30, 1895, Colnaghi.

72 **"National Gallery":** BB to ISG, January 19, 1896, *Letters,* 47.

72 **bought both:** Ibid.; ISG to BB, February 2, 1896, ibid., 48.

72 **"delicious music":** ISG to BB, April 25, 1896, ibid., 52.

72 **"*Mrs. Siddons as Tragic Muse*":** OG to BB, March 7, 1896, Colnaghi.

72 **stormy sky:** For *The Blue Boy,* see Robyn Asleson and Shelley M. Bennett, *British Paintings at the Huntington* (The Huntington Library, Art Collections and Botanical Gardens; New Haven, CT, and London: Yale University Press, 2001), 104–11.

72 **"YEBB":** BB to ISG, April 14, 1896, *Letters,* 51–52; BB to ISG, April 26, 1896, ibid., 53; ISG to BB, May 7, 1896, ibid., 54.

72 **"Crime—as the result":** Ibid.

73 **"quietly treated":** OG to BB, February 19, 1896, Colnaghi.

73 **"mien peaceful":** Ovid, Metamorphoses, II, 871, in David Carrier, "Mrs. Isabella Stewart Gardner's Titian," *Source* 20, no. 2 (Winter 2001), 21.

73 **"self-preservation":** Erwin Panofsky, *Problems in Titian, Mostly Iconographic* (New York: New York University Press), 166.

73 **"I send to you":** Titian to Philip II, 1562, quoted in Chong et al., *Eye,* 103.

74 **"masters of to-day":** Berenson, *Venetian Painters,* 47.

74 **"1st water":** OG to BB, February 19, 1896, Colnaghi.

74 **"whole Orleans gallery":** Francis Haskell, *Rediscoveries in Art* (Ithaca, NY: Cornell University Press, 1976), 46–47.

74 **Bode had turned the painting down:** On June 1, 1895, William McKay wrote Bode, "I think I ought to let you know that Lord Darnley has approached me through a relation with a view to sell his famous picture of *Europa* by Titian. I understand that you have had the picture under consideration at some time. Before proceeding, I have no doubt, I could buy much cheaper than you." June 1, 1895, Colnaghi.

74 **$100,000:** OG to BB, February 18, 1896, Colnaghi. "The price is £18,000 but we ought to get £20,000."

75 **"£18,000":** OG to BB, February 19, 1896, Colnaghi.

75 "offer would be entertained": Lord Bristol to Colnaghi, April 30, 1901, Colnaghi.

75 "1/3 shares": OG to BB, October 23, 1895, Colnaghi.

76 "able to see it!?": OG to BB, April 11, 1896, Colnaghi.

76 "hear of the offer, etc.": OG to BB, May 5, 1896, Colnaghi.

76 "like a good margin": OG to BB, April 22, 1896, Colnaghi.

76 "landscape, wonderful": OG to BB, April 28, 1896, Colnaghi.

76 only one English picture: Hadley, *Letters,* 56n3.

76 "at the same time": ISG to BB, December 2, 1895, ibid., 43.

77 "again to be sold": BB to ISG, May 10, 1896, ibid., 55.

77 "Damned B. B. [*Blue Boy*]": OG to BB, May 5, 1896, Colnaghi.

77 cost was 20,000 pounds: BB to ISG, May 10, 1896, ibid., 55.

77 20,000 pounds: Alan Chong, "The Afterlife of Cellini's Bust of Bindo Altoviti," *Raphael, Cellini & A Renaissance Banker: The Patronage of Bindo Altoviti* (Boston: Isabella Stewart Gardner Museum, 2003), 250.

77 "2,000 [pounds] a side": OG to BB, May 5, 1896, Colnaghi.

77 2,000 pounds: Colnaghi Private Ledger, 1894–1903, Berenson account.

78 "so be careful": OG to BB, May 2, 1896, Colnaghi.

78 it remained in London: BB to ISG, June 18, 1896, *Letters,* 57.

78 "in her new shrine' ": ISG to BB, July 19, 1896, ibid., 59.

78 "heart of yours": Ibid.

78 "proposition": BB to ISG, August 2, 1896, ibid., 61.

78 "supreme genius": Ibid., 62.

79 "liked so well": Ibid., 61.

79 "it does cost": ISG to BB, August 18, 1896, ibid., 63.

79 "too excited to talk": ISG to BB, August 25, 1896, ibid., 64.

79 "men of course": ISG to BB, September 11, 1896, ibid., 65.

79 "picture seems full of joy": ISG to BB, September 19, 1896, ibid., 66.

79 "Art and Joy go together": Mr. Whistler's "Ten O'Clock Lecture," *Correspondence.* See Linda J. Docherty, abstract of *Transatlantic Correspondence: James McNeill Whistler and Isabella Stewart Gardner,* Whistler Centenary Conference, University of Glasgow, September 3–6, 2003, ibid.

79 " 'I told you so' ": ISG to BB, September 19, 1896, *Letters,* 66.

79 "Daughter of Titian": Henry James to ISG, April 3, 1898, ISGMA.

80 "made an impression": ISG to BB, September 19, 1896, *Letters,* 66.

80 "I fear": ISG to BB, September 11, 1896, ibid., 65.

80 "rooms of the Vatican": Henry James to ISG, April 3, 1898, ISGMA.

80 *Turenne on Horseback*: OG to BB, December 5, 1896, Colnaghi.

80 menacing sky: OG to BB, February 11, 1897, Colnaghi.

80 "Do you agree or not": OG to BB, April 6, 1897, Colnaghi.

80 "her comfortable": MB to Alys Berenson, December 1896, in Samuels, *Connoisseur,* 275.

81 "all these questions": ISG to BB, February 25, 1897, *Letters,* 79.

81 **Edward Huth:** BB to ISG, June 9, 1897, *Letters,* 87. Holbein's *Sir Thomas More* is in The Frick Collection, New York.

81 **"pictures of the world":** BB to ISG, June 6, 1897, *Letters,* 86.

81 **"gold and lacquer":** BB, 1916, in Chong, et al., *Eye,* 57.

81 **"while the sun shines, eh?":** OG to BB, March 29, 1897, Colnaghi.

81 **"too-willing Eve":** ISG to BB, January 12, 1898, *Letters,* 116.

81 ***Tommaso Inghirami:*** ISG to BB, March 3, 1898, ibid., 127.

82 **Old Master pictures:** Orcutt, "Buy American," 83.

82 **"almost suicidal":** MB, diary entry, June 23, 1898, Strachey and Samuels, *Mary Berenson,* 76.

82 **Clinton-Hope:** About 121,200 pounds. OG to Bode, July 21, 1898, Staatliche Museen zu Berlin Zentralarchiv, NL, Bode 2268, Letters from Otto Gutekunst, 1898; *Wilhelm von Bode: Mein Leben,* eds. Thomas W. Gaethgens and Barbara Paul (Berlin: Nicolai, 1997), 284–5.

82 **entire collection:** BB to ISG, August 15, 1898, *Letters,* 149–50.

82 **"clever and strong":** ISG to BB, September 25, 1898, ibid., 154.

83 **"into operation":** MB to BB, October 12, 1898, Strachey and Samuels, *Mary Berenson,* 78.

83 **"that is the important thing":** MB, October 17, 1898, Berenson Archives, Villa I Tatti, Florence, in Rubin, "Portrait of a Lady," 41.

83 **"soon enough":** OG to BB, November 10, 1898, ibid., 41–42.

83 **public record:** BB to ISG, January 22, 1899, *Letters,* 166.

84 **"your shrewdness":** OG to BB, March 21, 1899, Colnaghi.

84 **"Alas, alas":** ISG to BB, February 11, 1899, *Letters,* 167.

84 **"the end has come":** ISG to BB, May 31, 1899, ibid., 177.

84 **"part with it and so on:"** MB to BB, June 9, 1899, Strachey and Samuels, *Mary Berenson,* 82, 304.

84 **"that Holbein business":** BB to ISG, June 13, 1899, in Samuels, *Connoisseur,* 306.

84 **"babe compared to them":** ISG to BB, June 27, 1899, *Letters,* 181.

85 **"take such risks":** OG to BB, June 16, 1899, Hall, "Old Masters," 14.

85 **"mellowed by life":** BB to MB, in Samuels, *Connoisseur,* 307.

85 **"meat and drink":** ISG to BB, May 25, 1900, *Letters,* 217–18.

86 **"Mrs. G. shines":** OG to BB, March 14, 1901, in Samuels, *Connoisseur,* 308–09.

86 **"more than she paid for them":** OG to BB, March 26, 1901, Colnaghi.

86 **"as a friend should":** OG to BB, March 26, 1901, Colnaghi.

86 **$750,000:** Garstang, "Colnaghi and Berenson," 21.

87 **Piermatteo d'Amelia:** Chong et al., *Eye,* 63. Of Gardner's major Old Masters, only two came from sources other than Colnaghi: Giotto's *Presentation in the Temple* (from J. P. Richter in 1900), and Piero della Francesca's *Hercules* (from the artist Joseph Linden Smith). Several pictures that Berenson bought from dealers other than Gutekunst turned out to be problematic. Most scholars think that *Tommaso Inghi-*

rami is a Raphael workshop version of a portrait in the Palazzo Pitti, Florence.

88 **"worth the money":** ISG, undated note, ISGMA.

88 **extraordinary pictures:** Chong asserts that "the overpriced mediocrities were a small price to pay for the great things." Chong et al., *Eye*, xii.

88 **"my mistakes myself":** OG to BB, December 30, 1934, Berenson Archive, Villa I Tatti, The Harvard University Center for Italian Renaissance Studies, Florence, Italy.

89 **"conquering intellects":** Samuels, *Connoisseur,* 401–31; BB to ISG, August 9, 1902, *Letters,* 297.

89 **"loathed than liked":** MB, December 31, 1903, in Samuels, *Connoisseur,* 409.

89 **"rottenest we have yet seen":** MB, January 28, 1904, ibid., 427.

89 **"Rosalina point lace":** ISG to BB, March 11, 1901, *Letters,* 251.

89 **"Is the Botticini one":** ISG to BB, July 22, 1901, ibid., 260.

90 **"fountains, balconies":** BB to MB, September 1897, in Samuels, *Connoisseur,* 287.

90 **courtyard in the Palazzo Barbaro:** Anne Hawley observes the same, "Forward," *Gondola Days* (Boston: Isabella Stewart Gardner Museum, 2004), vii.

90 **"haphazard fashion":** Rollin van N. Hadley, *The Isabella Stewart Gardner Museum* (Fort Lauderdale, FL: Woodbine Books, 1981), 6.

92 **"a peculiar new one":** Wilhelm von Bode, "Die amerikanische Konkurrenz im Kunsthandel und ihre Gefahr für Europa," *Kunst und Künstler,* 1902–3, in Frances Weitzenhoffer, *The Havemeyers: Impressionism Comes to America* (New York: Harry N. Abrams, Inc., 1986), 63.

92 **Rembrandts genuine:** Bode, "Die amerikanischen Gemäldesammlungen in ihrer neueren Entwicklung," *Kunst und Künstler* (Berlin: Bruno Cassirer, 1903–4), 387, 388, 389.

92 **"fine old disinterested tradition":** Henry James, *The American Scene,* ed. with introduction by John F. Sears (New York: Penguin, 1994), 188–89.

92 **her brilliance and her eccentricities:** See Anne Higonnet, "Museum Sight," in *Art and Its Publics,* ed. Andrew McClellan (Malden, MA, and Oxford: Blackwell Publishing, 2003), 135; Linda J. Docherty, "Collection as Creation: Isabella Stewart Gardner's Fenway Court," eds. W. Reinink and J. Stumpel, *Memory & Oblivion* (1999), 217–21.

92 **"in the United States":** Hilliard T. Goldfarb, in Higonnet, "Museum Sight," 139.

CHAPTER III. "MR. MORGAN STILL SEEMS TO BE GOING ON HIS DEVOURING WAY"

93 **"Devouring Way":** John G. Johnson to BB, December 29, 1909, John G. Johnson Collection Archive, Philadelphia Museum of Art.

93　**succeeded in buying one:** Jean Strouse, *Morgan, American Financier* (New York: Random House, 1999), observes the same, 413.

93　**esteem for centuries:** Haskell, *Rediscoveries*, 4.

93　**$1 billion:** Strouse, *Morgan,* 404.

94　**"greatest collector":** *Burlington Magazine,* 1913, in David Alan Brown, *Raphael and America* (Washington, D.C.: National Gallery of Art, 1983), 63.

95　**to the museum:** Strouse, *Morgan,* 494.

95　**$60 million on art:** Strouse, "J. Pierpont Morgan, Financier and Collector," *MMA Bulletin,* 57, no. 3 (Winter 2000), 6.

97　**thirty years:** See Linda Wolk-Simon, "Raphael at the Metropolitan, The Colonna Altarpiece," *MMA Bulletin,* 63, no. 4 (Spring 2006).

97　**"synonym of painting itself":** Ibid., 50.

98　**"*autograph* work by Raphael":** BB to ISG, November 9, 1897, *Letters,* 97.

98　**"dreary Colonna Raphael":** ISG to BB, November 14, 1897, in Brown, *Raphael,* 66.

98　**"hated to haggle":** Ron Chernow, *The House of Morgan* (New York: Atlantic Monthly Press, 1990), 117.

98　**"buying Raphaels":** Clinton Dawkins, December 10, 1901, and July 19, 1902, in Strouse, *Morgan,* 7, 415.

98　**"pretensions and price":** BB to ISG, January 14, 1902, *Letters,* 281.

98　**"rarity, and provenance":** Strouse, *Morgan,* 414.

99　**history of European art:** Brown, *Raphael,* 72.

99　**"to acquire the painting":** Ibid., 68.

99　**Raphael *Madonnas*:** Brown, *Raphael,* 69.

99　**Chigi:** Ibid., 34.

100　**"conception of beauty":** Herbert L. Satterlee, *J. Pierpont Morgan: An Intimate Portrait* (New York: Macmillan Company, 1940), 562.

100　**"same painter":** *New York Times,* October 23, 1901, in Wolk-Simon, "Raphael," 57.

100　**to $500,000:** New York *Herald,* January 1, 1902, ibid.

100　**"paid before":** Gaspard Farrer to James J. Hill, May 24, 1902, in Strouse, *Morgan,* 490.

100　**most cosmopolitan:** Flaminia Gennari Santori observes that "Morgan was considered by the press to be the most American of American collectors," *The Melancholy of Masterpieces: Old Master Paintings in America 1900–1914* (Milan: 5 Continents, c. 2003), 108.

100　**"London aristocrats":** Chernow, *Morgan,* 47.

101　**"modern world":** Clinton Dawkins to Alfred Milner, February 8, 1901, in Strouse, *Morgan,* 394.

101　**"Charles James Fox":** "Lady Georgiana Spencer," in *Thomas Gainsborough,* ed. Michael Rosenthal and Martin Myrone (London: Tate Publishing, 2002), 188.

102　**"proper places":** Sir Joshua Reynolds, in "Thomas Gainsborough: Art, Society, Sociability," ibid., 12.

102 **"single call"**: Gerald Reitlinger, *The Economics of Taste: The Rise and Fall of Picture Prices 1760–1960* (London: Barrie and Rockliff, 1961), 188.

104 **the British Isles**: Oliver Garnett, "Agnew's," in *Art Dictionary*, vol. 1, 454.

104 **"lunatic asylum"**: Satterlee, *Morgan*, 353.

104 **recent notoriety**: Strouse, *Morgan*, 412.

104 **"content or cost"**: Ibid.

105 **"wait my chance"**: Boughton to HGM, September 20, 1888, MMA Archives.

105 **"for love or money"**: OG to BB, 1891, Hall, "Old Masters," 21.

106 **"nor equaled since"**: Reynolds, "The Third Discourse," in Elizabeth G. Holt, *A Documentary History of Art*, vol. II (Garden City, NY: Doubleday & Co.), 278.

106 **six sittings a day**: *Joshua Reynolds: The Creation of Celebrity*, ed. Martin Postle (London: Tate Publishing, 2005), 25; David Mannings, *Sir Joshua Reynolds: A Complete Catalogue of His Paintings*, vol. 1 (New Haven, CT: Yale University, 2000), 4.

106 **"to paint circumstances"**: Reynolds in Rosenthal and Myrone, "Gainsborough," 23.

106 **"but at the expense of the likeness"**: Ibid.

107 **sovereign beauty**: Rosenthal and Myrone, 147.

108 **"hang it there?"**: Satterlee, *Morgan*, 434.

CHAPTER IV. "GRECO'S MERIT IS THAT HE WAS TWO CENTURIES AHEAD OF HIS TIME"

109 **"down the wharf"**: Louisine W. Havemeyer, *Sixteen to Sixty: Memoirs of a Collector*, ed. Susan Alyson Stein (New York: Ursus Press, 1993), 86.

109 **Baedeker's**: Karl Baedeker, *Spain and Portugal: Handbook for Travellers* (Leipsig, Germany: Karl Baedeker Publisher, 1898; New York: Charles Scribner's Sons, 1898), xi, xii, xv, xx.

110 **"be a Spaniard"**: MC to Emily Sartain, May 22, [1871], *Cassatt and Her Circle: Selected Letters*, ed. Nancy Mowll Mathews (New York: Abbeville Press, 1984), 70. For the Havemeyers in Spain, see Susan Alyson Stein, "Chronology," Frelinghuysen et al., *Splendid*, 230–31.

110 **"it belongs to you"**: Henri Rouart to Edgar Degas, December 30, 1896, in Ann Dumas, "Degas and the Collecting Milieu," *The Private Collection of Edgar Degas* (New York: Metropolitan Museum of Art, 1997), 133n38. For El Grecos owned by Rouart, 127.

110 **"thought so much of him"**: MC to LWH, February 6, 1903, MMA Archives.

110 **"some of Greco's"**: MC to LWH, February 6, [1903], in Nancy Mowll Mathews, *Mary Cassatt: A Life* (New York: Villard Books, 1994), 263; MC to Adolph Borie, July 27, 1910, in Weitzenhoffer, *The Havemeyers*, 192.

112 **17 by Mary Cassatt:** For the Havemeyer Collection, see Gretchen Wold, "Appendix," Frelinghuysen et al., *Splendid,* 291–384.

112 **"private individuals":** MC to Theodate Pope [September 1903], Mathews, *Letters,* 286.

113 **"impulsive":** LWH, *Sixteen,* 143.

113 **"own home":** LWH, ibid., 22.

114 **"even a little mad":** Jonathan Brown, "El Greco, the Man and the Myth," Toledo Museum of Art, *El Greco of Toledo* (Boston: Little Brown), 15, 20.

114 **lower-right-hand corner:** Gabriele Finaldi, "The Purification of the Temple," in *El Greco,* ed. David Davies (London: National Gallery Company, 2003), 89.

115 **on the price:** Jonathan Brown, "El Greco: An Introduction to his Life, Art, and Thought," in The Frick Collection, *El Greco: Themes and Variations* (New York: The Frick Collection, 2001), 13n.

115 **"wrong attributions":** Harold E. Wethey, *El Greco and His School,* vol. 2 (Princeton, NJ: Princeton University Press, 1962), 162–259.

115 **"great painter":** Paul Lefort, in Brown, "El Greco," 21.

115 **"artistic impressions":** Julius Meier-Graefe, *The Spanish Journey,* trans. J. Holroyd-Reece (New York: Harcourt, Brace & Co., [1926]), 128.

115 **"and its color":** LWH, *Sixteen,* 131.

116 **"could be seen":** Ibid., 132.

116 **"not consider it":** HOH, ibid., 152. For the meeting with Cossio, 132.

116 **"greatest pictures":** Ibid., 138, 141.

117 **dislikes of Old Masters:** Mathews, *Cassatt,* 262–63.

117 **"in your house":** MC to LWH, November 29, 1906, MMA Archives.

117 **"painters and connoisseurs":** MC in Erica E. Hirshler, "Helping 'Fine Things' Across the Atlantic: Mary Cassatt and Art Collecting in the United States," *Mary Cassatt: Modern Woman,* organized by Judith A. Barter (Chicago: Art Institute of Chicago in association with Harry N. Abrams, 1998), 183.

118 **"Goyas are a bargain":** MC to DR, January [1903], Lionello Venturi, *Les Archives de L'impressionnisme* vol. 2 (Paris and New York: Durand-Ruel, Editeurs, 1939), 117.

118 **they took it:** See Stein, "Notes," *Sixteen,* 326n224.

118 **"for a Nattier":** MC to LWH, Hirshler, "Fine Things," 203.

118 **"Tell him that":** MC in LWH, *Sixteen,* 289.

119 **"don't think her ugly":** LWH, *Sixteen,* 110; MC, ibid., 293.

119 **"big haul":** MC to LWH, Friday, February 6, 1903, in Weitzenhoffer, *The Havemeyers,* 139; Mathews, *Cassatt,* 262.

119 **"too commercial for me":** MC to Adolph Borie, July 27, 1910, MMA, Frances Weitzenhoffer Files.

119 **great works of art:** LWH, *Sixteen,* 160, 116, 268.

119 **early age:** for MC biography, see Mathews, *Cassatt.*

120 **"narrow and hard one":** LWH, *Sixteen,* 268.

120 **"my artistic life"**: MC to Oliver Payne, February 28, [1915], Mathews, *Letters*, 321.

121 **"ever met"**: LWH, *Sixteen*, 269.

123 **"bought it upon her advice"**: Ibid., 249–50.

123 **by Pissarro**: Stein, "Chronology," *Splendid*, 203.

123 **"judgment and advice"**: LWH, *Sixteen*, 268.

124 **independence of mind**: Ibid.

125 **"very angry"**: Ibid.; 24.

125 **"struck with a Cranach"**: MC to LWH, February 2, 1903, MMA Archives.

125 **asked at least $60,000**: *New York Times*, February 19, 1895; Esmée Quodbach, "'Rembrandt's "Gilder" is Here:' How America Got Its First Rembrandt and France Lost Many of Its Old Masters," *Simiolus* 31, no. 1/2 (2004–5), 105.

125 **"so costly"**: *New York Times*, in Weitzenhoffer, *The Havemeyers*, 53.

126 **"done Havemeyer twice"**: HGM to Samuel Avery, April 19, 1889, MMA Archives.

126 **"won't do"**: HGM to Luigi Cesnola, June 23, 1891, in Stein, "Chronology," *Splendid*, 234.

126 **"in our board"**: Samuel Avery to Luigi Cesnola, June 23, 1891, MMA Archives.

127 **"in Fifth Avenue"**: Wilhelm von Bode, the *New York Times*, October 11, 1893, in Weitzenhoffer, *The Havemeyers*, 79.

127 **picked up the refined**: Harry W. Havemeyer, *Frederick Christian Havemeyer: A Biography 1807–1891* (New York: Privately published, 2003), 42–43.

127 **"too arduous or beneath us"**: Theodore Havemeyer, *Louisiana Planter*, July 17, 1897, in Jack Simpson Mullins, *The Sugar Trust: Henry O. Havemeyer and The American Sugar Refining Company* (University of South Carolina, University Microfilms, 1964), 19.

128 **"cheaper . . . than anyone else"**: Theodore Havemeyer, March 23, 1891, in Havemeyer, *Havemeyer: A Biography*, 94–95.

128 **"King of the sugar market"**: Frederick C. Havemeyer to Theodore Havemeyer, May 10, 1885, and July 3, 1885, ibid., 146, 151.

128 **"a brute"**: John Parsons, in Richard Zerbe, "The American Sugar Refinery Company, 1887–1914: The Story of a Monopoly," *Journal of Law and Economics*, 12, no. 2, 350.

128 **"largely interested"**: *New York Tribune*, March 25, 1891; Weitzenhoffer, *The Havemeyers*, 69.

128 **"principal object"**: HOH testimony in Zerbe, "The American Sugar Refinery Company," 349.

128 **$28 million**: Mullins, *The Sugar Trust*, 122.

129 **"foreign nations" was illegal**: Sherman Antitrust Act, July 1890, in Alan Brinkley, *American History*, vol. 2 (Boston: McGraw-Hill, 1999), 667.

129 **"change enough, isn't it?"**: HOH in *Louisiana Planter*, 25 (November 4,

1905), in Mullins, *The Sugar Trust,* 73; $100,000 salary, Zerbe, "The American Sugar Refinery Company," 350.

129 **for the states:** Mullins, *The Sugar Trust,* 92–93.

129 **$1.1 million on the deal:** Ibid., 84. Zerbe, "The American Sugar Refinery Company," 154; for Arbuckle fight, 442.

130 **"not give way":** John Arbuckle, Hardwick Committee, Hearings III, 2332–3, in Mullins, *The Sugar Trust,* 23–24.

130 **"interest deeply Mr. Havemeyer":** LWH, *Sixteen,* 160, 161.

130 **as a copy:** Stein, "Notes"; ibid., 323, 184.

131 **"things go":** MC to LWH, June 16, 1901, ibid., 345n463.

131 **"with disappointments":** MC to HOH, undated letter [August 5 to 9, 1901], MMA, Weitzenhoffer Files.

131 **"until I had seen it myself":** MC to LWH, August 30, 1901. MMA Archives.

131 **"in a private gallery":** Ibid.

132 **retrospective of El Greco:** S. Viniegra, *Exposición de las Obras del Greco* (Madrid: Museo Nacional del Pintura, 1902).

132 **ANYTHING FOR YOU:** PDR to HOH, June 16, 1902, Durand-Ruel Archives, Paris.

132 **"not make good":** Camille Pissarro to Lucien Pissarro, April 25, 1891, in Hirshler, "Fine Things," 192.

132 **550 Old Master pictures:** Flavie Durand-Ruel, correspondence, April 5, 2007.

133 **"better luck in America":** MC to Alexander Cassatt, September 21 [1885], Mathews, *Letters,* 195.

133 **"stir in Paris":** PDR, in Weitzenhoffer, *The Havemeyers,* 41.

133 **"French collectors":** PDR to Fantin-Latour, ibid., 41–42.

134 **"something for a museum":** PDR to Joseph Wicht, July 2, 1902, Durand-Ruel Archives.

135 **actual space of the room:** Keith Christiansen, "A Cardinal," in *El Greco,* ed. Davies, 282.

135 **Sandoval y Rojas:** See Brown, *El Greco,* 69; Jonathan Brown and Dawson A. Carr, "Portrait of a Cardinal: Niño de Guevara or Sandoval y Rojas?" in *Figures of Thought: El Greco as Interpreter of History, Tradition, and Ideas,* ed. Jonathan Brown, *Studies in the History of Art,* vol. 2 (Washington, D.C.: National Gallery of Art, 1982), 33–42.

135 **"the finest thing of Greco's":** MC to LWH, February 13, 1902, MMA Archives.

136 *Cardinal's* **price:** PDR to Joseph Wicht, July 2, 1902, Durand-Ruel Archives.

136 **"buy or not":** HOH to MC, July 1, 1902, MMA, Weitzenhoffer Files.

136 **"by 1 meter 30":** PDR to HOH, July 10, 1902, Durand-Ruel Archives.

137 **"for the new gallery":** MC to LWH, November 20, [1902], Mathews, *Letters,* 288–89.

137 **to offer $10,000:** MC to LWH, Christmas Evening [1902], ibid.

137 **"*no account*":** MC to LWH, January 5, 1903, MMA Archives.

137 **too low:** Meier-Graefe, *Spanish Journey,* 323.

137 **"a large picture":** MC TO LWH, February 6, 1903, MMA Archives.

137 **"if we can get it":** MC to LWH, February 10, 1903, MMA Archives.

138 **"correspondence ... between us":** HOH to PDR, July 31, 1903, MMA, Weitzenhoffer Files.

138 **"difficult and dangerous":** PDR to HOH, November 13, 1903, Durand-Ruel Archives.

138 **"*three* masterpieces":** MC to PDR, [November 12, 1903], Venturi, *Archives,* 119. (He suggests the date of the letter is 1905.)

138 **"none of beauty":** MC to PDR, November 12, 1903, MMA, Weitzenhoffer Files.

138 **for the *Cardinal*:** PDR to MC, December 29, 1903, Weitzenhoffer, *The Havemeyers,* 166.

138 **"didn't want to sell at all":** PDR to MC, December 29, 1903, Durand-Ruel Archives.

139 **"same quality as the Cardinal":** PDR to MC, December 29, 1903, Durand-Ruel Archives.

139 **"to buy it":** PDR to Ricardo Madrazo, January 9, 1904, Durand-Ruel Archives.

139 **"big price":** John Singer Sargent to Edward Robinson, February 7, 1904, Director's Files, Museum Archives, Museum of Fine Arts, Boston.

139 **"have a cardinal":** LWH, *Sixteen,* 156.

139 **only $17,000:** Edward Robinson to Ricardo Madrazo, March 17, 1904, Director's Files, Museum Archives, Museum of Fine Arts, Boston. $17,165.84 including packing and shipping.

140 **"for an American museum":** PDR to HOH, April 1, 1904, Durand-Ruel Archives.

140 **"Cardinal by Greco":** April 11, 1904, in Weitzenhoffer, *The Havemeyers,* 153.

140 **150,000 francs for the *Cardinal*:** PDR to HOH, April 22, 1904, Durand-Ruel Archives.

140 **"very rare":** PDR to HOH, April 28, 1904, Durand-Ruel Archives.

140 **"BUY GRECO 225":** See PDR to HOH, May 10, 1904, Weitzenhoffer, *The Havemeyers,* 153. Flavie Durand-Ruel correspondence, April 5, 2007.

140 **"at his price":** PDR to HOH, May 10, 1904, in Weitzenhoffer, *The Havemeyers,* 153.

140 **225,000 francs:** PDR to HOH, May 20, 1904, MMA, Weitzenhoffer Files.

140 **"higher price":** HOH to PDR, May 6, 1904, in Weitzenhoffer, *The Havemeyers,* 153.

141 **"to have left Spain":** MC to Theodore Duret, November 30, [1904], Mathews, *Letters,* 295.

141 **"rivalry exists between museums":** Eugene Glaenzer to BB, May 31, 1904,

Berenson Archive, Villa I Tatti. See Glaenzer to BB, December 24, 1903, for 25% commission.

141 **"really approve"** and **"preposterous"**: BB to ISG, July 27, and ISG to BB, August 7, 1904, *Letters,* 341, 343.

142 **"fine paintings will be acquired"**: MC to Theodore Duret, November 30, [1904], Mathews, *Letters,* 295.

142 **"250,000 francs"**: PDR to MC, early December 1904, Weitzenhoffer, *The Havemeyers,* 157; PDR to MC, December 13, 1904, MMA, Weitzenhoffer Files; Durand-Ruel Archives.

142 **"what interest"**: Glaenzer to BB, December 24, 1906, Berenson Archive, Villa I Tatti.

142 **"untouched"**: MC to Charles L. Hutchinson, January 9, 1905, in Hirshler, "Fine Things," 205.

142 **seven to six**: July 17, 1906. Minutes of the Board of Trustees, vol. 3, 173, May 16, 1906; 178, June 7, 1906; 186, July 17, 1906, Institutional Archives, The Art Institute of Chicago.

142 **"Mr. Havemeyer"**: MC to LWH, October 17, 1906, in LWH, *Sixteen,* 291.

143 **Cathedral of Valladolid**: Susan Grace Galassi, "The Frick El Grecos," in The Frick Collection, *El Greco: Themes and Variations,* 37.

143 **"leaving Spain"**: Ricardo Madrazo to LWH, June 14, 1909, in Stein, "Chronology," *Splendid,* 250.

143 **"like a miniature"**: LWH, *Sixteen,* 139.

144 **"less full of artifice"**: Kenneth Clark, *Landscape into Art* (Boston: Beacon Press, 1961), 49.

CHAPTER V. "A PICTURE FOR A BIG PRICE"

145 **turned down**: BB to ISG, August 2, 1896, *Letters,* 62.

146 **to sell**: Frick had bought contemporary paintings from Tooth, including *Christ and the Disciples at Emmaus* (for $21,000) by P. A. J. Dagnan-Bouveret.

146 **"dies disgraced"**: Andrew Carnegie, "[Gospel of] Wealth," *North American Review* (June 1889), 139–40, in David Nasaw, *Andrew Carnegie* (New York: Penguin Press, 2006), 350.

148 **sharp-eyed accountant**: Nasaw observes: "Frick was a master accountant, with his eye firmly fixed on the bottom line," ibid., 395.

148 **"ruthless, domineering, icy"**: Charles M. Schwab, in Kenneth Warren, *Triumphant Capitalism: Henry Clay Frick and the Industrial Transformation of America* (Pittsburgh, PA: University of Pittsburgh Press, 1996), 374.

148 **"charitable side"**: James H. Bridge, ibid., 375.

148 **"habitual enthusiasms"**: Ibid., 41.

149 **"Baltimore & Ohio [Railroad]"**: HCF to AC, May 10, 1898, HCFP, GLB, vol. 16, TFC/FARL.

149 **"thrown in"**: HCF to AC, May 12, 1898, HCFP, GLB, vol. 16, TFC/FARL.

149 "unfits him for business": HCF to AC, May 9, 1898, HCFP, GLCB, vol. 16, TFC/FARL.

149 "agree with me": HCF to AC, May 9, 1898, HCFP, GLB, vol. 16, TFC/FARL.

150 "self-contained, dignified": HCF to Elbert Gary, May 7, 1919, in Warren, *Triumphant*, 359.

150 "energy of youth": HCF to CSC, July 29, 1908, HCFP, GLB, vol. 27, TFC/FARL.

150 "trade-unions...": Carnegie, "An Employer's View of the Labor Question," *Forum* (April 1886), in Nasaw, *Carnegie*, 279.

150 strikebreakers: "Results of the Labor Struggle," *Forum* (August 1886), ibid., 282.

151 "a battle with him": Nasaw, *Carnegie*, 568.

151 "King of Coke": For Frick biography, see Warren, *Triumphant*; George Harvey, *Henry Clay Frick: The Man* (1928; reprint, Washington, D.C.: Beard Books, 2002).

152 "enough to hurt": Warren, *Triumphant*, 13.

153 valued at $1 million: Ibid., 17.

154 to the steel magnate: Nasaw, *Carnegie*, 210.

154 "with the Frick Coke Co.": AC to HCF, February 25, 1886, in Warren, *Triumphant*, 41–42.

154 three times that much: Nasaw, *Carnegie*, 210.

154 future profits: Warren, *Triumphant*, 55, 209.

154 "your steel interests": HCF to Henry Phipps (and also to John Walker, May 13, 1887), in Warren, *Triumphant*, 48.

155 "do the same": HCF to AC, July 25, 1889, in Nasaw, *Carnegie*, 371.

155 "*managed as it can be*": AC to HCF, August 8, 1889, ibid., 371–72.

155 "Frick Coke Co. successfully": HCF to AC, August 9, 1889, ibid., 372.

155 "the *man*": AC to HCF, September 3, 1889, ibid., 373.

155 "energy, or transportation": Warren, *Triumphant*, 64.

155 "the most beneficial results": Carnegie, [Gospel of] *Wealth,* in Nasaw, *Triumphant*, 348–49.

155 "lid taken off": David Cannadine, *Mellon* (New York: Alfred A. Knopf, 2006), 107.

156 two dollars a day: Ibid.

156 "two weeks past": HCF to AC, June 30, 1891, Martha Frick Symington Sanger, *Henry Clay Frick: An Intimate Portrait* (New York: Abbeville Press, 1998), 141.

156 "close attention": HCF to AC, July 14, 1891, HCFP, GLB, TFC/FARL.

156 "the duties that surround me": AC to HCF, August 3, 1891, HCFP, C, TFC/FARL.

157 "somewhat autocratic": U.S. Congress House of Representatives, 1892, in Warren, *Triumphant*, 92.

157 "labor trouble": HCF to AC, July 18, 1892, in Nasaw, *Carnegie*, 435.

157 "interfere in any way": AC to the *New York World* (July 10, 1892), ibid., 429.

157 "those at seat of war": AC to George Lauder, Jr., July 17, 1892, ibid., 434.

157 "wrong with industrial America": Ibid., 460.

158 "the battle out": HCF to AC, July 23, 1892, in Warren, *Triumphant,* 89.

158 "never, never!" John Elmer Milholland, July 30, 1892, ibid., 89.

158 "then give way": AC to HCF, September 30, 1892, in Nasaw, *Carnegie,* 444.

158 "open for him": HCF to AC, September 10, 1892, ibid., 445.

158 "wrongly got": AC to HCF, October 1, 1892, ibid., 446.

158 "decline in the union:" Warren, *Triumphant,* 95.

159 reached $7 million: Nasaw, *Carnegie,* 469.

159 "Not one hour . . ." AC to George Lauder, Jr., June 23, 1899, ibid., 564.

159 $38,000: For the prices of HCF's painting purchases, see HCFP, Art Files, and HCFACF, TFC/FARL.

159 to Pittsburgh: Arthur Tooth & Co. to HCF, August 30, 1899, HCFP, C, TFC/FARL. "I have instructed our New York House to send you the Rembrandt picture. The price is 38,000 dollars."

160 "popular today than Rembrandt": Kenyon Cox, *Old Masters and New* (New York: Duffield & Company, 1908), 115.

160 first modern "blockbuster": Francis Haskell, *Ephemeral Museum,* 102.

160 "Rembrandt's style": Catherine Scallen, *Rembrandt: Reputation and the Practice of Connoisseurship* (Amsterdam: Amsterdam University Press, 2003), 134.

161 "better in England": *Times* (London), December 31, 1898, in Haskell, *Ephemeral Museum,* 143.

161 some thirty canvases: Quodbach, "Rembrandt's Gilder," 104.

161 over 640: Scallen, *Rembrandt,* 21.

161 "a high priced picture": P. & D. Colnaghi & Co. to A. Tooth & Sons, October 5, 1899, HCFP, C, TFC/FARL.

163 "not come through M.K & Co.": RK to HCF, October 9, 1899, HCFP, C, TFC/FARL.

163 "by Knight in stock": DeCourcy E. McIntosh, "Demand and Supply: The Pittsburgh Art Trade and M. Knoedler & Co.," in Gabriel P. Weisberg, DeCourcy E. McIntosh, Alison McQueen, *Collecting in the Gilded Age: Art Patronage in Pittsburgh, 1890–1910* (Pittsburgh, PA: Frick Art and Historical Center, 1997), 134.

163 singularity of his taste: Ibid., 135.

164 "particularly fine": HCF to RK, September 16, 1895, HCFP, GLB, vol. 10, TFC/FARL.

164 "preeminence in the Arts and Sciences": AC to William Frew, October 1897, in Nasaw, *Carnegie,* 503.

164 "the gem" of his collection: HCF to AC, August 2, 1898, in Warren, *Triumphant,* 225.

165 "high prices": RK to HCF, January 27, 1897, HCFP, C, TFC/FARL.

165 "silvery picture": RK to HCF, February 23, 1898, ibid.

166 "opportunity for you": HCF to RK, September 22, 1896, HCFP, GLB, vol. 12, TFC/FARL.

166 the "store": DeCourcy E. McIntosh provided information on Knoedler's early history.

166 "reputation for honesty": René Gimpel, *Diary of an Art Dealer,* 36.

167 Overholt: McIntosh, "Demand," 113.

167 grip as "firm": Minutes of a Special Meeting of the Board of Directors of M. Knoedler & Co. July 14, 1928, Knoedler.

167 "be the same": OG to CSC, February 14, 1906, Colnaghi; CSC to OG, March 2, 1906, Knoedler.

167 "important customer": Frances Howard to CSC, June 13, 1913, Knoedler.

168 "picture talks": CSC to OG, December 6, 1910, Knoedler.

168 "confidence in than yours": HCF to CSC, July 29, 1908, HCFP, GLB, vol. 27, TFC/FARL.

168 "you and Mrs. Frick were here": CSC to HCF, July 1, 1902, Knoedler.

168 "horrible existence": CSC to OG, February 20, 1907, Knoedler.

169 Joshua Reynolds's *Miss Puyeau:* McIntosh, "Demand," 145.

169 "*since its purchase*": CSC to HCF, February 19, 1902, HCFP, C, TFC/FARL.

170 "glory to any museum": CSC to HCF, November 24, 1900, Knoedler.

170 "by the masters": RK to Lockett Agnew, December 29, 1899, Knoedler.

170 "picture hunting": CSC to Andrew Mellon, December 8, 1906, Knoedler.

170 "art collectors in America": Colnaghi to J. Pierpont Morgan, February 21, 1900, in Hall, "Old Masters," 15.

170 "Rembrandt portrait already hanging there": Edmond Deprez to HCF, ibid., 15.

170 "business with you": Deprez to M. Knoedler, ibid., 18.

171 "insults in the future": HCF, Carnegie Steel, board minutes, in Nasaw, *Carnegie,* 570.

171 "below their value": HCF brief against AC, spring 1900, in Warren, *Triumphant,* 263.

171 "forced to leave": Charles Schwab and AC in ibid., 257.

171 $15 and $30 million: Nasaw, *Carnegie,* 575.

171 $40 million that year: Ibid., 578.

172 "not satisfied": "Response by Carnegie Steel Co. (Ltd.)," 1899, ibid., 576.

172 a $31.6 million share: Nasaw, *Carnegie,* 579.

172 some $60 million: Harvey, *Frick,* 268.

172 "had been expelled for the general good": Warren, *Triumphant,* 265.

173 "Thermopylae of bad taste": Edith Wharton in Colin B. Bailey, *Building the Frick Collection: An Introduction to the House and Its Collections* (New York: The Frick Collection in association with Scala, 2006), 19.

173 "paintings and their frames": Inventory of Furniture, etc., 640 Fifth Avenue, 1905, HCFP, Subject File 242, TFC/FARL.

173 **"size of the paintings":** Helen Clay Frick, Statement for Rockefeller Lawsuit, n.d., [1947], Helen Clay Frick Papers, Alphabetical File, John M. Harlan, TFC/FARL.

173 **Vanderbilt declined:** George Vanderbilt to HCF, October 20, 1905, HCFP, Subject File 242, The New York House, TFC/FARL.

173 **Dutch landscapes and English portraits:** See *The Frick Collection, An Illustrated Catalogue* (New York: The Frick Collection, 1968).

174 **"of the English school":** CSC to HCF August 30, 1904, HCFP, C, TFC/FARL.

175 **"Legion of Honor":** CSC to HCF, February 12, 1902, ibid.

175 *Saint Jerome as a Cardinal*: At the time the El Greco's subject was thought to be Cardinal Gaspar de Quiroga, Archbishop of Toledo.

175 **"apartments of the palace":** OG to CSC, July 14, 1905, Colnaghi.

175 **"for the nation":** Roger E. Fry, "Pietro Aretino by Titian," *Burlington Magazine* 7, no. 29 (August 1905), 344, 347.

176 **"on the left":** Thomas Gerrity to CSC, October 4, 1905, Knoedler.

176 **"GALLERY HUNG":** Gerrity to CSC, October 6, 1905, Knoedler.

176 **"for a lot more":** Gerrity to RK, October 4, 1905, Knoedler.

176 **"enough to settle it":** RK to CSC, November 17, 1905, Knoedler.

177 **"we don't want to talk about it":** CSC to Thomas Robinson, December 23, 1905, Knoedler.

177 **"just now seems America":** OG to CSC, December 30, 1905, Colnaghi.

177 **"in the country":** CSC to OG, January 9, 1906, Knoedler.

177 **"such a man":** OG to CSC, January 20, 1906, Colnaghi.

178 **"want in my collection":** HCF to Roger Fry, April 18, 1912, HCFP, C, TFC/FARL.

178 **"16,000 through Bode":** OG to CSC, February 1906, Colnaghi.

178 **"here & at Berlin":** OG to CSC, October 18, 1907, Colnaghi.

178 **"presented themselves lately":** OG to CSC, January 24, 1908, Colnaghi.

178 **"artistically warmed up":** OG to RK, October 18, 1907, Colnaghi.

179 **"by this steamer":** CSC to OG, January 10, 1911, Knoedler.

179 **give $300,000:** CSC to HCF, June 18, 1906, Knoedler.

179 **"immortal, unchanging interest":** *Times*, in *Dutch Paintings of the Seventeeth Century* (Washington, D.C.: National Gallery of Art, ca. 1995), 259n7.

179 **"for once & all":** OG to CSC, January 24, 1906, Colnaghi.

180 **"full length lady in blue!!!":** OG to CSC, December 30, 1905, Colnaghi.

180 **"for the money":** OG to CSC, February 5, 1906, Knoedler.

180 **DECISION CARSTAIRS:** CSC to HCF, November 5, 1906, HCFP, C, TFC/FARL.

180 **southwest of London:** Henry Edward Fox-Strangways, Earl of Ilchester, *Catalogue of Pictures,* [London], 1883.

181 **FIRST OFFER:** CSC to RK, November 7, 1906, Knoedler.

182 **borrowed from Frick:** "Notes," *MMA Bulletin* 1, no. 6 (May 1906), 88.

182 **"rage and laughter"**: Virginia Woolf, *Roger Fry: A Biography* (New York: Harcourt, Brace, Jovanovich, 1940), 153.

182 **"matter to any one"**: Herbert P. Horne, to Roger Fry, April 19, 1906, in Denys Sutton, "Herbert Horne and Roger Fry," *Apollo* 123, no. 282 (August 1985), 139.

182 **"Agnew's hands"**: Horne to Fry, May 14, 1906, in Sutton, "Horne," 140.

183 **"discuss the matter"**: Fry to Horne, May 17, 1906, ibid., 154.

183 **"for the whole year"**: Gennari Santori, "European Masterpieces," 107; Roger Fry in *Letters of Roger Fry,* vol. 1, ed., Denys Sutton (London: Chatto & Windus, 1972), 262.

183 **"mercies of Agnew"**: Horne to Fry, May 21, 1906, in Sutton, "Horne," 140.

183 **"acquire it himself"**: Fry to Bryson Burroughs, February 21, 1909, MMA, EP.

184 **"Rembrandt portraits of himself"**: Wilhelm von Bode, *The Complete Works of Rembrandt* (Paris: Charles Sedelmeyer, 1901), vol. 6, 13, no. 428, *Rembrandt Seated with a Stick in His Left Hand.*

184 keep it in place: "Rembrandt's fascination with the hand," explains Svetlana Alpers, "is related to the instrumental role of the artist's hand in the making of pictures," *Rembrandt's Enterprise* (Chicago: University of Chicago Press, 1988), 29.

185 **"picture for a big price"**: CSC to RK, July 17, 1906, Knoedler.

185 **"big game"**: OG to BB, May 20, 1897, Colnaghi.

185 IMPORTANT: OG to Fry, July 17, 1906, MMA, EP.

185 **"letting me know"**: Fry notes on July 18, 1906, on reverse of telegram text from Otto Gutekunst, July 17, 1906, MMA, EP.

185 "AMERICAN PURCHASER": Fry to J. P. Morgan, July 17, 1906, MMA, EP. Also in Carolyn Elam, *Roger Fry & the Re-Evaluation of Piero della Francesca* (New York: Council of the Frick Collection Lecture Series, 2004), 53n41.

185 "ARRANGE NOW": Morgan to Fry, July 17, 1906, MMA, EP.

186 *THE MUSEUM ONLY:* Fry to Morgan, July 18, 1906, MMA, EP.

186 "OUT OF POCKET": Ibid.

187 **"is our only hope"**: CSC to RK, July 19, 1906, Knoedler.

187 "ENTIRELY FREE": Fry to Deprez, cabled text scribbled at bottom of letter from Deprez to Fry, July 27, 1906, MMA, EP.

188 **"worth 3 times as much"**: CSC to RK, November 2, 1906, Knoedler.

188 **"at these times"**: RK to CSC, November 9, 1906, Knoedler.

188 **"not be interested in it"**: Ibid.

189 **"a great deal for it"**: CSC to RK, November 7, 1906, Knoedler.

189 **"over-admired Dutchman"**: BB to ISG, [London], 1906, *Letters,* 388.

189 **"four months" to pay**: CSC to Scott & Fowles, November 23, 1906, Knoedler.

189 **"made the offer"**: RK to CSC, November 23, 1906, Knoedler.

190 **"holding for $250,000"**: CSC to RK, November 23, 1906, Knoedler.

190 **"4 hundred thousand dollars"**: Ibid.

191 "to the Berlin gallery": CSC to HCF, November 23, 1906, HCFACF, TFC/FARL.

191 "ought to have the picture": RK to CSC, December 7, 1906, Knoedler.

191 "how much I like the picture": Ibid.

191 "or April 30th if you wish": RK to HCF, December 6, 1906, TFC/FARL.

191 $25,000: HCF Voucher to M. Knoedler & Co. "Received January 16, 1907, of H. C. Frick $200,000," HCFP, Art Files TFC/FARL.

192 "all things considered": CSC to RK, January 2, 1907, Knoedler.

192 "for 20% above that": CSC to OG, February 10, 1906, Knoedler.

192 "many moods": CSC to W. D. Lawrie, February 27, 1906, Knoedler.

192 "fine work": RK to HCF, July 29, 1900, HCFP, C, TFC/FARL.

192 "keeping us waiting": CSC to RK, December 7, 1915, Knoedler.

193 "force sales": M. K. Knoedler to Lewis L. Clarke, American Exchange Bank, February 11, 1915, Knoedler.

193 "very slowly": Henry Thole to CSC, June 1, 1906, Knoedler.

193 Frick's check arrived: Walter T. Herckenrath to RK, July 13, 1906, Knoedler.

193 "business we are doing": RK to HCF, June 1, 1906, July 3, 1906, HCFP, C, TFC/FARL.

193 "looks superb": RK to CSC, January 26, 1907, Knoedler.

194 "lucky to have it": CSC to HCF, February 18, 1907, HCFP, C, TFC/FARL.

194 "interested in them": RK to Maurice Hamman, December 7, 1906, Knoedler.

194 in the *Tribune*: Royal Cortissoz, "from the 'Tribune,' September 19, 1909," in *MMA Bulletin* 4, no. 10 (October 1909), 162.

194 museum's *Bulletin*: Byron P. Stephenson, "Great Dutch Artists," *MMA Bulletin,* 4, no. 10 (October 1909), 167.

194 "imaginative significance": W. R. Valentiner, *The Hudson-Fulton Celebration,* vol. 1 (New York: Metropolitan Museum of Art), xix.

195 agreed to their purchase: CSC to Lockett Agnew, February 1, 1911, Knoedler; HCF to Fry, January 26, 1911, HCFP, Art Files; telegram Fry to HCF, February 8, 1911, Purchase File, HCFAF, TFC/FARL.

195 "on human beings": Charles M. Schwab in Warren, *Triumphant,* 374.

196 "than Morgan": CSC to OG, December 22, 1905, Knoedler.

196 "rising [stock] market": CSC to Trotti, January 29, 1908, Knoedler.

196 $1.4 million on more than thirty pictures: "List of Oil Paintings, etc. owned by H. C. Frick" [1903], HCFP, GLB; "List of Paintings," account at January 1905, HCFP, Art File-Inventories, TFC/FARL.

196 spent $2.25 million: Bailey, *Building the Frick,* 22.

196 "up Fifth Avenue": *New York Times,* December 18, 1906, ibid., 22–23.

CHAPTER VI. "OCTOPUS AND WRECKER DUVEEN"

199 **"Octopus and wrecker Duveen":** OG to BB, December 22, 1909, in Samuels, *Legend*, 37.

199 **"knows no defeat":** Archer M. Huntington, in Mitchell A. Codding, "A Legacy of Spanish Art for America: Archer M. Huntington and The Hispanic Society of America"; Gary Tinterow and Geneviève Lacambre, *Manet/ Velázquez: The French Taste for Spanish Painting* (New York: Metropolitan Museum of Art; New Haven, CT: Yale University Press, 2003), 313.

199 **English portrait:** Edward Fowles, *Memories of Duveen Brothers* (London: Times Books, 1976), 23.

200 **"greatest pictures in the world":** Ibid., 37.

200 **21 million francs:** Rodolphe Kann Collection, Undisclosed Kann no. 1, Box 257, Folder 2, DBR.

200 **choice of pictures:** BB to ISG, *Letters*, 402.

200 **"England in everything":** Henry Duveen, in Fowles, *Memories*, 3.

201 **"first call on its artisans":** Ibid., 7.

201 **"show him the very finest":** HD to JD, April 8, 1913, in Frances Haskell, "The Benjamin Altman Bequest," *Past and Present in Art and History* (New Haven, CT, and London: Yale University Press, 1987), 196.

202 **"rate equal, others":** HD to HCF, June 30, 1906, Frick Residences-Eagle Rock, TFC/FARL.

202 **"last thing a man buys":** Fowles, *Memories*, 23.

202 **Wildenstein, in Paris:** Ibid.

202 **entire collection:** Rodolphe Kann, Paris Ledger, Kann Collection, Box 118, 1906–1908, DBR.

203 **"nursing a child":** HD to Altman, June 14 and July 11, 1912, in Haskell, "Altman," 196–97.

204 **"billiard room":** "The Travel Diaries of Otto Mündler," ed. Dowd, in *Walpole Society,* 152.

204 **"lying in wait":** Bode to McKay, May 24, 1900; McKay to RK, February 27, 1907, Colnaghi.

205 **to acquire the Genoese portraits:** 1907 Stock Book, Knoedler.

205 **"will he give the price?":** CSC to RK, December 18, 1906, Knoedler.

205 **"out of Genoa":** CSC to HCF, February 18, 1907, HCFP, C, TFC/FARL.

206 **"sold it [to] him already":** BB to ISG, July 21, 1907, *Letters,* 401.

207 **"bought them immediately":** CSC to HCF, July 2, 1908, HCFP, C, TFC/ FARL.

207 **Widener had negotiated:** CSC to HCF, July 21, 1908, HCFACF, TFC/ FARL.

207 **25 percent of the profits:** Samuels, *Legend,* 142.

207 **"things proposed":** BB to HD, February 25, 1913, Box 535, Folder 2, DBR.

208 **"authentic one":** BB to Louis Duveen, January 19, 1913, Box 535, Folder 2, DBR.

208 **"its condition":** BB to Louis Duveen, January 19, 1913, DBR.

208 **"course of further studies":** BB to Messrs. Duveen, October 15, 1913, Box 537B, Folder 7, DBR.

208 **"Rev. Langton Douglas":** Ibid.

208 **"many others":** MB to her family, January 12, 1913, in *Mary Berenson,* Strachey and Samuels, 186.

209 **"reputation and authority":** BB to HD, February 25, 1913, Box 535, Folder 2, DBR.

209 **"potent to you":** BB to Messrs. Duveen, April 7, 1913, Box 537B, Folder 7, DBR.

209 **"and so on":** MB to her family, January 12, 1913, in *Mary Berenson,* Strachey and Samuels, 186.

209 **"school of Jura":** MB to her family, October 25, 1913, ibid., 192.

209 **to fill his Prides Crossing house:** HCFP, Ledger No. 5, TFC/FARL.

209 **design of his clients' houses:** Nicholas Penny and Karen Serres, "Duveen and the Decorators," *Burlington Magazine,* 149, no. 1251 (June 2007), 401.

209 **"two Italian pictures":** RK to CSC, November 13, 1906; CSC to RK, November 23, 1906, Knoedler.

210 **"sell it to Mrs Jack Gardner":** HD to JD, Fowles, *Memories,* 34.

211 **"any price within reason":** RK to CSC, April 8, 1910, Knoedler.

211 **Duveen sign it:** HCF contract for *Lady Duncombe* and *Lady Milnes,* May 3, 1911, HCFACF, Purchases, TFC/FARL.

CHAPTER VII. "HIGHEST PRIZES OF THE GAME
OF CIVILIZATION"

213 **"very important":** HCF to CSC, August 22, 1908, HCFP, GLB, vol. 27, TFC/FARL.

213 **"and the Velasquez":** HCF to Fry, July 31, 1911, HCFP, C, TFC/FARL.

213 **"utterly great":** HD to Altman, June 26, 1912, in Haskell, "Altman," 197.

214 **"something exceptional, fine":** RK to CSC, March 28, 1911, Knoedler.

214 **"large, scientific catalogues":** Wilhelm von Bode, "Die Amerikanische Gefahr im Kunsthandel," *Kunst und Künstler* 5 (1906–07), 4, 5. RK to CSC, March 24, 1911, Knoedler.

214 **"bust up Widener's collection":** MB to ISG, December 5, 1908, *Letters,* 427.

214 **"banish several":** MB to ISG, December 16, 1908, ibid.

215 **"for one million marks [$250,000]":** Wilhelm von Bode, "Die Berliner Museen und die Amerikanische Konkurrenz," *Der Cicerone* 2 (1910), 83.

215 **Morgan's collections:** W. Loeb to J. C. Curtis, September 19, 1911, in Strouse, *Morgan,* 609.

215 **to begin:** Ibid., 642.

215 **"overtaking all of Europe":** Paul M. Kennedy, *The Rise and Fall of the Great Powers* (New York: Vintage Books, 1989), 243–44.

215 **Frick, $95 million:** Chernow, *Morgan,* 158; Bailey, *Building the Frick,* 93.

216 **60,000 pounds for the painting:** Flaminia Gennari Santori, "Hans Holbein: Christina of Denmark, Duchess of Milan," Richard Verdi, *Saved: 100 Years of the National Art Collections Fund* (London: Hayward Gallery, 2003), 92.

216 **"stripped Italy and Spain":** George Bernard Shaw in Juliet Gardiner, "Rebels and Connoisseurs," in Verdi, *Saved,* 21–22.

217 **40,000 pounds:** Gennari Santori, "Holbein," 92.

217 **not to go after the portrait:** National Gallery Director's memoranda, March 1908, ibid., 92.

217 **"obliged to accept":** Charles Holroyd, February 12, 1908, in Gennari Santori, "Holbein," 92.

217 **"doing anything definite":** HD to BB, n.d., in Samuels, *Legend,* 770.

217 **"difficult task":** "Holbein's 'Duchess of Milan,' " *Times,* May 1, 1909, 12.

217 **have to match:** Gennari Santori, "Holbein," 92. "This new price meant that the art dealers would profit by £11,000: a public scandal was inevitable."

217 **"practically numbered":** Philip Burne-Jones, "Holbein's Christina," letter to the editor, *Times,* May 3, 1909.

218 **Prince of Wales 125 pounds:** "Holbein's 'Duchess of Milan,' " message from the Prince and Princess of Wales, *Times,* July 1, 1909, 17.

218 **"decided in 11 days":** OG to BB, May 20, 1909, Colnaghi.

218 **"EXPIRED YESTERDAY":** HCF to CSC, June 1, 1909, HCFACF, TFC/FARL.

218 **to the bank:** "NATION RETAIN HOLBEIN BALANCE MONEY SUBSCRIBED TODAY REGRET CANT BE YOURS CARSTAIRS," CSC to HCF, June 1, 1909, Knoedler.

218 **"lift the veil":** James to Edmond Gosse, June 4, 1909, *Selected Letters of Henry James and Edmund Gosse, 1882–1915,* ed. Rayburn S. Moore (Baton Rouge, LA, and London: Louisiana State University Press, 1988), 240.

218 **"hung so long":** CSC to HCF, June 1, 1909, HCFPAF, TFC/FARL.

218 **"HAVE WRITTEN":** HCF to CSC, ca. June 3, 1909, HCFPAF, TFC/FARL.

218 **half of the canvases go:** according to Philip Conisbee, "about half the works on show there had been sold out of the British Isles," Philip Conisbee, "The Ones That Got Away," in Verdi, *Saved,* 26. In 1909 and 1910, Robert C. Witt claimed that the value of works of art exported from Great Britain exceeded 1.1 million pounds. "The Nation and Its Art Treasures," in Frank Herrmann, *The English as Collectors,* 375.

219 **"poverty and squalidness":** Strouse, *Morgan,* 638.

219 **"target and victim":** Cannadine, *Decline,* 48.

219 **The Polish Rider:** See Colin B. Bailey, "Henry Clay Frick, Roger Eliot Fry, and Rembrandt's *Polish Rider,*" *Frick Collection Members' Magazine* (Spring/Summer 2002), 10–12.

219 **Rembrandt's value:** Fry to HCF, April 24, 1910, HCFACF, TFC/FARL.

219 **"for the museum":** Strouse, *Morgan,* 570

219 **"one hundred years"**: Abraham Bredius in Scallen, *Rembrandt*, 130.

220 **"apotheosis" of the picture**: Bredius to Tarnowski, HCFACF, TFC/FARL.

220 **"REACH ME EIGHTEENTH"**: Fry to HCF, April 15, 1910, HCFACF, TFC/FARL.

220 **"as my Rembrandt"**: HCF to Fry, cable, ca. April 16, 1910, HCFACF, TFC/FARL.

220 **"AMSTERDAM EXHIBITION"**: Fry to HCF, cable, April 16, 1910, HCFACF, TFC/FARL.

220 **"he would sell"**: Fry to HCF, April 24, 1910, HCFACF, TFC/FARL.

220 **painting's condition**: Fry to HCF, cable April 16, 1910, and April 24, 1910, HCFACF, TFC/FARL.

221 **"all matters"**: HCF to Fry, undated cable, HCFACF, TFC/FARL.

221 **"TO VIENNA"**: Fry to HCF, cable, April 19, 1910, HCFACF, TFC/FARL.

221 **"family may see it"**: HCF to Fry, cable, April 20, 1910, HCFACF, TFC/FARL.

221 **"£80,000 and £100,000"**: Fry to HCF, April 24, 1910, HCFACF, TFC/FARL.

221 **"end of my resources"**: Fry to his mother, April 24, 1910, *Letters of Roger Fry,* ed. Sutton, 330.

221 **"difficult matter to transact"**: Fry to HCF, April 24, 1910, HCFACF, TFC/FARL.

222 **"important pictures for me"**: HCF to Fry, May 12, 1910, HCFP, Art Files, TFC/FARL.

222 **"this Rembrandt through you"**: HCF to RK, May 13, 1910, HCFP, C, TFC/FARL.

222 **"stands quite alone"**: Fry to HCF, June 2, 1910, HCFACF, TFC/FARL.

222 **"ENCHANTED"**: HCF to Fry, July 22, 1910, HCFP, Art Files, TFC/FARL.

222 **a work by Sutermans**: RK to CSC, November 13, 1911, Knoedler.

223 **"few rich people that exist"**: CSC to OG, December 18, Knoedler.

224 **thirty-four other pictures**: OG to Knoedler, November 26, 1910; OG to CSC, November 30, 1910, Colnaghi.

224 **"Also the Prince of Wales"**: OG to CSC, December 7 and 17, 1910, Colnaghi.

224 **"one of the finest V. painted"**: OG to CSC, December 24, 1910, Colnaghi.

224 **"to have been expected"**: CSC to OG, December 6, 1910, Knoedler.

224 **"in this artist"**: Ibid.

224 **"but humble folks"**: CSC to OG, January 10, 1911, Knoedler.

225 **"spoken to confidentially"**: RK to CSC, March 28, 1911, Knoedler.

226 **"little VERMEER"**: CSC to RK, April 11, 1913, Knoedler.

226 **Amsterdam industrialist**: August Janssen, Amsterdam (Washington, D.C.: National Gallery of Art, On-line Collection Catalog).

226 **"so grand an advertisement"**: CSC to RK, March 13, 1911, Knoedler.

227 **"it is *priceless*"**: CSC to HCF, April 4, 1911, HCFP, C, TFC/FARL.

227 **"more understandable"**: HD to Altman, Haskell, "Altman," 197.

227 **"poor Rembrandt himself"**: OG to BB, March 18, 1911, Berenson Archives, Villa I Tatti.

228 **"interested in the Velázquez"**: CSC to OG, January 17, 1911, Knoedler.

229 **"$175,000 for them"**: CSC to OG, January 10, 1911, Knoedler.

229 **"prohibitive in price"**: CSC to OG, January 17, 1911, Knoedler.

229 **"old rose and white"**: Tom Robinson to CSC, January 28, 1911, Knoedler.

229 **"100,000–120,000 [pounds]"**: OG to CSC, February 7, 1911, Colnaghi.

229 **half of his half**: CSC to OG, February 7 and 21, 1911, Knoedler.

229 **"hopes of his buying it"**: CSC to OG, February 21, 1911, Knoedler.

229 **"(say by March fifteenth)"**: CSC to HCF, February 21, 1911, Knoedler.

229 **for *The Mill***: CSC to Colnaghi, cable, February 23, 1911, Knoedler: "VELAZQUEZ SOLD FRICK."

229 **"ever seen"**: Fry to HCF, February 14, 1911, HCFACF, TFC/FARL.

230 **still a record sum**: Samuels, *Legend,* 166.

CHAPTER VIII. "THANKS NOT IN [THE] MARKET AT PRESENT"

231 **changed his plans**: Chernow, *Morgan,* 146.

231 **"Island of Sicily"**: HCF to Philander Knox, January 2, 1912, HCFP, C, TFC/FARL.

231 **voyage home**: Philander Knox to HCF, May 18, 1912, HCFP, C, TFC/FARL. "I congratulate you upon your safe return and especially upon the lucky circumstances that you gave up your sailing on the Titanic."

231 **"would eat nothing"**: Dan Farr to CSC, April 15, 1912, Knoedler.

231 **"informed of it on the dock"**: A. S. W. Rosenbach to Belle da Costa Greene, in Strouse, *Morgan,* n644.

232 **"die of grief"**: George Davey to CSC, April 15, 1912, Knoedler.

232 **"money oligarchy"**: Samuel Untermeyer in Strouse, *Morgan,* 659.

232 **"dying financier"**: Chernow, *Morgan,* 156.

232 **"respect and gratitude"**: Ibid., 172.

232 **it might ever be needed**: Edward Robinson, November 29, 1912, in Tomkins, *Merchants,* 178.

233 **"40,000 pounds by Friday"**: CSC to Charles Henschel, June 10, 1913, Knoedler.

233 **house in Roehampton**: CSC to Arthur M. Grenfell, August 15, 1912, Knoedler. He paid 110,000 pounds for Bellini's *St. Francis* and Rembrandt's *Dutch Merchant* together.

233 **"and three others"**: Grenfell to HCF, September 5, 1913, HCFP, C, TFC/FARL.

233 **only 30,000 pounds**: CSC to Grenfell, June 12, 1913, Knoedler. CSC to Charles Henschel, June 10, 1913, Knoedler.

234 **"importance of some of the pictures"**: R. Langton Douglas to Margaret E. Gilman, November 30, 1943, TFC Curatorial Files, TFC/FARL.

234 **"creating a sensation"**: Tom Robinson to CSC, January 12, 1912, Knoedler.

234 **"*Receiving the Stigmata*"**: MB to ISG, July 27, 1912, *Letters* 497.

234 **"Grenfell . . . gotten into"**: CSC to Henschel, June 12, 1913, Knoedler.

234 **"suffer severe losses"**: CSC to Henschel, July 2, 1913, Knoedler.

235 **"much time to write"**: CSC to RK, August 11, 1913, Knoedler.

235 **Carstairs had refused it**: CSC to Agnew, November 18, 1914, Knoedler.

235 **Radnor pictures**: CSC to RK, October 29, 1912, Knoedler.

235 **"put in order"**: CSC to RK, August 19, 1913, Knoedler.

235 **"any additional money"**: CSC to RK, May 26, 1914, Knoedler.

235 **"wonderfully brilliant effect"**: CSC to HCF, June 16, 1914, HCFP, C. TFC/FARL.

236 **"as much as they can"**: Robert Fleming to HCF, May 21, 1914, HCFP, Art Files, TFC/FARL.

237 **"masterpieces" in London**: Grenfell to HCF, April 21, 1914, HCFP, Art Files, TFC/FARL.

237 **Man in a Red Cap**: The Titian went for 13,650 pounds. See Christie, Manson & Woods, *Important Pictures by Old Masters,* London, June 16, 1914.

237 **"GRENFELL SALE"**: CSC to HCF, July 6, 1914, HCFP, C, TFC/FARL.

237 **"MARKET AT PRESENT"**: HCF to CSC, handwritten on telegram, July 6, 1914, HCFACF, TFC/FARL.

237 **"pictures at cost"**: James Dunn to HCF, cable, July 27, 1914, HCFP, C, TFC/FARL.

237 **"in your library"**: CSC to HCF, July 24, 1914, HCFACF, TFC/FARL.

238 **"playing daily"**: HCF to CSC, August 1, 1914, HCFP, Art Files, TFC/FARL.

CHAPTER IX. "IF THIS WAR GOES ON, MANY THINGS
WILL BE FOR SALE"

241 **"If This War Goes On"**: MC to LWH, July 5, 1915, MMA Archives.

241 **"cities of Europe"**: MC to LWH, August 13, 1914, MMA Archives.

241 **"only subject"**: MC to LWH, November 8, 1914, MMA Archives.

241 **"too sickening"**: MC to LWH, November 11, [1914], in Mathews, *Letters,* 317–18.

241 **"escaped"**: MC to LWH, December 3, 1914, MMA Archives.

242 **"treacherous years"**: Henry James, *Letters of Henry James*, ed. Percy Lubbock, vol. 2, 384.

242 **"what will be the outcome"**: CSC to Knoedler, New York, August 14, 1914, Knoedler.

242 **send him money**: BB to Duveen, September 23 and October 10, 1914, DBR.

242 **St. Francis—to New York**: CSC to RK, September 24, 1914, Knoedler.

242 **"for security"**: National Gallery, London, board meeting minutes, September 18, 1914, National Gallery Archives.

242 **"opportunity has come"**: Michael Knoedler & Co. to Lewis L. Clarke, Esq., President, American Exchange Bank, New York, February 11, 1915.

243 **"his triumph and your defeat"**: Gimpel, *Diary,* 41–42.

243 **"trouble in Europe"**: HCF to James Dunn, September 15, 1914, in Warren, *Triumphant,* 350.

244 **"proportions immensely"**: HCF to RK, June 3, 1914, HCFP, C, TFC/FARL.

244 **"character of our band"**: CSC to OG, December 12, 1914, Knoedler.

244 **"interested in it"**: Fred Menzies to CSC, November 16, 1914, Knoedler.

244 **"CLAY INTEREST"**: CSC to Menzies, November 16, 1914, Knoedler.

245 **"influence him to close"**: Menzies to CSC, November 17, 1914, Knoedler.

245 **"tie it up"**: CSC to Lockett Agnew, November 18, 1914, Knoedler.

245 **sent to Frick**: M. Knoedler & Co. to HCF, December 4, 1914, HCFACF, TFC/FARL.

246 **"for your pictures"**: HCF to CSC, December 4, 1914, HCFP, Art Files, TFC/FARL.

246 **"Owing to war losses"**: A. E. Stanley Clarke to HCF, May 5, 1916, HCFP, C, TFC/FARL.

247 **"it will be able to acquire"**: Knoedler to Lewis L. Clarke, February 11, 1915, Knoedler.

247 **"heard from you"**: Menzies to CSC, April 1, 1915, Knoedler.

247 **"or go bankrupt"**: Alice Creelman to HCF, April 2, 1915, HCFP, Art Files, TFC/FARL.

247 **together for $365,000**: Creelman to HCF, April 10, 1915, HCFP, Art Files, TFC/FARL.

247 **"her & friend"**: Ibid.

248 **"of Knoedler & Company"**: HCF to Creelman, April 13, 1915, HCFP, Art Files, TFC/FARL. He instructed Bankers Trust to pay Hugh Lane and Creelman for the portrait.

248 **"deal direct"**: Hugh Lane to HCF, April 21, 1913, HCFP, C, TFC/FARL.

248 **"Red Cap Titian"**: Creelman to HCF, May 11, 1915, HCFP, Art Files, TFC/FARL.

248 **"under £10,000 [$50,000]?"**: BB to Duveen, May 18, 1915, Box 390A, Folder 3, DBR.

248 **"the war is over"**: CSC to HCF, July 23, 1915, HCFP, C, TFC/FARL.

248 **50 Old Master pictures**: Chernow, *Morgan,* 172.

249 **"capable of making"**: Edward Robinson, February 15, 1914. *MMA Bulletin,* 9, 2 (February 1914), 36.

249 **"around to Morgan's "**: Gimpel, *Diary,* 43.

249 **around $1 million**: Strouse, *Morgan,* 687.

249 **in the new house**: "Cost of Fragonard Room," Ledger, September 23, 1915, HCFP, Art Files, TFC/FARL.

249 **"for my dining room"**: HCF to Jack Morgan, April 20, 1915, in Strouse, *Morgan,* 688.

250 **"in the history of the firm"**: JD to BB, July 14, 1915, in Samuels, *Legend,* 194.

250 **and eighteenth-century furniture**: Bailey, *Building the Frick,* 76.

250 **"advertisement for them"**: Menzies to CSC, March 11, 1915, Knoedler.

250 **"please him"**: JD to BB, May 14, 1915, Box 24, Reel 79, Folder 26, DBR.

250 **$460 a share**: Knoedler & Co. to Agnew's, August 11, 1915, Knoedler.

250 **"ALL ITALIAN ART"**: BB to Duveen, May 16, 1915, HCFACF, TFC/FARL.

251 **"nerves & endurance"**: Grenfell to HCF, November 1, 1915, HCFP, C, TFC/FARL.

251 **"before many months"**: HCF to Grenfell, November 29, 1915, HCFP, C, TFC/FARL.

251 **five from Duveen**: "List of 59 Paintings Acquired by H.C. Frick 1898–1914," HCFACF, TFC/FARL.

252 **$843,316 on paintings**: "Statement of Purchases from M. Knoedler & Co. July 1, 1914–August 1, 1915," HCFACF, TFC/FARL.

252 **$190 million in 2006 dollars**: "List of Paintings Acquired December 29, 1910 to August 23, 1919," HCFACF, TFC/FARL.

CHAPTER X. *THE FEAST OF THE GODS*

253 **"secret from"**: BB to Duveen, June 24, 1916, Box 535, Reels 390 A–C, Folder 4, DBR.

253 **"other hands"**: BB to Duveen, telegram copies, September 30, 1913, Box 535, Reels 390 A–C, Folder 4, DBR.

254 **"don't dare"**: BB to JD, October 4, 1916, Box 535, Reels 390 A–C, Folder 4, DBR.

255 **bought the painting together**: *The Feast of the Gods* (Washington, D.C.: National Gallery of Art, On-line Collection Catalog, 12.07); *Agnews 1817–1967* (London: B. Agnew Press, 1967), 47.

255 **"million dollars"**: BB to ISG, November 26, 1916, *Letters,* 591.

255 **"its present ownership"**: BB to ISG, January 7, 1917, ibid., 593.

255 **"great mind"**: MB to ISG, January 7, 1917, ibid., 595.

255 **"mysterious and beautiful!"**: MB to ISG, January 15, 1917, ibid., 596.

256 **"behind me!"**: ISG to BB, May 18, 1917, ibid., 602.

257 **"fascinates you"**: Arthur J. Sulley to Joseph E. Widener, April 23, 1917, National Gallery of Art, Washington, D.C., Curatorial Records.

257 **"subterranean fortress"**: Charles J. Holmes, *Self & Partners* (London: Constable, 1936), 327.

257 **"to accept"**: Ibid., 333–34.

258 **"place it"**: Sulley to Widener, September 26, 1921, National Gallery of Art, Washington, D.C., Curatorial Records.

258 **"own national gallery"**: David Cannadine, *Mellon,* 376.

259 **125 Old Master paintings**: Ibid., 566.

EPILOGUE

263 *The Blue Boy*: Shelley M. Bennett, "The Formation of Henry E. Huntington's Collection of British Paintings," in Asleson and Bennett, *British Paintings*, 8.

263 **Vermeer (*A Lady Writing*)**: It was a gift of Harry Waldron Havemeyer and Horace Havemeyer Jr. in memory of their father, Horace Havemeyer.

263 **"Musée d'Orsay in Paris"**: Gary Tinterow, "The Havemeyer Pictures," Frelinghuysen et al., *Splendid*, 3.

264 **"genuine regret"**: *Burlington Magazine*, 53, no. 305 (August 1928), 95.

264 **"in London"**: OG to BB, May 5, 1943, Berenson Archive, Villa I Tatti.

264 **"Worldwide adulation"**: Samuels, *Legend*, xiii.

264 **"Culture as a commodity"**: Schapiro, "Mr. Berenson's Values," 224.

265 **"collectors to acquire"**: Bernard Berenson, *Sunset and Twilight*, 264.

Bibliography

BOOKS

Adler, Kathleen, et al. *Americans in Paris*. London: National Gallery, 2006.

Agnew's 1817–1967. London: B. Agnew Press, 1967.

Ainsworth, Maryan W., and Keith Christiansen, eds. *From Van Eyck to Bruegel: Early Netherlandish Paintings in the Metropolitan Museum of Art*. New York: Metropolitan Museum of Art, 1998.

Alpers, Svetlana. *The Art of Describing: Dutch Art in the Seventeenth Century*. Chicago: University of Chicago Press, 1983.

———. *Rembrandt's Enterprise: The Studio and the Market*. Chicago: University of Chicago Press, 1988.

American Art Association. *The Henry G. Marquand Collection*. New York, 1903.

American Renaissance 1879–1913. Brooklyn: Brooklyn Museum, distributed by Pantheon Books, 1979.

Asleson, Robyn, and Shelley M. Bennett. *British Paintings at the Huntington*. San Marino, CA: Huntington Library, Art Collections, and Botanical Gardens in association with Yale University Press, 2001.

Assouline, Pierre. *Discovering Impressionism: The Life of Paul Durand-Ruel*. New York: Vendome Press, 2004.

Auchincloss, Louis. *J. P. Morgan: The Financier as Collector*. New York: Harry N. Abrams, 1990.

Ayres, William S. "The Domestic Museum in Manhattan: Major Private Art Installations in New York City, 1870–1920." Thesis (Ph.D.), University of Delaware, 1993.

Baedeker, Karl. *Spain and Portugal: Handbook for Travellers*. Leipsig, Germany: Karl Baedeker, 1898.

Bailey, Colin B. *Building the Frick Collection: An Introduction to the House and Its Collections*. New York: Frick Collection in association with Scala, 2006.

————. *Patriotic Taste: Collecting Modern Art in Pre-Revolutionary Paris.* New Haven: Yale University Press, 2002.

Barter, Judith A., with contributions by Erica E. Hirshler et al. *Mary Cassatt, Modern Woman.* New York: Art Institute of Chicago in association with Harry N. Abrams, 1998.

Bauman, Guy, and Walter A. Liedtke. *Flemish Paintings in America: A Survey of Early Netherlandish and Flemish Paintings in the Public Collections of North America.* Antwerp: Fonds Mercator, 1992.

Behrman, S. N. *Duveen.* New York: Harmony Books, 1982.

Berenson, Bernard. *The Letters of Bernard Berenson and Isabella Stewart Gardner, 1887–1924, with Correspondence by Mary Berenson.* Ed. Rollin von N. Hadley. Boston: Northeastern University Press, 1987.

————. *Sketch for a Self-Portrait.* New York: Pantheon, 1949.

————. *Sunset and Twilight, from the Diaries of 1947–1958.* New York: Harcourt, 1963.

————. *The Venetian Painters of the Renaissance, with an Index to Their Works.* New York, London: G. P. Putnam's Sons, 1894.

————. *Venetian Painting in America: The Fifteenth Century.* New York: F. F. Sherman, 1916.

Berenson, Bernard, et al. *Paintings in the Collection of Joseph Widener at Lynnewood Hall.* Elkins Park, PA: Privately printed, 1923.

Berenson, Mary, *Mary Berenson, a Self-Portrait from Her Letters & Diaries.* Ed. Barbara Strachey and Jayne Samuels. New York: Norton, 1983.

Bode, Wilhelm von. *Catalogue of the Rodolphe Kann Collection: Pictures.* 2 vols. Paris: C. Sedelmeyer, 1907.

————. *Gemälde-Sammlung Des Herrn Rudolf Kann in Paris.* Wien: Gesellschaft für vervielfältigende Kunst, 1900.

————. *Wilhelm Von Bode: Mein Leben.* Ed. Thomas W. Gaehtgens and Barbara Paul. Berlin: Nicolai, 1997.

Bode, Wilhelm von, with C. Hofstede de Groot. *The Complete Work of Rembrandt.* Trans. Florence Simmons. 8 vols. Paris: Charles Sedelmeyer, 1897.

Bodkin, Thomas. *Hugh Lane and His Pictures.* Dublin: Published by the Stationery Office for an Chomhairle Ealaíon (the Arts Council), 1956.

Brinkley, Alan. *American History: A Survey.* 10th ed. 2 vols. Boston: McGraw-Hill College, 1999.

Britton, John. Paul Cobb Methuen Collection. *Historical Account of Corsham House, Wiltshire.* 1806.

Broos, B. P. J., et al. *Great Dutch Paintings from America.* The Hague: Mauritshuis; Zwolle: Waanders Publishers, 1990.

Brown, Christopher, and Hans Vlieghe. *Van Dyck, 1599–1641.* London: Royal Academy; Antwerp: Antwerpen Open, 1999.

Brown, David Alan. *Berenson and the Connoisseurship of Italian Painting: A Handbook to the Exhibition.* Washington, DC: National Gallery of Art, 1979.

————. *Raphael and America.* Washington, DC: National Gallery of Art, 1983.

Brown, David Alan, et al. *Bellini, Giorgione, Titian, and the Renaissance of Venetian Painting.* Washington, DC: National Gallery of Art; Vienna: Kunsthistorisches Museum in association with Yale University Press, 2006.

Brown, Jonathan. *El Greco of Toledo.* Boston: Little, Brown, 1982.

———. *Figures of Thought: El Greco as Interpreter of History, Tradition, and Ideas.* Washington, DC: National Gallery of Art, 1982.

———. *Kings & Connoisseurs: Collecting Art in Seventeenth-Century Europe.* Princeton, NJ: Princeton University Press, 1995.

———. *Velázquez: Painter and Courtier.* New Haven: Yale University Press, 1986.

Brown, Jonathan, et al. *Velázquez in New York Museums* [New York]: The Frick Collection, 1999.

Brown, Jonathan, and Susan Grace Galassi. *El Greco: Themes & Variations.* [New York]: The Frick Collection, 2001.

Brown, Jonathan, and John Huxtable Elliott. *The Sale of the Century: Artistic Relations between Spain and Great Britain, 1604–1655.* New Haven and London: Yale University Press, 2002.

Bryant, Julius. *The Iveagh Bequest, Kenwood.* London: English Heritage, 2001.

Burns, Ric, and James Sanders, with Lisa Ades. *New York: An Illustrated History.* New York: Alfred A. Knopf, 1999.

Burrows, Edwin G., and Mike Wallace. *Gotham: A History of New York City to 1898.* New York: Oxford University Press, 1999.

Cabanne, Pierre. *The Great Collectors.* New York: Farrar, Straus and Giroux, 1963.

Cannadine, David. *The Decline and Fall of the British Aristocracy.* New Haven: Yale University Press, 1990.

———. *Mellon: An American Life.* New York: Alfred A. Knopf, 2006.

Carr, Dawson W., et al. *Velázquez.* London: National Gallery; [New Haven]: Distributed by Yale University Press, 2006.

Carter, Morris. *Isabella Stewart Gardner and Fenway Court.* Boston, New York: Houghton Mifflin Company, 1925.

Chernow, Ron. *The House of Morgan: An American Banking Dynasty and the Rise of Modern Finance.* New York: Atlantic Monthly Press, 1990.

Chong, Alan, et al. *Eye of the Beholder: Masterpieces from the Isabella Stewart Gardner Museum.* Boston: Isabella Stewart Gardner Museum, in association with Beacon Press, 2003.

———. *Raphael, Cellini & a Renaissance Banker: The Patronage of Bindo Altoviti.* Boston: Isabella Stewart Gardner Museum, 2003.

Christiansen, Keith. *From Filippo Lippi to Piero Della Francesca: Fra Carnevale and the Making of a Renaissance Master.* New York: Metropolitan Museum of Art; Milan: Edizioni Olivares; New Haven: Yale University Press, 2005.

Clark, Kenneth. *Landscape into Art.* Boston: Beacon Press, 1961.

Cohen-Solal, Annie. *Painting American: The Rise of American Artists, Paris 1867–New York 1948.* New York: Alfred A. Knopf, 2001.

Conn, Steven. *Museums and American Intellectual Life, 1876–1926*. Chicago: The University of Chicago Press, 1998.

Constable, W. G. *Art Collecting in the United States of America: An Outline of a History*. London, New York: Nelson, 1964.

Corsham Court. Wiltshire: privately printed, 1993.

Cossio, Manuel B. *El Greco*. Madrid: V. Suarez, 1908.

Cox, Kenyon. *Old Masters and New: Essays in Art Criticism*. New York: Duffield, 1908.

Crowe, Joseph, and Giovanni Cavalcasselle. *A New History of Painting in Italy from the Second to the Sixteenth Century*. 3 vols. 1864–68.

Cultural Leadership in America: Art Matronage and Patronage. Boston: Trustees of the Isabella Stewart Gardner Museum, 1997.

Curry, David Park. *James McNeill Whistler at the Freer Gallery of Art*. Washington, DC: Freer Gallery of Art; New York: W. W. Norton, 1984.

Cutten, George Barton, and Callie Huger Efird. *The Silversmiths of Georgia: Together with Watchmakers and Jewelers, 1733–1850*. Savannah, GA: Oglethorpe Press, 1998.

Davies, David, et al. *El Greco*. London: National Gallery Company, 2003.

Demarest, David P., and Fannia Weingartner. *"The River Ran Red": Homestead 1892*. Pittsburgh: University of Pittsburgh Press, 1992.

Dieckvoss, Stephanie M. "Wilhelm von Bode and the English Art World." Master's thesis, Courtauld Institute of Art, University of London, 1995.

Dumas, Ann, et al. *The Private Collection of Edgar Degas*. New York: Metropolitan Museum of Art, distributed by Harry N. Abrams, 1997.

Duncan, Carol. *Civilizing Rituals: Inside Public Art Museums*. London: Routledge, 1995.

Duveen, James Henry. *The Rise of the House of Duveen*. London, New York: Longmans, 1957.

Duveen Pictures in Public Collections of America. New York: William Bradford Press, 1941.

Edel, Leon. *Henry James, a Life*. New York: Harper & Row, 1985.

Eichner, Alfred S. *The Emergence of Oligopoly: Sugar Refining as a Case Study*. Baltimore: Johns Hopkins University Press, 1969.

Elam, Caroline. *Roger Fry & the Re-Evaluation of Piero Della Francesca*. The Council of the Frick Collection Lecture Series. New York: Frick Collection, 2004.

Exhibition of Portraits by van Dyck from the Collections of Mr. P. A. B. Widener and Mr. H. C. Frick. New York: Knoedler, 1909.

Fowles, Edward. *Memories of Duveen Brothers*. London: Times Books, 1976.

Francis, A. D. *The Methuens and Portugal, 1691–1708*. Cambridge: Cambridge University Press, 1966.

Franits, Wayne. "Johannes Vermeer." *The Dictionary of Art*. Ed. Jane Turner. New York: Grove's Dictionaries, 1996. Vol. 32, 260–69.

Freedman, Jonathan L. *Professions of Taste: Henry James, British Aestheticism and Commodity Culture*. Stanford: Stanford University Press, 1990.

Frelinghuysen, Alice Cooney, et al. *Splendid Legacy: The Havemeyer Collection.* New York: Metropolitan Museum of Art, 1993.

Friedländer, Max J. *Reminiscences and Reflections.* Ed. Rudolf M. Heilbrunn. Greenwich, CT: New York Graphic Society, 1969.

The Frick Collection. Vols. I and II. New York: The Frick Collection, distributed by Princeton University Press, 1968.

Ganz, Peter F., ed. *Kunst und Kunsttheorie: 1400–1900.* Wiesbaden: Harrassowitz, 1991.

Garstang, Donald. *Art, Commerce, Scholarship: A Window onto the Art World: Colnaghi 1760 to 1984.* London: P. & D. Colnaghi, 1984.

Gennari Santori, Flaminia. *The Melancholy of Masterpieces: Old Master Paintings in America, 1900–1914.* Milan: 5 Continents, 2003.

Gimpel, René. *Diary of an Art Dealer.* New York: Farrar, Straus and Giroux, 1966.

Goldfarb, Hilliard T. *Isabella Stewart Gardner, the Woman and the Myth.* Boston: Isabella Stewart Gardner Museum, 1994.

Goldfarb, Hilliard T., and David Bohl. *The Isabella Stewart Gardner Museum.* Boston: Isabella Stewart Gardner Museum; Yale University Press, 1995.

Gould, Cecil. "Titian." *Dictionary of Art.* Ed. Jane Turner. New York: Grove's Dictionaries, 1998. Vol. 31, 31–45.

Green, Christopher, ed. *Art Made Modern: Roger Fry's Vision of Art.* London: Courtauld Gallery, Courtauld Institute of Art in association with Merrell Holberton, 1999.

Gregory, Lady. *Hugh Lane's Life and Achievement: With Some Account of the Dublin Galleries.* London: Murray, 1921.

Hadley, Rollin van N. *Isabella Stewart Gardner Museum.* Ft. Lauderdale, FL: Woodbine Books, 1981.

Hale, Nancy. *Mary Cassatt.* Reading, MA: Addison-Wesley Publishing Co., 1987.

Hall, Nicholas H. J. *Colnaghi in America.* New York: Colnaghi, 1992.

Handbook of the Benjamin Altman Collection. New York: Metropolitan Museum of Art, 1914.

Harris, Neil. *The Artist in American Society.* New York: G. Braziller, 1966.

——. *Cultural Excursions.* Chicago and London: University of Chicago, 1990.

Harvey, George. *Henry Clay Frick, the Man.* 1928. Reprint, Washington, DC: Beard Books, 2002.

Haskell, Francis. *The Ephemeral Museum: Old Master Paintings and the Rise of the Art Exhibition.* New Haven: Yale University Press, 2000.

——. *Past and Present in Art and Taste: Selected Essays.* New Haven: Yale University Press, 1987.

——. *Rediscoveries in Art: Some Aspects of Taste, Fashion, and Collecting in England and France.* Ithaca, NY: Cornell University Press, 1976.

Havemeyer, Harry W. *Frederick Christian Havemeyer: A Biography 1807–1891.* New York: privately published, 2003.

Havemeyer, Louisine Waldron. *Sixteen to Sixty: Memoirs of a Collector.* Ed. Susan Alyson Stein. New York: Ursus Press, 1993.

Hawes, Elizabeth. *New York, New York*. New York: Alfred A. Knopf, 1993.

Heckscher, Morrison H. *The Metropolitan Museum of Art: An Architectural History*. New York: Metropolitan Museum of Art, 1995.

Hendy, Philip. *Catalogue of the Exhibited Paintings and Drawings*. Boston: Isabella Stewart Gardner Museum, 1931.

Herrmann, Frank. *The English as Collectors: A Documentary Source Book*. New Castle, DE: Oak Knoll Press; London: John Murray, 1999.

Holmes, C. J. *Self & Partners (Mostly Self)*. London: Constable, 1936.

Holmes, Oliver Wendell. *John Lothrop Motley. A Memoir*. Boston: Houghton, Osgood and Company, 1879.

Howe, Winifred E. *A History of the Metropolitan Museum of Art, with a Chapter on the Early Institutions of Art in New York*. New York: Metropolitan Museum of Art, 1913.

Hynes, Samuel Lynn. *The Edwardian Turn of Mind*. London: Pimlico, 1991.

Ives, Colta Feller, and Susan Alyson Stein. *Goya in the Metropolitan Museum of Art*. New York: Metropolitan Museum of Art, 1995.

Jackson, Kenneth T., and David S. Dunbar. *Empire City: New York through the Centuries*. New York: Columbia University Press, 2002.

Jackson-Stops, Gervase, ed. *The Treasure Houses of Britain: Five Hundred Years of Private Patronage and Art Collecting*. Washington, DC: National Gallery of Art; New Haven and London: Yale University Press.

Jaffe, David, ed. *Titian*. London: National Gallery, 2003.

Jaffe, Michael. "van Dyck." *Dictionary of Art*. Ed. Jane Turner. New York: Grove's Dictionaries, 1996. Vol. 9, 475–89.

James, Henry. *American Scene*. Ed. John F. Sears. New York: Penguin Books, 1994.

———. *The Complete Letters of Henry James, 1855–1872*. Ed. Pierre A. Walker and Greg W. Zacharias. 2 vols. Lincoln: University of Nebraska Press, 2006.

———. *The Golden Bowl*. New York: Penguin Books (1904), 1987.

———. *Hawthorne*. Ithaca: Cornell University Press (1879), 1967.

———. *Letters from the Palazzo Barbaro*. Ed. Rosella Mamoli Zori. London: Pushkin Press, 1998.

———. *The Letters of Henry James*. Ed. Percy Lubbock. New York: Octagon Books, 1970.

———. *The Painter's Eye: Notes and Essays on the Pictorial Arts*. Ed. John L. Sweeney. London: Rupert Hart-Davis, 1956.

———. *The Portrait of a Lady*. Ed. Geoffrey Moore. London and New York: Penguin Books (1881), 2003.

———. *The Outcry*. New York: New York Review of Books (1911), 2002.

———. *Roderick Hudson*. London and New York: Penguin Books (1875), 1986.

———. *Selected Letters of Henry James to Edmund Gosse, 1882–1915. A Literary Friendship*. Ed. Rayburn S. Moore. Baton Rouge: Louisiana State University Press, 1988.

———. *The Wings of the Dove*. Harmondsworth: Penguin Books (1902), 1976.

Jensen, Robert. *Marketing Modernism in Fin De Siècle Europe*. Princeton, NJ: Princeton University Press, 1994.

Johnston, William R. *William and Henry Walters: The Reticent Collectors*. Baltimore: Johns Hopkins University Press, in association with the Walters Art Gallery, 1999.

Kennedy, Paul M. *The Rise and Fall of the Great Powers: Economic Change and Military Conflict from 1500 to 2000*. New York: Vintage Books, 1989.

Kilmurray, Elaine, and Richard Ormond, eds. *John Singer Sargent*. Boston: Museum of Fine Arts, 1999.

Kuhrau, Sven. *Der Kunstsammler Im Kaiserreich: Kunst und Repräsentation in Der Berliner Privatsammlerkultur*. Kiel: Ludwig, 2005.

La Farge, John, and Augusto Floriano Jaccaci. *Noteworthy Paintings in American Private Collections*. New York: Garland, 1979.

Lavin, Marilyn Aronberg. *The Eye of the Tiger: The Founding and Development of the Department of Art and Archaeology, 1883–1923*. Princeton, NJ: Princeton University Press, The Department of Art and Archaeology and the Art Museum, 1983.

Lears, T. J. Jackson. *No Place of Grace: Antimodernism and the Transformation of American Culture, 1880–1920*. New York: Pantheon Books, 1981.

Lerman, Leo, and Thomas Hoving. *The Museum: One Hundred Years and the Metropolitan Museum of Art*. New York: Viking Press, 1969.

Liedtke, Walter A. *Anthony Van Dyck*. New York: Metropolitan Museum of Art, 1985.

———. *Dutch Paintings in the Metropolitan Museum of Art*. New York: Metropolitan Museum of Art; New Haven and London: Yale University Press, 2007.

———. *Flemish Paintings in the Metropolitan Museum of Art*. 2 vols. New York: Metropolitan Museum of Art, 1984.

Liedtke, Walter A., et al. *Vermeer and the Delft School*. New York: Metropolitan Museum of Art: New Haven and London: Yale University Press, 2001.

Longhi, Roberto, with Keith Christiansen. *Piero Della Francesca*. Riverdale-on-Hudson, NY: Stanley Moss-Sheep Meadow Press, 2002.

Maas, Jeremy. *Gambart: Prince of the Victorian Art World*. London: Barrie & Jenkins, 1975.

MacDonald, Margaret F., Susan Grace Galassi, and Aileen Ribeiro. *Whistler, Women, & Fashion*. New York: Frick Collection in association with Yale University Press, 2003.

Manca, Joseph, ed. *Titian 500. Studies in the History of Art*. 45. Washington, DC: National Gallery of Art, 1993.

Mandler, Peter. *The Fall and Rise of the Stately Home*. New Haven: Yale University Press, 1997.

The Master's Hand: drawings and manuscripts from the Pierpont Morgan Library. New York: Pierpont Morgan Library, 1998.

Mathews, Nancy Mowll. *Mary Cassatt: A Life.* New York: Villard Books, 1994.

Mathews, Nancy Mowll, ed. *Cassatt and Her Circle: Selected Letters.* New York: Abbeville Press, 1984.

McCarthy, Kathleen D. *Women's Culture: American Philanthropy and Art, 1830–1930.* Chicago: University of Chicago Press, 1991.

McCauley, Elizabeth Anne, et al. *Gondola Days: Isabella Stewart Gardner and the Palazzo Barbaro Circle.* Boston: Isabella Stewart Gardner Museum, 2004.

McClellan, Andrew. *Art and Its Publics: Museum Studies at the Millennium.* Malden, MA: Blackwell Publishing Co., 2003.

———. *Inventing the Louvre: Art, Politics, and the Origins of the Modern Museum in Eighteenth-Century Paris.* Cambridge and New York: Cambridge University Press, 1994.

McFadden, Elizabeth. *The Glitter & the Gold.* New York: Dial Press, 1971.

McQueen, Alison. *The Rise of the Cult of Rembrandt: Reinventing an Old Master in Nineteenth-Century France.* Amsterdam: Amsterdam University Press, 2003.

Meier-Graefe, Julius. *The Spanish Journey.* Trans. J. Holroyd-Reece. New York: Harcourt, Brace & Company, 1926.

Methuen, Paul Ayshford. *An Historical Account of Corsham Court.* Corsham: Corsham Estate, 1965.

Miller, Lillian B. *Patrons and Patriotism: The Encouragement of the Fine Arts in the United States, 1790–1860.* Chicago: University of Chicago Press, 1966.

Minty, Nancy. "Dutch and Flemish Seventeenth-Century Art in America, 1800–1940." Thesis (Ph.D.), New York University, Institute of Fine Arts, 2003.

The Morgan Library: An American Masterpiece. New York and London: Pierpont Morgan Library, in association with Scala Publishers, 2000.

Morison, Samuel Eliot. *The Oxford History of the American People.* New York: Oxford University Press, 1965.

Motley, John Lothrop. *History of the United Netherlands.* 4 vols. New York: Harper, 1866.

Mullins, Jack Simpson. *The Sugar Trust: Henry O. Havemeyer and the American Sugar Refining Company.* Thesis, University of South Carolina, 1964.

Nasaw, David. *Andrew Carnegie.* New York: Penguin Press, 2006.

Ormond, Richard, and Elaine Kilmurray. *John Singer Sargent: The Complete Paintings.* Vols. 1 and 2. New Haven and London: Published for the Paul Mellon Centre for Studies in British Art by Yale University Press, 1998, 2002.

Paintings from the Frick Collection. New York: H. N. Abrams in association with the Frick Collection, 1990.

Panofsky, Erwin. *Problems in Titian, Mostly Iconographic.* New York: Published for the Institute of Fine Arts, New York University, by New York University Press, 1969.

Paret, Peter. *The Berlin Secession: Modernism and Its Enemies in Imperial Germany.* Cambridge, MA: The Belknap Press of Harvard University Press, 1980.

Passavant, Johann David, with Colin J. Bailey. *Tour of a German Artist in England.* East Ardsley: EP Publishing, 1978.

Pears, Iain. *The Discovery of Painting: The Growth of Interest in the Arts in England, 1680–1768.* New Haven and London: published for the Paul Mellon Centre for Studies in British Art by Yale University Press, 1988.

Pope-Hennessy, John. "Roger Fry and the Metropolitan Museum of Art," in E. Chaney and N. Ritchie, eds. *Oxford, China and Italy, Writings in Honour of Sir Harold Acton.* London: Thames and Hudson, 1984.

Postle, Martin, ed. *Joshua Reynolds: The Creation of Celebrity.* London: Tate Publishing, 2005.

Quodbach, Esmée. *The Age of Rembrandt.* New York: Metropolitan Museum of Art, 2007.

Reitlinger, Gerald. *The Economics of Taste: The Rise and Fall of Picture Prices, 1760–1960.* London: Barrie and Rockliff, 1961.

Rembrandt: collection des oeuvres du maître réunies, à l'occasion de l'inauguration de S.M. la Reine Wilhelmine. Amsterdam: Imprimerie Roeloffzen-Hubner and Van Santen, 1898.

Rosenthal, Michael, and Martin Myrone. *Gainsborough.* London: Tate Publishing, 2002.

Ruskin, John. *Fors Claviger: Letters to the Workmen and Labourers of Great Britain.* Ed. Dinah Birch. Edinburgh: Edinburgh University Press, 2000.

———. *Selected Writings.* Ed. Kenneth Clark. London and New York: Penguin Books, 1991.

Ryskamp, Charles, et al. *Art in the Frick Collection: Paintings, Sculpture, Decorative Arts.* New York: Harry N. Abrams in association with the Frick Collection, 1996.

Saarinen, Aline B. *The Proud Possessors.* New York: Random House, 1958.

Saltzman, Cynthia. *Portrait of Dr. Gachet: The Story of a van Gogh Masterpiece.* New York: Viking, 1998.

Samuels, Ernest. *Bernard Berenson: The Making of a Connoisseur.* Cambridge, MA: Belknap Press, 1979.

Samuels, Ernest, and Jayne Samuels. *Bernard Berenson: The Making of a Legend.* Cambridge, MA: Belknap Press, 1987.

Sanger, Martha Frick Symington. *Henry Clay Frick: An Intimate Portrait.* New York: Abbeville Press Publishers, 1998.

———. *The Henry Clay Frick Houses: Architecture, Interior, Landscapes in the Golden Era.* New York: Monacelli Press, 2001.

Satterlee, Herbert Livingston. *J. Pierpont Morgan: An Intimate Portrait.* New York: The Macmillan Co., 1939.

Scallen, Catherine B. *Rembrandt, Reputation, and the Practice of Connoisseurship.* Amsterdam: Amsterdam University Press, 2004.

Schapiro, Meyer. *Theory and Philosophy of Art: Style, Artist, and Society.* New York: George Braziller, 1994.

Secrest, Meryle. *Being Bernard Berenson*. New York: Holt, Rinehart and Winston, 1979.

———. *Duveen: A Life in Art*. New York: Alfred A. Knopf, 2004.

Seligman, Germain. *Merchants of Art, 1880–1960: Eighty Years of Professional Collecting*. New York: Appleton-Century-Crofts, 1961.

Shand-Tucci, Douglass. *The Art of Scandal: The Life of Isabella Stewart Gardner*. New York: HarperCollins, 1997.

Sheehan, James J. *Museums in the German Art World from the End of the Old Regime to the Rise of Modernism*. New York: Oxford University Press, 2000.

Simpson, Colin. *Artful Partners: Bernard Berenson and Joseph Duveen*. New York: Macmillan, 1986.

Simpson, Marc, et al. *Uncanny Spectacle: The Public Career of the Young John Singer Sargent*. New Haven: Yale University Press; Williamstown: Sterling and Francine Clark Art Institute, 1997.

Sonnenburg, Hubert von, and Walter A. Liedtke. *Rembrandt/Not Rembrandt in the Metropolitan Museum of Art*. 2 vols. New York: Metropolitan Museum of Art, 1995.

Stern, Robert A. M., Gregory Gilmartin, and John Montague Massengale. *New York 1900: Metropolitan Architecture and Urbanism, 1890–1915*. New York: Rizzoli, 1983.

Strahan, Edward. *The Art Treasures of America*. 3 vols. Philadelphia: Gebbie & Barrie, 1880.

Strehlke, Carl Brandon. *Italian Paintings, 1250–1450, in the John G. Johnson Collection and the Philadelphia Museum of Art*. Philadelphia: Philadelphia Museum of Art, in association with the Pennsylvania State University Press, 2004.

Strouse, Jean. *J. Pierpont Morgan, Financier and Collector*. New York: Metropolitan Museum of Art, 1999.

———. *Morgan: American Financier*. New York: Random House, 1999.

Sutton, Denys, ed. *Letters of Roger Fry*. 2 vols. London: Chatto & Windus, 1972.

Sutton, Peter C. *A Guide to Dutch Art in America*. Washington, DC: Netherlands-American Amity Trust; Grand Rapids: Eerdmans, 1986.

Sweet, Frederick Arnold. *Miss Mary Cassatt, Impressionist of Pennsylvania*. Norman: University of Oklahoma Press, 1966.

Thackeray, William Makepeace. *Vanity Fair: A Novel Without a Hero*. London and New York: Penguin Books, 2001.

Tharp, Louise Hall. *Mrs. Jack: A Biography of Isabella Stewart Gardner*. Boston: Little, Brown, 1965.

Tietze, Hans. *Masterpieces of European Painting in America*. New York: Oxford University Press, 1939.

Tillyard, Stella K. *Aristocrats: Caroline, Emily, Louisa and Sarah Lennox, 1750–1832*. London: Chatto & Windus, 1994.

Tinterow, Gary, and Geneviève Lacambre. *Manet/Velázquez: The French Taste*

for Spanish Painting. New York: Metropolitan Museum of Art; New Haven: Yale University Press, 2003.

Tolles, Thayer, et al., eds. *American Sculpture in the Metropolitan Museum of Art*. 2 vols. New York: Metropolitan Museum of Art; New Haven: Yale University Press, 1999.

Tomkins, Calvin. *Merchants and Masterpieces: The Story of the Metropolitan Museum of Art*. New York: H. Holt, 1989.

Turner, Jane, ed. *The Dictionary of Art*. 34 vols. New York: Grove's Dictionaries, 1996.

Valentiner, Wilhelm Reinhold. *Catalogue of a Collection of Paintings by Dutch Masters of the Seventeenth Century*. 2 vols. New York: Metropolitan Museum of Art, 1909.

Venturi, Lionello. *Les Archives de l'impressionnisme*. Paris, New York: Durand-Ruel, 1939.

Verdi, Richard, et al. *Saved! 100 Years of the National Art Collections Fund*. London: Hayward Gallery and the National Art Collections Fund, in association with Scala, 2003.

Viniegra, S. *Exposición de las Obras del Greco*. Madrid: Museo Nacional de Pintura, 1902.

Voorsanger, Catherine Hoover, and John K. Howat, eds. *Art and the Empire City: New York, 1825–1861*. New York: Metropolitan Museum of Art; New Haven: Yale University Press, 2000.

Wall, Joseph Frazier. *Andrew Carnegie*. Pittsburgh: University of Pittsburgh Press, 1989.

Warner, Malcolm, and Robyn Asleson. *Great British Paintings from American Collections: Holbein to Hockney*. New Haven: Yale Center for British Art, 2001.

Warren, Kenneth. *Triumphant Capitalism: Henry Clay Frick and the Industrial Transformation of America*. Pittsburgh: University of Pittsburgh Press, 1996.

Weisberg, Gabriel P., DeCourcy E. McIntosh, and Alison McQueen. *Collecting in the Gilded Age: Art Patronage in Pittsburgh, 1890–1910*. Pittsburgh: Frick Art & Historical Center, 1997.

Weitzenhoffer, Frances. *The Havemeyers: Impressionism Comes to America*. New York: Harry N. Abrams, 1986.

Wethey, Harold E. *El Greco and His School*. 2 vols. Princeton, NJ: Princeton University Press, 1962.

Wheelock, Arthur K. *Dutch Paintings of the Seventeenth Century*. Washington, DC: National Gallery of Art, 1995.

Wheelock, Arthur K., ed. *Johannes Vermeer*. Washington, DC: National Gallery of Art; The Hague: Royal Cabinet of Paintings, Mauritshuis, 1995.

White, Christopher et al. *Rembrandt in Eighteenth-Century England*. New Haven: Yale Center for British Art, 1983.

Whitehill, Walter Muir. *Museum of Fine Arts, Boston: A Centennial History*. 2 vols. Cambridge, MA: Belknap Press, 1970.

Widener, Peter A. B. *Without Drums*. New York: G. B. Putnam's Sons, 1940.

Wilhelm von Bode, Museumsdirektor und Mäzen: Wilhelm von Bode zum 150. Geburtstag. Berlin: Staatliche Museen zu Berlin, 1995.

Wilton, Andrew, and Ilaria Bignamini. *The Grand Tour: The Lure of Italy in the Eighteenth Century.* London: Tate Publishing, 1996.

Wolk-Simon, Linda. *Raphael at the Metropolitan: The Colonna Altarpiece.* New York: Metropolitan Museum of Art; New Haven: Yale University Press, 2006.

Wollheim, Richard. *On Art and the Mind.* Cambridge, MA: Harvard University Press, 1974.

Woolf, Virginia. *Roger Fry: A Biography.* New York: Harcourt, Brace Jovanovich, 1940.

Wright, Gwendolyn. *Formations of National Collections of Art and Archaeology.* Washington, DC: National Gallery of Art, 1996.

Young, Dorothy Weir. *The Life & Letters of J. Alden Weir.* New Haven: Yale University Press, 1960.

PERIODICALS

Alexander, E. A. "Mr. Henry G. Marquand." *Harper's New Monthly Magazine* 94, no. 562 (March 1897): 560–71.

Anderson, Jaynie. "The Political Power of Connoisseurship in Nineteenth-Century Europe: Wilhelm von Bode versus Giovanni Morelli." *Jahrbuch des Berliner Museen.* Berlin: Gebr. Mann, 1996, 107–19.

Baetjer, Katharine. "Buying Pictures for New York: The Founding Purchase of 1871." *Metropolitan Museum Journal* 39 (2004): 161–95.

Baker, Malcolm. "Bode and Museum Display: The Arrangement of the Kaiser-Friedrich-Museum and the South Kensington Response." *Jahrbuch der Berliner Museen.* Berlin: Gebr. Mann, 1996, 144–53.

Bailey, Colin. "Henry Clay Frick, Roger Eliot Fry, and Rembrandt's *Polish Rider.*" *The Frick Collection: Members' Magazine* (Spring/Summer 2002): 10–12.

Bode, Wilhelm. "Alte Kunstwerke in den Sammlungen der Vereinigten Staaten," *Zeitschrift für bildende Kunst* 6 (1895): 13–19.

———. "Die Amerikanische Konkurrenz im Kunsthandel und ihre Gefahr für Europa." *Kunst und Kunstler* 1 (1902): 5–12.

———. "Die amerikanischen Gemäldesammlungen in ihrer neueren Entwicklung." *Kunst und Kunstler* 2 (1903–4): 387–89.

———. "Die Amerikanische Gefahr im Kunsthandel." *Kunst und Kunstler* 5 (1906–7): 3–6.

———. "Paris und London unter dem Gestirn der Americanischen Kaufwut." *der Cicerone* 1 (1909): 441–43.

———. "Die Berliner Museen und die Amerikanische Konkurrenz." *der Cicerone* 2 (1910): 81–84.

———. "The Berlin Renaissance Museum." *The Fortnightly Review*, no. 56 (October 1891): 506–15.

Boone, M. Elizabeth. "Gilded Age Values and a Golden Age Painter: American Perceptions of Jan Vermeer." *Rutgers Art Review* 12–13 (1991–1992): 47–67.

Brandt, Kathleen Weil-Garris. "Mrs. Gardner's Renaissance." *Fenway Court* (1972): 10–30.

Brown, David Alan. "Berenson and Mrs. Gardner: The Connoisseur, the Collector and the Photograph." *Fenway Court* (1978): 24–29.

———. "Bode and Berenson: Berlin and Boston." *Jahrbuch der Berliner Museen*. Berlin: Gebr. Mann, 1996, 101–6.

Burroughs, Bryson. "A Loan Exhibition of Mr. Morgan's Paintings." *Metropolitan Museum of Art Bulletin* 8, no. 1 (January 1913): 1–13.

Carrier, David. "Mrs. Isabella Stewart Gardner's Titian." *Source* 20, no. 2 (Winter 2001): 20–24.

Clark, Kenneth. "Bernard Berenson." *Burlington Magazine* 102, no. 690 (September 1960): 381–386.

Cortissoz, Royal. "Old Dutch Masters." *Metropolitan Museum of Art Bulletin* 4, no. 10 (October 1909): 83, 85.

Cox, Kenyon. "Dutch Pictures in the Hudson-Fulton Exhibition" *Burlington Magazine* 16, no. 83 (February 1910): 302–6.

Cust, Lionel. "The New Van Dyck in the National Gallery." *Burlington Magazine* 11, no. 53 (August 1907): 324–26.

de Forest, Robert W. "William Tilden Blodgett and the Beginnings of the Metropolitan Museum of Art." *Metropolitan Museum of Art Bulletin* 1, no. 3 (February 1906): 37–40.

Eisler, Colin. "Bode's Burden—Berlin's Museum as an Imperial Institution." *Jahrbuch der Berlin Museen*. Berlin Gebr. Mann, 1996, 25–31.

Elam, Caroline. " 'A More and More Important Work': Roger Fry and the *Burlington Magazine*." *Burlington Magazine* 145, no. 1200 (March 2003): 142–52.

Fahy, Everett. "Italian Paintings at Fenway Court and Elsewhere." *Connoisseur* 198, no. 795 (May 1978): 28–43.

Fry, Roger E. "Notes." *Burlington Magazine* 9, no. 41 (August 1906): 363.

———. "Pietro Aretino by Titian." *Burlington Magazine* 7, no. 29 (August 1905): 344–47.

———. "Ideals of a Picture Gallery." *Metropolitan Museum of Art Bulletin* 1, no. 4 (March 1906): 58–60.

———. "Principal Accessions." *Metropolitan Museum of Art Bulletin* 2, no. 10 (October 1907): 172–73.

Gennari Santori, Flaminia. "Holmes, Fry, Jaccaci and the 'Art in America' Section of the *Burlington Magazine*, 1905–1910." *Burlington Magazine* 145, no. 1200 (March 2003): 153–63.

Goetzmann, William N. "Accounting for Taste." *American Economic Review* 83, no. 5 (December 1993): 1370–76.

Hadley, Rollin Van N. "The Isabella Stewart Gardner Museum." *Connoisseur* 198, no. 795 (May 1978): 2–9.

Haskell, Francis. "The Benjamin Altman Bequest." *Metropolitan Museum Journal* 3 (1970): 259–80.

Havemeyer, Louisine W. "The Prison Special." *Scribner's Magazine* 71, no. 6 (June 1922): 661–74.

———. "The Suffrage Torch." *Scribner's Magazine* 71, no. 5 (1922): 528–39.

Holmes, C. J. "Rembrandt and Van Dyck in the Widener and Frick Collections." *Burlington Magazine* 13, no. 65 (August 1908): 306–11, 14–16.

Kisluk-Grosheide, Danielle O. "The Marquand Mansion." *Metropolitan Museum Journal* 29 (1994): 151–81.

Knaufft, Ernest. "Henry G. Marquand as an American Art Patron." *American Monthly Review of Reviews* 27 (January–June, 1903): 172–76.

Laidlaw, Christine Wallace. "Silver by the Dozen: The Wholesale Business of Teunis D. Dubois." *Winterthur Portfolio* 23, no. 1 (Spring 1988): 25–50.

"The Marquand Gallery." *Metropolitan Museum of Art Bulletin* 6, no. 1 (January 1911): 3–6.

Muller, Priscilla E. "Discerning Goya." *Metropolitan Museum Journal* 31 (1996): 175–87.

Nathanson, Carol A. "The American Reaction to London's First Grafton Show." *Archives of American Art Journal* 25, no. 3 (1985): 2–10.

Orcutt, Kimberly. "Buy American? The Debate over the Art Tariff." *American Art* 16, no. 3 (Autumn 2007): 82–91.

Penny, Nicholas, and Karen Serres. "Duveen and the Decorators." *Burlington Magazine* 149, no. 1251 (June 2007).

Pomeroy, Jordana. "The Orléans Collection: Its Impact on the British Art World." *Apollo* (February 1997): 26–31.

Quodbach, Esmée. "The Last of the American Versailles: The Widener Collection at Lynnewood Hall." *Simiolus* 29, no. 1/2 (2002): 42–96.

———. " 'Rembrandt's "Gilder" Is Here.' " *Simiolus* 31, no. 1/2 (2004–5): 90–107.

"The Pierpont Morgan Gift." *Metropolitan Museum of Art Bulletin* 13, no. 1 (January 1918): 2–19.

"Rearrangement of a Picture Gallery at the Museum." *Metropolitan Museum of Art Bulletin* 1, no. 5 (April 1906): 69.

"Recent Changes in the Gallery." *Metropolitan Museum of Art Bulletin* 1, no. 6 (May 1906): 86–87.

Roberts, Keith. "Frick, Gulbenkian & Co." *Burlington Magazine* 114, no. 831 (June 1972): 405–9.

Robinson, Frank T. "Van Dyck's Masterpiece." *Boston Evening Transcript, Boston Weekly Transcript* (January 29, 1887).

Rosasco, Betsy. "The Teaching of Art and the Museum Tradition: Joseph Henry to Allan Marquand." *Record of the Art Museum, Princeton University* 55, no. 1/2 (1996): 7–52.

Rubin, Patricia. "Portrait of a Lady: Isabella Stewart Gardner, Bernard Berenson and the Market for Renaissance Art in America." *Apollo* (September 2000): 37–44.

Simpson, Marc. "Windows on the Past: Edwin Austin Abbey and Francis Davis Millet in England." *American Art Journal* 22, no. 3 (1990): 64–85.

Stephenson, Byron P. "Great Dutch Artists." *Metropolitan Museum of Art Bulletin* 4, no. 10 (October 1909): 167–73.

Sutton, Denys. "Herbert Horne and Roger Fry." *Apollo* 123, no. 282 (August 1985): 130–59.

———. "The Letters of Bernard Berenson and Isabella Stewart Gardner 1887–1924." *Burlington Magazine* 130, no. 1026 (September 1988): 710.

Valentiner, Wilhelm R. "Die Ausstellung Hollandischer Gemälde in New York." *Monatshefte für Kunstwissenschaft* 3 (1910): 5–12.

———. "Important Rembrandts in American Collections." *Art News* 28, no. 30 (April 26, 1930): 3–4.

Walsh, John. "Paintings in the Dutch Room." *Connoisseur* 198, no. 795 (May 1978): 50–61.

Warren, Jeremy. "Bode and the British." *Jahrbuch der Berliner Museen*. Berlin: Gebr. Mann, 1996, 124–42.

Weinberg, H. Barbara. "The Career of Francis Davis Millet." *Archives of American Art Journal* 17, no. 1 (1977): 2–18.

———. "Late-Nineteenth-Century American Painting: Cosmopolitan Concerns and Critical Controversies." *Archives of American Art Journal* 23, no. 4 (1983): 19–26.

Wilson-Bareau, Juliet. "Goya and the X Numbers: The 1812 Inventory and Early Acquisitions of 'Goya' Pictures." *Metropolitan Museum Journal* 31 (1996): 159–74.

Zerbe, Richard. "The American Sugar Refinery Company, 1887–1914: The Story of a Monopoly." *Journal of Law and Economics* 12, no. 2 (October 1969): 339–75.

ARCHIVAL MATERIAL

Berenson Archive, Villa I Tatti, The Harvard University Center for Italian Renaissance Studies, Florence, Italy—Berenson Correspondence

P. & D. Colnaghi and Co., Ltd., London

The Frick Collection and Frick Art Reference Library, New York—Curatorial Files, Henry Clay Frick Art Collection Files, Henry Clay Frick Papers and Helen Clay Frick Papers

Isabella Stewart Gardner Museum Archives, Boston—Isabella Stewart Gardner Correspondence and Painting Files

Getty Research Institute, Los Angeles—Duveen Brothers Records

Knoedler & Company, New York

The Metropolitan Museum of Art, New York—Department of American Decorative Arts—Frances Weitzenhoffer Files; Department of European Paintings—Henry G. Marquand Correspondence and Roger Fry Correspondence; Museum Archives—Mary Cassatt Letters to Louisine Havemeyer, Henry G. Marquand Files

The Morgan Library and Museum, New York—The Pierpont Morgan Papers—
ARC 1196, House inventory, Princes Gate 1912; Morgan Collections Correspondence, ARC 1310, Duveen and Glaenzer folders, ARC 01914, Sedelmeyer folder; ARC 1444, 1456, 1496, Satterlee Family Papers, Photograph Albums

National Gallery, London—Archives—Board Minutes

National Gallery of Art, Washington, D.C.—Curatorial Records

Princeton University Library, Princeton, New Jersey—Rare Books and Special Collections, Allan Marquand Papers

Staatliche Museen zu Berlin Zentralarchiv, Berlin—SMB-ZA Bode 2268

Index

Note: Page numbers in italics refer to
illustrations.

Adoration of the Magi (Botticelli), 259
Adoration of the Shepherds (El Greco), 115,
 141–142
Agnew, Lockett, 104, 170, 244–245, 255
Agnew, Morland, 104, 228–229
Agnew, Thomas (the elder), 103–104
Agnew, Thomas (the younger), 103–104
Agnew, William, 102–104
Agnew's, London, 71, 84, 102–104,
 182–183, 202, 223, 226, 229, 233
Alba Madonna (Raphael), 259
Alexander, John White, 12, 24
Allegory of Virtue and Vice (Veronese), 195
Allegory of Wisdom and Strength
 (Veronese), 195
Allen, Elizabeth Love: *see* Marquand,
 Elizabeth Allen
Alma-Tadema, Lawrence, 29–30, 42
Altman, Benjamin, 6, 173, 194, 201–203,
 210, 213–215, 224, 226–227, 229, 232, 266
America: art collectors in, 1–4, 214;
 artistic tastes of, 17, 46–47, 75–76, 125,
 168; culture of, 1, 12, 16, 19; Dutch
 paintings and, 38–39; English portraits
 and, 106–107, 263; fine arts courses in,
 40; Gilded Age of, 7, 25, 230;
 Impressionist art and, 112, 133–134;
 industrial era and, 1, 6, 16, 19, 43, 101,
 107, 145–146, 150, 155–157, 179, 230, 243;
 nudes in art and, 75–76; Old Master
 collectors in, 173; promotion of art and,
 13; railroads and, 23; tariffs on art by,
 35, 82, 95, 99, 187, 215; wealth of,
 215–216; World War I and, 242–243
American Scene, The (James), 92
American School of painting, 13
American, The (James), 52
Andrea del Castagno, 6–7, 202, 263
Angelico, Fra, 219
Angerstein, John Julius, 29
Anne, Countess of Clanbrassil (van Dyck),
 246
Annunciation (Fiorenzo di Lorenzo), 86–87
Annunciation (van der Weyden), 202
Ansidei Madonna (Raphael), 29, 93,
 97–98, 102
Anslo and His Wife (Rembrandt), 69
*Antwerp: Van Goyen Looking Out for a
 Subject* (Turner), 192
Arbuckle, John, 129–130
architecture, 19, 25, 42–44, 90, 99
Aristotle with the Bust of Homer
 (Rembrandt), 200, 202, 266
Armory Show, New York, 243
*Arrangement in Black and Gold: Comte
 Robert de Montesquieu-Fezensac*
 (Whistler), 246–247
*Arrangement in Brown and Black: Portrait
 of Miss Rosa Corder* (Whistler), 246
art auctions, 4, 26–27, 42, 45–46, 68, 102,
 233, 236–237

art collectors, 2–3, 6–7, 214, 216–217; *see also* individual names ·
art dealers, 5–7, 75, 170; commissions charged by, 57, 222; competitiveness of, 222–223; techniques of, 46, 178, 193, 213–214; *see also* individual names
Art Fund, England, 217–218
Art Institute of Chicago, 7, 142
art market, 34, 35, 69, 84, 96; in America, 67, 71, 146, 166, 177–179, 214, 263; connoisseurs and, 64; decline of, 232–234, 242; Dutch painting and, 174; in England, 27, 177–178, 216; in Europe, 41, 166, 215–216; flourishing of, 4–6; and French Impressionsim, 133–134, 166; New York Stock Exchange and, 237, 259; value of art and, 188, 196; World War I and, 248
Art of Painting, The (Vermeer), 38, 118
Art Treasures of Great Britain exhibition, 27
Arthur Tooth & Sons, 145–146, 159, 161–162, 170
Ashburnham, Lord, 45, 57, 67, 69
Assumption of the Virgin (El Greco), 114, 137–138, 140, 142
Atlantic Monthly, 15, 65
Avery, Samuel, 126, 142

Bacchanal (Bellini and Titian): *see Feast of the Gods, The* (Bellini and Titian)
Baker, Samuel, 27
Ball at the Opera (Manet), 112
Ballet Rehearsal (Degas), 122–123
Banks of the Seine (Sisley), 112
Barbizon school, 132, 145, 164, 168, 174
Baroque art, 4, 26, 32
Bellini, Giovanni, 6, 74, 78, 182, 208, 233–235, 244, 247, 250, 253–259
Bellows, Henry, 16
Benois Madonna (Leonardo), 4, 230
Berenson, Bernard, 6, 7, 170, 178; appearance and personality of, 58–59, 64–65; as art dealer, 71, 74–75, 78, 141, 145, 248, 253–255, 259, 264–265; as art expert, 45, 61–67, 97, 207–208, 214, 230, 264; Botticelli's *Death of Lucretia* and, 45, 57, 67; childhood and education, 58, 60–61; deceives Gardner, 77, 82–85; Duveens and, 207–209, 217; finances of, 80, 242; Gutekunst and, 67, 69–71, 75–77, 86, 105, 264; I. S. Gardner and, 45, 47, 49, 57–62, 64, 67–68, 71–72, 76–86, 88–89,

97–98, 119, 189, 195, 205–206, 210, 255–256; travels of, 61, 64–65, 78, 89; Villa I Tatti and, 65, 67, 208, 264; writings by, 45, 61–63, 65–66, 74, 119
Berenson, Mary, 64–67, 80, 82–84, 208–209, 214, 234, 255, 258, 264
Berlin Gemäldegalerie, 16, 40, 214
Betrayal of Christ, The (van Dyck), 12, 14–15, 34
Bigelow, William Sturgis, 79
Birth of Venus, The (Botticelli), 253
Blodgett, William Tilden, 18
Blue Boy, The (Gainsborough), 72, 75–77, 263
Boating (Manet), 112, 137
Bonheur, Rosa, 164
Boston Evening Transcript, 36
Boston, Massachusetts, 37, 48–49, 54, 58, 60, 92, 261
Botticelli, Sandro, 7, 45, 47, 57, 67, 69, 81, 86, 208, 253, 259
Boucher, François, 118, 180
Boughton, George, 36, 104
Bouguereau, William, 164
Bourgeois, Stephen, 46
Bredius, Abraham, 219–220
Breton, Jules, 164, 191
Bridge, The (Maris), 245–246
Bronzino, Agnolo, 13, 203, 234, 237–238, 242, 251
Brown, Henry Kirke, 22
Bruegel (Pieter), 7
Bryant, William Cullen, 16
Bull Fight, The (Manet), 245–246
Burial of the Count of Orgaz (El Greco), 116
Burlington Magazine, 94, 175, 264
Burton, Frederick, 26, 28–29, 31, 97–98
Byers, Alexander, 146

Cabbage Gatherers, The (Pissarro), 123
Caravaggio (Michelangelo Merisi), 7, 13
Carfax gallery, 219, 222
Carlisle, Earl of, 70, 78, 162
Carnegie, Andrew, 146, 148–160, 164, 171–172, 215
Carnegie Institute, Pittsburgh, 164
Carstairs, Carroll, 264
Carstairs, Charles, 233–234; appearance and personality of, 162–163, 167–169; competes with Duveen, 199, 209, 211; Frick and, 6, 163, 167–170, 173–181, 184–185, 187–196, 205–207, 213, 217–218,

222, 224–227, 229–230, 235–238,
244–245, 248, 251–252, 258, 264;
Gutekunst and, 177–178, 180–181, 183,
185–186, 188, 190, 204–205, 223–229,
234, 238, 244, 252; Knoedler and,
167–168, 170, 176, 184–194, 231–232, 247;
World War I and, 242, 248
Cassatt, Alexander, 117, 120, 133
Cassatt, Mary, 1, 142, 241; advises
Havemeyers, 109, 111–112, 114–119, 123,
130, 136–138, 140; art by, 112, 120–123,
130, 133, 263; art training of, 19, 110, 120;
artistic tastes of, 117–118; childhood of,
119–120; Durand-Ruel and, 132–133,
135–139; friendship with L. Havemeyer,
109, 121–123, 142; I. S. Gardner and,
124–125; Impressionist art and, 112, 117;
travels to Spain, 110, 131
Cassatt, Robert, 119–120
Catherine the Great, 160
Catholic Church, 13, 114
Cattaneo, Marchesa Elena Grimaldi,
204–207
Cattaneo, Marchesa Giovanna, 206
Cavalcaselle, Giovanni Battista, 62
Cavendish, William: *see* Devonshire, 5th
Duke of
Cazin, Jean-Charles, 164
Cellini, Benvenuto, 90, 92
Central Italian Painters of the Renaissance
(Berenson), 66
Cesnola, Luigi P. di, 41, 43, 126
Cézanne, Paul, 110, 112, 130, 182, 243
Charles I, 13, 33, 77
Charlotte, Lady Milnes (Romney), 211
Chase, William Merritt, 19
Chicago Art Institute, 142
Chigi, Agostino, 99
Choate, Joseph C., 17, 41
Christ Before Pilate (van Leyden), 35
Christ Carrying the Cross (El Greco), 115,
130
Christ in the Storm on the Sea of Galilee
(Rembrandt), 82, 261
Christie, James, 26–27
Christie's, 4, 26–27, 102, 233, 236–237
Christina of Denmark, Duchess of Milan
(Holbein), 216–218
Christus, Petrus, 41, 42
Church, Frederick, 25, 51
Clifton, Arthur, 219
Clinton-Hope, Francis Pelham, 82

Clovio, Giulio, 114
Cole, Thomas, 25
Collector, The, 40
Colman, Samuel, 25, 113
Colnaghi (P. & D. Colnaghi), London, 67,
69, 224, 234–235, 261; B. Berenson and,
84–85, 178; Frick and, 161, 170–171;
Gutekunst and, 71–72, 242; Hermitage
sale and, 259; history of, 67, 69;
Holbein's *Christina of Denmark* and,
217–218; I. S. Gardner and, 81, 84–88;
Ilchester Rembrandt and, 181, 185–187,
190–191; Titian's *Europa* and, 74–75, 77,
175; van Dyck's Cattaneo portraits and,
204–205
Colnaghi, Dominic, 69
Colnaghi, Paul, 69
Cologne: Arrival of a Packet Boat: Evening
(Turner), 235, 244
Colonna Madonna (Raphael), 93–94, 205,
226, 249, 266
Concert, The (Vermeer), 46, 261
Constable, John, 264
Cook, Herbert, 182
Corner of the Loge, A (Cassatt), 120–121
Corot, Jean-Baptiste-Camille, 112, 130,
162, 164–165
Corsham Court, England, 11–15, 26,
28–29, 32, 35, 266
Cossio, Manuel B., 116, 135, 138, 140
Costelloe, Frank, 65, 67
Costelloe, Mary Smith, 64
Count-Duke of Olivares (Velázquez), 230
Counter-Reformation, 114
Courbet, Gustave, 25, 111, 125
Couture, Thomas, 120
Cowper, Earl of, 100
Cox, Kenyon, 25, 160
Creelman, Alice, 247–248
Crivelli, Carlo, 81, 208
Cromwell, Thomas, 235–237
Crowe, Joseph Arthur, 62
Curtis family, 55
Cuyp, Aelbert, 173, 202, 233

Daisy Miller (James), 52
Dancers (The Rehearsal) (Degas), 245–246
Dante Society, 54
Darnley, 4th Earl of, 72, 74–75, 77
David and Abigail (Ruben), 28
David, Gerard, 234, 251
David, Jacques-Louis, 16

de Hooch, Pieter, 202
Death of Lucretia, The (Botticelli's *The Tragedy of Lucretia*), 45, 47, 57
decorative arts, 200–203, 209, 249–250
Degas, Edgar, 110–112, 117, 120–123, 130, 245–246
Delmé, Lady Elizabeth, 105–106
Denbigh, Earl of, 246
Denon, Dominique Vivant, 18
Deposition (David, G.), 234, 251
Deprez, Edmond, 68, 170, 179–180, 186–187, 190, 205
Derby, Earl of, 102, 107
Desborough, Lady Ethel, 228
Deschamps, Charles, 12, 18, 29–31, 34–37
Devonshire, 5th Duke of, 101
Devonshire, Duchess of (Georgiana Spencer), 101–102
Divine Comedy, The (Dante), 54
Don Balthasar Carlos with a Dwarf (Velázquez), 70
Doña Narcisa Barañana de Goicoechea (Goya), 137
Donatello (Donato di Niccolodi Betto Bardi), 208
Dordrecht: Sunrise (Cuyp), 173
Douglas, R. Langton, 234
Drawbridge, The (Monet), 123
Drawings of the Florentine Painters (Berenson), 66
Driver, Sarah Anne, 234
Duccio di Buoninsegna, 4
Dunn, James Hamet, 234, 237–238, 244–245
Durand, Asher B., 13
Durand-Ruel, Charles, 134
Durand-Ruel, Joseph, 134, 139
Durand-Ruel, Paul, 111–112, 118, 131–143
Dürer, Albrecht, 7, 43, 86
Duret, Theodore, 131, 141–142
Dutch painting, 38–39, 46, 110, 125, 160, 173, 200, 203
Duveen, Benjamin, 207
Duveen Brothers, 200, 202, 228, 230, 251, 253
Duveen, Ernest, 5, 207–208
Duveen, Henry, 200–204, 207–210, 214, 217, 227, 242, 248
Duveen, Joel Joseph, 200
Duveen, Joseph, 6, 167, 199–202, 207–211, 249–250, 253–255, 263
Duveen, Louis, 207–208
Duveen, Rosetta Barnett, 200

Eakins, Thomas, 19
Ecole des Beaux-Arts, Paris, 19
Edward VII, 108
Elder, Adaline, 121
Elder, Anne, 121
Elder, George (the elder), 121
Elder, George (the younger), 121
Elder, J. Lawrence, 124, 127
Elder, Louisine Waldron, 3; *see also* Havemeyer, Louisine
Elder, Mary Louise, 124
Elder, Mathilda Waldron, 121
Elena Grimaldi (van Dyck), see *Marchesa Elena Grimaldi Cattaneo* (van Dyck)
Elizabeth Farren (Lawrence), 107–108, 249, 262, 266
Elizabeth, Lady Taylor (Reynolds), 211
Elkins, William L., 206
England, 19, 34, 257; American artists in, 30–31; American collectors and, 3; auctions in, 199; country estates of, 26–28, 78; Old Masters lost to America, 218–219; private art collections and, 13, 15, 26–29, 80, 233, 235; taxes and, 216
English portraits, 103–108, 125, 145, 168–169, 173–175, 199, 211, 246–247, 249, 263
Europa (Titian), 72–77, 79–81, 85, 90, 92, 104

Farren, Elizabeth, 107–108
Feast of the Gods, The (Bellini and Titian), 6, 78, 253–259
Fenway Court: *see* Isabella Stewart Gardner Museum, Boston
Ferdinand, Archduke Franz, 236
Ferdinand I, king of Naples and the two Sicilies, 97
Filippo Cattaneo (van Dyck), 206
Fiorenza di Lorenzo, 86–87
Florentine Painters of the Renaissance (Berenson), 66
Forge, The (Goya), 245–246
Fortnightly Review, 63
Forum, 150
Fourment, Suzanne, 174
Fowles, Edward, 200–202
Fox-Strangways, Giles, 180–183; *see also* Ilchester, 6th Earl of
Fox-Strangways, Henry (5th Earl of Ilchester), 181
Fragonard, Jean-Honoré, 118, 249–250

Franco-Prussian War, 18, 97, 120
Fray Hortensio Félix Paravicino (El Greco), 138–140
Frederick-William II, 16
French Revolution, 3, 27, 120, 242
Frick, Adelaide Childs, 153–154, 156–157, 159, 165, 168, 176, 222, 231, 247, 249, 258, 263
Frick Collection, The, New York, 263–264; *see also* Frick, Henry Clay
Frick, Helen Clay, 148, 156, 166, 173
Frick, Henry Clay, 3, 6–7, 87; appearance and personality of, 146–148, 153–154, 158–159, 168, 188, 243; as art collector, 145–146, 152, 174, 176, 177–178, 195–196, 234–238, 244–245, 249, 258; artistic tastes of, 173, 185, 195, 243, 249; business interests of, 145–146, 148–159, 171–172, 206, 215, 238, 245–246; Andrew Carnegie and, 146, 148–160, 171–172; Carstairs and, 163, 167–171, 173–181, 183, 185, 235–238, 244–245, 248, 251–252, 258; collecting ambitions of, 213–214, 225; decorative art and, 209, 250; Dutch paintings and, 224–227, 229; Duveens and, 201–202, 209–211, 222, 250; English portraits and, 246–247, 249; erects picture gallery, 243–245; extravagance of, 149, 156, 173, 196; family of, 153–154, 156, 158; French paintings and, 164, 246; Roger Fry and, 219–220, 222; Gutekunst and, 175, 177–181; Knoedler and, 163–167, 174, 176–177, 185, 223, 225, 251; loans to museums, 168, 182, 194; mansions of, 149, 156, 162, 172–173, 175–177, 189, 196, 213, 243–245; J. P. Morgan and, 150, 249–250; Old Masters and, 159–162, 168–170, 173–180, 185, 188, 196, 205–207, 209–211, 216–217, 230, 248, 250–251; Prides Crossing mansion, 209, 222, 224–225, 243–244; Rembrandt's *The Polish Rider* and, 219–222; Rembrandt's *Portrait of a Young Artist* and, 159, 161–162, 170; Rembrandt's *Self-Portrait* (1658) and, 180–194, 213; travels abroad, 145, 151, 153–154, 159, 163–164, 168, 231, 235; World War I and, 243, 245–246
Frick, Martha, 156
Fry, Roger, 1–2, 18, 43, 175, 178, 182–183, 185–187, 191, 195, 213, 217, 219–222, 229

Gainsborough, Thomas, 27, 33, 72, 101–105, 107, 174–175, 211, 234, 246, 259, 263
Gardner, Eliza, 50
Gardner, Isabella Stewart, 3, 6–7, 110, 170, 256–257; appearance and personality of, 47–52, 55, 58, 124–125, 150; as art collector, 46, 54, 68, 71–73, 88–89, 181, 185, 189, 195, 202; B. Berenson and, 45, 47, 49, 57–62, 64, 67–68, 71, 76–78, 86, 88–89, 97–98, 205–206, 210, 255–256; Boston homes of, 47–51, 54, 79; Colnaghi and, 81, 86–88; Dutch paintings and, 46, 161, 174; Fenway Court; *see* Gardner, Isabella Stewart, museum of; finances of, 56, 80–81, 83–84, 88; Gutekunst and, 68, 71–73, 105; Henry James and, 52–53, 55–56, 79–80, 92; museum of, 50, 71, 78–80, 83, 89–92, 95, 261–262; Old Masters and, 56–57, 59, 67–68, 76, 78–82, 85–86, 89–90, 255–257; photographs of, *48, 56, 91, 256*; portraits of, 49–50, 53–55, 61, 90, 261, *265*; travels of, 49–50, 52, 54–55, 57, 59, 79, 84; Venice home of, 55–56, 90
Gardner, John Lowell "Jack," 46, 48–52, 54–57, 79, 81–83, 85
Gardner, John Lowell, 50
Gardner, Joseph (the elder), 52
Gardner, Joseph (the younger), 52
Gardner, Julia, 50–51
Gare Saint-Lazare (Manet), 112
Garland, James A., 95
Gauguin, Paul, 243
Gentleman of the House of Leiva (El Greco), 143
Gentleman with a Tall Hat and Gloves, A (Rembrandt), 161, 179
George, David Lloyd, 218–219
George III, 102, 106–107
George IV, 69
Georgiana, Duchess of Devonshire (Gainsborough), 101–105, 107
Germany, 41, 63–64
Gérôme, Jean-Léon, 120
Gerrity, Thomas, 176
Ghirlandaio, Domenico, 202
Gimpel, René, 166, 200, 223, 243, 249
Giorgione, 67, 74, 80, 208
Giotto, 47
Giovanna Tornabuoni (Ghirlandaio) 202

Girl Interrupted at Her Music (Vermeer), 173–174, 225
Girl Reading a Letter at an Open Window (Vermeer), 38
Girl with a Flute (Vermeer), 226
Glaenzer, Eugene, 138, 141–142
Glass of Wine, The (Vermeer), 82
Golden Bowl, The (James), 53
Gospel of Wealth (Carnegie), 155
Gosse, Edmund, 218
Goupil & Cie gallery, 166
Goya, Francisco, 109, 111, 116, 118, 131, 137–138, 173, 242, 244–246, 263
Grand Tour, 26
Greco, El (Domenikos Theotokopoulos), 32, 109–111, 114–116, 119, 132, 134–144, 173, 175–176, 193, 235, 244, 263, 266
Grenfell, Arthur Morton, 233–234, 236–237, 244, 250–252
Groot, Cornelis Hofstede de, 160, 223
Grueze, Jean-Baptiste, 159
Guinness, Edward Cecil, 105
Gutekunst, Heinrich, 68
Gutekunst, Lena Obach, 70
Gutekunst, Otto, 89, 167–168, 242; appearance and personality of, 68–70, 87, 88; as art dealer, 70–88, 145–146, 170–171, 177–181, 183, 185–186, 188, 190–192, 217–218, 223–229, 261; B. Berenson and, 67–71, 75–77, 81, 83–86, 264; Carstairs and, 223, 234, 238, 244, 252; competes with Duveen, 199, 209; expertise of, 68–69, 86; Frick and, 175, 252; I. S. Gardner and, 71–73, 80, 86, 105; Kann collection and, 204–205

Hadley, Rollin van N., 90
Hainauer Collection, 207
Hals, Frans, 19, 39, 42, 44, 173, 194, 203, 211, 214, 233
Hamilton, Carl, 258
Hamilton, Duke of, 28
Hamilton, Emma, 174
Harbor of Dieppe, The (Turner), 244–245
Harmony in Blue and Silver: Trouville 1865 (Whistler), 53
Harmony in Pink and Grey: Portrait of Lady Meux (Whistler), 246
Harnisch, Arthur, 118
Harper's Monthly, 23, 40
Harvard Center for Italian Renaissance Studies, 264

Haseltine, Charles, 167
Haseltine, Esther, 167
Hastings, Thomas, 243
Havemeyer, Adaline, 124
Havemeyer, Electra, 124, 143
Havemeyer, Frederick Christian, 127–128
Havemeyer, George, 127
Havemeyer, Harry O., 3, 143; appearance and personality of, *111*, 113, 126, 128; art collection of, 173; Cassatt advises, 109, 111–112, 130–132, 136–138, 140; Durand-Ruel and, 132, 134–140; homes of, 113, 124, 127; Impressionist art and, 111–112, 130; Old Masters and, 114–119, 125–127, 130–132, 137, 140; sugar trade and, 127–130; travels abroad, 109–110, 115–116, 118–119, 130
Havemeyer, Horace, 124, 263
Havemeyer, Louisine, 142–143, 241, 263; appearance and personality of, 111–113; as art collector, 124–125, 143–144, 173; Cassatt and, 111–112, 115–119, 121–125, 130–132, 136–138; Impressionist art and, 112–113, 121–123, 130; *see also* Havemeyer, Harry O.
Havemeyer, Theodore, 127–129
Havemeyer, Thomas, 127
Hawthorne, Nathaniel, 1
Hayes, Rutherford B., 17
Heart of the Andes (Church), 51
Henry E. Huntington Library, 7
Henry VIII, 216, 235, 247
Henschel, Charles, 234, 259, 264
Herman Doomer (Rembrandt), 125–126, 266
Hermitage Museum, Leningrad, 259
Higginson, Henry Lee, 51
History of Painting in North Italy, A (Cavalcaselle), 62
Hobbema, Meyndert, 39, 173, 202
Hogarth, William, 234
Holbein, Hans, 7, 68, 81, 83–84, 86–88, 216–219, 235–237, 247–248
Holford, George, 233
Holmes, Charles J., 71, 257–258
Holroyd, Charles, 216–218, 226, 242, 244–245
Holy Family (Titian), 98
Hon. Frances Duncombe, The (Gainsborough), 211
Hon. Lucy Byng, The (Hoppner), 169
Honorable Henry Fane and His Guardians, Inigo Jones and Charles Blair, The (Reynolds), 107

Hooper, Edward William, 79
Hoppner, John, 169, 199
Horne, Herbert P., 181–183
Hudson River School, 25
Hunt, Richard Howland, 43
Hunt, Richard Morris, 16, 19, 25, 42–43,
 265–266
Huntington, Arabella, 6, 199, 202, 213,
 230, 263
Huntington, Archer, 199
Huntington, Henry, 263
Hutchinson, Charles L., 142

Ilchester, 1st Earl of (Stephen Fox), 183
Ilchester, 6th Earl of, 180, 182–183,
 185–186; *see also* Fox-Strangways, Giles
Ilchester Rembrandt: *see Self-Portrait*
 (1658) (Rembrandt)
Impressionist art, 25, 109, 111–112,
 117–118, 120–121, 132–134, 263
Isabella Stewart Gardner Museum,
 Boston, 89–92, 261–263; *see also*
 Gardner, Isabella Stewart, museum of
Italian Renaissance, 3–4, 7, 18, 35, 43, 47,
 61–63, 74, 86, 93, 98, 114, 261
Italy, 3, 5, 17, 26, 38–39

James, Henry, 1, 15, 22, 27–28, 31, 37, 49,
 51–53, 55–56, 79–80, 92, 218, 241–242
*James Stuart, Duke of Richmond and
 Lennox* (van Dyck), 12, 31–37, 39,
 42–44, 266
Jameson, Anna, 27
Jan Six (Rembrandt), 190
Johnson, Eastman, 25
Johnson, John G., 129, 171, 206
Johnson, Samuel, 106
Johnston, John T., 16, 41
Julia, Lady Peel (Lawrence), 174

Kaiser-Friedrich Museum, 82
Kann collection, 200, 202–204, 207, 215, 249
Kann, Maurice, 200
Kann, Rodolphe, 200, 202, 207; *see also*
 Kann collection
Kensett, John, 16
King Philip IV of Spain (Velázquez), 80,
 227–230
Knight, Daniel Ridgway, 163
Knoedler, Michael, 166
Knoedler, Roland, 194, 211; Carstairs and,
 167, 205, 209, 226, 235, 264; Frick and,

 163–167, 170–171, 176–177, 193,
 222–226, 235, 244; galleries of, 167, 223;
 Ilchester Rembrandt and, 180–181,
 185–192; *see also* M. Knoedler & Co.

La Farge, John, 25
Lady Elizabeth Delmé and Her Children
 (Reynolds), 105–106, 249, 262–263
Lady Hamilton (as "Nature") (Romney),
 174
Lady Harcourt (Reynolds), 188, 192
Lady Margaret Butts (Holbein), 83–84
Lady with an Ostrich-Feather Fan, A
 (Rembrandt), 161, 179
Lady Writing, A (Vermeer), 44, 263
Laffan, William, 142
Lamentation (Christus), 42
Lamentation (van Eyck), 40–41
Landscape (van Ruisdael), 40, 42
Landscape with an Obelisk (Rembrandt),
 85, 261
Lane, Hugh, 235–237, 247–248
Lansdowne, Lord, 80–81, 226
Last Gleanings, The (Breton), 164, 191
Lawrence, Thomas, 107–108, 174–175,
 249, 262, 266
Lefort, Paul, 115
Leighton, Sir Frederick, 36
Leonardo da Vinci, 4, 40–41, 93, 230
Lippi, Filippino, 47, 71, 208
Lippi, Fra Filippo, 42, 208–209, 262
Little Note in Yellow and Gold, The
 (Whistler), 53
Lives of the Artists (Vasari), 253
Loeser, Charles, 60
London, England, 4, 6, 26–27, 69, 101,
 103–104, 200, 242, 257
Lorenzo Lotto (Berenson), 65–66
Louis Philippe, duc d'Orléans, 74
Louvre Museum, Paris, 15–18, 38, 43, 117,
 120, 138–139

M. Knoedler & Co., 166, 174, 264;
 branches of, 168, 179, 223; deals in Old
 Masters, 170, 186, 218, 229, 244,
 249–250, 258–259; financial troubles of,
 188, 192, 247; Frick and, 163, 222,
 251–252; private collectors and,
 233–234; World War I and, 242; *see also*
 Knoedler, Roland
Madame X (Sargent), 31, 37, 49
Maddalena Cattaneo (van Dyck), 206

Madonna and Child (Duccio), 4

Madonna and Child with Saint Martina and Saint Agnes (El Greco), 143

Madonna (Bellini), 208

Madonna (Leonardo), 40–41

Madonnas (Raphael), 4, 6, 93, 106

Madrazo, Ricardo de, 136, 139–141, 143

Maid Asleep, A (Vermeer), 200, 202

Majas on the Balcony (Goya), 116, 137

Man in Black (Moroni), 59

Man with a Steel Gorget (Rembrandt), 203

Manchester, England, 27, 104

"Manet and the Post-Impressionists" exhibition, 182

Manet, Edouard, 25, 110–112, 130, 134, 137, 182, 245–246

Mannerist paintings, 114–115, 175, 203

Manzi, Michel, 110

Marchesa Elena Grimaldi Cattaneo (van Dyck), 204–207

Maris, Jacobus Hendrikus, 245–246

Malborough, Duke of, 28–29

Marquand, Allan, 40, 41

Marquand Bros., 20–21

Marquand, Elizabeth Allen, 23, 36–37, 41, 49

Marquand, Frederick, 20–22, 40

Marquand, Henry Gurdon, 25, 110–111; appearance and personality of, 12, 21–22, 24, 42; as art collector, 12, 16, 19, 25, 30, 32, 34, 36–37, 39–40, 76, 173; background of, 20, 23; business interests of, 12–13, 19–23; Corsham Court and, 11–15, 32; donates art, 17, 39–40, 42; English portraits and, 32–37, 104; Metropolitan Museum of Art and, 3, 12–14, 16–19, 24, 34, 39–43, 76, 126, 266; Old Masters and, 17–20, 25, 46, 161, 182, 215; supports American artists, 13, 23, 25; trips abroad, 22–23, 37

Marquand, Isaac, 20–21

Marquand, Josiah, 22

Marquise de Blaizel (Lawrence), 175

Masaccio, 35–36, 40, 42

Matador, A (Manet), 112

Mauritshuis, The Hague, 219

Mayer, Gustave, 242, 259

McKay, William, 69, 170–171, 204

Mellon, Andrew, 152–153, 170, 258–259, 263

Mellon, Thomas, 152–153

Memling, Hans, 202

Menzies, Frederick, 244–245, 250

Methuen art collection, 11–15, 26–29, 32, 35

Methuen, Frederick Henry Paul, 26, 28–32

Methuen, Sir Paul, 11, 26, 28, 35

Metropolitan Museum of Art, New York: building of, 40, 42–43, *44*, 265–266; *Bulletin* by, 194; collections of, 4, 14–18, 39–44; donations to, 107, 263; history of, 12, 14–18, 21, 24, 41–43; Marquand and, 12–14, 42–43, 76, 95; Morgan's collection and, 232, 248–249, 262; Old Masters and, 7, 42, 141–142, 266; Roger Fry and, 1–2, 181–183, 186–187

Metsu, Gabriel, 200, 202, 249

Michelangelo, 43, 74, 106, 114, 194

Mill, The (Rembrandt), 4, 80–81, 226–227, 230

Millet, Frank, 30–31, 34

Millet, Jean-François, 130

Miss Manners (Hoppner), 199

Miss Mary Edwards (Hogarth), 234

Miss Mary Finch Hatton (Romney), 169

Miss Puyeau (Reynolds), 169

Mlle. V . . . In the Costume of an Espada (Manet), 112

Monet, Claude, 112, 123, 132–133

Montesquiou-Fezensac, Robert de, 246–247

Moore, William, 151, 159

Morelli, Giovanni, 63

Morgan, Frances Louisa Tracy, 99

Morgan, J. Pierpont, 231–232; appearance and personality of, *94*, 99–100, 150; as art collector, 3, 6–7, 93, 96, 98, 100, 110–111, 173, 194, 196, 205, 213, 225–226; artistic tastes of, 95–96; business interests of, 93–94, 98, 100–101, 172, 206; collections of, 93, 99, 215, 232, 264; Colonna Madonna and, 96–100; decorative art and, 95–96, 249–250; English portraits and, 101–108; homes of, 96, 99–100, 105–106, 108; Ilchester Rembrandt and, 185–187; Kann collection and, 202–204; library of, 99–100, 173, 243; Metropolitan Museum of Art and, 41, 95, 142, 183, 194, 219, 248–249; Old Masters and, 93, 95–96, 105, 183

Morgan, Jack, 232, 248–249, 261–262

Morgan, Junius Spencer, 94, 100–102, 104, 107

Morgan Library, 261–262; *see also* Morgan, J. Pierpont, library of

Morisot, Berthe, 168

Moroni, Count, 59

Mother and Child (Cassatt), 263

Mrs. James Cruikshank (Raeburn), 176

Mrs. Peter William Baker (Gainsborough), 246

Mrs. Siddons as the Tragic Muse (Reynolds), 72

Murray, Charles Fairfax, 95

Museum of Fine Arts, Boston, 7, 70, 75–76, 139

Music Lesson, The (ter Borch), 82

Music Lesson, The (Vermeer), 38

Napoleon, 16–17, 27, 216, 242

National Academy of Design, New York, 133

National Art Collection Fund, England: *see* Art Fund, England

National Gallery, London: founding and building of, 16, 29; funds raised for, 217–218; Old Masters and, 28–29, 46, 205–206, 244–245; Raphaels and, 93, 97–99; Rembrandt's *The Mill* and, 227; World War I and, 242, 257.

National Gallery of Art, Washington D.C., 7, 259, 263

National Portrait Gallery, London, 71

Nattier, Jean-Marc, 98, 159

Negroli, Filippo, 95

Netherlands, the, 17, 19, 38–39

New York Herald, 100

New York, New York: architecture of, 16–17, 19–20, 25, 44; as art center, 16, 23–24, 172, 232; art exhibitions in, 133–134, 243, 248–249; as capital of finance, 21–22, 101, 172, 232; major art collections in, 173, 203; Metropolitan Museum of Art and, 14, 266; *see also* Metropolitan Museum of Art, New York; nineteenth-century life in, 21, 203

New York Stock Exchange, 22–23, 259

New York Times, 15, 100, 125, 127, 196

New York Tribune, 128, 194

Nicolaes Ruts (Rembrandt), 95, 105, 264

Noble Slav, The (Rembrandt's *Man in Oriental Costume*), 28

Nocturne in Blue and Silver (Whistler), 53

Norfolk, Duke of, 216–217

Northern Renaissance, 80

Northumberland, Duke of, 253, 255

Norton, Charles Eliot, 54, 57, 60

Officer and Laughing Girl (Vermeer), 225

Old Masters: attributions of, 31–32, 63, 86–87; England stripped of, 216–217; exhibitions of, 104, 218, 248; Gilded Age and, 230; market for, 34–35, 69, 104, 162, 170, 179, 203–204, 214–215, 225–226; market decline of, 232–234, 237; record prices of, 93, 100, 102, 202, 215, 226, 230, 259; scholarly knowledge of, 41; smuggling of, 205; taste for, 93, 125; value of, 4, 6, 29, 31–32, 34–35, 39, 41, 45–46, 69, 181, 190

Old Woman Cutting Her Nails (Rembrandt), 202

Ottaviano Canevari (van Dyck), 175–176

Overholt, Abraham, 152

P. & D. Colnaghi, London: *see* Colnaghi (P. & D. Colnaghi), London

painters, 3–4, 30, 120

Palazzo Barbaro (Venice), 55–56, 90, 262

Paola Adorno (van Dyck's *Portrait of a Genoese Noblewoman*), 246

Paredes de Nava, Count of, 134, 137–138, 140

Paris, France, 3, 6, 17–19, 27, 37, 109, 117, 132

Paris Salon, 120

Patinir, Joachim, 130

Payne, Oliver, 117–118

Peacock Room (Whistler), 54

Peel, Lady, 174

Pennsylvania Academy of the Fine Arts, 120

Perugino, 208

Philadelphia Museum of Art, 7

Philadelphia, Pennsylvania, 119–120

Philip II, 73–74, 77

Philip IV, 77, 227

Philip IV (Velázquez), 244

Phipps, Henry, 151, 154, 159

photography, 63

Pietà (Raphael), 85

Pietro Aretino (Titian), 175–177, 182, 193

Pilate Washing His Hands (Rembrandt), 202

Pinturicchio (Bernardino di Betto), 208

Pissarro, Camille, 123, 132–133, 168

Pittsburgh, Pennsylvania, 145–146, 152, 159–160, 164, 167, 185

Polish Rider, The (Rembrandt), 161, 219–222

Pollaiuolo, Antonio del, 209–210

Pond, The (Corot), 164

Portrait of a Cardinal (El Greco), 116,
131–132, 134–141, 173
*Portrait of a Lady and a Gentleman in
Black* (Rembrandt), 82, 261
Portrait of a Lady, The (James), 53
*Portrait of a Man and a Woman at a
Casement* (Fra Filippo Lippi), 42
Portrait of a Man (Hals), 42
Portrait of a Man in a Fur Coat (Dürer), 86
Portrait of a Man in a Red Cap (Titian),
233, 237, 247–248, 250
Portrait of a Man (Rembrandt), 19, 161
Portrait of a Man (Rubens), 35
Portrait of a Man (Tintoretto), 72
Portrait of a Medici Prince (Bronzino's
Lodovico Capponi), 234
Portrait of a Woman and Child (van Dyck),
105
Portrait of a Woman with a Rose (van
Dyck), 81
Portrait of a Young Artist (Rembrandt),
78–79, 145–146, 159–162, 170
Portrait of a Young Man (Andrea del
Castagno), 6–7, 202, 263
Portrait of an Elderly Gentleman (El
Greco), 115
Portrait of an Elderly Gentleman (Hals), 211
*Portrait of Thomas Howard, 2nd Earl of
Arundel* (Rubens), 81
portraits, 34, 39, 103
Poussin, Nicolas, 7
Prado (Museo Nacional del Prado),
Madrid, 16, 110, 115, 131–132, 134,
136–138
Primavera (Botticelli), 253
prints, 121, 166
Progress of Love, The (Fragonard), 249–250
Pujo, Arsene, 232
Purification of the Temple (El Greco),
114–115

Raeburn, Henry, 176
railroads, 20, 23
Raphael (Raffaello Sanzio), 43, 68, 259;
Ansidei Madonna by, 29, 93, 97–98, 102;
Colonna Madonna by, 96–100, 249, 266;
Madonnas by, 4, 106; *Pietà* by, 85; *The
Small Cowper Madonna* by, 228, 230,
259; *Tommaso Inghirami* by, 81–82, 92
Reading from Homer (Alma-Tadema), 42
Rembrandt van Rijn, 32, 37, 39, 69, 87,
203; American collectors and, 6, 47, 58,
125–127, 137, 173, 233; *Aristotle with the
Bust of Homer* by, 200, 202; art market
and, 4, 72, 167, 169–170; attributions of,
85, 92; catalogue raisonné of, 266; *Christ
in the Storm on the Sea of Galilee* by, 82,
261; exhibitions of, 160–161, 179,
219–220; Ilchester *Self-Portrait* (1658)
by, 180–194; *The Mill* by, 4, 80–81,
226–227; in museum collections, 259,
263, 266; *Nicolaes Ruts* by, 95, 105, 264;
Noble Slav by, 28; *The Polish Rider* by,
219–222; *Portrait of a Young Artist* by,
78–79, 145–146, 159–162; portraits by,
19, 72, 82, 125, 132, 146, 179, 227, 261;
Self-Portrait (1629) by, 72; *see also*
individual works by
Reynolds, Sir Joshua, 33, 72, 102, 105–107,
169, 175–176, 188, 192, 210–211, 249,
259, 262–263
Rhinelander, Frederick, 141–142
Richmond, Duke of, 34
Richter, Jean Paul, 68
Rijksmuseum, Amsterdam, 16
Robert, Fernand, 46
Robinson, Edward, 43, 139, 232, 249
Robinson, Thomas, 177, 225, 229, 234
Roderick Hudson (James), 22, 52
Rodin, Auguste, 37
Rokeby Venus (Velázquez's *Toilet of
Venus*), 217
Romney, George, 33, 105, 169, 174, 211
Rosa, Salvator, 13
Rothschild, Ferdinand de, 102
Rouart, Henri, 110
Royal Academy of Arts, London, 36–37,
72, 106, 108, 234
Rubens, Peter Paul, 7, 13–14, 28, 31–32, 35,
81, 98, 174, 213, 219, 222, 241, 266
Ruskin, John, 53
Ruysdael, Solomon, 202

Sacred and Profane Love (Titian), 81
Saint Dominic in Prayer (El Greco), 110
Saint Ferdinand (Goya), 138
Saint George Slaying the Dragon (Crivelli),
81
Saint Ildefonso (El Greco), 110, 143
*Saint Lawrence Enthroned with Saints and
Donors* (Lippi), 262
Saint Martin and the Beggar (El Greco), 143
Salmon (Manet), 134
Santayana, George, 60

Sarah, Lady Innes (Gainsborough), 234

Sargent, John Singer, 19, 30–31, 34, 36–37, 42, 49–50, 54–55, 61, 91, 139, 235, 261, 265

Sartain, Emily, 121

Satterlee, Herbert L., 100, 108

Satterlee, Louisa, 262–263

Schaus, William, 125

Schwab, Charles M., 148, 171, 195

Scott & Fowles, New York, 189, 229

Sears, Willard, 83

Sedelmeyer, Charles, 93, 98, 100, 223

Ségur-Périer, Countess de, 223

Self-Portrait (Rembrandt; 1629), 72

Self-Portrait (Rembrandt; 1658), 180–194, 213

Seligmann, Jacques, 202, 223

Selina, Lady Skipwith (Reynolds), 188

Shaw, George Bernard, 216–217

Shaw, Quincy Adams, 79

Sir John Suckling (van Dyck), 246

Sir Thomas More (Holbein), 235

Sir William Butts (Holbein), 83–84

Sisley, Alfred, 112, 133

Sixteen to Sixty: Memoirs of a Collector (Havemeyer, L.), 124

Small Cowper Madonna, The (Raphael), 228, 230, 259

Smith, H. Herbert, 29, 35

Smith, Logan Pearsall, 60, 64

Sotheby's, 27

Spain, 16–17, 19, 38–39, 109–110, 135, 143

Spencer, Georgiana: *see* Devonshire, Duchess of

St. Botolph Club, Boston, 49

St. Francis in the Desert (Bellini), 233–235, 244, 247, 250

St. Jerome (El Greco), 115, 143, 175, 193, 244

Stedelijk Museum, Amsterdam, 146

Stewart, Adelia Smith, 50

Stewart, David, 50

Stillman, James, duke of Richmond and Lennox, 117–118

Stuart, Gilbert, 126

Stuart, James, 33

Sulley, Arthur J., 223, 227, 255, 257–258

Sunflowers (van Gogh), 4

Symphony in Flesh Colour and Pink: Portrait of Mrs. Frances Leyland (Whistler), 246–247

Tarnowski, Count Zadislas, 219–221

Taunton, Lord, 235

Taylor, Lady Elizabeth, 210

Tempest, The (Giorgione), 80

ter Borch, Gerard, 82, 86, 200, 249

Thackeray, William Makepeace, 69

Thole, Henry, 193

Thomas Cromwell (Holbein), 235–237, 247–248

Thoré, Théophile, 27, 38–39, 45–46, 218

Tiepolo, Giovanni Battista, 266

Tiffany, Louis Comfort, 113, 263

Times (London), 40, 161, 179, 217

Tintoretto, Jacopo, 47, 58, 71–72, 114, 208

Titian (Tiziano Vecellio), 114, 208; attributions of, 62, 66, 86; *Europa* by, 72–77, 79–81, 90, 92; *The Feast of the Gods* by, 253, 257, 259; *Holy Family* by, 98; *Pietro Aretino* by, 175–177, 182, 193; *Portrait of a Man in a Red Cap* by, 233, 237, 247–248, 250; *Sacred and Profane Love* by, 81; style and reputation of, 74, 93

Titus (Rembrandt), 202

Tocqueville, Alexis de, 20

Toilet of Venus (Velázquez), 217

Toledo, Spain, 114, 116, 137, 143–144

Tommaso Inghirami (Raphael), 81–82, 92

Torre, Anthony, 69

Tracy, Frances Louisa: *see* Morgan, Frances Louisa Tracy

Trotti & Cie, Paris, 175, 193, 205

Turner, J. M. W., 192, 235, 244–245

Valentiner, Wilhelm, 161, 194, 206, 214, 224

Valvrojenski, Albert, 60

Valvrojenski, Judith M., 60

van der Weyden, Rogier, 3, 202

van Dyck, Anthony, 27, 67, 72, 180, 196; *Anne, Countess of Clanbrassil* by, 246; *The Betrayal of Christ,* by, 12–15, 31, 34; Cattaneo portraits by, 204–206, 215; collectors and, 29–37, 214, 233, 246, 259; *James Stuart* portrait by, 12–13, 31–37, 39, 42, 266; *Ottaviano Canevari* by, 175–176; *Paola Adorno* by, 246; *Portrait of a Woman and Child* by, 105; *Portrait of a Woman with a Rose* by, 81; *Sir John Suckling* by, 246; smuggling his works, 5

van Eyck, Jan, 3, 7, 40–41

van Gogh, Vincent, 4, 166, 243

van Goyen, Jan, 39

van Leyden, Lucas, 35



van Ruisdael, Jacob, 39, 40, 42
Vanderbilt, George, 173
Vanderbilt, William H., 172–173
Vanderbilt, William K., 25
Vanity Fair (Thackeray), 69
Vasari, Giorgio, 253
Vaux, Calvert, 16
Velázquez, Diego, 19, 43, 47, 67, 70–71, 80, 105, 110, 130, 217, 219, 227–230, 244
Venetian Painters of the Renaissance (Berenson), 45, 61–63, 65, 74
Venetian School of Painting, 62–63
Venice, Italy, 55–56
Vermeer, Johannes, 57, 178, 194, 219; *The Art of Painting* by, 81, 118; *The Concert* by, 46, 261; *Girl Interrupted at Her Music* by, 173–174, 225; *Girl with a Flute* by, 226; *The Glass of Wine* by, 82; *A Lady Writing* by, 44; *Maid Asleep* by, 200, 202; in museum collections, 259, 263, 266; *Officer and Laughing Girl* by, 225; *Woman Holding a Balance* by, 223–225; *A Young Woman Standing at a Virginal* by, 46; *Young Woman with a Water Pitcher* by, 37–39, 42, 44
Veronese, Paolo, 13, 119, 130, 195, 244
View of Toledo (El Greco), 143–144
Villa I Tatti (Settignano, Italy), 65, 67, 208, 264
Village Among Trees (Hobbema), 173
Ville D'Avray (Corot), 164
Vincenzo Anastagi (El Greco), 235
Virgin and Child with an Angel (Botticelli), 81
Virtue and Vice (Veronese), 195
Visit to the Nursery, The (Metsu), 200, 249
Volpi, Elia, 70
von Bode, Wilhelm, 82, 178–179, 184; American collectors and, 64, 214, 222; as art expert, 40, 63, 69, 126–127, 204; *Europa* and, 74; Rembrandt catalogue by, 40, 72, 161, 185, 189, 220; Rembrandt retrospective and, 160–161; in U.S., 40–41, 91–92, 225

Wales, Prince of, 106
Wallace Museum, London, 205
Warren, Edward, 61
Warren, Samuel, 75

Warren, Susan Cornelia, 75–77
Washington, George, 126
Watteau, Jean-Antoine, 7, 118
Weir, J. Alden, 18–19
Wellington, Duke of, 131
Wertheimer, Asher, 82, 255, 258
Westminster, Duke of, 75–76
Wethey, Harold E., 115
Wharton, Edith, 173
Whistler, James McNeill, 19, 49, 53–54, 61, 79, 246–247
White Horse, The (Constable), 264
Whittredge, Worthington, 16
Wicht, Joseph, 130–132, 135–136
Wicht, "Pepita," 136–137
Widener, Eleanor Elkins, 231–232
Widener, George, 231
Widener, Harry Elkins, 231–232
Widener, Joseph, 206, 227, 257–259
Widener Library, Harvard University, 232
Widener, Peter A. B., 4, 206–207, 213–215, 224–225, 227–232, 243
Wildenstein, Nathan, 200, 202, 223
Wings of the Dove, The (James), 56
Wisdom and Strength (Veronese), 195
Wolf and Fox Hunt (Rubens), 13–14, 266
Woman Holding a Balance (Vermeer), 223–225
Woman with the Umbrella (van Dyck), 206
Woman's Portrait, A (Goya's *A Portrait of a Lady [Maria Martinez de Puga]*), 245
women artists and collectors, 120–121, 125
Woolf, Virginia, 182
World War I, 2–4, 241–242, 250–251
World War II, 264

Young Man and Woman in an Inn (Hals), 203
Young Woman at Her Toilet with a Maid (ter Borch), 200, 249
Young Woman Standing at a Virginal, A (Vermeer), 46
Young Woman with a Water Pitcher (Vermeer), 37–39, 42, 44, 266
Youssoupoff art collection, 161, 179, 185, 192

Zorn, Anders, 55

Grateful acknowledgment is made for permission to reprint excerpts from the following works:

The Letters of Bernard Berenson and Isabella Stewart Gardner, 1887–1924, with Correspondence by Mary Berenson, ed. Rollin van N. Hadley (Boston: Northeastern University Press, 1987) with permission of University Press of New England.

Correspondence in The Berenson Archive, Villa I Tatti, The Harvard University Center for Italian Renaissance Studies, Florence, Italy.

The correspondence of Mary Cassatt to Louisine Havemeyer, in The Metropolitan Museum of Art Archives, by permission of Robert Maguire, Shoreham, Vermont.

Correspondence in the P & D Colnaghi Archives by permission of Konrad O. Bernheimer, Chairman, P & D Colnaghi Ltd., London.

The correspondence of Paul Durand-Ruel, © Archives Durand-Ruel, Paris. La Société Durand-Ruel & Cie. Maintains all the rights to the citations [from their documents] in order to be able to use them as it wishes.

The Duveen Brothers Records, Research Library, The Getty Research Institute, Los Angeles, California (960015).

The Henry Clay Frick Art Collection Files and the Henry Clay Frick Papers, The Frick Collection/Frick Art Reference Library, New York.

The correspondence of Roger E. Fry and of Henry Gurdon Marquand in the Department of European Paintings, The Metropolitan Museum of Art, New York.

A letter from Isabella Stewart Gardner to Charles Eliot Norton, MS AM 1088 (2494), the Houghton Library, Harvard University, by permission of the Houghton Library, Harvard University.

Letters to Isabella Stewart Gardner from: Ralph Curtis, August 12, 1892; Henry Lee Higginson, May 28, 1919. Excerpts from John Lowell Gardner's diary, December 5, 1892; and an undated note by Isabella Stewart Gardner, Isabella Stewart Gardner Museum Archives, Boston, by permission of the Isabella Stewart Gardner Museum, Boston.

Correspondence of H. O. Havemeyer, Mary Cassatt, and Paul Durand-Ruel in the Frances Weitzenhoffer Files, The Metropolitan Museum of Art, New York.

Correspondence of M. K. Knoedler & Co., by permission of Ann Freedman, President, Knoedler & Company, New York.

Letters from Henry James to Isabella Stewart Gardner, January 29, [1880], April 3, 1898, and February 2, 1899, Isabella Stewart Gardner Museum Archives, Boston, with the permission of Bay James, Literary Executor for the James family and the Isabella Stewart Gardner Museum.

Letters from Arthur J. Sulley to Joseph Widener, April 23, 1917, and September 26, 1921, Curatorial Files, 1942.9.1. Department of Curatorial Records, National Gallery of Art, Washington, D.C.

ILLUSTRATION CREDITS

Text

Page 2: Alice Boughton (1865/6–1943), Henry James, ca. 1906. Photograph, gelatin silver print, 20.2×13.2 cm. Gift of Allan M. Price. National Portrait Gallery, Smithsonian Institution, Washington, D.C., U.S.A. Photo credit: National Portrait Gallery, Smithsonian Institution / Art Resource, NY.

Page 11: Corsham Court. Courtesy James Methuen-Campbell, Corsham Court, Wiltshire, England.

Page 15: Picture Gallery, Corsham Court. Courtesy James Methuen-Campbell, Corsham Court, Wiltshire, England.

Page 24: John White Alexander, American (1856–1915), *Henry G. Marquand*, 1896. Oil on canvas, 198×107 cm (77^{15}/16 in.×42⅛ in.). Princeton University Art Museum. Presented by the daughters of Mr. and Mrs. Allan Marquand in 1950. PP344 © Photo: Trustees of Princeton

University. May not be reproduced without permission in writing from Princeton University Art Museum, Princeton, NJ 08544.

Page 30: Frederick, 2nd Baron Methuen. Courtesy James Methuen-Campbell, Corsham Court, Wiltshire, England.

Page 44: The Metropolitan Museum of Art Fifth Avenue façade, photographed 1917. Image copyright © The Metropolitan Museum of Art.

Page 48: Isabella Stewart Gardner, 1888. Taken by J. Thompson, Grosvenor Street, London. Isabella Stewart Gardner Museum, Boston, MA.

Page 56: Isabella Gardner and a gondolier on the Grand Canal, 1894. Isabella Stewart Gardner Museum, Boston, MA.

Page 59: "Bernard Berenson As I First Saw Him." Isabella Stewart Gardner Museum, Boston, MA.

Page 65: Bernard Berenson, 1903. The Berenson Archive, The Harvard University Center for Italian Renaissance Studies, Villa I Tatti, courtesy of the President and Fellows of Harvard College.

Page 66: Bernard Berenson and Mary Berenson, 1901. The Berenson Archive, The Harvard University Center for Italian Renaissance Studies, Villa I Tatti, courtesy of the President and Fellows of Harvard College.

Page 87: Otto Gutekunst. The Berenson Archive, The Harvard University Center for Italian Renaissance Studies, Villa I Tatti, courtesy of the President and Fellows of Harvard College.

Page 91: Isabella Stewart Gardner, ca. 1915. Courtesy of the Boston Public Library, Print Department.

Page 94: Pach Brothers (ca. 1867–1993). John Pierpont Morgan (1838–1913). Photograph by Pach Bros Studio, NY. Archives of the Pierpont Morgan Library. The Pierpont Morgan Library, New York, NY, U.S.A. Photo credit: The Pierpont Morgan Library / Art Resource, NY.

Page 103: Thomas Gainsborough (1727–88), *Georgiana, Duchess of Devonshire (1757–1806)*. Chatsworth Photo Library.

Page 111: H. O. Havemeyer and Louisine W. Elder, ca. 1883. Courtesy of Harry W. Havemeyer.

Page 122: Mary Cassatt (1844–1926), *Portrait of the Artist*, 1878. Gouache on wove paper laid down to buff-colored wood-pulp paper, 23⅝ × 16³⁄₁₆ in. (60.1 × 41.2 cm). Bequest of Edith H. Proskauer, 1975 (1975.319.1). The Metropolitan Museum of Art, New York, NY, U.S.A. Image copyright © The Metropolitan Museum of Art / Art Resource, NY.

Page 133: Paul Durand-Ruel, ca. 1910. Photo Dornac © Archives Durand-Ruel, Paris.

Page 147: Henry Clay Frick, ca. 1880. Courtesy of The Frick Collection/Frick Art Reference Library Archives.

Page 153: Adelaide Childs Frick, 1910. Falk Studio. Courtesy of The Frick Collection/Frick Art Reference Library Archives.

Page 165: Adelaide Frick and Roland Knoedler Playing Cards, Palm Beach, 1904. Courtesy of The Frick Collection/Frick Art Reference Library Archives.

Page 169: Charles Carstairs. Courtesy Charles Towers and Diana Towers McNamara.

Page 181: Cable from Charles Carstairs to Henry Clay Frick, 1906. Courtesy of The Frick Collection/Frick Art Reference Library Archives.

Page 201: Joseph Duveen, ca. 1900. Sterling and Francine Clark Art Institute Library, Williamstown, Massachusetts, from the Duveen Archives.

Page 210: Sir Joshua Reynolds (1723–92), *Elizabeth, Lady Taylor*, ca. 1780. Oil on canvas, 50⅛ × 40¼ in. (127.32 × 102.24 cm). Henry Clay Frick Bequest. 1910.1.101. Copyright The Frick Collection, New York.

Page 228: Raphael (1483–1520), *The Small Cowper Madonna*, ca. 1505. Oil on panel, 59.5 × 44 cm (23⅜ × 17³⁄₈ in.). Widener Collection, 1942.9.57. Image courtesy of the Board of Trustees, National Gallery of Art, Washington, D.C.

Page 236: Hans Holbein the Younger (1497/1498–1543), *Thomas Cromwell*, 1532–33. Oil on oak panel, cradled, 30⅞ × 25³⁄₈ in. (78.42 × 64.45 cm). Henry Clay Frick Bequest. 1915.1.76. Copyright The Frick Collection, New York.

Page 252: Arthur Morton Grenfell. Courtesy of Frances Campbell-Preston.

Page 256: Isabella Stewart Gardner, ca.1910. Courtesy of the Boston Public Library, Print Department.

Page 262: Courtyard, Isabella Stewart Gardner Museum, 1915. Isabella Stewart Gardner Museum, Boston, MA.

Page 265: John Singer Sargent (1856–1925), *Mrs. Gardner (1840–1924) in White*. Watercolor on paper. © Isabella Stewart Gardner Museum, Boston, MA, U.S.A./ The Bridgeman Art Library.

Insert

Page 1, above: Anthony van Dyck (1599–1641), *James Stuart (1612–1655), Duke of Richmond and Lennox*, ca. 1634–35. Oil on canvas, 85 × 50¼ in. (215.9 × 127.6 cm). Marquand Collection, Gift of Henry G. Marquand, 1889 (89.15.16). The Metropolitan Museum of Art, New York, NY, U.S.A. Image copyright © The Metropolitan Museum of Art / Art Resource, NY.

Page 1, below: John Singer Sargent, American (1856–1925), *Elizabeth Allen Marquand, 1887*. Oil on canvas, 169 × 107 cm (66⁹⁄₁₆ × 42⅛ in.). Princeton University Art Museum. Gift of Eleanor Marquand Delanoy, granddaughter of the sitter (Y1977–77). © Photo: Trustees of Princeton University. May not be reproduced without permission in writing from Princeton University Art Museum, Princeton, NJ 08544.

Page 2, above: Johannes Vermeer (1632–75), *Young Woman with a Water Pitcher*, ca. 1662. Oil on canvas, 18 × 16 in. (45.7 × 40.6 cm). Marquand Collection, Gift of Henry G. Marquand, 1889 (89.15.21). The Metropolitan Museum of Art, New York, NY, U.S.A. Image copyright © The Metropolitan Museum of Art / Art Resource, NY.

Page 2, below: Johannes Vermeer (1632–75), *The Concert*, ca.1665. Oil on canvas. © Isabella Stewart Gardner Museum, Boston, MA, U.S.A./ The Bridgeman Art Library.

Page 3, above: John Singer Sargent (1856–1925), *Isabella Stewart Gardner* (1840–1924), 1888. Oil on canvas. © Isabella Stewart Gardner Museum, Boston, MA, U.S.A./ The Bridgeman Art Library.

Page 3, below: Rembrandt Harmensz. van Rijn (1606–69), *Self Portrait*, 1629. Oil on panel. © Isabella Stewart Gardner Museum, Boston, MA, U.S.A./ The Bridgeman Art Library.

Page 4: Titian (Tiziano Vecellio) (ca. 1488–1576), *Europa*, 1560–62. Oil on canvas. © Isabella Stewart Gardner Museum, Boston, MA, U.S.A./ The Bridgeman Art Library.

Page 5, above: Raphael (Raffaello Sanzio) (1483–1520), *Madonna and Child Enthroned with Saints*. Altarpiece, ca. 1504. Oil and gold on wood; main panel, overall 67⅞ × 67⅞ in. (172.4 × 172.4 cm), painted surface 66¾ × 66½ in. (169.5 × 168.9 cm); lunette, overall 29½ × 70⅞ in. (74.9 × 180 cm), painted surface 25½ × 67½ in. (64.8 × 171.5 cm). Gift of J. Pierpont Morgan, 1916 (16.30ab). The Metropolitan Museum of Art, New York, NY, U.S.A. Image copyright © The Metropolitan Museum of Art / Art Resource, NY.

Page 5, below: Sir Joshua Reynolds, British (1723–92), *Lady Elizabeth Delmé and Her Children*, 1777–79. Oil on canvas, 239.2 × 147.8 cm (94⅛ × 58⅛ in.) Andrew W. Mellon Collection, 1937.1.95. Image courtesy of the Board of Trustees, National Gallery of Art, Washington, D.C.

Page 6, above: El Greco (1541–1614), *Portrait of a Cardinal, Probably Cardinal Don Fernando Niño de Guevara* (1541–1609), ca. 1600. Oil on canvas, 67¼ × 42½ in. (170.8 × 108 cm). H. O. Havemeyer Collection, Bequest of Mrs. H. O. Havemeyer, 1929 (29.100.5). The Metropolitan Museum of Art, New York, NY, U.S.A. Image copyright © The Metropolitan Museum of Art / Art Resource, NY.

Page 6, below: Edgar Degas, *At the Louvre*, ca. 1879. Pastel on seven pieces of paper joined together, 28 × 21¼ in. (17 × 54 cm), Vente stamp lower right. Private Collection. Courtesy Sotheby's, New York.

Page 7, above: Rembrandt Harmensz. van Rijn (1606–69), *The Polish Rider*, ca. 1655. Oil on canvas, 46 × 53⅛ in. (116.84 × 134. 94 cm). Henry Clay Frick Bequest. 1910.1.98. Copyright The Frick Collection, New York.

Page 7, below: Rembrandt Harmensz. van Rijn (1606–69), *Self-Portrait*, 1658. Oil on canvas, 52⅝ × 40⅞ in. (133.67 × 103.82 cm). Henry Clay Frick Bequest. 1906.1.97. Copyright The Frick Collection, New York.

Page 8, above: Giovanni Bellini (ca. 1430–1516), *St. Francis in the Desert*, 1480. Oil and tempera on poplar panel, 49 × 55⅞ in. (124.46 × 141.92 cm). Henry Clay Frick Bequest. 1915.1.03. Copyright The Frick Collection, New York.

Page 8, below: Giovanni Bellini, Venetian (ca. 1430/1435–1516). Titian, Venetian (ca. 1490–1576), *The Feast of the Gods*, 1514/1529. Oil on canvas, 170.2 × 188 cm (67 × 74 in.). Widener Collection, 1942.9.1 Image courtesy of the Board of Trustees, National Gallery of Art, Washington, D.C.